Editorial Director
Myrna Davis

Editor & Copy Editor
Emily Warren

Design
Giampietro+Smith

Production Assistant
Diana Meyerson

DVD Title Design
Matt Sung

Editorial Assistant
Kate Farina

Publisher
RotoVision SA
Route Suisse 9
CH-1295 Mies
Switzerland

Sales & Editorial Office
Sheridan House
114 Western Road
Hove, East Sussex
BN3 1DD, United Kingdom
Tel: +44 (0) 1273 727268
Fax: +44 (0) 1273 727269
sales@rotovision.com
www.rotovision.com

ADC
The Art Directors Club
106 W.29th St.
New York, NY 10001
United States of America

www.adcglobal.org

ISBN
978-2-940361-79-3

Paul
Lavoie
President

new forms of visual expression. And in the process
continued to challenge its members to strive for the
of expression within all media. The paradox of this l
legacy of youthful curiosity, continually preoccupie(
and defining future modes of expression over dwel

That spirit lives in this the 85th ADC Annual, judge(
group of talented creative men and women from ar
They were unbiased in their review and they were ri
final selections.

If your work has been published in this annual you s
proud, your work forms Chapter 85 of a prestigious
design and advertising ranks that include Charles E
Brodovitch, Richard Avedon, Paul Rand, Walt Disn
Ikko Tanaka, Bill Bernbach—and of course some o
innovative creatives working around the globe tod

As President of the Art Directors Club of New York,
in three dimensions. Past. Present. Future. The ADC
from its extraordinary foundation of creative history.
of the ADC board and staff, I am committed to uph(
and relevance of the club in the present to creative p
anywhere in the world. From a more accessible clut
program of activities, to expansion of the existing
And through the Young Guns program and educatic
workshops, the ADC aims to guide and inspire the r

These pages continue a great legacy; celebrate the
moment; and most of all strive to pique all of our cu
the future. Enjoy.

Myrna
Davis
Executive
Director

Art Directors Annual 85 represents the newest installment in the longest-running archive in the world of advertising and design. This is work singled out by peers that points the future of the industry. Begun in 1920 with a competition, exhibition of winners, and a book, the 85 Annuals published to date constitute an unparalleled resource for creative professionals and students. "This," an eminent creative director stated, "is where you take your place in history."

ADC's 85th Annual Awards Competition drew 11,531 entries from 51 countries. 440 winners made the cut. We are proud to present the year's best creative work in advertising, design, interactive media, illustration, photography and other convergent means of visual communication worldwide. Each represents innovation and excellence in its category on a global playing field.

The judges, award winners themselves, were drawn from around the world to meet at the ADC in New York for days of intensive review. The process is as fair as we can make it. There is no prescreening. Every single entry is looked at by multiple independent judges. Their votes are secret. After the final round, they view together all fiinalists in their category—Advertising, Interactive, Design, Photography, Illustration— to get a complete overview. The juries' choices are free of any concerns other than merit. Concept, innovation, execution. What is distilled will excite and inspire.

The ADC Annual Awards also supports our vital educational programs including scholarships, portfolio reviews, The ADC Hall of Fame, speaker events and symposia, exhibitions, and Saturday workshops to introduce talented high school juniors to careers in these fields. Highlights from the year's activities are featured in the section, "ADC Now."

Have a great year with this book. And send us your best for the next one.

Judges
Advertising

KEVIN RODDY
CHAIR
Advertising, Hybrid
Kevin Roddy is the Executive Creative Director of BBH New York and sits on the BBH Group Board. Having begun his career in account management, he says his switch to the creative side has been "a good decision." As a copywriter/creative director, Kevin has worked at many great agencies including Fallon and Cliff Freeman and Partners. During this time he's worked on a variety of clients including Little Caesars, Coca-Cola, Starbucks, Volvo, Timberland, *TIME* and *Sports Illustrated* magazines, FOX Sports, and FX Network. Kevin has also won his share of awards including ADC cubes, D&AD pencils, Cannes Lions, Clios, One Show pencils, and many others. In fact, Kevin is the only person to ever win the One Show's "Best of Show" award, twice.

GREG BOKOR
Advertising
Greg Bokor left his last agency, Mullen, in the late spring of 2004 to be in the position to act on any idea that he was excited about. So far the majority of his professional time has been spent freelancing. Working on 50 different brands in a year and seeing the workings of dozens of shops has been extraordinary. His new company Cloud Factory is set up to service the advertising world as well as any other world that is exciting. Last work worth noting: Swiss Army, L.L. Bean, Four Seasons. Proudest accomplishment (professional): running a group with Jim Garaventi (partner), Michael Hart, Chris Lange, Gerard Caputo, Monica Taylor, Dylan Lee and Susan Ebling.

JEROEN BOURS
Advertising
Jeroen is Executive Creative Director, Hill Holliday, New York. As a foreign creative working in New York in the 1980s, Bours worked his way up through various small and large agencies, from Ammirati & Puris, to the New York office of Armando Testa Milano, to DDB Worldwide, McCann-Erickson Worldwide, Ogilvy & Mather Worldwide, and now, Hill Holliday. Jeroen is credited with creating the famed MasterCard "Priceless" campaign. At Ogilvy, he helped introduce mLife for AT&T Wireless and American Express's Blue Card, and was responsible for the launch of the new BP campaign. Jeroen was born in Holland but left for Israel to begin his advertising and design career. He speaks four languages and lives in New York with his wife Robin and sons Benjamin and Aaron.

PINIT CHANTAPRATEEP
Advertising
Pinit is the Deputy Chairman, Chief Creative Officer, JWT Thailand. He has championed creativity at JWT Bangkok for over ten years. In that time, the agency has become a creative powerhouse. His guidance has resulted in prestigious new business acquisitions and numerous awards from both local and international shows, including Cannes, D&AD, Clio, New York Festivals, AAA and Adfest. Outside the agency, Pinit is an active committee member of the Bangkok Art Directors Club and Adman Awards, and has served on judging panels at some of the worlds most influential awards shows such as Clio, LIAA and D&AD.

GRAHAM CLIFFORD
Advertising
Graham was trained as a typographic designer. He worked for some of London's best advertising agencies before moving to New York to TBWA\Chiat\Day and Ogilvy. He opened his own design consultancy 12 years ago, collaborating with agencies and clients on advertising, logo design and brand identity. Recent assignments include packaging for Moby's Teany brand, One Show Annual cover, Virgin Atlantic's *Jetrosexual Magazine* and Molson Twin Technology. This year he was appointed to the Board of Directors of the Type Directors Club. Awards include the One Show, Communication Arts, Type Directors Club, ADC, Cannes Lion and a silver at D&AD.

DAVID CRAWFORD
Advertising
As a Senior VP, Group Creative Director at GSD&M, David has been accountable for all creative strategies and campaigns for Kohler Company, Norwegian Cruise Lines, American Legacy Foundation, Krispy Kreme Doughnuts and BMW. His account experience includes Land Rover North America, Pennzoil, Texas Tourism, North Carolina Tourism, Southwest Airlines, Piedmont Airlines, Rolling Stone, RC Cola, Americans for the Arts and Rock the Vote. Awards include Communication Arts, One Show, Cannes, ADC, the Athena's and Addy's. David was also selected as an ADWEEK Creative All-Star.

SUSAN CREDLE
Advertising

Susan Credle, an AAF Hall of Achievement inductee, began her BBDO career in 1985 after graduating from the University of North Carolina at Chapel Hill. Currently, she is EVP, Executive Creative Director and a member of the Board of Directors of BBDO New York. Under her direction, the ubiquitous M&M's spokes-candy advertising has become part of global pop culture. As co-creative leader, Susan helped land and put Cingular on the map. She also contributes to other accounts including Armstrong, FedEx, Lowe's, Masterfoods and Pepsi. Susan's work has won at Cannes, New York Festivals, LIAA, Effies, Communications Arts and more.

HAL CURTIS
Advertising

A native Texan, Hal has a marketing degree from Southern Methodist University in Dallas, Texas and a fine arts degree from Art Center College of Design in Pasadena, California. He has been at Wieden+Kennedy since 1994, and a creative director on Nike since 1997. Hal's work includes "What are you getting ready for?", "The Morning After," "Hackeysack," "Freestyle," "What if" and "Move." He's a four-time Emmy nominee and has won two. Awards include D&AD, The Art Directors Club, The One Show, Communications Arts, MoMA, Graphis and Cannes. He is a member of the Board of Directors of VCU's AdCenter and a mentor to students in advertising at the University of Oregon.

DAVE DOUGLASS
Advertising

A graduate of Ontario College of Art, Dave started out creating insightful work for Lexus, Toyota, Mackenzie Financial and Children's Aid. He accepted a position in London, England where he developed successful campaigns for British clients such as Hamlet Cigars, McEwans Lager, Hampton Court Palace and the Tower of London. Since returning to his beloved homeland, Dave has been recognized for his work on Alexanders Keith's, Budweiser, Rogers AT&T, General Motors, Lexus, Motrin, Quaker, Stella Artois, and others. Most recently as Group Creative Director/Art Director at TAXI, Dave has continued to be recognized with Astral Media – The Movie Network, The Canadian Film Centre, Molson Canada and Robert Bosch Inc. – SKIL.

MATT ELHARDT
Advertising

Matt started at Fallon McElligott on Coca-Cola, Children's Defense Fund, and Northwest Airlines. From there went to Hunt/Adkins, on Rohol Liquer, REV 105 Radio, and Cape Cod Potato Chips. In 1996, he moved to Wieden+Kennedy returning to Coca-Cola, and creating memorable work for Barq's Root Beer, Nike and ESPN. After freelancing in Southeast Asia, Matt moved to San Francisco, on Adidas, CNET and KQED Public Television at Leagas Delaney. After a stint at Goodby (HP, Oakland A's and Saturn), he went to Publicis & Hal Riney as a VP/Associate Creative Director on Sprint, Hewlett-Packard, and Jamba Juice. 2005 brought TBWA\Chiat\Day, NY as Group Creative Director on the Sprint/Nextel, Embassy Suites, American Century Investments and Stonyfield Yogurt. He now freelances. Awards include One Show, ADC, Cannes, D&AD, Andy Awards, CA and Clio Awards.

ÁTILA FRANCUCCI
Advertising

Founder, Famiglia. After working for DPZ, Almap/BBDO, and Young & Rubicam in Brazil, Átila became Creative Vice-President of Lowe Lintas in 1999. A year later, he started his own advertising agency, Cápsula, which in six months became TBWA\Cápsula. In 2002, Francucci became national creative director of Fischer América, and in 2004, co-president and creative VP of JWT Brazil, where he was named Chief Creative Officer in 2005. He is a member of the Worldwide Creative Council. Awards include 12 Lions, London Festival, New York Festival, ADC, and One Show. Clients include VW, Ford, Renault, Unilever, Banco Real, Citibank, Banco Itaú, Danone, Vivo, Electrolux, LG, Monsanto, Toyota, and Schincariol.

JENS GEHLHAAR
Advertising

Jens Gehlhaar is Creative Director at Brand New School, a bicoastal collective of directors and designers. He has been responsible for the on-air identities of VH1 Classic, Fuel TV and IMF, and the look for MTV Sunday Stew's first four seasons. His directing credits include a music video for Muse, a campaign for the VW Beetle and 25 shorts for the VW Passat. Before joining Brand New School, Jens worked as an art director for Wieden+Kennedy, ReVerb, Imaginary Forces and Dreamworks. He has taught typography at both CalArts and Art Center College of Design.

JAE GOODMAN
Advertising

Jae Goodman is Co-Executive Creative Director at Publicis & Hal Riney, where his clients include Sprint, HP, 24 Hour Fitness, and Jamba Juice. He began his career as an account guy, but "saw the light" and became a copywriter at Wieden+Kennedy and Leagas Delaney, working on Virgin Mobile, Mavi Jeans, Sega, Linkin Park, Sun Microsystems, Microsoft and many more. Jae's work has been recognized by award shows and annuals alike, but he is most proud of his 2005 MVPA award for a Fatboy Slim video he co-wrote with director Brian Beletic. An early believer in the collision of advertising and entertainment, Goodman consults on music videos for a variety of artists and directors, and he creates and executive produces television shows.

GERRY GRAF
Advertising

Graf began as a stockbroker, but once he realized that advertising offered him a chance to write, he did an internship program at Saatchi, landing his first job at Wells Rich Greene. In 1994, he joined BBDO where he created Snickers "Not going anywhere for a while?" campaign, which Adweek named campaign of the year in 1997. Then he joined Goodby, Silverstein on Nike, Budweiser, and Isuzu. He created the "It's time for E*Trade" campaign, whose "Monkey" spot was named to the top 5 Super Bowl commercials of all time by USA Today. He returned to BBDO as executive creative director on FedEx, Guinness, Red Stripe, and Harp Lager. Now at TBWA\Chiat\Day, he works on Absolut, Nextel, Skittles, Starburst and Embassy Suites. Awards include D&AD, Clios, One Show, Cannes Lions and Emmy's.

MARK GROSS
Advertising
Senior VP & Group Creative Director, DDB Chicago. With a BFA in Advertising Design from Syracuse University, Mark began his advertising career in 1990 in New York designing movie titles and logos for post-production house R. Greenberg Associates. Mark then landed a junior art director position at TBWA\Chiat\Day in 1991, on accounts such as MTV, Reebok, American Express and New York Lottery. At DDB, Mark created the Bud Light "Real Men of Genius" campaign, now known as the most-awarded radio campaign in advertising history. Awards include Andy's, Clios, Radio Mercury Awards, Kinsale Awards, One Show, D&AD, ADC, New York Festivals and the Grand Prix for radio at Cannes.

MIKE HOWARD
Advertising
Mike is a writer at Crispin Porter + Bogusky. Mike has produced work for a number of accounts, including the American Legacy Foundation's truth campaign, EarthLink, GAP, and, most recently, he was one of the creatives responsible for CP+B's very first work for Volkswagen of America.

MIKE JOYCE
Advertising
Mike Joyce is the founder of Stereotype Design in New York and formerly an art director at MTV Networks. Before that, he was the creative director at Platinum Design. He has designed CD packaging for established artists and upstarts, from Iggy Pop and Natalie Merchant to Fall Out Boy and Robbers on High Street. Stereotype's work has been featured in publications such as *IdN, Print, Communication Arts, HOW, Rolling Stone* and *+81*. Exhibitions include the AIGA, Type Directors Club, The One Show, ADC's first Young Guns show, and the Permanent Collection of the Library of Congress. In 2004 Mike was selected to co-chair ADC Young Guns 4. He also teaches typography and design at the School of Visual Arts in Manhattan.

MARC LUCAS
Advertising, Hybrid
Marc Lucas in 50 words or less: career = design student, copywriter, creative director - Ball Hong Kong, Chiat New York, Ogilvy New York, Ogilvy Manila, D'Arcy Hong Kong, freelance, SS+K New York. Awards = yes. Personal = father, motorcyclist, traveler, cook, reader, writer, cook + ad geek.

BILL MORDEN
Advertising
Chief Creative Officer, BBDO Detroit since 2002. Bill is responsible for the DaimlerChrysler, Jeep, Chrysler, Dodge and Mopar brands. He led the repositioning of Dodge to "Grab Life by the Horns," and developed the Jeep brand for 11 years. Bill has put his creative stamp on work such as Chevrolet's "Heartbeat of America," Hush Puppies' "We invented Casual," Coleman outdoor gear, and Ford's "Have you driven a Ford lately" while working at JWT, Leo Burnett, Campbell-Ewald, Bozell and FCB. Awards include Cannes Gold and Silver Lions, Andy's, Clios, International Automotive Advertising Awards, AAAA O'Toole Awards, Addy's, Mobius Awards, ADC, among others, and "Best of Show" for 9 years at the Detroit Caddy Awards.

KIM PAPWORTH
Advertising
Being a dyslexic mushroom farmer, it was only a matter of time before Kim moved into the world of advertising. After graduating from Epsom College of Art & Design in 1981, he landed his first job at Demonde, followed four years later by BMP. It was here he teamed up with Tony Davidson, working on such clients as VW, Courage and Heinz. After 10 years, Kim and Tony moved away from Paddington and into Leagus Delaney, creating work for Adidas, Hyundai, Guardian and the BBC. 1992 saw them move to BBH, where they worked on Levis, Audi, One2One and Lynx. In 2000, Kim became joint Creative Director of Wieden+Kennedy with Tony, working on clients such as Nike and Honda.

BOB RANEW
Advertising
Bob Ranew is SVP/Associate Creative Director at McKinney in Raleigh, NC. Bob graduated from Ringling School of Art with an Illustration major. After working for 3 years as an illustrator thought he'd try his hand at art direction and never looked back. Bob joined McKinney in 1992. After taking a few years off to stretch his wings, quickly returned. In 1997 produced one of the first spots to take on a viral life of it's own for SmartBeep. Other clients include Audi, Royal Caribbean Cruise Lines, Karastan and Sony. Bob's has been awarded pencils from The One Show, numerous Awards of Excellence from *Communication Arts,* Art Directors Club, Cannes and Clio awards. Bob and his wife, Trudi, are proud parents of two teenage daughters, Marley and Jordan.

GUY SEESE
Advertising
Under Guy's leadership at Cole & Weber, the agency was named by Brandweek as a 2005 Guerrilla Marketer of the Year, among other accolades. His multi-media campaign for Rainier Beer won AICP/AdAge's inaugural Battle of the Brands, Best of Show at the Addy's, a gold Clio and the only ADC Hybrid gold cube. Previously, Seese worked on brands (Intel, Volvo, MCI Worldcom, Evian) at Euro RSCG New York. After 4 years as senior art director, he joined Mad Dogs and Englishmen as partner and creative director. Awards include *Archive Magazine, Communication Arts,* the Clios, Kelly's, Cannes, ADC and *Graphis.* In 2004, *Graphis* featured his retrospective, calling him an "international creative leader." Seese recently joined Goodby, Silverstein and Partners.

JOANNE THOMAS
Advertising

Joanne is a founding member of The Jupiter Drawing Room, Cape Town where she is an art director on advertising and a creative director on design. Besides awards at both ADC and One Show, her work has had nominations in D&AD, Gold at London's Design Week awards and acceptance into *Communication Arts*. She has spoken at the prestigious International Design Indaba, which takes place in Cape Town every year. Again using Jupiter's achievements to highlight the strength of "through-the-line" thinking, her talks opened up the debate of an "ad" agency's ability to produce award-winning design.

LO SHEUNG YAN (MaYan)
Advertising

Lo Sheung Yan is Executive Creative Director of JWT Northeast Asia, since 2001. Known as MaYan, he infuses his work and his creative department with a love of life. "You need to have a real life in order to be inspired. Advertising is about humanity. If we live a real life, then inspiration comes from our family, our friends, our surroundings." He worked as a secondary school teacher, amateur stage actor, and Cantonese pop song lyricist before trying his hand at copywriting. MaYan joined JWT in 1996, helping put the Shanghai office at the forefront of the Asian creative scene. His award-winning work includes Nike, 999 Pharmaceuticals, *TIME*, Unilever, Panasonic, and Siemens.

Judges
Graphic Design

BRIAN COLLINS
CHAIR
Graphic Design, Hybrid
Brian is the Executive Creative Director of the Brand Integration Group, Ogilvy & Mather. Clients include American Express, Mattel, Hershey's, Motorola, Kodak, *National Geographic,* and The Dove Company. Team projects include the design of a 15-story chocolate factory in Times Square for Hershey's, a new global design system for Coca-Cola, Kodak's new brand identity program, and the CNN Diner in New York City. BIG produced the NY Times best seller *Brotherhood*, a pictorial review of the lives of New York firefighters in the aftermath of 9/11. Done in partnership with American Express, the book raised over $1 million for city charities. *Fast Company* recently named Brian as the Peak Performer in Design for 2005.

CHUCK ANDERSON
Graphic Design
Chuck Anderson is a freelance artist from Tinley Park, IL who has been working as NoPattern since early 2004, less than a year after he finished high school. Since the start of his career, Chuck has had the opportunity to work for clients like ESPN, *Teen People,* Absolut Vodka, Earthlink, McDonalds, and Microsoft, to name a few. Most recently, Chuck collaborated with Reebok to create a line of shoes, shirts, hats, and other apparel called the "DJ" series. Chuck has also spoken at the Semi-Permanent Design Conference in New York at Lincoln Center, the University of Cincinnati, and is lined up to speak in Mexico City at OFFF, Toronto, CA at FITC, and Columbia College Chicago.

PETER BILAK
Graphic Design
Peter studied in England, USA, France, The Netherlands, and Slovakia. Before starting his studio in The Hague, he worked at Studio Dumbar. Presently, he works in editorial, graphic and type design, on projects such as the stamp design for the Dutch Royal mail, a series of dance performances, design of Arabic fonts, designing books and publications for The Hague art center, exhibition design at the Dutch Architectural Institute, and curating exhibitions at the Biennale of Graphic Design, Brno. Peter has designed several fonts including Eureka and Fedra. With Stuart Bailey, Peter co-founded, edits and designs *Dot Dot Dot,* an art and design magazine. He teaches

WESTON BINGHAM
Graphic Design, Hybrid
Weston joined Wolff Olins as Creative Director, developing brands for The New Museum of Contemporary Art and Gap. Prior to Wolff Olins, he was a Creative Director at BIG, Ogilvy & Mather, on Kodak, Sprite, DuPont and AT&T Wireless/Ogo. He was a Creative Director at the dot-com marchFIRST, working with Saks Fifth Avenue and NTT DoCoMo, and co-founded Deluxe Design for Work + Leisure for cultural and non-profit projects. He received his BFA from Pratt Institute and his MFA from CalArts, working for Paula Scher and Chermayeff & Geismar in between. His work has been recognized and published internationally, and he has

HANS DIETER
Graphic Design
Hans has been Publisher, Editor and Art Director of *Baseline* since 1995. Since 1993, he has also been Director of the design company HDR: Visual Communications; clients include Rockport, Phaidon, Linotype AG, Mercedes Benz AG, Norman Foster Architects Ltd., Maiden Media, British Museum, and Milton Keynes Theatre. Hans is a member of AGI, an Honorary Fellow of the Grafic Biennale in Brno, the Royal Society of Arts and the International Society of Typographic Designers. Hans has served as external assessor and lecturer at the Universities of Reading, Bath Spa, Northampton and in honor of his academic

STEPHEN DOYLE
Graphic Design
Stephen Doyle is creative director at Doyle Partners, a New York-based design studio that specializes in not specializing. Notable projects include branding and packaging Martha Stewart Everyday for its first five years in Kmart, identities for Barnes & Noble, The St. Regis Hotel, the World Financial Center, Clarence House and Tishman Speyer. The studio's range is demonstrated by its use of 4-point type in *Spy Magazine* and 9,826 point type on the floor of Grand Central Terminal. *I.D.* reports that he "rejects fashionable styles in favor of solid, functional approaches rooted in concept, not adornment . . . all without losing his sense of humor."

WILLIAM DRENTTEL
Graphic Design
William Drenttel is a designer and publisher who works in partnership with Jessica Helfand at Winterhouse, a design studio in Northwest Connecticut. He is president emeritus of the AIGA, a trustee of the Cooper-Hewitt National Design Museum, and a Fellow of the New York Institute of the Humanities at New York University.

ELLIOTT EARLS
Graphic Design
Elliott was appointed Designer-in-Residence and Head of the Graduate Graphic Design Department at Cranbrook Academy of Art in 2001. His posters "The Conversion of Saint Paul," "Throwing Apples at the Sun," "The Temptation of Saint Wolfgang" and "She a Capulet," are in permanent collection at the Cooper-Hewitt and Smithsonian. With Émigré, Inc., he released "Catfish" in 2002, a documentary of his work, using animation, stop motion photography, drawing, typography and live action. Earls was awarded an Emerging Artist grant by Manhattan's Wooster Group, with whom he was a featured performer in 1999. Earls spent 2000-2001 as a designer-in-residence at Fabrica, Benetton's studio/research center in Treviso, Italy.

GENEVIEVE GAUCKLER
Graphic Design
Genevieve is a Paris-based artist with broad experience in graphic design, illustration and art direction. Starting with French record company F Communications, she later worked with Kuntzel & Deygas on music videos, commercials, titles and short movies. In 1999, she created boo.com's online fashion magazine, and then went to London where she helped create a new version of the same site. While there, she developed web projects for Me Company. Since 2001, she has done videos with Pleix, websites, illustrations, and character design. She also created the comic book, *L'Arbre Genialogique*. In 2004, she held 2 exhibitions with the Colette store in Paris and Colette Meets Comme Des Garçons store in Tokyo.

ROB GIAMPIETRO
Graphic Design
Rob is a principal of Giampietro+Smith, a New York design studio founded with Kevin Smith focusing on editorial and strategic design for cultural, non-profit, and corporate clients including Gagosian Gallery, Knoll, Creative Time, *The New York Times Magazine,* The Global Fund to Fight AIDS Tuberculosis & Malaria, the United Nations, and the NYC2012 Olympic Bid. Rob is currently a Senior Thesis instructor in the Communication Design program at Parsons, a branding columnist for *BusinessWeek* Online, a contributor to *Dot Dot Dot,* and Co-Creative Director of *Topic Magazine.* Awards include *I.D., Print,* the Type Director's Club, and AIGA.

BARBARA GLAUBER
Graphic Design
Barbara Glauber is the principal of Heavy Meta, a graphic design studio based in New York. In 1993, she curated the exhibition "Lift and Separate: Graphic Design and the Quote Unquote Vernacular" at the Cooper Union and edited the accompanying publication. She served as the chair for the eighteenth annual American Center for Design 100 Show and is a founding partner of the Smoking Gun website. Occasionally, she works as a creative director on large-scale projects with the Brand Integration Group of Ogilvy & Mather. Her work is in the collection of the Cooper Hewitt National Design Museum and has won numerous awards. In 1984, she received a BFA from SUNY Purchase and in 1990, an MFA from California Institute of the

NANCYE GREEN
Graphic Design, Hybrid
Nancye began her career as a designer, founding Donovan and Green, a design and marketing communications consultancy with Michael Donovan. Clients include Pleasant Company, Sony, Hoffman La Roche, and the Ronald Reagan Presidential Library. Most recently, she co-founded EQmedia, to bring high quality products to market through infomercials and home shopping. She is past President of AIGA and the International Design Conference in Aspen. In 1998, she received an honorary doctorate from The Corcoran School of Art in Washington, DC. She is on the Board of Directors of Hallmark Cards and Waterworks, and the Design Advisory Board of Procter & Gamble and is a non-executive director of the UK and US brand con-

CHARLES HALL
Graphic Design
Charles Hall is your midnight, cupid, pimp, lover, fighter, linebacker, poet, chocolate bubble bath, skinny dippin', bon vivant, jester, prince. A corporate concubine for The Office of Brand Affairs in New York, he is best known for his work on the NYC 2012 Olympic Bid Committee, Jordan Brand, Nike New York, Bridge Runners, Reebok, the L.A. Commission on Assaults Against Women and Benetton SportSystem. His short film "Are You Cinderella?" was honored at the Toronto Film Festival, FESPACO, Urban World and sold to HBO. Charles is also the founder and designer of Fat Daddy Loves You Bath Couture, a luxury brand that tailors chic and sexy bath coats for fabulous men and women.

DIMITRI JEURISSEN
Graphic Design
Dimitri co-founded graphic design studio Traces de Doigts in Brussels. The agency specialized in creative direction and brand development, and in 1998 changed its name to Base and opened studios in New York and Barcelona. Today Base has 5 offices, its most recent additions in Paris and Madrid. Base's diverse clients include MoMA, Puma, L'Oréal, the European Socialist Party, and Wrangler. The work is always in the context of a collective "Base" contribution, characterized by a conceptual approach. Jeurissen has spoken at conferences and workshops at La Cambre (his alma mater) and the Design Academy in Eindhoven, Belgium, as well as the 2005 Designthinkers conference in Toronto.

HARMINE LOUWÉ
Graphic Design
Harmine is a graphic designer living and working in Amsterdam. She graduated from the St. Joost Art Academy in Breda, followed by a position at Studio Dumbar. Since then she has worked independently for clients such as government-related corporations, cultural institutes and independent artists. She worked as an illustrator and freelance art director for Wieden+Kennedy and Kesselskramer in Amsterdam. Her work has been published in *Eye, Idea, Items and Experience, New Typographics 2,* "And She Told Two Friends" (curated by Kali Nikitas), *Corporate Profile Graphics nr. 3, Studio Dumbar: Behind the Seen, Graphic Design* and "Typography in The Netherlands," and *Apples and Oranges and False Flat.*

BOBBY C. MARTIN, JR.
Graphic Design
Bobby is Design Director at Jazz at Lincoln Center. With a BFA in Illustration and Communication Arts & Design from VCU, he began at newspapers, and then became art director at Gear and Yahoo! Internet Life magazines. He took a two-year hiatus for his MFA in Design at the SVA. For his graduate thesis, he developed a comprehensive visual identity for the Abyssinian Baptist Church of Harlem, and went on to create their regional public service billboard campaign with a Sappi "Ideas that Matter" grant. He is currently developing Abyssinian's bicentennial campaign "Abyssinian 2000." Previously, he worked at BIG at Ogilvy & Mather. Recent clients include NYC2012, CNN, Coca-Cola, and *NYT Magazine.*

REBECA MÉNDEZ
Graphic Design
Rebeca is Professor at UCLA Design | Media Arts Department in L.A. Born and raised in Mexico City, she received her BFA and MFA from Art Center College of Design in Pasadena. Her career covers various areas of practice—academic, social, cultural and corporate. She runs Rebeca Méndez Communication Design whose collaborations include video artist Bill Viola, architect Thom Mayne of Morphosis, and film director Mike Figgis, and clients such as Caltech, Microsoft, Guggenheim, Whitney and MoCA. From 1999-2003 she was creative director of BIG, at Ogilvy & Mather, NY and L.A. She lectures internationally, and her work has been the subject of numerous publications and exhibitions.

CRAIG MOD
Graphic Design
Craig Mod is a Tokyo-based partner and art director for Chin Music Press, a small, progressive publisher in Seattle. Mod led the company's branding efforts after its inception in 2002, designed its first two hardback books and played the lead role in several web-based projects, including buzztracker.org. He also runs the company's Japan-based design studio. Recent clients include Dentsu, Mitsubishi Estates, Knee High Media and Toppan Printing, where Mod acts as a design consultant. Mod studied fine arts and computer science at the University of Pennsylvania where he received a B.S.E. He also graduated from Waseda University's intensive Japanese language research program.

NOREEN MORIOKA
Graphic Design
Noreen is a partner at AdamsMorioka in Los Angeles. The firm's philosophy spearheaded a revolution in the design community from chaos and complexity, to honesty and simplicity. Awards include *Communication Arts,* AIGA, *Graphis,* Type Directors Club, The British ADC, *I.D.,* and ADC. In 2000, San Francisco MoMA exhibited AdamsMorioka in a solo retrospective. Adams and Morioka were named to the I.D. Forty, and are Fellows of the International Design Conference at Aspen. Noreen is a past president of AIGA L.A. and chair of the AIGA National President's Council. AdamsMorioka's book, *Logo Design Workbook* was published in 2004. Clients include ABC, Adobe, Gap, Old Navy, Frank Gehry Associates, Nickelodeon, USC, Sundance and The Walt Disney Company.

LEIGH OKIES
Graphic Design
Leigh Okies is a design lead at Stone Yamashita Partners in San Francisco. After getting a BFA in theater design from the Claremont Colleges, she worked as a costume designer on several feature films, theater and opera. Later she studied graphic design at Art Center College of Design, where she co-art directed *Fishwrap Magazine,* since instituted at the school as a quarterly publication. Clients include Coca-Cola, Dove, Amex and IBM. She designed book covers for Random House's designing Pantheon Books, and co-taught a class at SVA in New York. She was published in the "new visual artist's" issue of *Print* in 2005, which features designers under thirty, as well as *STEP Magazine's* "field guide," an article about new young designers.

DAN OLSON
Graphic Design
As Duffy & Partner's Creative Director, Dan has lead multi-disciplinary branding for clients such as Coca-Cola, The Thymes, Toyota, and the Islands of the Bahamas, which have been recognized by virtually every major design competition. Dan first partnered with Joe Duffy in 1994, pioneering the field of interactive design. At Duffy, he has worked on brands such as Nikon, Qualcomm, BMW, Jim Beam, United Airlines, EDS, and International Trucks. Prior to Duffy, Dan was a principal in his own firm, Olson Johnson Design. He studied art and graphic design at the University of Minnesota and Minneapolis College of Art and Design and his work is featured in many permanent design collections.

YUKO SHIMIZU
Graphic Design
Yuko worked in PR in Japan for 11 years before starting her career in the US in illustration. She worked on advertising campaigns for TARGET, promotional projects for NPR and MAC Cosmetics, and works regularly for *The New Yorker.* Other clients include *Rolling Stone, SPIN, VIBE, Interview, Premiere, Entertainment Weekly, NYLON, Fortune, The New York Times, Wall Street Journal* and *Financial Times.* Awards include Society of Illustrators, American Illustration, *Communication Arts,* Society of Publication Designers and New American Paintings. Yuko was chosen as one of "150 top working illustrators" by Taschen, in *"Illustration Now!"* At SVA, Yuko teaches senior Illustration and Cartooning students business and marketing, utilizing her PR and illustration experience.

Judges
Illustration

PAUL DAVIS
CHAIR
Illustration, Hybrid
Paul was first published in *Playboy* in 1959, the year he joined Push Pin Studios. He began his freelance career in 1963 and since then his work has appeared in *Time, Rolling Stone, The New York Times, The New Yorker, Fast Company, Wired, Vanity Fair* and *GQ.* Davis served as art director for New York Shakespeare Festival and for *Wig Wag* and *Normal* magazines. Recent clients include *GQ, The New York Times,* The Geffen Playhouse, A&E television network and Saatchi & Saatchi. He has had numerous one-man exhibitions in galleries and museums in Europe, the U.S. and Japan. Paul is a faculty member at SVA, a fellow of the American Academy in Rome, and in the ADC Hall of Fame.

EMILY CRAWFORD
Illustration, Hybrid
Emily Crawford is the Design Director of *Travel+Leisure* in *New York.* From 1996 to 2002, she worked as Deputy Art Director at *Fast Company* magazine in Boston. During her tenure there, the magazine received ASME awards for both design and general excellence, as well as the Society of Publication Designers' Magazine of the Year award. Her design work and art direction has received recognition from SPD, Art Directors Club, *American Illustration, American Photography,* and has been included in various books on publication design. Emily has commissioned at least 1,000 illustrations over the last 10 years.

BRIAN CRONIN
Illustration
Brian Cronin is an artist and illustrator originally from Dublin, Ireland. He studied Graphic Design at college and began illustrating shortly thereafter. He currently lives in New York City and upstate New York. Clients include *The New York Times Magazine,* Microsoft, Hearmusic, Virgin Atlantic, B.M.W, J.P Morgan private bank, New York University, Stanford, M.I.T, *The Wall Street Journal, Time, Newsweek,* Audobon, Blab, Penguin Books, Farrar Straus and Giroux, *The Washington Post, Los Angeles, GQ, Esquire, Texas Monthly, and Entertainment Weekly.* He has received gold awards from the Art Directors Club, The Society of Illustrators, The Society of Publication Designers and a yellow pencil from D&AD.

DAVE DYE
Illustration
Dave has spent the last twenty years working in London advertising agencies pretty much within the same square mile, such as Leagas Delaney, BMP DDB London and Abbott Mead Vickers. In 2002, he set up Campbell Doyle Dye, during which time he won 17 One Show pencils.

BOB HAGEL
Illustration
Bob Hagel, a native New Yorker, has been an artist since childhood. Before joining forces with John Peterman and Don Staley, he had a career in advertising. Hagel says he gave the best years of his life to the art direction, illustration, and excellence of the original *J. Peterman Catalog* and *Peterman's Eye.* He calls what he did for the company "a labor of love." "I studied with George Tscherney at the School of Visual Arts. George has a simple philosophy: 'when the world zigs, you zag'." Hagel still zigs and zags in Jersey City where he lives with his wife Sally and their 12-year-old Springer Spaniel, Frannie.

GAIL POLLACK
Illustration
Gail Pollack, a Group Creative Director/Art Director at Energy BBDO (formerly BBDO Chicago), winner of the BBDO Worldwide Creative Director award, has worked on many of the agency's banner accounts including Wrigley's and Jim Beam, and has been honored by creative awards and publications including London International, NY Festivals, *Print Design Annual, Creativity Magazine,* AdCritic.com, Communication Arts, and International Archive, and has received several Effies in confections and spirits. She has also worked at Leo Burnett and Ogilvy & Mather, and enjoyed a successful freelance career prior to BBDO. Besides spirits and confections, Gail's advertising experience includes food and retail with a special emphasis on product launches and re-energizing tired brands. She enjoys travel, nature, music, architecture and art, and recently began collecting urban vinyl toys.

Judges
Interactive

MATT FREEMAN
CHAIR
Interactive

Matt founded and runs TribalDDB's network of 32 offices in 20 countries, for clients such as PepsiCo, Philips, Johnson & Johnson and McDonald's. Awards include Grand Prix and Gold Lions at Cannes, ADC, New York Festivals, International Andy's, EFFIE, and "Best of Show" in One Show Interactive. Matt has been recognized by *Wall Street Journal, New York Times,* CNN, CNBC, CBS Market Watch, Forrester Research, *AdAge, Adweek* and *Creativity.* Matt is the founder and chairman of the IAB's Agency Board, serves on the board of the Advertising Club and is a member of the AAAA's Interactive Committee. Before advertising, Matt worked for MTV, wrote for magazines and was an English teacher. He has a B.A. in English and Art History from Dartmouth and attended SVA.

JUSTIN BAROCAS
Interactive

As a partner at Anomaly, Justin leads Communications Planning and ensures media innovation informs every initiative for clients like Coca-Cola, *The New York Times,* Virgin America, ESPN and Nike/Jordan as well as Anomaly-owned properties and products such as Mobile U and Lucky Media. Prior to founding Anomaly, Justin developed the $200MM+ full service media department of Wieden+Kennedy NY and created award winning, integrated solutions for Nike, Microsoft, ESPN, JetBlue, Avon, SVA and SHARP.

LARS BASTHOLM
Interactive

As Executive Creative Director, Lars runs the creative department of AKQA New York. After starting Grey Interactive in Scandinavia, he joined Framfab in Copenhagen as Creative Director. There he worked on brands including Nike, LEGO, Coca-Cola and Carlsberg. Lars is one of the most-awarded creatives in the digital marketing industry, having won three Cyber Lions Grand Prix in Cannes in addition to almost 20 other international awards (Cyber Lions, Clios, One Show Interactive Pencils and London International Advertising

DAVE BATISTA
Interactive, Hybrid

As Co-Founder and Executive Creative Director of BEAM, working on MINI, PUMA and Comcast. Previously, he was co-founder and Chief Creative Officer of Euro RSCG Circle. At Circle, he created thetruth.com, IKEA's unbor-ing.com and MINIUSA.com. There he also oversaw Verizon, Campbell's Soup Company, AND 1 and ING. Dave has been a featured speaker for Macromedia and Forrester Research at Seybold Seminars and Davis Symposium. His work has received awards from a wide range of advertising, interactive and business

INGRID BERNSTEIN
Interactive

Ingrid joined iDeutsch in 1998 as Creative Director. As Director of Creative and Strategy, which she took on in 2005, Ingrid oversees the group's creative vision and manages the production and technology required to deliver it. Clients include Almay, IKEA, Lamisil, Monster Worldwide, MCI, Revlon, Snapple, Zelnorm, Zyrtec, Tylenol and Novartis to name a few. Previously, Ingrid designed and produced interactive marketing initiatives for companies including TV Guide, Fox News and Fox Sports, HarperCollins, Warner

PAUL BICHLER
Interactive

Paul Bichler joined StrawberryFrog New York in 2005 as executive cre-ative director of interactive. Prior to StrawberryFrog, Paul was the interac-tive creative director for Fallon's New York office. Throughout his career he has created work for an extensive list of respected brands including BMW of North America, Virgin Mobile, Microsoft, Lee Dungarees, Brawny and Audi of America. His work has been recognized by several leading publications and competitions including the *New York Times, Communication Arts, I.D.,* The One

BEN CLAPP
Interactive, Hybrid
Previously senior creative on TribalDDB London's Volkswagen, Guardian and TUI accounts, Ben took over as Creative Director in Spring 2004. Since his appointment, TribalDDB has added Philips, Domestos, Austravel, Marmite, Speedo, MobileShop and Harvey Nichols to their client list. As well as previous wins at Epica, IMMAA and The One Show, he recently picked up silver at D&AD 2005 for *The Guardian* "Clark County" viral project.

ANDREAS COMBUECHEN
Interactive
Andreas is Chief Creative Officer, CEO and a founding partner of Atmosphere BBDO. Atmosphere is the online agency of record for some of the world's biggest brands including AOL, Cingular and GE, as well as Emirates Airlines, Snickers, Red Stripe beer, and E*TRADE FINANCIAL. Under Andreas' leadership, Atmosphere has created some of the most admired and talked about work in the industry, including the GE "Pen" (which won a Gold Pencil from One Club and a Silver Cannes Lion) and 2005's "Interactive Ad of the Year" ("Ecomagination") according to BtoB magazine. Other recent noteworthy work includes snickerssatisfies.com and makemedance.com, and launched the world's first iTunes phone for Cingular.

OLAF CZESCHNER
Interactive
Olaf Czeschner is creative director at Neue Digitale GmbH, the creative agency for digital brand leadership in Frankfurt, Germany. He assumed the head position in 1996 after having worked for several years in a freelance capacity in Germany, the US and the Netherlands. In 1999, he became a managing partner of the agency. Neue Digitale earned its reputation as an agency for creative and effective online brand leadership through the successful implementation of projects for international clients such as Adidas-Salomon AG, Germanwings, Daimler-Chrysler, Olympus Europa and Coca-Cola.

JASON DOORIS
Interactive
Jason joined Saatchi & Saatchi in 2004 having spent the last two years setting up a global interactive advertising network for a leading agency group. He is highly credentialed and awarded. As the ex-CEO of MediaCom in the UK and Deputy European CEO Europe, Jason has been instrumental in regionalizing the interactive offer and leveraging pan-regional client learning. Having also spent time with JWT Italy, Ogilvy New York and Grey in Scandinavia, Jason's multicultural perspective brings great depth to the strategic planning and development process.

RICARDO FIGUEIRA
Interactive
Ricardo Figueira has been the Creative Director for interactive projects for 7 years, running a 40 person creative team at AgênciaClick in Brazil. He is responsible for the creative process, methodologies and quality control of all work concerning design, information architecture, online advertising and interactive strategies. He has accumulated more than 60 Brazilian and international awards including Gold Cannes Lions, London International Awards Advertising, One Show, and many others. Ricardo has already developed more than 400 projects for the internet and led creative solutions for clients such as The Coca-Cola Company, MSN, Diageo, Nike, WWF, and Fiat Latin America.

KEVIN FLATT
Interactive, Hybrid
Kevin Flatt harnesses the powerful, creative thinking from the diverse talent at Fallon to create the most compelling digital brand experiences. At Fallon since 1995, Kevin has been creating work for clients such as Amazon.com, Archipelago, BMW of North America, The Bahamas Ministry of Tourism, Brawny, Holiday Inn, International Trucks, Lee Jeans, Miller Brewing Company, Nordstrom, McDonald's, Microsoft, Timberland, United Airlines, and Virgin Mobile. His work has received recognition from many respected industry competitions, including *Communication Arts, Graphis,* the Type Directors Club, The Art Directors Club, Clio, the EFFIES, the One Show, Cannes and first-ever Titanium Cyber Lion for BMW Films.

GARY FREEDMAN
Interactive
Gary is a co-founder and director at The Glue Society, a creative collective based in Sydney and New York. Established in 1998 by Freedman and his partner Jonathan Kneebone, The Glue Society has created advertising campaigns in Australia, Asia, the UK and US, winning awards at D&AD, One Show and the 2004 Direct Grand Prix and the Cannes Titanium award in 2005. The Glue Society works only on a project-basis in collaboration with agencies and clients as a creative resource. In addition to their work in advertising, they have produced and contributed to several books, publications and art exhibitions. Previously, Gary was as an art director at Young and Rubicam, Sydney.

ALEX GIORDANO
Interactive
Alex has been considered the "enfant terrible" of Italian communications. A pioneer of the Internet, he organizes cultural events, speaks on the airwaves, serves as a production inspector for Italian television, and is a journalist and a communications expert and teacher. After completing a master's degree in Marketing and Communication, Alex was a strategic planner for advertising agencies. He is the co-founder with Mirko Pallera of www.NinjaMarketing.it, the first Italian online-observatory/blog devoted to non-conventional marketing techniques. He also teaches Creative Marketing at universities and private schools.

KAY HOOK
Interactive
Kay has experience from almost every field. He was Managing Director for OgilvyOne, taking it from bottom rankings to Direct Agency of the Year, Managing Director for Ogilvy Interactive, an interactive media planner at CIA, Marketing Director for Fritidsresor (TUI), Managing Director for Sportresor (TUI) and Advertising Director for ATG (Swedish horse betting). In short, he's tried it all. At Scholz & Friends Stockholm he combines all this experience into one single generalist offer, and is doing it successfully. In the first year of the agency's existence it has been ranked Best Agency within the Scholz & Friends network and has won awards spanning from interactive campaigns to TV-programming.

JOHN C. JAY
Interactive
John is a partner and Executive Creative Director for Wieden+Kennedy's global network. Previously he was Executive Creative Director for the W+K Tokyo office. In 2003, Jay launched the agency's independent DVD music label, W+K Tokyo Lab and in 2005, opened the W+K Shanghai office. He was named to the "40 Most Influential" in design by *I.D.*, and one of "80 Most Influential" by *American Photographer Magazine.* His book, *Soul of the Game* was named one of the "14 Most Beautiful Books in the World" by the Copenhagen Applied Arts Museum. He writes on design and popular culture in *The New York Times, SOMA, American Demographics, Big, Zoo,* and *Theme.* He established the Jay Scholarship Fund at Ohio State University for Asian students pursuing careers in the arts.

SHUJI KASAI
Interactive
Kasai Shuji, Interactive Creative and Senior Creative Director, leads the creative team of Hakuhodo, Inc., one of the largest and most highly respected advertising agencies in Asia. In addition to being a renown Art Director of traditional print and TV commercials for major automotive, beer, and electronic game console companies, he has explored, unlike many others in his field and position, new media such as mobile phone portal design, game conception and interface designs. He also teaches computer theory at Tama Art University.

KRIS KIGER
Interactive, Hybrid
Kris is Executive Creative Director at R/GA, on brands including Bed, Bath & Beyond, IBM, Levi's, Purina, Nike, Target and Verizon. Prior to R/GA, Kris gained extensive experience in corporate identity and interactive design on projects for Time Warner, Bloomberg, Microsoft and a wide portfolio of clients in the healthcare, technology and non-profit sectors. Over her career Kris has won almost 40 awards including Broadcast Design Association, Cannes Cyber Lions, London International Advertising Awards and One Show Interactive. She is a member of AIGA and holds a BFA from the University of Arizona.

CLEMENT MOK
Interactive
Clement Mok is a designer, digital pioneer, software publisher/developer, author, and design patent holder. A former creative director at Apple, he founded multiple successful design-related businesses — Studio Archetype, CMCD and NetObjects. Most recently he was the Chief Creative Officer of Sapient, and the president of AIGA. Currently, he runs a stock image business and consults for Sapient on a new *Experience Market* service. Recognition includes *I.D.,* which named him among 1994's 40 most influential designers, and *Chief Executive Magazine* which named him in 1998's Tech 100 CEOs. He also serves on the advisory boards of numerous technology companies, colleges and non-profit organizations.

STEVE MYKOLYN
Interactive, Hybrid
Steve began as an editorial art director. He joined TAXI in 2001 on accounts including Nike, Pfizer, BMW Group (MINI), TELUS and MSN. Steve has netted over 400 international awards for his design and interactive work including a Gold Cyber Lion in 2005. Outside of work Steve has collaborated on, authored and designed a number of books, including *Metal Leather Flesh,* and directed a documentary film entitled, "El Dia La Noche Y Los Muertos," about Mexico's Day of the Dead festival. The film closed a Latino Film Festival at the Smithsonian Institute during Hispanic Month.

MIRKO PALLERA
Interactive
A communication and marketing consultant, sociologist and journalist, Mirko co-founded, with Alex Giordano, www.NinjaMarketing.it, the first Italian online-observatory/blog devoted to non-conventional marketing. Creative Marketing professors and consultants to marketing, media and advertising agencies, Mirko and Alex research new theoretical models and practical tools for communication. Mirko studied cultural movements, particularly hip-hop culture, and promoted several major events in the Italian hip-hop scene. After completing a Master's degree in Marketing and Communication, he joined the advertising world, first as an account planner then as communication manager of Mirata. He directed the first Italian publication on alternative media.

BAIPING SHEN
Interactive
A former physicist at a Laser Laboratory in Beijing and a pizza delivery driver in Sydney, Baiping started in brand communication at George Patterson/Sydney in 1994. He joined Leo Burnett China in 1998 as Director of Planning and became National Planning Director in 1999. In addition to his national strategy responsibilities, he was selected into the management committee of Leo Burnett Shanghai in 2002. Clients include Mars, Arnott's, Optus Communication, and NationalPak in Australia. In China, clients include Procter & Gamble, Coca-Cola, Hewlett Packard, Bass International, Prudential, Ping An Insurance, Motorola, McDonald's, and others. Baiping is a graduate in Applied Physics, and holds and MBA and Master of Applied Finance.

JACKSON TAN
Interactive

Jackson and four friends formed :phunk (Studio) in 1994, working on projects ranging from graphic design publications to audio-visual graphic installations. They have exhibited and lectured worldwide, featured in international books and magazines such as *I.D., Tokion, XLR8R, Studio Voice, Plus 81, Mass Appeal, IDN, Black + White* and *SOMA*. He is also a co-founder of Black Design, a multi-disciplinary visual communications agency based in Singapore specializing in branding, design and design content development. Clients include Discovery Channel, DesignSingapore, MTV, Diesel, and Daimler Chrysler. Black was commissioned by the DesignSingapore Council in 2004 to conceptualize, curate and design a highly successful landmark exhibition called 20/20, a showcase of 20 of Singapore's finest creative talents.

ANDY TARAY
Interactive, Hybrid

Andy Taray is an art director at MTV Networks and designer/owner of Ohioboy Design. Before that, he worked for 5 years as an art director and designerat Platinum Design. Andy is currently teaching typography and design at the School of Visual Arts. His work has been featured by AIGA, The Art Directors Club, *Print, Communication Arts, HOW Magazine,* One Show Awards, *Plus 81,* and *PDN*. Andy also devotes his time to Campfire Clothing, an online t-shirt and apparel line that launched in 2005.

Gold
Multi-Channel, Campaign

**GOO "FILL THE CITY
WITH QUESTIONS!"**
Video, Other Media, Print,
Environmental, Interactive

Art Director
Yoichi Komatsu,
Makoto Sawada
Copywriter
Satoshi Takamatsu,
Naoya Hosokawa,
Yohei Ugaeri
Creative Director
Satoshi Takamatsu
Designer
Makoto Sawada,
Yasunari Mori, Masayuki Ikeda,
Junko Igarashi
Production Company
Taki Coporation
Agency
ground
Client
NTT-Resonant Inc.
Country
Japan

In Tokyo and Osaka over 80% of the
people utilize trains of subways to
move around. We discovered that
the total cost for buying all the
space in all Tokyo and Osaka
stations was equivalent in cost to a
small scale TV spot campaign. We
were successful in buying almost all
the poster space. Thirty types
of questions became 30 types of
posters, saturating the station.
Further more, for making the subject
become even wider topically, we
simultaneously conducted a
campaign with questions posed
from the land, sea and sky, where
the first to correctly respond
received prizes. We used an
enlarged Outlook Express standard
font to express the image of ques-
tions being asked on the Internet.
Results far exceeded expectations.
Immediately after launch, "Answer
it! Goo" access increased by 400%.
Advertising reach rates, that only TV
spot campaigns were thought to be
able to attain, were realized.

教えて！goo Answer it! goo
www.goo.ne.jp www.goo.ne.jp

Internet Potal Site "goo"

goo 2005 Comprehensive Outline
"goo – 'Fill the city with questions!' Project"

PRODUCTS : goo is a well recognized internet portal site in Japan, and this campaign spotlights its 'Answer it ! goo' service. Users enter a question; others answer it. Over 1 million questions have been entered (with a response rate of 99.2%). The campaign aimed to augment visibility of the service and highlight the diversity of the questions asked.
IDEA : For maximum impact and reach, we made unprecedented use of the media where we placed extremely intriguing questions. Over 80% of people in Tokyo and Osaka commute on trains and subways. And various walls of the train stations are smothered with poster ads. If all commuters looked at posters in the station, then the ad-awareness factor should surpass that of a TV spot campaign. And, if questions were posed in unique locations, then the subject would become even more topical.
IMPLEMENTAION : We "discovered" that the total cost for purchasing the entire available ad space in all Tokyo and Osaka stations (more than 600 stations!) was equivalent in cost to a small scale TV spot campaign. We were successful in buying almost all the poster ad space. And we decide not to use TV spots. 30 different questions were made into 30 types of posters, and the train stations were saturated with them. Furthermore, we synchronously conducted a campaign posing questions from land, sea and sky. The first person to correctly respond to the question received prizes.
RESULTS : Advertising reach that only TV spot campaigns were thought to be attainable were realized. The extraordinary media and creative gave rise to a viral effect, offering a campaign effect unimaginable from the budget. Almost all commuters not only saw goo posters, but also read the questions, and discussed them with their peers. The traffic on "Answer it ! goo" during this period increased drastically.

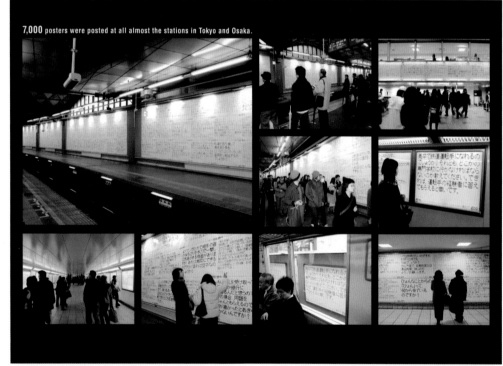

7,000 posters were posted at all almost the stations in Tokyo and Osaka.

Question of the week! goo challenge

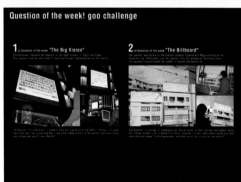

The Train Station Jack Project

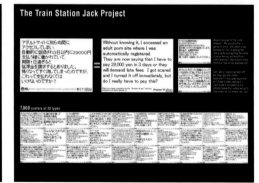

FINAL Question of the week "Answer it! goo Championship"

The grand finale of the 7 week campaign was the "Answer it! goo" Championship.
A new champion was born from among the winners of each week's "Answer it! goo" question of the week and 500 applicants.

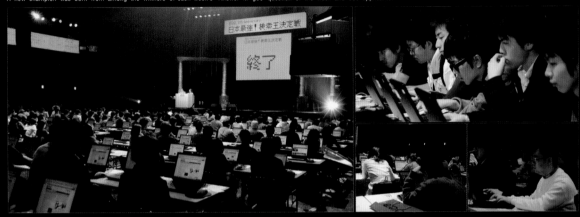

3rd Question of the week "The YAKATA-Ship"

The question was found on the roof of the Yakata-ship moving down the river. The Kachidoki Bridge of Tokyo was filled with participants gazing down upon the river. The question was in conjunction with Kanji characters of fish such as 鱧, 鰤, and 鰊.

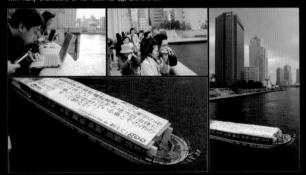

3rd Question : "鱧鰤鰊鯛鮎鯵鯖蛙鱸鰡鰆鰰" Among the Kanji characters of fish found on the right, name all the characters, that cannot be used for a person's name, but has been designated as the "city's fish" by the municipal government of Japan and for what city is it?

4th Question of the week "The Helicopter Night Sign"

A helicopter appeared above the night sky of Shibuya. The LEDs placed on its body bore the question. This media, referred to as the "Night Sign," was a first for Japan. The question was about junior high schools in Shibuya and about planetariums.

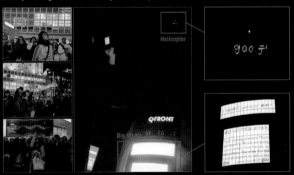

4th Question : Could you tell me all the junior high schools in the Shibuya District that have a "Volunteer Club"?

**120 NOT-SO-STANDARD
FEATURES**
Print, Broadcast, Interactive

Art Director
Paulo Lopez, Paul Lee,
Phillip Squier, Colin Jeffery
Copywriter
Chris Carl, Dave Weist
Creative Director
Ron Lawner, Alan Pafenbach,
Dave Weist, Chris Bradley,
Chris Carl, Colin Jeffery
Director
Keith Hamm, Arran Brownlee,
Corran Brownlee, LOBO,
Luis Blanco, Michael Uman,
Eric Merola, Ugly Pictures
Producer
Amy Favat
Production Company
Brickyard, LOBO,
Curious Pictures
Agency
Arnold Worldwide
Client
Volkswagen
Country
United States

What do you do creatively with a car
that's all about its features? Why,
you make a short film about each
one. Even if you have to make 120
of them. That's what we did in the
new Passat FEATURE FILMS
CAMPAIGN. To pull it off, we had to
change the way we normally
worked. We had to be the keeper of
the idea but let hundreds of artists
from around the world do their thing.
The result was something that grew
organically and became more inter-
esting with every new addition.

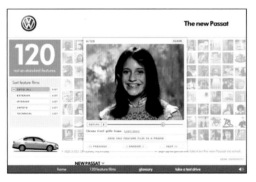

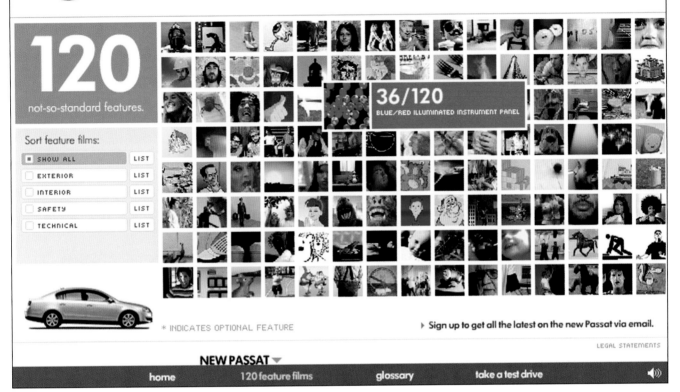

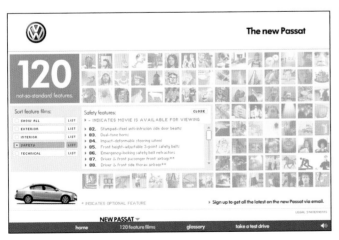

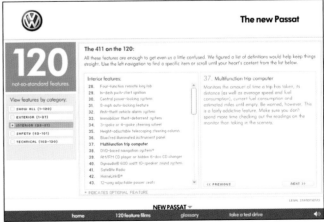

Silver
Multi-Channel, Campaign

NOW WHAT?
Broadcast: AC, Business
Trip, Date, Car for Sale,
AC/Date Radio
Environmental: Tow Truck,
Bike Locks
Interactive: Nowwhat.com

Art Director
Kurt Riemersma,
Laura Gaines, D.J. Webb,
Keith Henneman,
Rob Robinson, Brian Morris
Copywriter
Grey Ingram, Jason Gorman,
Casey Kundert,
Alice Dobrinski, Keith Tutera,
Deb Pahl
Creative Director
Rick Korzeniowski,
Dan Bogosh, Jason Koerner
Director
Michael Downing
Editor
Greg Sunmark, Red Car
Producer
Kate Hildebrant, Doris Jenkins,
Denise Delahorne, Carol Dorf
Production Company
Harvest, Earhole Studios
Agency
DDB Chicago
Client
State Farm
Country
United States

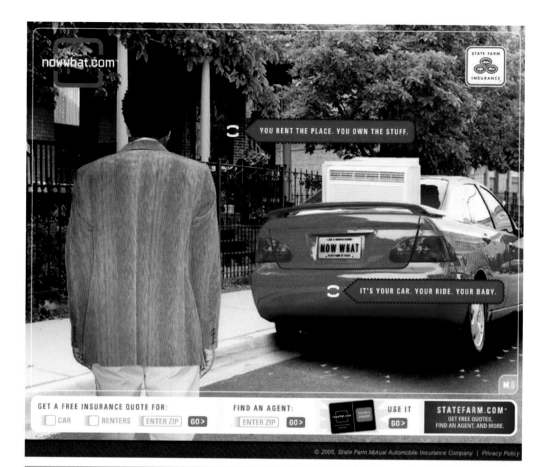

Hybrid
24

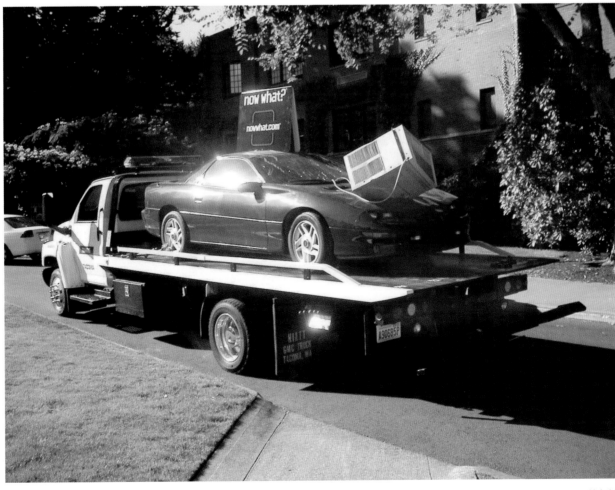

Distinctive Merit
Multi-Channel, Campaign

DC SHOES
Diagram, TV Spots,
dannydoeschina.com

Art Director
Con Williamson
Copywriter
Michael Haje
Creative Director
Con Williamson, Michael Haje
Director
Con Williamson
Producer
Jim Juvonen, Michael Haje
Production Company
LODGE 212
Editor
Gary Knight, Kat O'Reilly
Agency
JWT/Lodge 212
Client
DC SHOES
Country
United States

DC Shoes was a simple assignment: Tell the world that Danny Way is going to jump the Great Wall of China on a skateboard. It was an event that was sanctioned by the minister of extreme sports in China (yes they really have one). So for something that big and culturally important, we decided that we should let the Chinese people do the talking; turns out they know lots about information dissemination. The rest was history.

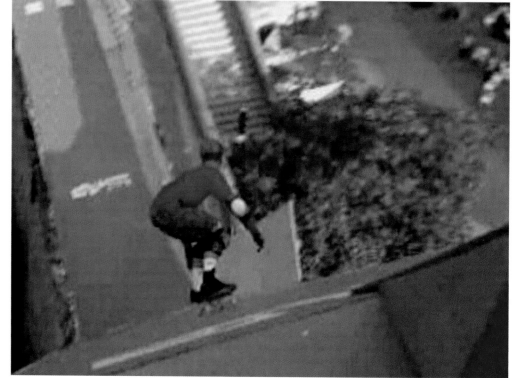

The T V

$900 .00

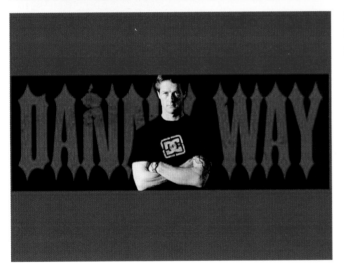

The Web

ALTOIDIA
Print: Wolves, Prowess,
Gum Rocks
Broadcast: People of Pain,
Fable of the Fruit Bat,
Mastering the Mother
Tongue, www.altoidia.com

Art Director
Noel Haan
Copywriter
G. Andrew Meyer
Creative Director
Noel Haan, G. Andrew Meyer
Director
Craig Gillespie
Editor
Paul Martinez
Producer
Vincent Geraghty
Production Company
MJZ Los Angeles
Agency
Leo Burnett
Client
Altoids
Country
United States

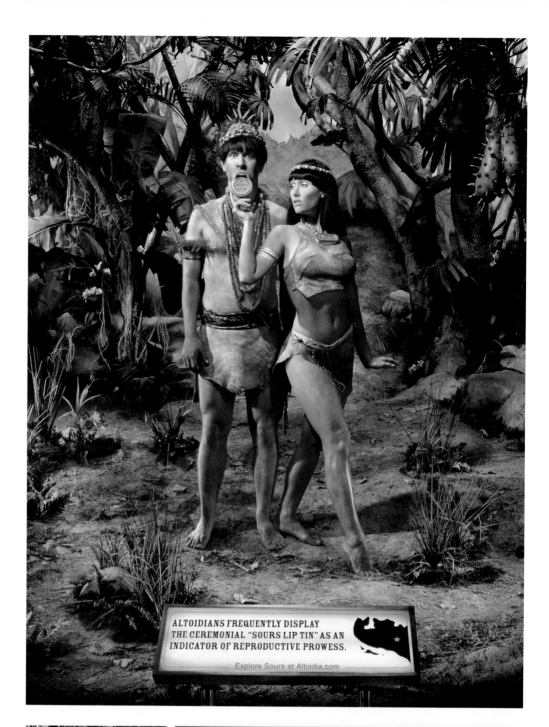

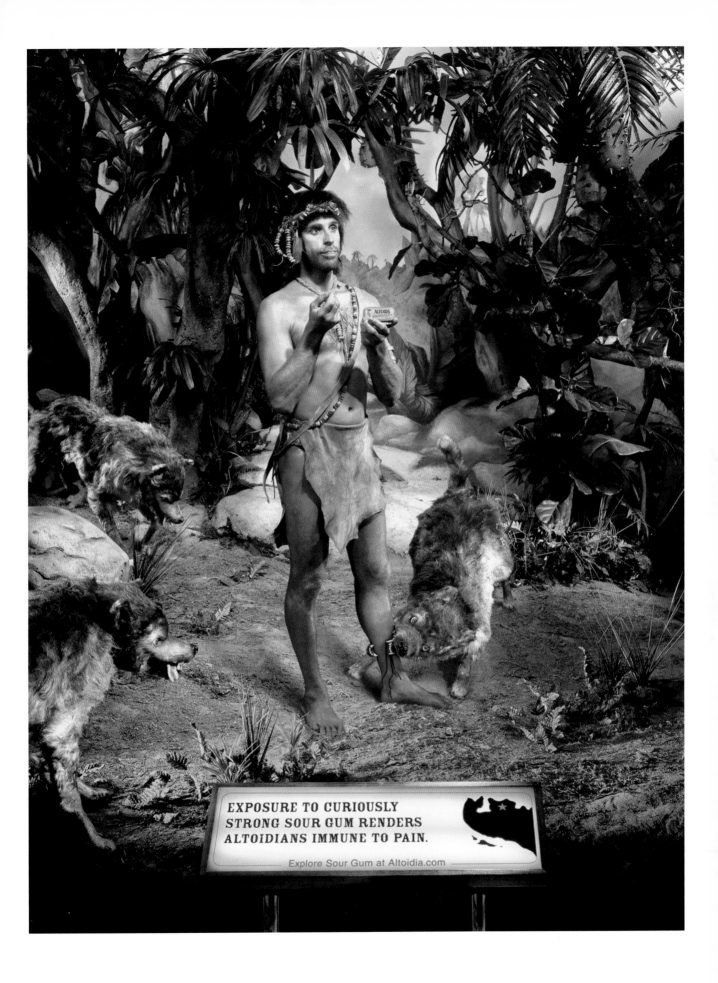

EXPOSURE TO CURIOUSLY STRONG SOUR GUM RENDERS ALTOIDIANS IMMUNE TO PAIN.

Explore Sour Gum at Altoidia.com

Distinctive Merit
Multi-Channel, Nonprofit,
Campaign

FAIR ENOUGH
Print, Broadcast, Interactive

Art Director
Mike Costello, Rob Kottkamp,
Phil Covitz, Chris Bakay,
Jason Ambrose,
Geordie Stephens,
Meghan Siegal
Copywriter
Marc Einhorn, Will Chambliss,
Dustin Ballard, Franklin Tipton,
Dave Kennedy, Jason Yun
Creative Director
Ron Lawner, Pete Favat,
Alex Bogusky, John Kearse,
Tom Adams
Designer
Meghan Siegal,
Chris Valencius,
Max Pfennighaus,
Neal Bessen, Templar Studios
Director
Martin Granger
Editor
Jun Diaz
Producer
Jessica Dierauer, David Rolfe,
Rupert Samuel, Corey Bartha,
Linda Donlon, Kathy McMann,
Carron Pedonti,
Barry Frechette
Production Company
Moxie Pictures, Soundtrack
Agency
Arnold Worldwide
Client
American Legacy Foundation
Country
United States

Big Tobacco is at it again! It's Fair
Enough, the world's first reality
sitcom, based entirely on actual,
internal tobacco industry docu-
ments. Complete with theme music
and a laugh track the 60-second
"episodes" feature actors posing as
tobacco employees, and pondering
such age old questions as: How will
Big Tobacco reach inner city
blacks? And, what do cigarettes
and Twinkies have in common? And
like any successful sitcom
marketing campaign, we also devel-
oped promotional print ads to help
boost viewership. Also, like others
before it the sitcom inspired a Fair
Enough cartoon series. Online, we
featured a series of web banners
where users can play a few games
featuring our very own tobacco
executives, and of course, the offi-
cial Fair Enough fan site, where folks
can enjoy a look behind the scenes;
see the actual tobacco documents
on which each episode is based;
and watch each hilarious episode.

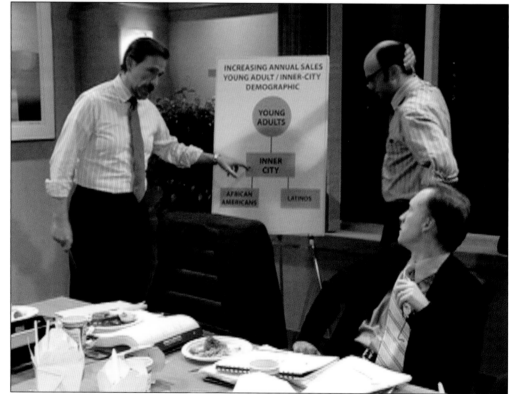

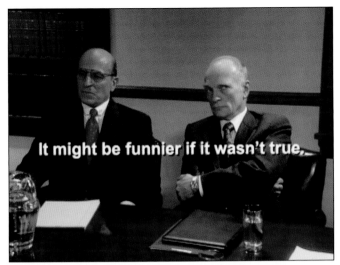

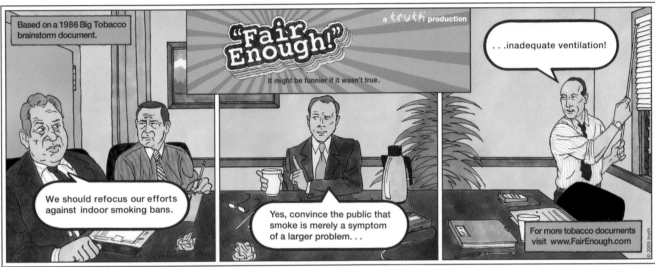

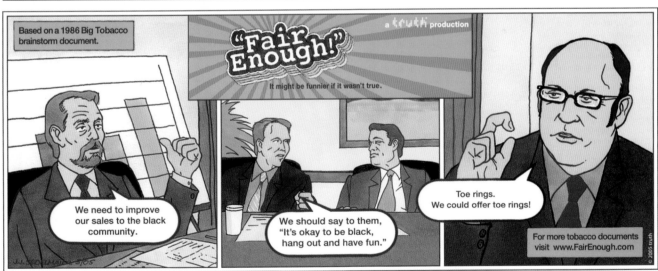

Merit
Multi-Channel, Campaign

Also for Advertising
SEE PAGES 113, 116, 142,
146 & 149

**EBAY "IT" BRANDED
CONTENT**
Broadcast: Anthem, Steak,
Dodgeball, The Making of It
Print: It Fuzzy, It Grass,
It Wood, It Wild Postings,
www.whatisit.com

Creative Director
David Lubars, Bill Bruce,
Greg Hahn
Art Director
James Clunie, Scott Kaplan,
Chuck Tso
Copywriter
Kara Goodrich, Greg Hahn,
Tom Christmann,
Chris Maiorino
Agency
BBDO New York
Client
Ebay/half.com
Country
United States

Everybody knows weird, one-of-a-kind things are sold on eBay. What we wanted to show was the extent of endless new items sold. This integrated campaign aimed to clarify that absolutely everything can be bought on eBay—and nothing sums up "everything" better than the word "it." If you can invent it, wear it, throw it, give it, break it, drive it, etc…you can get "it" on eBay. First, a blind teaser spot planted the campaign seed to let people know that something called "it" was coming. Viewers were directed to a website where several short films were shown, revealing nothing about the identity of" it" Simultaneously, large "it's," in the form of giant posters, exhibited all over—again, giving no indication of who was responsible for this strange campaign. Finally, brand spots began running and explained "it" was from eBay. Consumer and trade print advertising appeared. Once people associated "it" with eBay, various: 15 second, categorically targeted television spots started airing. "It" was on its way.

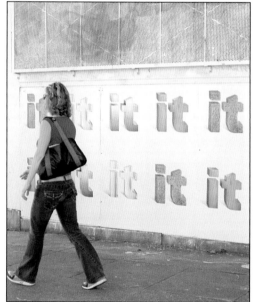
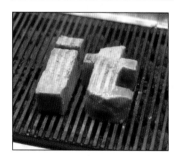

Hybrid
32

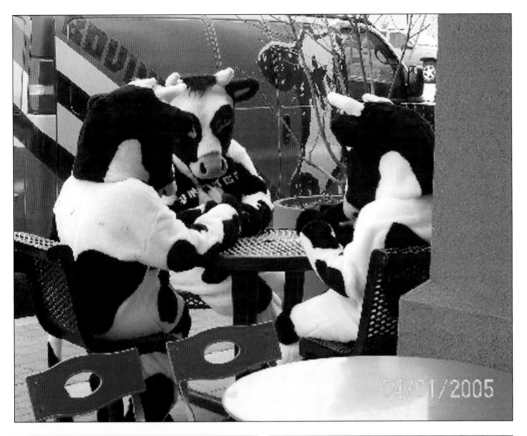

Merit
Multi-Channel, Campaign

COWS
Interactive: BovineUnite.com,
Bovine Web Banner
Guerilla: Guys in Cow Suits
Outdoor: Billboard Teaser
Print: Newspaper Teaser
Broadcast: Cows (TV :60 spot)

Art Director
Helen Goldring
Copywriter
Brian Eden
Creative Director
Scott Sugiuchi,
Thomas Rodgers,
Stephen Etzine,
Craig Strydom, Mark Rosica
Designer
Scott Sugiuchi, Thomas
Rodgers
Director
Raafi Rivero, Bruce Dowad
Editor
Jinx Godfrey
Producer
Donna Schoch-Spana,
Jeremy Barrett
Production Company
Bruce Dowad & Associates
Agency
Eisner Communications
Client Maryland State Lottery
Country United States

This project was intended to reach a younger Lottery audience. The campaign included teaser ads, people in cow suits who pulled pranks, television and internet advertising.

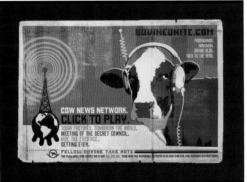

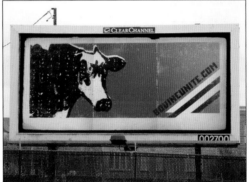

10 CANE RUM
Viral Films, 60-page
Magazine, Outdoor Postings,
Tasting Room, Promotional
Kit, Magazine Series,
www.10cane.com

Art Director
Sean Carmody
Copywriter
Todd Lamb
Creative Director
Linus Karlsson,
Paul Malmstrom
Designer
Sean Carmody,
David Mashburn
Director
Linus Karlsson
Editor
Luis Moreno
Producer
Margaux Ravis, Karla Olmedo
Production Company
Mother Films
Photographer
Lars Topelmann,
Thomas Hannich
Designer
Kirt Gunn + Associates
Agency
Mother New York
Client
LVMH
Country
United States

The 10 Cane materials were inspired
by the jokes, stories, and riddles
told by Sir Royalty, the unofficial
king of Trinidad. Royalty is a Trinida-
dian legend. He tapes laminated
artwork inside his mini-van and
invites all people to enjoy the fruits
of his labor. Each 10 Cane piece
was scrutinized by none other than
Sir Royalty, prior to its release into
society. Each passed with his
seventeen star approval rating.

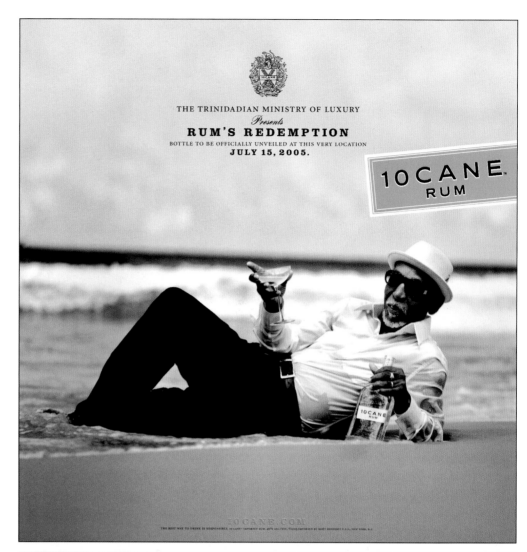

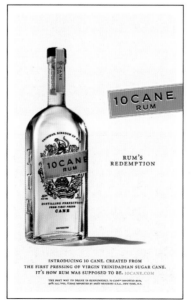

Merit
Viral Campaign

SHADOW OF THE COLOSSUS
Giantology Site, Interactive Blogs, Interactive Podcasts

Art Director
Mako Miyasato
Copywriter
Glenn Sanders, Rob Ingall,
Eric Haugen, Nick Davidge
Creative Director
Jerry Gentile,
Nathan Hackstock,
Nick Davidge
Director
Nick Davidge
Editor
Nick Davidge
Programmer
Malik Jones, Todd Resudek
Producer
Chincha Evans
Production Company
Studio B
Agency
TEQUILA\Los Angeles
Client
Sony Playstation
Country
United States

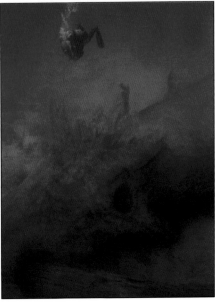

Imagine a world where giants once walked the earth. Where bizarre creatures trapped for centuries are only now being discovered around the globe. And one man—the fictional Eric Belson—is cataloging it all on his blog at Giantology.net. The "Giantology" viral campaign is an immersive online puzzle intended to spark discussion and controversy, involving six websites, four viral videos, four podcasts and even working international phone numbers, all to promote the PlayStation game, Shadow of the Colossus. By design, the consumers became our messengers in blogs, forums, emails, chat rooms, even dinner parties. Giantology has been discussed on thousands of websites, the G4TV gaming network, the world's most popular late-night radio show, and even spawned several fan sites. 23 million people have viewed the viral videos, driving 2.6 million people to the campaign websites. Best of all, the game surpassed one-year projected sales in six weeks.

Multiple Winner**

Merit
Multi-Channel, Nonprofit,
Campaign

Also for Graphic Design
Distinctive Merit
Poster Design,
Public Service/ Nonprofit/
Educational, Campaign
SEE PAGE 271

RETIRED WEAPONS
Print, www.retired.jp,
Street Vision

Art Director
Yuji Tokuda
Copywriter
Yusuke Shimazu
Designer
Daisuke Inazumi,
Katsuhiro Nagai
Director
Hideo Hara, Fuyu Arai,
Keigo Kohata
Editor Rayco Hogen,
Daniel Cox, Bao Weiqing
Producer
Junya Ishikawa,
Kunihiko Inoue, Junichi Iwai,
Rei Owada, Masaaki Kato,
Masato Yamauchi
Creative Director
Yuji Tokuda, Junya Ishikawa
Agency
junya-ishikawa.com
Client
Retired Weapons
Country
Japan

The 20th century was a century of
the invention of materials. The 21st
century needs to be a century of the
invention of dialogue. We wish our
art to be a dialogue starter among
people and create little steps
towards the goal of this new
century.

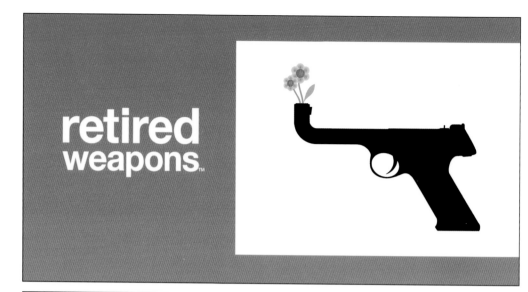

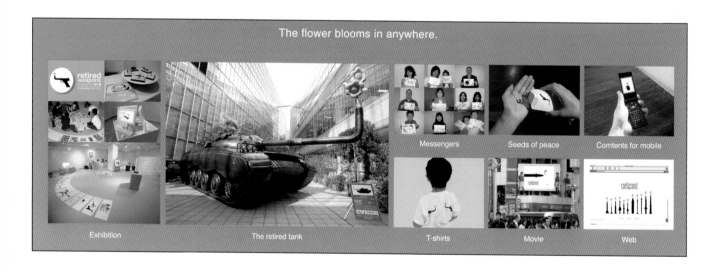

The flower blooms in anywhere.

Exhibition

The retired tank

Messengers

Seeds of peace

Comtents for mobile

T-shirts

Movie

Web

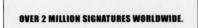

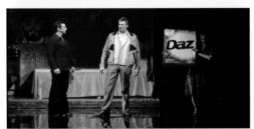

Merit
Multi-Channel, Nonprofit,
Campaign

THE ONE CAMPAIGN
Magazine Ads, TV Spots,
Booklet, Collateral

Copywriter
Joe O'Neil
Director
Marcus Tomlinson
Editor
Andy Keir, Josh Pearson,
Jon Schwartz
Producer
Jon Kamen, Frank Scherma,
Greg Schultz
Production Company
@radical.media
Agency
@radical.media
Client
DATA
Country
United States

The ONE Campaign is a new effort
to rally Americans to fight the emer-
gence of global AIDS and extreme
poverty. When it launched, The ONE
goal was to recruit one million
people to call for more efforts to
fight poverty and AIDS by signing
the ONE Declaration. To date there
have been over two million signa-
tures worldwide.

Merit
Other, Single

**WORST FUCKING IDEA I'VE
EVER HEARD IN MY LIFE**

Art Director
Jim Thornton, Don Bowen,
Dave Beverley, Paul Jordan,
Angus Macadam, Rick Brim,
Dan Fisher, Philip Deacon,
Martin Richartz
Copywriter
Jim Thornton, Don Bowen,
Dave Beverley, Paul Jordan,
Angus Macadam, Rick Brim,
Dan Fisher, Philip Deacon,
Martin Richartz
Creative Director
Jim Thornton, Don Bowen,
Dave Beverley, Paul Jordan,
Angus Macadam, Rick Brim,
Dan Fisher, Philip Deacon,
Martin Richartz
Agency
Leo Burnett
Client
Pimms, P&G Always,
McDonald's, P&G Max Factor,
P&G Daz, Scottish Widows,
Nintendo, Strongbow,
Heinz Ketchup, Heinz Fairy,
Kellogg's Frosties,
Department of Health,
Department of Transportation
and Hallmark
Country
United States

ADVERTISING

BALLS

Art Director
Juan Cabral
Creative Director
Richard Flintham
Director
Nicolai Fuglsig
Editor
Russell Icke
Producer
Nellie Jordan
Production Company
MJZ
Agency
MJZ
Client
Sony
Country
United Kingdom

Sony was struggling to maintain
share because of the switch to flat
screens from Cathode Ray Tube
technology. In a commoditized
market, more people were ques-
tioning why it was necessary to pay
200 Euros more for a Sony TV. The
brief was to launch Bravia and show
that it has color like no other. 1.
Create an emotionally powerful
experience. 2. Demonstrate that
best color equals best picture
quality. Rationale: Create fame for
the launch of Bravia with a simple
visual metaphor for color using
250,000 bouncy balls. Create a
powerful experience by doing it for
real and dropping the balls down the
steep streets of San Francisco. Use
viral communications to multiply the
ways in which people can connect
with the experience. Create a sense
of joyful calm by setting the child
like simplicity of bouncy balls to the
"unplugged" music of Jose
Gonzalez. Target audience: Selling
TVs in such a wide-open category
meant that we needed an idea that
would connect with everyone
regardless of demographics or local
culture. We needed a universal idea
based on a human truth that would
transcend all boundaries. Color
communicated through the "balls"
executions does just that. Sony's
competition was dealing in rational
messaging based on product
features. We sought to differentiate
ourselves by engaging with the
audience on an emotional level.

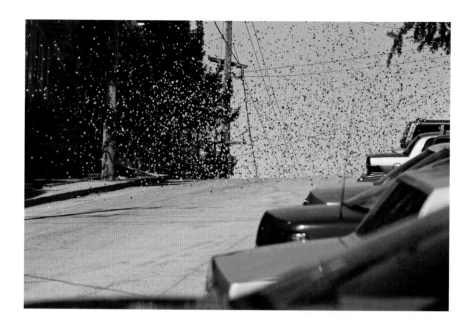

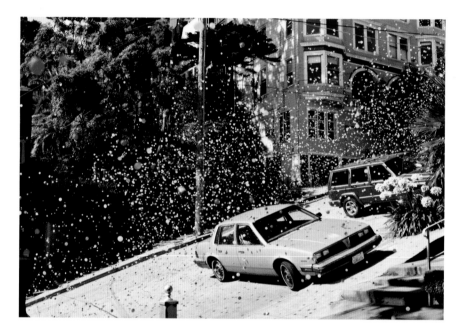

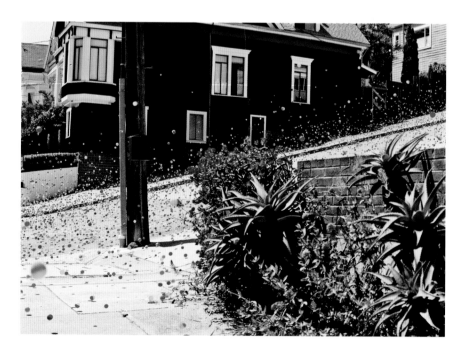

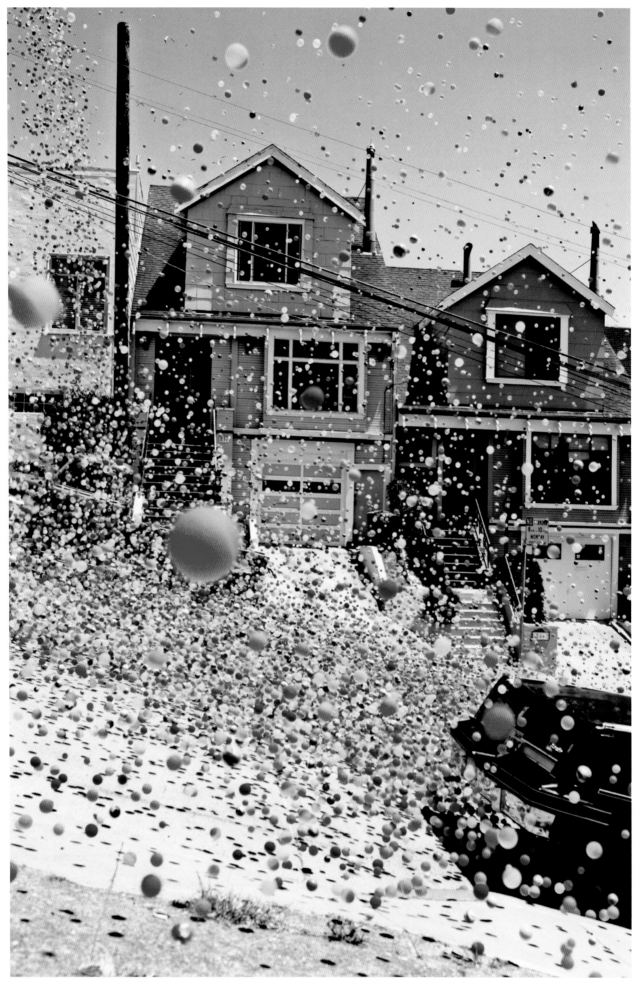

HELLO TOMORROW

Art Director
Lee Clow
Copywriter
Chuck McBride
Executive Creative Director
Chuck McBride, Lee Clow
Creative Director
Joe Kayser
Director
Spike Jonze
Editor
Haines Hall, Spot Welders
Designer
Floyd Albee
Executive Producer
David Zander, Jeff Scruton
Producer
Jennifer Golub
Production Company
MJZ Los Angeles
Account Person
Doug Sweeny
Art Director
Joe Kayser
Agency
TBWA\Chiat\Day, MJZ
Client
adidas
Country
United States

The world's first intelligent shoe
actually adapts to your every foot-
step. Because of this, the world in
front of you would be different than
before. Literally, you would be
taking your first steps again. So we
came up with a story about a guy
waking up in nothingness. Only to
reveal a new world he creates as he
walks and then runs in his new
adidas One shoes.

Multiple Winner**

Gold
Radio Advertising,
30 Seconds Or Less,
Campaign (Grandma,
Video, Backyard BBQ)
Silver
Radio Advertising,
Over 30 Seconds,
Single (Video)
Distinctive Merit
Radio Advertising, Over 30
Seconds, Single (Grandma)

**GRANDMA, VIDEO,
BACKYARD BBQ**

Copywriter
Joe Schrack, Daniel Giachetti,
John Clement, Brad Emmett
Creative Director
Sal DeVito
Producer
Barbara Michelson
Production Company
McHale Barone
Agency
DeVito/Verdi
Client
National Thoroughbred
Racing Association
Country
United States

We spend so much time mining our life experiences for things to write about in these ads. Some are funny. Some are serious. But all of them are true. That's what makes them so interesting. Well, not all of them are true. Some were made up. Like the porno tape thing. That was totally made up. No, really.

In trying to make horse racing an attractive activity to as many people as possible, we first tried to position it as better than sex. But that seemed like a bit of an overstatement. So we went with better than masturbating.

GRANDMA

ANNOUNCER ONE
And they're off. Out of the gate, it's GRANDMA'S HOUSE with WEIRD SMELL and HARD CANDY. Now here comes the favorite, PHOTO ALBUM with BABY PICTURES and BARE BOTTOMS. Oh no, here comes KISSING and PINCHING. It's PINCHING. It's KISSING. And GRANDMA'S TEETH is nowhere in sight. Now here comes STAY FOR DINNER with STEWED PRUNES and CREAMED SPINACH followed by HAVE SOME MORE. And HAVE SOME MORE is relentless. But what's this? Inside of CREAMED SPINACH it's, I don't believe it, GRANDMA'S TEETH. And CREAMED SPINACH is all over GRANDMA'S TEETH. And in the end, it's YOU NEVER VISIT, I WON'T BE AROUND FOREVER and ONE DOLLAR BILL.

ANNOUNCER TWO
For a better time, go to the track. National Thoroughbred Racing. We bet you love it.

VIDEO

ANNOUNCER ONE
And they're off. Out of the gate, it's WIFE'S GONE SHOPPIN' and
FINALLY SOME TIME ALONE. Here comes DOING SOME YARD
WORK and CLEANING THE GUTTERS. But out of nowhere, it's
ADULT VIDEO. And ADULT VIDEO is pulling out all the stops with
RHONDA RUFFINGTON, ROCK HARDINGTON and BEEF
WELLINGTON. But here comes SURPRISE SURPRISE with
GARAGE DOOR coming up fast! And now it's MAD SCRAMBLE and
HIDE THE TAPE. But MAD SCRAMBLE just isn't fast enough, and
here comes THE MRS. with SHORT FUSE and LONG MEMORY.
And in the end, it's YOU'RE BUSTED, DON'T TOUCH ME MISTER
and SHAME SHAME SHAME.

ANNOUNCER TWO
For a better time, go to the track. National Thoroughbred Racing.
We bet you love it.

BACKYARD BBQ

ANNOUNCER ONE
And they're off. Out of the gate, it's BACKYARD BBQ with BEAUTIFUL
DAY and ALL BEEF PATTIES. Now here comes CHARCOAL GRILL
with OPEN FLAME. But OPEN FLAME is fading fast and here
comes the favorite, LIGHTER FLUID. LIGHTER FLUID is all over
CHARCOAL GRILL. And oh no, it's LET'S LIGHT A MATCH. And now
it's KABOOM and EYEBROWS are nowhere in sight. Where the heck did
EYEBROWS go? And from out of nowhere comes THUNDERSTORM
with THUNDER, LIGHTNING and GET OUT OF THE POOL. And in
the end, it's RUNNING FOR COVER, LET'S ORDER CHINESE and
DID ANYONE REMEMBER TO BRING IN GRANDPA.

ANNOUNCER TWO
For a better time, go to the track. National Thoroughbred Racing.
We bet you love it.

Multiple Winner**

Gold
Radio Advertising,
Over 30 Seconds, Single
(Mr. 80 SPF Wearer)
Distinctive Merit
Radio Advertising,
Over 30 Seconds, Campaign
(Real Men of Genius
Campaign 3)
Distinctive Merit
Radio Advertising,
Over 30 Seconds, Single
(Mr. Miniature Train Modeler)

**REAL MEN OF GENIUS
CAMPAIGN 3:
MR. MINIATURE TRAIN
MODELER, MR. 80 SPF
WEARER, MR. PARANOID
OF THE OCEAN GUY**

Creative Director
Mark Gross, John Immesoete
Copywriter
Aaron Pendleton, Jeb Quaid,
John Baker, Robert Calabro
Engineer
Dave Gerbosi
Composer
Sandy Torano
Producer
Marianne Newton
Production Company
Chicago Recording Company
Agency
DDB Chicago
Client
Anheuser-Busch
Country
United States

Writing "Real Men of Genius" radio is much like affinage (ah-fee-nahj), the part art and part science of cheese aging. Each cheese, much like each Real Men of Genius spot, has different needs and the needs of one cheese sometimes conflict with the needs of another cheese. Care must be taken, because everything can make a difference in the way a particular cheese tastes, beginning with the land where the animal grazes and including the animal's mood when the milk was produced. Cheeses, much like our spots, will be brushed, beat, washed and rotated, depending on the requirements of the specific cheese, until they have attained the ideal maturity and taste. The affineurs, much like copywriters, embrace cheese's sensitivity to the environment and the differences it creates.

MR. 80 SPF WEARER

ANNOUNCER
Bud Light presents: Real Men of Genius.

SINGER
Real Men of Genius!

ANNOUNCER
Today we salute you, Mr. 80 SPF Sunblock Wearer.

SINGER
Mr. 80 SPF Sunblock Wearer!

ANNOUNCER
There's 24 hours in a day. You're wearing 80-hour protection. If the sun fails to go down, you'll be ready.

SINGER
Don't forget the boat light.

ANNOUNCER
Your coconut scented force field blocks out all the sun's rays. And any stray rays, from another sun, in another galaxy.

SINGER
You're a star!

ANNOUNCER
30 SPF? Please. You might as well be wearing cooking oil.

SINGERS
Something smells delicious.

ANNOUNCER
So, crack open an ice cold Bud Light, Mr. 80 SPF Sunblock Wearer. In fact, feel free to crack one open at high noon in the middle of the Sahara desert.

SINGER
Mr. 80 SPF Sunblock Wearer!

ANNOUNCER
Bud Light beer, Anheuser-Busch,
St. Louis, Missouri.

MR. MINIATURE TRAIN MODELER

ANNOUNCER
Bud Light presents:
Real Men of Genius.

SINGER
Real Men of Genius.

ANNOUNCER
Today we salute you,
Mr. Miniature Train Modeler.

SINGER
Mr. Miniature Train Modeler.

ANNOUNCER
Yours is a perfect magical
world, wedged neatly between
your furnace and your hot
water heater.

SINGER
Keep on dreamin'!

ANNOUNCER
Your mini town has a mini ice
cream store, complete with a
mini soda jerk, guaranteeing
there will always be at least 2
jerks in your world.

SINGER
You'll never be alone.

ANNOUNCER
Woo, woo, all aboard,
first stop, Nutsville.

B/U SINGER
Chug chug, woo woo!

ANNOUNCER
So crack open an ice cold
Bud Light, Master of your
Mini-World. You'rekoo-koo
about choo-choos and that's
fine by us.

SINGER
Mr. Miniature Train Modeler.

ANNOUNCER
Bud Light Beer. Anheuser
Busch, St. Louis, Missouri.

MR. PARANOID OF THE OCEAN GUY

ANNOUNCER
Bud Light presents:
Real Men of Genius.

SINGER
Real Men of Genius.

ANNOUNCER
Today we salute you, you...Mr.
Paranoid Of The Ocean Guy.

SINGER
*Mr. Paranoid Of The
Ocean Guy...*

ANNOUNCER
Windsurfing. Parasailing.
Body boarding. Not you. You
prefer activities like flailing,
shivering and whimpering.

SINGER
Please don't judge me

ANNOUNCER
Bravely you step into the water.
One wrong move,
and you could be pinched
to death by a hermit crab.

SINGER
Tell my wife I love her!

ANNOUNCER
Was that a piece of seaweed
that brushed up against
your leg? Or, a giant man-
eating eel?

SINGER
Ooooohhh!

ANNOUNCER
So crack open an ice cold
Bud Light Oh Swimmerus
Minimus. Because someone
has to man those shallow
waters, and that someone
is you.

SINGER
*Mr. Paranoid Of The
Ocean Guy.*

ANNOUNCER
Bud Light Beer. Anheuser
Busch, St. Louis, Missouri

Gold
Posters & Billboards
Promotional, Single

**DO YOU SEE MUSIC?
(EXERCISE YOUR MUSIC
MUSCLE)**

Art Director
Rodrigo Butori
Copywriter
Kristina Slade
Creative Director
Court Crandall
Photographer
Vincent Dixon
Producer
David Safian
Photo Editor
Catherine Chauvet
Agency
ground zero advertising
Client
Virgin Digital
Country
United States

Looking to create an experience
that would engage people, rather
than just make a poster to walk
past, we created this piece with
more than 75 visual metaphors of
musical artists and bands. The
piece challenged music fans to
"Exercise Your Music Muscle" and
see how many artists and bands
they could spot. This image was
meant to be displayed on the Virgin
Digital website, in Virgin Mega-
stores, in print ads and sent to the
Virgin Digital subscribers. But
shortly after it's release, dozens of
blogs, music related websites, and
online communities around the
world spontaneously promoted it by
embracing the challenge. Lists of
possible solutions circled the globe
and even some foreign newspapers
and magazines picked up the story,
calling it an "international mania."
The main accomplishment of this
piece was to keep people staring at
an ad for such a long time. To get a
consumer to pay attention to your
ad is hard. To get him to spend
hours with it is almost impossible.

BIG AD

Art Director
Grant Rutherford
Copywriter
Ant Keogh
Creative Director
James McGrath
Director
Paul Middleditch
Editor
Peter Whitmore
Production Company
Plaza Films
Producer
Pip Heming, Peter Masterton
Agency
George Patterson Y&R
Client
Carlton Draught
Country
Australia

Writer Ant Keogh and Art Director Grant Rutherford created the "Made from Beer" Campaign in 2003. Creative Director was James McGrath. We'd built up the client's trust with the success of two previous TV ads which had helped increase market share considerably. We then presented the new idea of sending up the genre of big ads. The client loved it and the script was approved without research (though the campaign idea had been tested on earlier executions). From concept to the finished ad took six months, three of which was spent doing post-production. Because of the post-production, everything was meticulously planned and pre-visualized so the ad looks pretty much identical to the storyboard. Paul Middleditch suggested shooting in New Zealand because the scenery there is amazing. It's where they shot Lord of the Rings. Even though there is a big effects component, we always tried to think of the spot as a humor/performance ad—it was crucial to get that bit right, casting and performance. When it came to CGI we often asked the effects guys if they could the whole thing look more wonky and human, like a whole bunch of beer drinking blokes were in charge, which gives it its charm. Of course, the humor comes out of pushing everything to edge of ludicrousness so we just jammed in every cliché we could think of. Seeing the inside workings of the Big Man always seemed funny to me because it's that bit too much information.

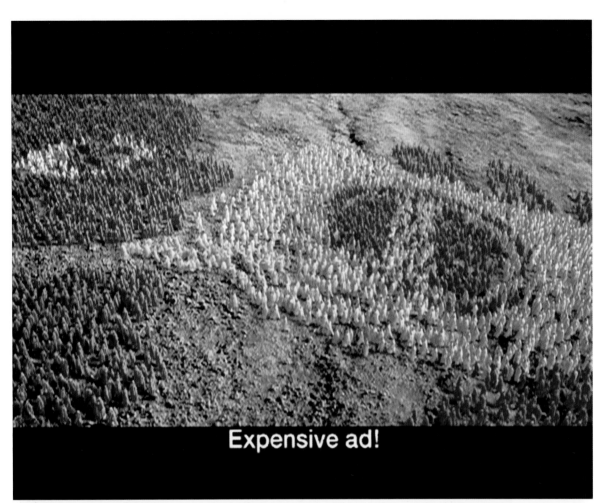

Expensive ad!

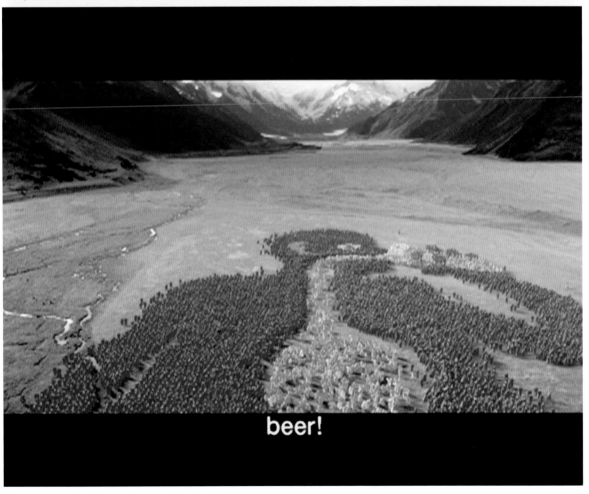

beer!

Multiple Winner**

Silver
Television & Cinema Crafts,
Special Effects, Single (60")
Distinctive Merit
Television & Cinema
Commercials, Cinema:
Over 30 Seconds, Single (50")
Distinctive Merit
Television & Cinema Crafts,
Music/Sound Design,
Single (60")
Distinctive Merit
Television & Cinema
Commercials, TV:
Over 30 Seconds, Single (60")
Distinctive Merit
Television & Cinema Crafts,
Editing, Single (60")
Distinctive Merit
Television & Cinema Crafts,
Art Direction, Single (60")
Merit
Television & Cinema Crafts,
Animation, Single (60")

NOITULOVE

Art Director
Matt Doman
Copywriter
Ian Heartfield
Creative Director
Paul Brazier
Director
Danny Kleinman
Editor
Jonnie Frankel
Producer
Yvonne Chalkley
Production Company
Kleinman Productions
Agency
Abbott Mead Vickers BBDO
Client
Guinness
Country
United Kingdom

We were given the opportunity to go
back to the end line "good things
come to those who wait." We took
it. For our own sanity we blocked
the glorious ads of the past from our
minds, and tried to do our own
thing. Post-production was obvi-
ously our biggest challenge. We had
to make all the different elements
(live action, c.g. animation, stock
footage, etc…) sit together and
work as one. It took us the best part
of a year, from brief to airdate. A lot
of very talented people spent long
days and nights getting the film
looking and sounding as good as it
does. Hopefully they all agree that it
was worth it.

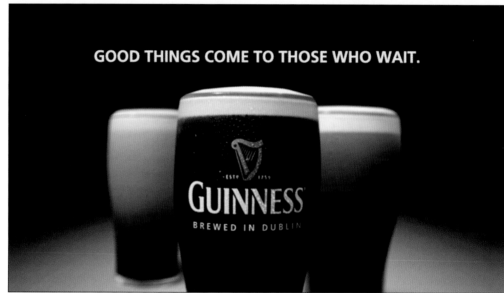

MR. GANGSTA RAPPER POSSE MEMBER

ANNOUNCER
Bud Light presents:
Real Men of Genius.

SINGER
Real Men of Genius!

ANNOUNCER
Today we salute you, Mr. Gangsta
Rapper Posse Member.

SINGER
Mr. Gangsta Rapper Posse Member.

ANNOUNCER
Behind every great man there
is a woman. And behind that
woman - fourteen guys with
sideways baseball caps and
really baggy pants.

SINGER
Those pants are giant!

ANNOUNCER
What do you do when you have no
talent whatsoever? Attach yourself
to someone who does.

SINGER
Fahizzle my schnizzle.

ANNOUNCER
Gold tooth? Check. Giant Gold
Medallion? Check. Royalties from
record sales? No check.

SINGER
Help a brother out.

ANNOUNCER
So crack open an ice cold Bud
Light, Baron of the Brown Nose.
Then, crack open another thirteen for
the rest of the crew.

SINGER
Mr. Gangsta Rapper Posse Member.

ANNOUNCER
Bud Light beer, Anheuser-Busch,
St. Louis, Missouri.

MR. TINY DOG CLOTHING MANUFACTURER

ANNOUNCER
Bud Light presents:
Real Men of Genius.

SINGER
Real Men of Genius.

ANNOUNCER
Today we salute you, Mr. Tiny Dog
Clothing Manufacturer.

SINGER
Mr. Tiny Dog Clothing Manufacturer.

ANNOUNCER
Great men ask the tough questions.
Where did we come from? What
is gravity? How do you help a
schnauzer through a fashion crisis?

SINGER
Smashin' fashion.

ANNOUNCER
You see no irony in designing a
thick fur coat, for an animal born
with a thick, fur coat.

SINGER
It's warm in here.

ANNOUNCER
A dog licking himself, disgusting.
A dog licking himself in an argyle
sweater, adorable!

SINGER
Smoochable pooch.

ANNOUNCER
So crack open an ice cold Bud
Light, oh, Purveyor of the Pooch.
They may be just dumb animals.
But thanks to you, they'll always
be smartly dressed.

SINGER
Mr. Tiny Dog ClothingManufacturer.

ANNOUNCER
Bud Light Beer. Anheuser Busch,
St. Louis, Missouri.

MR. BATHROOM STALL DIRTY JOKE WRITER

ANNOUNCER
Bud Light presents:
Real Men of Genius.

SINGER
Real Men of Genius!

ANNOUNCER
Today we salute you, Mr. Bathroom
Stall Dirty Joke Writer.

SINGER
*Mr. Bathroom Stall Dirty
Joke Writer.*

ANNOUNCER
Armed with your trusty marker,
you do the impossible: Made an
incredibly dirty place even dirtier.

SINGER
Scribble it down now.

ANNOUNCER
Your jokes make us pee our pants.
Lucky for us, they're down around
our ankles.

SINGER
Yeah!

ANNOUNCER
You answer our most vexing
question: what ever happened
to the man from Nantucket?

SINGER
Oh that's a good one.

ANNOUNCER
So crack open an ice cold Bud
Light, Oh, Ruler of the Rhyme.
Because when we're looking for a
good time . . . we call you.

SINGER
*Ohhh, Mr. Bathroom Stall Dirty Joke
Writer.*

ANNOUNCER
Bud Light beer, Anheuser-Busch,
St. Louis, Missouri.

MR. HOT STOCK TIP GIVER OUTER

ANNOUNCER
Bud Light presents:
Real Men of Genius.

SINGER
Real Men of Genius.

ANNOUNCER
Today we salute you,
Mr. Hot Stock Tip Giver Outer.

SINGER
Mr. Hot Stock Tip Giver Outer.

ANNOUNCER
Why go to professional
analysts when we can get inside infor-
mation from your brother-
in-law's sister's fourth cousin's
stepfather?

SINGER
On your mother's side.

ANNOUNCER
Sure, you may know absolutely
nothing, but we know even less.

SINGER
Big, big, big ole dummy.

ANNOUNCER
Your motto: buy low/sell low.
Get other people to buy low
and sell low.

SINGER
Keep hope alive!

ANNOUNCER
So crack open an ice cold Bud
Light, Oh, Titan of the Tip.
Although you're always wrong,
you'll always be our Mr. Right.

SINGER
Mr. Hot Stock Tip Giver Outer.

ANNOUNCER
Bud Light Beer. Anheuser Busch,
St. Louis, Missouri.

MR. BACKYARD BUG ZAPPER INVENTOR

ANNOUNCER
Bud Light presents: Real Men of Genius.

SINGER
Real Men of Genius!

ANNOUNCER
Today we salute you,
Mr. Backyard Bug Zapper Inventor.

SINGER
Mr. Backyard Bug Zapper Inventor . . .

ANNOUNCER
Not content to harmlessly repel insects with lotion,
you discovered a way to fry them with electricity
until their bodies explode.

SINGER
Zap, kaboom . . .

ANNOUNCER
Ah the sounds of summer. Crickets chirping. Birds
singing. The blood-curdling scream of a moth having
700 volts of electricity shoot through its body.

SINGER
Music to my ears . . .

ANNOUNCER
Every night, a magical explosion of exoskeleton and
insect goo that can only mean one thing. Summer's here.

SINGER
Die bugs, die!

ANNOUNCER
So crack open an ice cold Bud Light, Mr. June Bug
Blaster. Then sit back and watch the fireworks.

SINGER
Mr. Backyard Bug Zapper Inventor . . .

ANNOUNCER
Bud Light beer, Anheuser-Busch, St. Louis, Missouri

MR. BASKETBALL COURT SWEAT WIPER UPPER

ANNOUNCER
Bud Light presents:
Real Men of Genius.

SINGER
Real Men of Genius.

ANNOUNCER
Today we salute you,
Mr. Basketball Court
Sweat Wiper Upper!

SINGER
*Mr. Basketball Court Sweat
Wiper Upper!*

ANNOUNCER
You'll do anything for court-
side seats. Even if it means
mopping another man's
sweat off the floor.

SINGER
Smelly man sweat!

ANNOUNCER
Superstars may fall. But
superstars don't *wipe up*
sweat *after* they fall…
You do that.

SINGER
Uoooohh!

ANNOUNCER
While they soak up the glory,
you soak up pretty much
everything else.

SINGER
Super absorbent!

ANNOUNCER
Their shoes aren't squeakin'
till your towel's a reakin!

SINGER
Pee-uuu!

ANNOUNCER
So crack open a nice cold
Bud Light, O Prince of
Perspiration. Because we
know a champion when
we smell one.

SINGER
*Mr. Basketball Court Sweat
Wiper Upper!*

ANNOUNCER
Bud Light Beer. Anheuser
Busch, St. Louis, Missouri

MR. NOSEBLEED SECTION TICKET HOLDER GUY

ANNOUNCER
Bud Light presents:
Real Men of Genius.

SINGER
Real Men of Genius.

ANNOUNCER
Today we salute you,
Mr. Nosebleed Section
Ticket Holder Guy

SINGER
*Mr. Nosebleed Section Ticket
Holder Guy…*

ANNOUNCER
Congratulations, with the
help of two sherpas and a
mountain goat, you have
finally reached your seats.

SINGER
Touch the sky!

ANNOUNCER
Tickets, check. Souvenir,
check. Oxygen mask, check.

SINGER
Gettin' dizzy!

ANNOUNCER
From where you sit, you can
see your house. And Canada.
And Japan.

SINGER
I see Okinawa!

ANNOUNCER
The one thing you can't see?
The game.

SINGER
Oh no!

ANNOUNCER
So crack open an ice cold
Bud Light, oh Chairman of the
Cheap Seats. Because you, sir,
sit on top of the world. Liter-
ally.

SINGER
*Mr. Nosebleed Section Ticket
Holder Guy*

ANNOUNCER
Bud Light Beer. Anheuser
Busch, St. Louis, Missouri.

Multiple Winner**

Silver
Radio Advertising,
Over 30 Seconds,
Single (Jalapeno)
Distinctive Merit
Radio Advertising,
Over 30 Seconds,
Campaign (Jalapeno,
Wrong Number, Banana)
Distinctive Merit
Radio Advertising,
Over 30 Seconds,
Single (Wrong Number)
Merit
Radio Advertising,
Over 30 Seconds,
Single (Banana)

**JALAPENO,
WRONG NUMBER,
BANANA**

Agency
Fallon
Client
Virgin Mobile USA
Country
United States

JALAPEÑO

PHIL
Hello.

NICK
Hey, Phil.

PHIL
Who's calling?

NICK
It's Nick.

PHIL
Oh hey, what happened to you yesterday?

NICK
You gotta be kidding. You hit me in the eye with that jalapeño.

PHIL
Oh yeah, that was funny.

NICK
It's not funny.

PHIL
It's kinda funny.

NICK
I had to go to the doctor.

PHIL
(LAUGHS)

NICK
I have to wear an eye patch for 3 weeks.

PHIL
It's kinda funny.

SFX
MUSIC STARTS

SUPER
For the love of music, get the new Virgin Mobile VOX 8610 color flip phones for $20 off. And when you activate before September 18th, get three *free* real music ring tones. Other phones as low as $59.99. No contracts, no hidden fees, no monthly bills. Virgin Mobile. Live without a plan.

WRONG NUMBER

GUY
Hello.

NATALIE
Hey hey, it's Natalie.

GUY
Hey, baby.

NATALIE
What are you doing?

GUY
Nothing much. Hang on for a second, I got another call. Hello?

GUY TWO
Hey hey hey, Frank, I've been waiting for you down here for 20 minutes. Where the hell are you?

GUY
Sorry, but I think you've got the wrong number.

GUY TWO
Sorry about that.

GUY
Hey, Natalie.

NATALIE
Who was that?

GUY
I don't know, some crazy white guy looking for a Frank.

SFX
MUSIC STARTS

SUPER
For the love of music, get the new Virgin Mobile VOX 8610 color flip phones for $20 off. And when you activate before September 18th, get three *free* real music ring tones. Other phones as low as $59.99. No contracts, no hidden fees, no monthly bills. Virgin Mobile. Live without a plan.

BANANA

GUY
Hello.

JASON
Hey, what's up? Where you at right now?

GUY
Who is this?

JASON
It's Jason. I'm just calling you back.

GUY
All right.

JASON
Yeah, whatcha doin?

GUY
Nothin. Just eating a banana.

JASON
How's that going for you?

GUY
It's kinda brown.

JASON
Don't eat it, then.

GUY
Nasty and brown.

JASON
You're gonna throw up, dawg.

SFX
MUSIC STARTS

SUPER
For the love of music, get the new Virgin Mobile VOX 8610 color flip phones for $20 off. And when you activate before September 18th, get three *free* real music ring tones. Other phones as low as $59.99. No contracts, no hidden fees, no monthly bills. Virgin Mobile. Live without a plan.

Multiple Winner**

Distinctive Merit
Television & Cinema
Commercials, TV:
Under 30 Seconds,
Campaign
Merit
Television & Cinema
Commercials, TV:
Under 30 Seconds,
Single (Golf)

GOLF, OFFICE, COACH

Art Director
Ron Smrczek
Copywriter
Irfan Khan
Creative Director
Zak Mroueh, Lance Martin
Director
Joachim Back
Editor
Mick Griffin
Producer
Jennifer Mete, Gigi Realini,
Link York
Production Company
Partners Film Co.
Agency
TAXI
Client
Pfizer Canada, Viagra
Country
Canada

In this campaign, men in everyday
situations are so elated about their
newfound abilities that they can't
help but share it with the world. But
before they can get into the actual
details, a Viagra logo appears over
their mouth and an accompanying
"bleep" censors their dialogue.

GOLF
We open on a well-mani-
cured green of a golf course
as a ball rolls into the hole.

MAN
(Amazed) Can you believe
that?!

MAN 2
That's nothin'.
This morning I . . .

SUPER
Viagra Logo

SFX
A constant single non-
musical tone [Completely
drowns out the remainder of
his explanation.]

The man who dropped the
amazing putt continues to
tell his friend about his
morning under the tone,
while a Viagra logo appears
over his mouth.

MAN 2
[Chuckles]

SUPER
Talk to your doctor.

OFFICE
We open in an office.
A man (Alex) and woman
(Samantha) are in the
kitchen as another man
(Tom) enters and pours
a cup of coffee

ALEX
Hey Tom,

TOM
Morning.

ALEX
You're Looking good.
Been workin' out?

TOM
No. But I have been...

SUPER
Viagra Logo

SFX
A constant single non-
musical tone [Completely
drowns out the remainder of
his explanation.]

Tom continues his
explanation under the
tone and the Viagra logo
appears over his mouth.

Samantha and Alex smile.

SAMANTHA
[Casually] Bravo.

SUPER
Talk to your doctor.

COACH
Hundreds of camera flashes
light up the room as an older
man in a formal suit stands
in front of several micro-
phones at a press
conference. Reporters
instantly start barking
questions at him until
one breaks through.

SFX
Cameras flashing and
several reporters jockeying
for the floor.

REPORTER 1
Coach, how does
it feel to retire?

COACH
Pretty darn good. Next?

REPORTER 2
What are you going to do
with all your free time?

SUPER
Viagra Logo

COACH
Well, I'm going to
spend more time . . .

The camera flashes die
off as Mr. Taylor continues
with his explanation under
the tone.

SFX: A constant single non-
musical tone [Completely
drowns the remainder of
the Coach's explanation.]

Reporter2 sits down.

Single camera flash goes off.

Cut back to the coach as he
scans the room for another
question.

COACH
Next?

SUPER
Talk to your doctor.

JUMP ROPE

Art Director
Geoff Edwards
Copywriter
Scott Duchon
Creative Director
Scott Duchon, Geoff Edwards,
John Boiler, Glenn Cole
Director
Frank Budgen
Producer
David Verhoef, Alicia Bernard
Production Company
Gorgeous Enterprises,
Anonymous Content
Editor
Angus Wall
Agency
McCann-Erickson
Client
XBOX 360
Music
Din Dah Dah
by George Kranz
Country
United States

In one seamless take we see a of
people watching two young kids
jumping rope in a public area. Two
other people come in and take the
ropes from the kids without having
them stop. We then see people
come in and out of the moving
ropes, jumping, running and flipping
as the ropes continue to move
without stopping. Along with a
couple of kids we see basketball
star Ben Wallace get into the ropes
for the finale. In the end everyone
walks away as the small crowd
applauds and the title "Jump In"
fades up over picture.

Multiple Winner**

Distinctive Merit
Posters & Billboards
Point-of-Purchase, Campaign
Distinctive Merit
Magazine, Consumer,
Spread, Campaign

**CALENDAR: BEANS, CAT,
JIGSAW, TOILET ROLL**

Art Director
Justin Tindall
Copywriter
Adam Tucker
Photographer
James Day
Creative Director
Justin Tindall, Adam Tucker
Agency
DDB London
Client
Harvey Nichols
Country
United Kingdom

As the High Church of Fashion,
Harvey Nichols represents hallowed
ground for those who come to
worship. This campaign is aimed at
The Fashionista—connoisseurs of
fashion driven by an almost obses-
sive need to own the latest thing.
Our idea demonstrates the sacrifices
these people are prepared to make
in order to possess these must-
have items. They call it "Fashion
Maths." To afford a pair of Christian
Louboutin shoes, they will eat baked
beans for a month. For a Luella bag,
they will go without toilet paper.

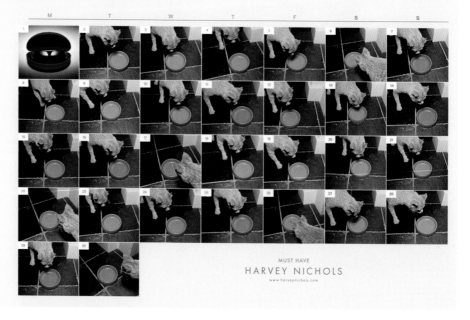

June

April

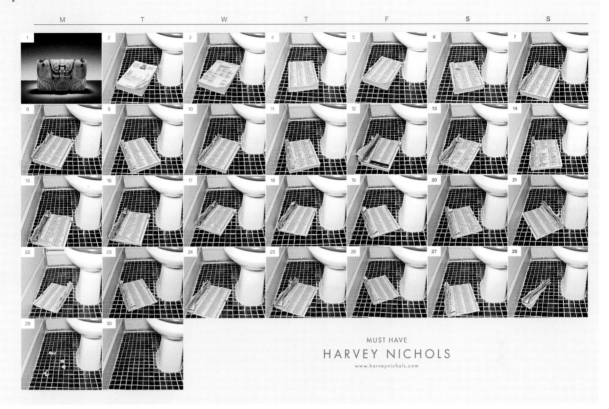

October

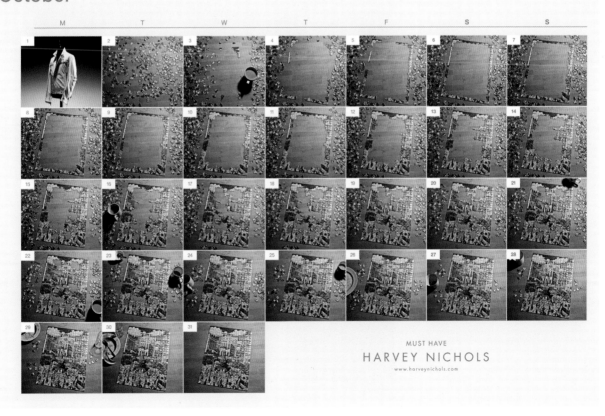

Distinctive Merit
Television & Cinema Crafts,
Cinematography, Single
Merit
Television & Cinema Crafts,
Special Effects, Single

GIMME THE BALL

Art Director
Andy Fackrell, Dario Nucci
Copywriter
Dario Nucci, Andy Fackrell
Executive Creative Director
Andy Fackrell
Director
Fredrik Bond
Editor
Rick Russell
Producer
Debbie Turner, Suza Horvat,
Peter Cline, Cedric Gairard
Production Company
MJZ London
Agency
MJZ, 180 Amsterdam
Client
Adidas F50, Uli Becker,
Arthur Höld,
Martina Jahrbacher
Country
United Kingdom,
Netherlands

A young couple from a nearby
housing estate encounters a
rampaging football fantasy through
an adjacent enchanted forest,
culminating in a Delacroix-like
masterpiece. The integrated adver-
tising campaign titled "Gimme the
ball" includes TV, Cinema, Print and
Outdoor.

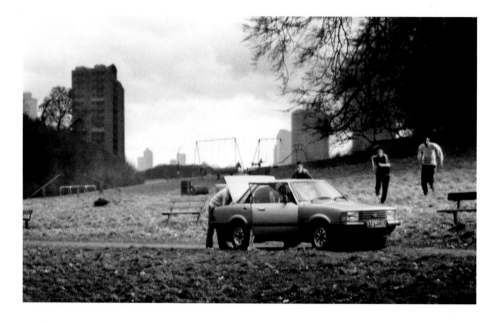

THE BUILD

Art Director
Joel Rodriguez
Copywriter
Scott Kaplan & John Patroulis
Executive Creative Director
Gerry Graf
Creative Director
Joel Rodriguez
Director
Stylewar
Editor
Jun Diaz,
Mackenzie Cutler Editorial
Producer
Ozzie Spenningsby,
Patrick Milling Smith,
Brian Carmody
Production Company
Smuggler
Agency
TBWA\Chiat\Day New York
Client
Nextel
Country
United States

Nextel was the smallest of all of the national cell phone companies and had the lowest share of voice and share of spending in the category. Though Nextel had developed a loyal following among its customers because of its feature-rich, walkie-talkie phones, it was relatively unknown to the outside world. The company needed breakthrough work that gave a reason for people to choose Nextel over other cell phone carriers. The solution was to focus on how Nextel walkie-talkie phones really help group productivity. "The build" commercial was a simple case study of a group of construction workers that used Nextel phones while building the Borgata hotel. The creative team decided to present this study in a visually arresting style by giving each worker the attributes and powers of an ant. Ant colonies are known for their incredible group efficiency. So this comparison really brought home the "group" strategy and also made for some entertaining television.

In a massive, chaotic setting, we see construction workers actually moving and working like ants - in very orderly lines, carrying massive concrete and steel objects over their heads with super-human strength. Some walk straight up walls carrying heavy building supplies, others crawl upside down, underneath steel girders.

One worker uses his Nextel Walkie-Talkie to guide a supply truck into place.

WORKER
Keep left.

DRIVER OF CRANE
Got it.

A group of workers crawl all over each other, carrying impossibly heavy spools of wire as one uses his Nextel Phone to pay for a delivery with a credit card.

Another uses his Nextel Phone to scan in building supplies.

Finally, we pull back – and see the massive building rising like an ant hill among the seemingly chaotic but clearly efficient swarm of construction workers.

SUPER
NEXTEL HELPS GROUPS GET THINGS DONE.

TITLE CARD
NEXTEL. DONE.

Distinctive Merit
Television & Cinema
Commercials, TV:
Over 30 Seconds, Single

TV WANTS MORE

Art Director
Jerome Marucci
Copywriter
Dan Kelleher
Creative Director
David Lubars, Eric Silver
Director
Noam Murro
Director of Photography
Toby Irwin
Editor
Owen Plotkin
Producer
Andy Wilcox
Production Company
Biscuit
Agency
BBDO New York
Client
DirecTV
Country
United States

The objective was to convince current cable subscribers to switch to DirecTV. The challenge was that most cable subscribers are comfortable with their service and don't realize the advantages of satellite television. Our solution was to get the message out that cable's antiquated delivery system for television content is old and tired. DirecTV is the way of the future and can offer much more.

Open on a woman in laundry commercial. She is bored and apathetic. She barely has the energy to read the cue cards while she holds up the detergent.

WOMAN
(Apathetic) With Love My Laundry, you just pour in a cup and stains disappear like magic.

Cut to two news anchors. They are both nodding off during a live broadcast.

Cut to kid's show with a barney type character. All the kids are bored. The guy inside the barney type costume has fallen asleep. His costume head falls off.

Cut to a cooking show. The French chef looks like he could care less about what he is preparing.

VOICE OVER
Face it . . . your TV . . . is tired.

Cut to a daytime talk show. Everyone on it can barely stay awake.

HOST
(Sleepy) Where did you get the idea to write a movie about cats?

GUEST
(Sleepy) It's a book.

HOST
(Sleepy) Oh.

Cut to a police drama. The police have a criminal cornered but no one in the scene seems to care.

VOICE OVER
It wants more . . . more channels, movies . . . more choices.

Cut to an mtv video. The performers don't really feel like lip-synching and dancing.

VOICE OVER
It wants 100% digital quality on every channel.

Cut to a game show. Everyone looks like they'd rather be somewhere else and could care less.

HOST
(Bored) Who was responsible for the Dictionary of the English language?

CONTESTANT
(Bored) Samuel Johnson.

HOST
(Bored) That's right.
You win.

LOGO
DIRECTV. RETHINK TV.

VOICE OVER
It's time. It's time to rethink TV.

Distinctive Merit
Television & Cinema
Commercials, TV:
Over 30 Seconds, Single

LIFE

Art Director
Brent Anderson
Copywriter
Eric Samsel
Creative Director
Tim Hanrahan
Director
Brent Anderson, Eric Samsel
Designer
Matt Clark
Production Company
ManBaby
Agency
Johnson Cowan Hanrahan
Client
Brooks Running
Country
United States

This work for Brooks Running
Company stems from a philosophy
that running is playing and playing is
fun. We were tasked to avoid two
specific advertising elements that
are common to the category: "The
Big Shoe" (a hero shot of the
product, highlighting the latest tech-
nology that will likely be obsolete or
copied tomorrow) and "The Big
Sweat" (the lone runner in a
deserted setting who is running to
"find herself"). The goal was to
demonstrate that beyond the latest
foam or therapy-du jour, there exists
a common thread in running—the
lifelong joy of it that all runners can
identify with.

Open on a baby boy being
born, running from the
moment it enters the world.

As the child grows, he enjoys
running and its part in the
carefree, playful things of
childhood.

Entering adolescence and his
college years, he runs
for mischief, idealism, and
for the escape from everyday
worries.

As he becomes an adult, the
runner continues running for
recreation, competition and
for fitness reasons.

Entering his golden years,
he's still running on, perhaps
realizing that for all the
various reasons he's run
throughout his entire life,
it's all for the fun.

At the end of his life, the
fun of running continues
its never-ending cycle by
inhabiting the next runner to
come into the world.

CARD
Run World, Run.

Cut to baby girl being born.

LOGO
Brooks

Distinctive Merit
Television & Cinema
Commercials, TV:
Over 30 Seconds, Single

KING KONG

Art Director
Rungsun Suwannachitra,
Taya Soonthonvipat
Copywriter
Wichian Thongsuksiri
Creative Director
Pinit Chantaprateep
Director
Thanonchai Sornsriwichai
Editor
Manop Boonvipas
Producer
Poj Rajkulchai,
Piyawan Mungkung
Production Company
Phenomena Co., Ltd.
Agency
JWT
Client
Ford Sales & Service
Thailand - Ford Ranger
Opencab
Country
Thailand

A giant monkey hand
snatches a banana-laden
Truck. Playfully the monkey
mistreats the truck. The
monkey's Dad arrives, telling
junior it's lunchtime. Junior
ignores Dad and continues
playing. Dad picks up the car,
tossing it away and smacks
junior's ear.

SUPER
Stop playing!
Go and eat your lunch.

VOICE OVER
In a man's world, you must
be tough.

SUPER
In a man's world,
you have to tough.

Distinctive Merit
Television & Cinema
Commercials, TV:
Over 30 Seconds, Single

GAP DUST

Art Director
John Parker
Copywriter
Evan Fry
Creative Director
Andrew Keller, Alex Bogusky
Director
Spike Jonze
Editor
Eric Zumbrunnen,
Final Cut LA c/o Mint
Executive Producer
David Zander, Jeff Scruton
Producer
Rupert Samuel, David Rolfe
Production Company
MJZ
Designer
Floyd Albee
Agency
MJZ
Client
Gap
Country
United States

Open on a young man in
a Gap pulling a stack of
t-shirts off the shelf to
look for his size.

The entire stack falls
to the floor.

A Gap employee who is
helping the customer
notices, and, as a gesture of
solidarity, tips over a couple
more stacks of shirts.

Another customer who
has witnessed this turn of
events gently pushes over
a mannequin.

Cut to a Gap employee who
is inspired to push over
another mannequin.

Cut to the Gap manager
behind the counter. He
cranks the volume on the
store music as if to encour-
age more of the same.

More customers notice
and begin to join in on
the demo party.

Customers and employees
band together to pull down
displays.

Customers and employees
work to remove changing-
room doors from hinges by
prying with mannequin arms.

See a Gap employee carry a
customer on his shoulders so
she can reach a light fixture
and pull it down.

They use cash registers to
demo the checkout.

A larger group works together
to carry a heavy display table
and run it through a wall.

Cut to see a store fixture fly
out the window and land in
a pile of other old Gap
pieces out on the curb.

Cut to see a van smash
through the Gap front
window.

Cut to the corner of the store
where a customer yanks the
arm off the last manequinn.

SUPER
Pardon our dust.

SUPER
The all-new Gap is coming.

LOGO
Gap
(treated in blueprint style)

SUPER
April 22nd

Distinctive Merit
Television & Cinema
Commercials, TV:
Over 30 Seconds, Single

THE MARCH OF THE EMPERORS

Art Director
Romain Guillon, Eric Astorgue
Copywriter
Pierre Riess, Luc Rouzier
Director
The Glue Society
Editor
Gery Bouchez,
Sylvain Lefebvre, No Brain
Producer
Guy Pechard
Production Company
@radical.media
Creative Director
Stephane Xiberras
Agency
BETC Euro RSCG,
Radical Media
Client
Canal Plus
Country
United States

BAREFOOT RUN

Art Director
Monica Taylor
Copywriter
Derek Barnes
Creative Director
Hal Curtis, Mike Byrne
Director
Noam Murro
Editor
Avi Oron
Producer
Gina Pagano
Production Company
Biscuit Filmworks
Agency
Wieden+Kennedy
Client
Nike
Country
United States

A big part of the advertising challenge with Nike Free was that it needed to introduce not only a new shoe, but also the new concept of barefoot training. The task of educating runners on barefoot training and the benefits of the Free shoe would be addressed in print and online. But with the TV launch, Nike needed to provocatively, yet simply, convey the sensory appeal of barefoot training to runners. Fortunately, Vangelis and the movie Chariots of Fire did it for us roughly 20 years ago.

Open on CU of legs as they run on beach

MUSIC
The theme from "Chariots of Fire" through the water

Tilt up to reveal "Chariots of Fire" runners running

Cut to wide shot of pack running down the beach

Cut to profile shots of the pack running. Parking meters pass in the foreground

Cut to medium shot of pack running. The camera tilts down to reveal them running over a manhole cover

Cut to the pack passing a man reading a newspaper while sitting on a park bench

Cut to medium shot of pack running toward camera

Cut to CU of feet running

Cut to pack running past a fire escape suspended in air

Cut to reveal a taxi driving by them in the water

Cut to our hero leading the pack past a row of newspaper stands

Cut to pack running toward camera as they pass a tree growing out of the beach

Cut to a 3/4 shot of them running past a businessman putting mail into a mailbox

Cut to a CU of our hero

Cut to a wide as the pack runs toward camera

A bus wipes frame to reveal our hero running alone

SFX: Bus in the city

The hero stops and runs in place
SFX: City sounds

Cut to CU of Nike Free shoes

The shoes run out of frame to reveal supers

Musical reprise

SUPER
run barefoot.

SUPER
Swoosh and nikefree.com

Distinctive Merit
Television & Cinema Crafts,
Special Effects, Single

FLY

Art Director
Kristoffer Heilemann
Copywriter
Ludwig Berndl
Creative Director
Amir Kassaei,
Wolfgang Schneider,
Mathias Stiller
Director
Henry Littlechild
Editor
Arthur Jagodda
Producer
Simona Daniel, Nele Schilling
Production Company
Markenfilm
GmbH & Co. KG, Hamburg
Agency
DDB Germany
Client
Volkswagen AG
Country
Germany

The Golf GT commercial "Fly" aimed
to illustrate in an unusual, surprising
and humorous way the innovative
TSI® technology in the new Golf GT.
We see a frog sitting on a leaf in a
pond waiting for his prey. He jumps
for a fly. But the fly turns the tables:
sticking to his tongue, she drags the
frog easily out of the water and right
up in the air—"maximum power
condensed"—just like the TSI® twin
charger engine of the new Golf GT.

Distinctive Merit
Television & Cinema
Commercials, TV:
30 Seconds, Single

HAPPY BIRTHDAY

Art Director
Molly Sheahan
Copywriter
Marty Senn
Creative Director
Ari Merkin
Director
Happy
Editor
Maury Loeb
Producer
Betsy Schoenfeld
Production Company
Smuggler
Agency
Fallon
Client
General Pacific/Brawny
Country
United States

The challenge here was simple:
make people feel better about a
brand and product they don't spend
much time thinking about. The solu-
tion was even simpler: forget
thinking about Brawny, let's have
them fantasize about it. A doting
husband, a birthday cake, puppies.
You can't go wrong with puppies.

VIDEO
Open on a white house.
It is a fall day and leaves
are falling.

VIDEO
Cut to a kitchen, where the
Brawny man is making
frosting for a cake.

VOICE OVER
Hmm . . . what's this,
something's cooking at
the Parkers.

VIDEO
Cut to the cake
getting frosted.

VOICE OVER
Oooh. . . that's a nice touch.
She'll like that.

VIDEO
Cut to frosting spilled
on the table.

VOICE OVER
Oooh. . . what have we here?

VIDEO
Cut to the Brawny man
ripping off a towel from
the paper towel roll. He
leans over the counter
and wipes up the spill.

VOICE OVER
Nothing Brawny
can't handle.

VIDEO
Cut to paper towels and the
soft logo across the screen.

VOICE OVER
So strong. That's Brawny.

VIDEO
Cut to the Brawny man
wiping off a puppy's face
with a Brawny towel.

VOICE OVER
Now that's a bad little boy.
VIDEO
Cut to paper towels and soft
written across the screen.

VOICE OVER
So soft. That's Brawny.

VIDEO
Cut to the Brawny man
holding the birthday cake
and the puppy. They are
walking toward the camera.

VOICE OVER
Happy birthday to you, Mrs.
Parker. . . happy birthday. . .
to you.

VIDEO
Cut to Brawny towels
and triple action
performance icon.

VIDEO
Cut to Brawny towels and
finger pointing.

SUPER
That's Triple Action
Performance. That's Brawny.

Distinctive Merit
Posters & Billboards
Point-of-Purchase, Campaign

**BABES ON CARS:
ALEXANDRA ON BMW Z4,
ALLA ON LAMBORGHINI
DIABLO, FERNANDA ON
DODGE VIPER**

Art Director
Jens Petter Waernes
Copywriter
Simone Nobili
Creative Director
Jan Rexhausen,
Doerte Spengler-Ahrens
Designer
Erik Dagnell
Photographer
Stephan Abry
(Nerger MAO Photographers)
Agency
Jung von Matt AG
Client
Cars-and-Boxes
Country
Germany

Cars and Boxes, the German toy car specialist, wanted to create awareness for the online store www.carsandboxes.de and the point of sale. The core market is the collectors' community of adult men who love toy cars and who also love the aesthetics involved in muscle car culture. The campaign is the proof that the toy cars from Cars and Boxes are so authentic that the cliché "women and cars" concept still works.

**THE WHOLE WORLD
OF COLORS: SANTA CLAUS,
MARILYN, MONA LISA,
STATUE OF LIBERTY**

Art Director
Jan Knauss
Copywriter
Thies Schuster
Creative Director
Oliver Voss,
Deneke von Weltzien
Designer
Stephan Nau,
Sina Gieselmann
Agency
Jung von Matt AG
Client
DULUX paints deco
Country
Germany

Dulux, as one of Germany's leading
paint manufacturers, offers a wide
range of high quality colors. This
diversity is reflected in a striking
print campaign themed "the whole
world of colors." Professional
craftsmen, DIY and just about
anybody who has an interest in
paints and colors, represent the
target group.

Distinctive Merit
Collateral Advertising,
Point-of-Purchase Display,
Campaign

**TOURIST CAMPAIGN
(LEAFLETS): SPLIT UP,
ANIMAL FREAK,
HUNGOVER, YELLOW,
HAPPILY DEPRESSED**

Art Director
Juan Cabral
Copywriter
Juan Cabral
Creative Director
Richard Flintham,
Andy McLeod
Designer
Practise, Iain Richardson,
Ginny Carrel
Traffic Manager
Arjun Singh, Tom Appleby
Agency
Fallon
Client
Tate
Country
United Kingdom

Merit
Television & Cinema
Commercials, TV:
30 Seconds, Single
Merit
Television & Cinema Crafts,
Copywriting, Single

WRONG

Art Director
Jonathan Mackler
Copywriter
Jim LeMaitre
Creative Director
Eric Silver, David Lubars
Director
Hank Perlman, Jo Willems
Editor
Gavin Cutler
Producer
Elise Greiche
Production Company
Hungryman
Agency
BBDO New York
Client
FedEx
Country
United States

An employee in the shipping room
suggests that FedEx is too expen-
sive for ground deliveries. His co-
workers take this opportunity to tell
him that not only is he wrong about
FedEx, he's wrong about most
everything else. Many people
assume that since FedEx is a
premium product, it is expensive.
This is not the case. We needed to
find a way to correct this mispercep-
tion in a memorable way—a way
that small business owners can
relate to.

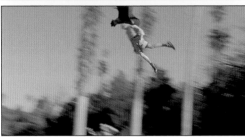

Open on a wide shot of a primitive tropical village on the isle of altoidia.

TITLE CARD
Altodia: Fable of the fruit bat.

GERALD
Altodia: Fable of the fruit bat.

Cut to Gerald Waters conversing with a tribal elder.

GERALD
Natives here on Altoidia live in fear of schee-schee, the fabled fruit bat, a winged giant driven mad at the slightest hint of sours.

Gerald pauses to enjoy and altoids sour. In the background, unbeknownst to gerald, an enormous fruit bat hangs from a tree.

GERALD
Of course, it's madness, this. A bogeyman sham cooked up by a shaman.

The fruit bat takes flight, seizes gerald and carries him aloft.

GERALD
Bugger! Bad doggie! Bad doggie!

He is lifted from the scene by the bat and dropped onto a nearby land rover. He gets up and dusts himself off, seemingly unharmed.

TITLE CARD
Explore sours at Altoidia.com

GERALD
Right, then. I'm all right. Nothing to see here.

Multiple Winner**

Merit
Television & Cinema
Commercials, TV:
30 Seconds, Single
Merit
Television & Cinema
Crafts, Art Direction, Single

Also for Hybrid
SEE PAGE 28

FABLE OF THE FRUIT BAT

Art Director
Noel Haan
Copywriter
G. Andrew Meyer
Creative Director
Noel Haan, G. Andrew Meyer
Director
Craig Gillespie
Editor
Paul Martinez
Producer
Vincent Geraghty
Production Company
MJZ Los Angeles
Agency
Leo Burnett
Client
Altoids
Country
United States

Multiple Winner**

Merit
Television & Cinema
Commercials, TV:
Over 30 Seconds, Single
Merit
Television & Cinema Crafts,
Art Direction, Single

MONSTER

Art Director
Philip Bonnery
Copywriter
Alex Flint
Creative Director
Gary Koepke, Lance Jensen
Director
Noam Murro
Editor
Avi Oron
Producer
Shawn Tessaro
Production Company
Biscuit
Agency
Modernista
Client
General Motors –
HUMMER Division
Country
United States

A monster crashes through a city,
smashing everything in its path. It
demolishes a huge building. As the
building falls, it reveals a giant robot.
The two monsters stare at each
other. We think they are about to
engage in battle. But then they fall in
love. We follow them as their loves
deepens, until one day, it becomes
clear that she is pregnant. Her preg-
nancy develops and she eventually
gives birth. To an H3. The new small
Hummer. Proud parents release
their little one to the ground and
watch as it takes its first turns on the
asphalt. SUPER: It's a little Monster.
The new H3.

Multiple Winner**

Merit
Television & Cinema
Commercials, TV:
Over 30 Seconds, Single
Merit
Television & Cinema
Crafts Art Direction, Single

PALM

Art Director
David Horowitz
Copywriter
David Horowitz
Creative Director
Kevin Mackall
Director
David Horowitz
Editor
Nathan Byrne, Post Millennium
Production Company
MTV In-House
Producer
Betsy Blakemore
Agency
Rock Fight
Client
MTV
Country
United States

PEOPLE OF PAIN

Art Director
Noel Haan
Copywriter
G. Andrew Meyer
Creative Director
Noel Haan, G. Andrew Meyer
Director
Craig Gillespie
Editor
Paul Martinez
Producer
Vincent Geraghty
Production Company
MJZ Los Angeles
Agency
Leo Burnett
Client
Altoids
Country
United States

Open on Gerald Waters in a strange and wonderful tropical environment: The Isle of Altoidia. He cruises up in a small motorboat.

TITLE CARD
Altoidia: Land of Sour. People of Pain.

GERALD
Altoidia. Land of Sour, People of Pain.

Cut to Gerald shaking hands with the natives.

Cut to Gerald in a tent, pointing to a spiky fruit on the table.

GERALD
This constant exposure to curiously strong sour has rendered these islanders immune to pain.

Cut to Gerald and a native measuring a spiky fruit on a tree. Cut to a native man—he's hit in the butt with an arrow, and feels no pain.

GERALD
As evident in simple greetings . . .

Cut to two natives. They casually kick each other in the groin as a greeting.

GERALD
Even daily tasks.

Cut to two natives. One is chopping brush with a machete. The other walks past. The machete hits him in the head and sticks; yet, he seems not to notice.

GERALD
After months of study, I was invited to join their clan.

Cut to a native chief. He has a tin of sours inserted into his lip as a lip disk. He removes the top and hands a sour to Gerald, who eats it.

GERALD
Observe, the sacred pain ritual.

Cut to Gerald, straddling a giant catapult. Two natives launch off a platform, and the catapult vaults gerald into the air. He lands, and gets up, seemingly uninjured.

GERALD
A bit much, that! Carry on, then.

Cut back to tribal chief nodding.

TITLE CARD
Explore sours at altoidia.com.

"Altoidia: People of Pain"

Open on the front door of a modest suburban apartment complex. Hank, a young salesman, exits holding rolled-up presentation materials under his arm, and a Starbucks Doubleshot Espresso Drink. He takes a sip of the Doubleshot.

A high energy "Hank" mascot jumps into frame and pumps his fist next to hank, holding a portable stereo playing a high energy, motivating song.

Hank pauses, in mid sip, a bit stunned.

Cut wide to reveal an entire section of gymnasium bleachers, awkwardly sitting on the lawn in front of the apartment complex. In the audience are various people that motivate, or inspire hank.

Cut to hank rising on an escalator. The bleachers are sitting flush against the esca-lator, the bleacher seats rising at the same angle as hank. He passes various inspirational and motivating audience members shouting words of encouragement.

Cut to hank sitting on the waiting couch of a semi-intimidating corporate reception area. The bleachers are next to him. The audience quietly buzzing.

A receptionist comes through the large doors to the conference room.

RECEPTIONIST
Hank?

Hank stands. The audience stands with him. He takes his first step toward the door, and the crowd explodes.

Cut to title card with a can of Starbucks Doubleshot.

VOICE OVER
Delicious Starbucks Doubleshot Espresso Drink. Bring on the day.

Merit
Television & Cinema Commercials, TV: Over 30 Seconds, Single

HANK

Art Director
Wayne Best
Copywriter
Adam Alshin
Creative Director
Ari Merkin, Wayne Best
Director
Tom Kuntz
Editor
Gavin Cutler
Producer
Zarina Mak
Production Company
MJZ
Agency
Fallon
Client
Starbucks
Country
United States

Merit
Television & Cinema Crafts,
Cinematography, Single
Merit
Television & Cinema Crafts,
Special Effects, Single
Merit
Television & Cinema Crafts,
Editing, Single

IMPOSSIBLE FIELD

Art Director
Dean Maryon
Copywriter
Ben Abramowitz
Executive Creative Director
Andy Fackrell
Creative Director
Dean Maryon
Director
Daniel Kleinman,
Kleinman Productions, London
Editor
Steve Gandolfi,
Cut & Run, London
Producer
Peter Cline, Tony Stearns,
Johnnie Frankel
Production Company
Kleinman Productions, London
Agency
180 Amsterdam
Client
adidas International;
Uli Becker, Arthur Höld,
Martina Jahrbacher
Country
Netherlands

The campaign centers on a 60-
second commercial in which we see
the players take on an army of
opponents all intent on owning the
ball. With a mix of precision,
balance and power the adidas team
performs on the raised lines of a
football pitch. Unable to run on
anything other than the white lines,
the players are forced to push their
skills, demonstrating the superior
level of football that is inherent to
these players. The raised playing
field provides a unique perspective
on the game of football, creating a
360° experience of the players in
action. The integrated advertising
campaign titled "Impossible Field"
includes TV, Cinema, Print and
Outdoor.

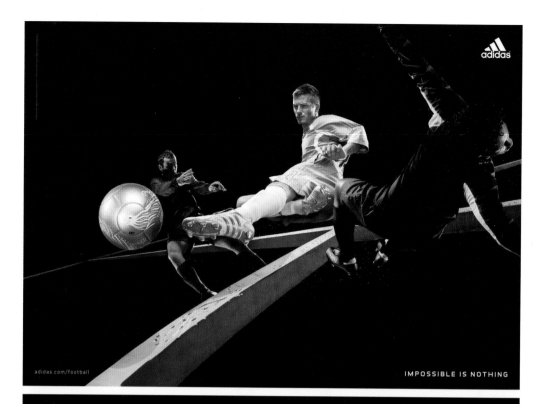

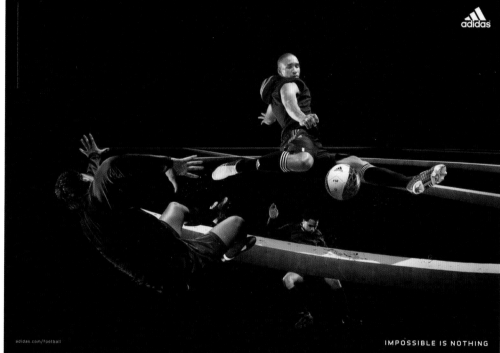

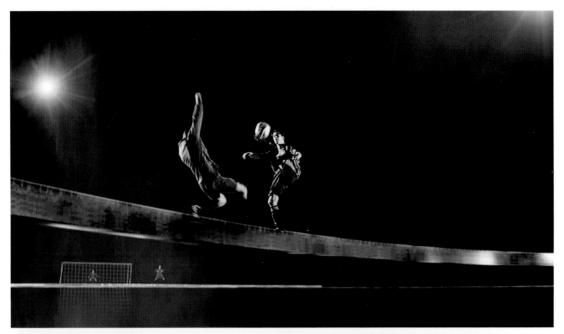

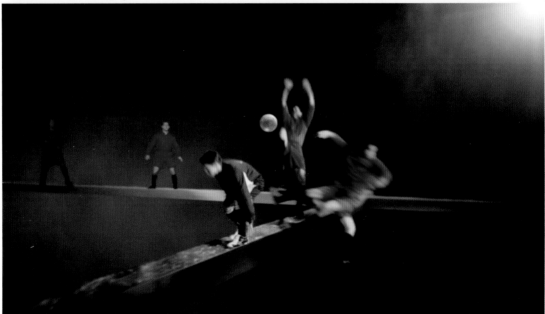

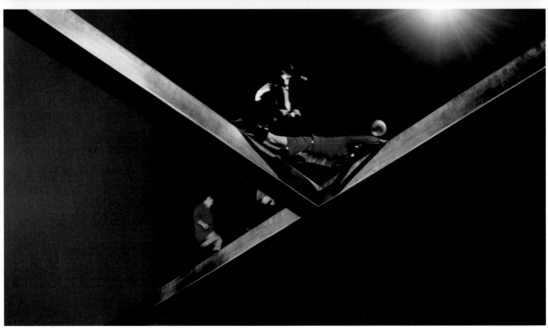

Multiple Winner**

Merit
Television & Cinema Crafts,
Cinematography, Single
Merit
Television & Cinema Crafts,
Editing, Single

WATER BALLOONS

Art Director
Nate Able
Copywriter
Mat Bunnell
Creative Director
Scott Duchon, Geoff Edwards,
John Boiler, Glenn Cole
Director
Frank Budgen
Producer
David Verhoef, Alicia Bernard
Production Company
Gorgeous Enterprises,
Anonymous Content
Editor
Angus Wall
(Rock, Paper, Scissors)
Cinematographer
Simon Richards
Agency
McCann-Erickson
Client
XBOX 360
Country
United States
Music
"Teddy Bear's Picnic"
by Gilbert Russell

Open on a man throwing a water
balloon out the window of a
dilapidated apartment complex.
Cut to a woman looking out her
windowsill getting hit by water
balloon. Cut to a posterior shot
of group of kids running into
courtyard. As they enter the
scene, they are ambushed by a
group of kids hiding behind a
low wall. Cut to shot of a group
of adults in street nailing each
other with water balloons. An
older man sprints for cover as he
is peppered by an onslaught of
incoming balloons. Cut to kids
lobbing balloons in unison off
top of stairwell like they're
grenades. A truck drives through
the scene, getting hit from all
sides with balloons. We see a
line of kids on steps handing
down balloons like an ammo
line, a teen sliding down slick-
ened wall, a little kid taunting
throwers from above before he
nervously ducks for cover. Cut to
shot of team of people launching
a sheet full of balloons off the
top of building, as it pulls wide
we see the balloons coming
down amidst the escalating
action. Cut to a shot of a large
puddle of water as we see
reflection of the scene, people
running into the fray.

Multiple Winner**

Merit
Magazine, Consumer,
Spread, Campaign
Merit
Posters & Billboards
Outdoor/Billboard,
Campaign

**DOTS: EYE, LIPS,
BELLY BUTTON**

Art Director
Sandra Birkemeyer,
Katja Kröger
Copywriter
Regine Becker
Creative Director
Dietrich Zastrow
Producer
Alexander Heldt
Production Company
Helmut Gass Reprotechnik
Agency
TBWA\Germany
Client
Beiersdorf AG – NIVEA
Country
Germany

Nivea Creme cares your skin every-
where. From a distance, you see a
mouth, an eye and a bellybutton.
Getting closer you can see lots of
Nivea Creme tins in different sizes.

Multiple Winner**

Merit
Magazine, Consumer,
Spread, Campaign
Merit
Posters & Billboards
Point-of-Purchase, Campaign

ANTI-PIRACY:
VOCAL CORDS,
SUPPORTERS, FINGERS,
SWEAT, HEART

Art Director
Philippe Taroux, Benoit Leroux
Copywriter
Benoit Leroux
Creative Director
Erik Vervroegen
Illustrator
Philippe Taroux, Benoit Leroux
Agency
TBWA\Paris
Client
EMI
Country
France

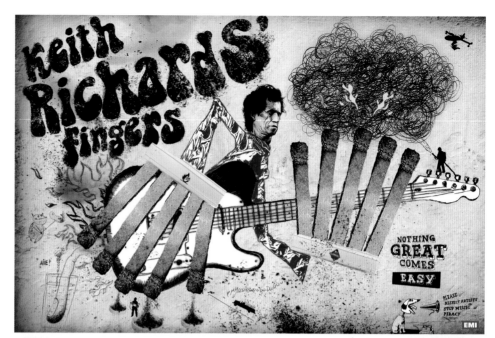

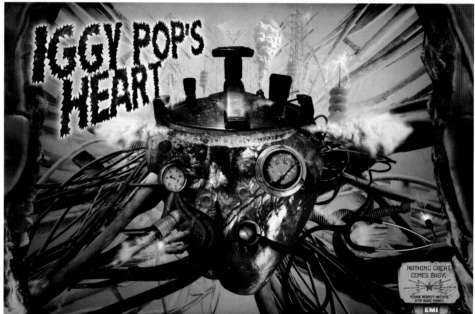

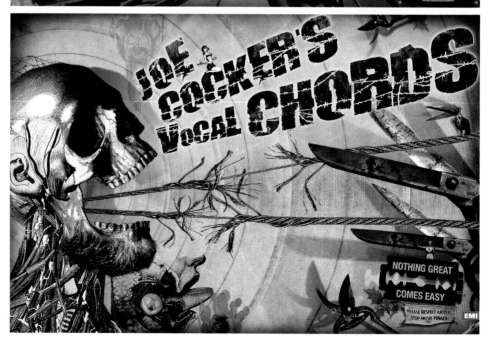

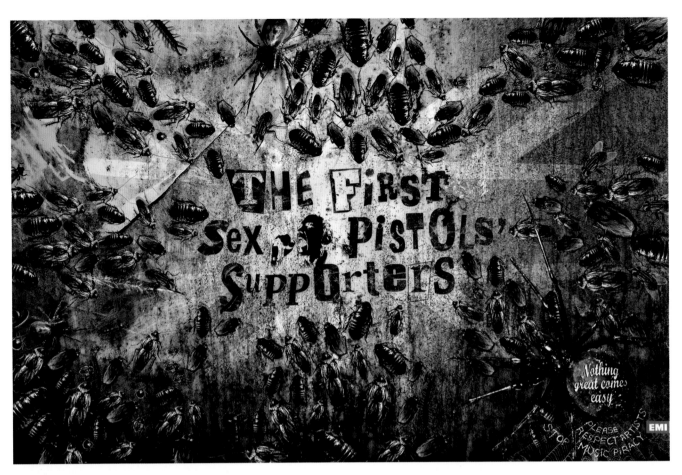

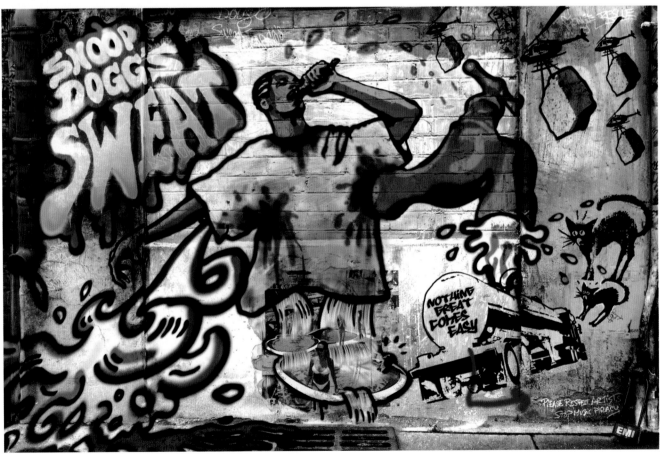

**GERMAN FOUNDATION
FOR MONUMENT
PROTECTION "BANK NOTE"
CAMPAIGN: OLD
NECKAR BRIDGE,
HEIDELBERG CASTLE,
WILHELMA IN STUTTGART**

Art Director
Simon Oppmann
Copywriter
Peter Roemmelt
Creative Director
Simon Oppmann,
Peter Roemmelt
Photo Editor
Hana Kostreba
Photographer
Hana Kostreba
Agency
Ogilvy & Mather
Werbeagentur GmbH & Co. KG
Client
German Foundation
for Monument Protection
(Deutsche Stiftung
Denkmalschutz)
Country
Germany

The German Foundation for Monu-
ment Protection (Deutsche Stiftung
Denkmalschutz) primarily lacks one
thing in its preservation of threat-
ened monuments: donations.

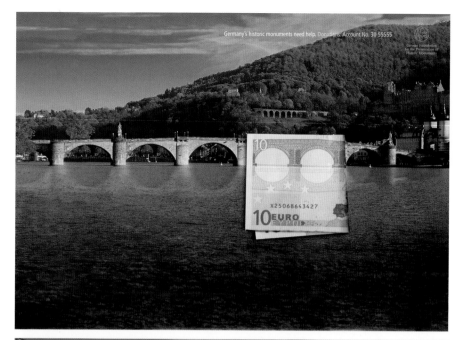

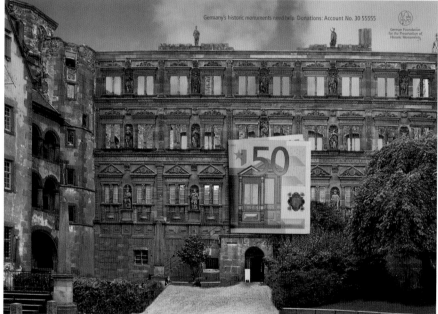

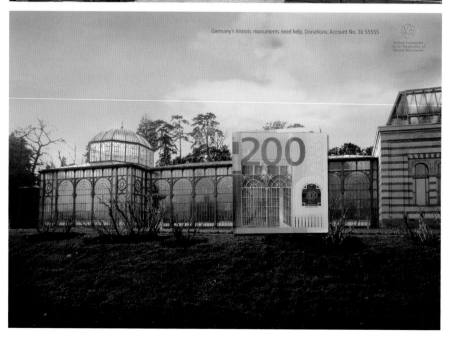

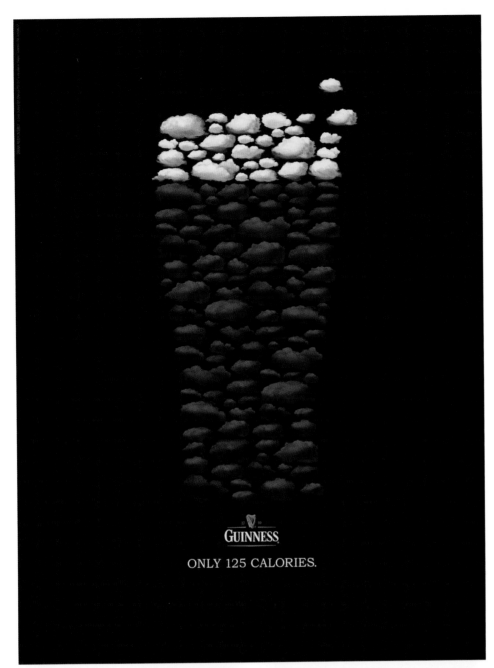

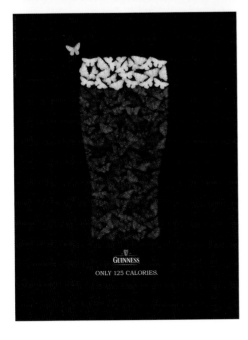

**125 CALORIE POSTER
CAMPAIGN: FEATHERS,
BUTTERFLIES, CLOUDS**

Art Director
Jerome Marucci
Copywriter
Ari Weiss
Creative Director
David Lubars, Eric Silver
Agency
BBDO New York
Client
Guinness
Country
United States

Guinness has always been associ-
ated with manliness. With this
comes the perception of a hearty,
high-calorie beverage. In facing a
more health conscience market,
Guinness wanted to communicate
that they actually have fewer calories
than most beers. Creatively, we
wanted to accomplish this without
alienating our core target. We stuck
with the iconic black and white pint,
while using imagery that communi-
cated the relative weightlessness of
the drink. And for the die hard Guin-
ness fans out there, there are actu-
ally 125 individual feathers in this ad.

Multiple Winner**

Merit
Posters & Billboards
Point-of-Purchase, Campaign
(Dexter Russell Wood
Campaign: Onion, Apple,
Lemon)
Merit
Posters & Billboards
Point-of-Purchase, Single
(Lemon)
Merit
Posters & Billboards
Point-of-Purchase, Single
(Onion)

**DEXTER RUSSELL
WOOD CAMPAIGN:
ONION, APPLE, LEMON**

Copywriter
James Clunie
Creative Director
David Lubars
Art Director
James Clunie
Agency
BBDO New York
Client
Dexter Russell Cutlery
Country
United States

These posters were simply meant to
communicate the precision and
accuracy of these knives. If you
need something cut so thin that you
almost lose it on your cutting board,
these will do the trick. Simply, these
knives will easily cut everything that
needs slicing.

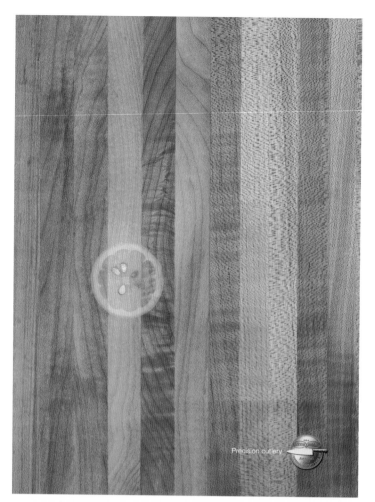

Precision cutlery

Multiple Winner**

Merit
Posters & Billboards
Point-of-Purchase, Campaign
Merit
Magazine, Consumer,
Spread, Campaign

TREATS: LADY, KID, FOREST

Art Director
Chris Garbutt
Copywriter
Matthew Branning
Creative Director
Erik Vervroegen
Photographer
Garry Simpson
Agency
TBWA\Paris
Client
Pedigree
Country
France

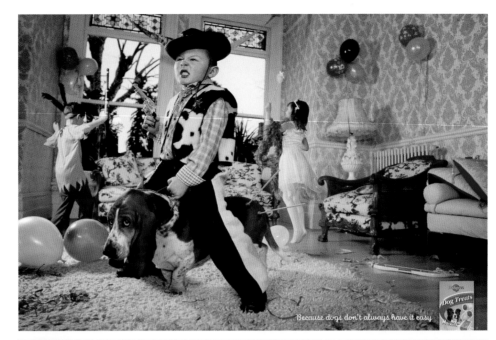

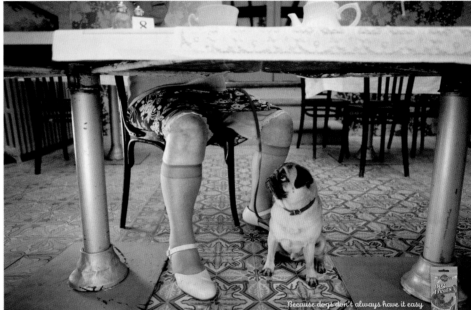

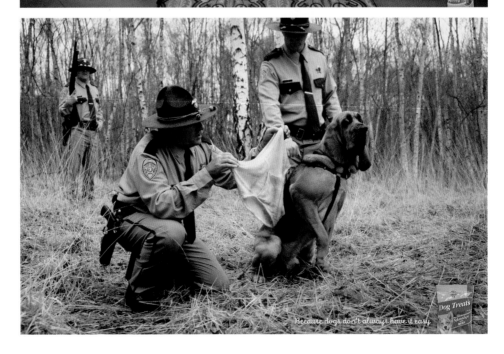

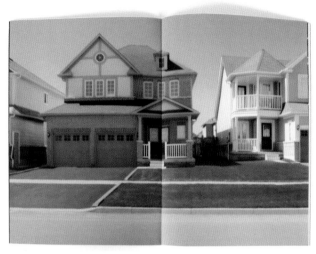

Multiple Winner**

Merit
Collateral Advertising,
Direct Mail, Single

STICKER BOOK

Copywriter
Jonathan Careless
Creative Director
Elspeth Lynn, Lorraine Tao
Designer
Paul Hogarth
Photographer
Michael Kohn, Sandy Pereira
Art Director
Paul Hogarth
Producer
Aimee Churchill
Production Company
The Production Kitchen
Agency
ZiG, Inc.
Client
Evergreen
Country
Canada

Evergreen is a non-profit organization that has been helping Canadians bring nature back to their cities over the past 15 years. To continue growing, Evergreen needed to solicit more donations. Advertising needed to prime potential supporters for fundraising calls by raising awareness of Evergreen and its raison d'être. This brochure was created to inspire people to start imagining their cities with nature. Inside are images of subdivisions without trees, business districts without grass and school grounds that resemble prison yards. In the center of the brochure is a sticker sheet of plants, trees, birds and insects that when peeled off and stuck on the images, helps people to quickly see the real difference that even a little nature makes.

Multiple Winner**

Merit
Collateral Advertising,
Product/Service Promotion,
Single
Merit
Collateral Advertising,
Guerrilla/Unconventional,
Single

HIGHLIGHTER

Art Director
Chuck Tso
Copywriter
Eric Schutte
Creative Director
David Lubars, Eric Silver
Agency
BBDO New York
Client
FedEx/Kinko's
Country
United States

FedEx was looking for a bold and
innovative idea to announce its new
online office supply store,
fedexkinkos.com. The result was
big. Literally. Oversized sculptures
of highlighters, whiteout bottles, and
desk lamps were placed in various
high-traffic outdoor locations and
played off the natural environment.
The monstrous highlighter looked as
if it had just painted a fresh yellow
streak on the curb of a no parking
zone, the white-out gave the
impression of a freshly painted
white cross-walk and the desk lamp
was equipped with a sensor that
would illuminate areas where people
would typically go to read, like a
park or an outdoor seating area.

Music throughout

Open to CU profile of boy
with freckles

He turns to face the camera

He closes his eyes

Cut to ECU of his face

SUPER
Orange + Green

Boy opens his green eyes

SUPER
Nike Product + URL + ID

Merit
Television & Cinema
Commercials, TV:
Under 30 Seconds,
Single

ORANGE+GREEN

Art Director
Sorenne Gottlieb
Copywriter
Alberto Ponte
Creative Director
Mike Byrne, Hal Curtis
Director
Malcolm Venville
Producer
Jeff Selis
Agency
Wieden+Kennedy
Client
Nike
Country
United States

The Nike ID campaign was a cele-
bration of individuality. All the exam-
ples in this campaign show what is
unique about a person. It could be
your opinion, the way you dance,
what do you do, etc…The idea of
customization can be more than just
choosing the colors of your shoes. It
could be another way of expressing
yourself and who you are.

Merit
Television & Cinema
Commercials, TV:
30 Seconds, Single

DANCER

Art Director
Doris Cassar
Copywriter
Bill Bruce
Creative Director
David Lubars, Bill Bruce
Director
Traktor
Editor
Tom Muldoon
Producer
Hyatt Choate, Melissa Everett
Production Company
Partizan
Agency
BBDO New York
Client
Sierra Mist
Country
United States

Michael Ian Black steps into a convenience store and looks for a Sierra Mist. He sees Jim Gaffigan behind the counter and Jim tells him they are all in the back. Michael asks if he would go in the back and get one and Jim asks him if he will dance for it. Michael sheepishly agrees and goes into a crazy dance. Michael stops and asks for the Sierra Mist again and Jim tells him he is all out.

Merit
Television & Cinema
Commercials, TV:
30 Seconds, Single

JAIL

Art Director
Jonathan Mackler
Copywriter
Jim LeMaitre
Creative Director
David Lubars, Eric Silver
Director
Ulf Johannson, Carl Nilsson
Editor
Gavin Culter
Producer
Ed Zazzera
Production Company
Smith & Jones Films
Agency
BBDO New York
Client
Snickers
Country
United States

À la the typical prison movie, a
Snickers bar is passed around, as
if it's a shiv, from one prisoner to
another. Finally, in the prison yard,
a prisoner tries to stab a guard
with the Snickers. The results are
less than satisfying. Snickers is
considered a candy bar for an
older generation. Where there's
room for growth is with teens.
The objective, then, was to make
Snickers more appealing to a
younger audience…"cooler."

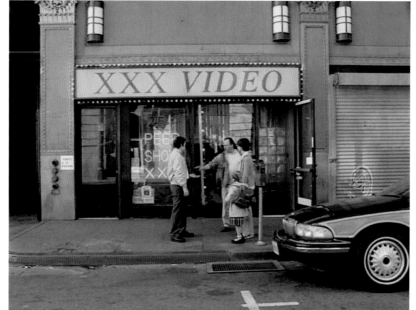

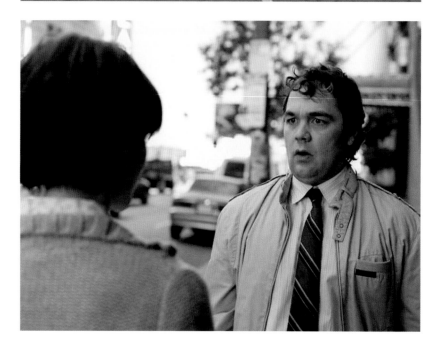

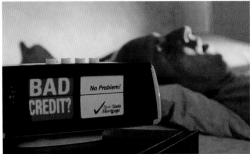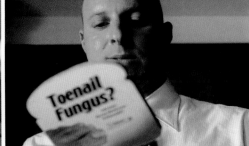

Merit
Television & Cinema
Commercials, TV:
30 Seconds, Single

POP UP

Art Director
Mark Rawlins
Copywriter
Rob Katzenstein
Creative Director
Russell Lambrecht,
John Trahar, Brian Born,
Mark Ray
Director
Frank Todaro
Editor
Jim Hutchins
Producer
Monika Prince
Production Company
Moxie Pictures
Agency
GSD&M
Client
SBC
Country
United States

Open on a man asleep in bed early in the morning. The alarm clock on his end table reads, "6:59." as the numbers change, an ad for a mortgage company appears on the clock.

Cut to the man walking into his bathroom. He opens his medicine cabinet. A poster for "win a Caribbean vacation" blocks his way. He rips through the poster and grabs his toothpaste.

Cut to the man in his kitchen. He opens a bag of bread and reaches in. Instead of a slice of bread, he pulls out a small square ad that reads, "toenail fungus?" he tosses it aside.

Cut to the man walking down the hall. The hallway is covered in balloons advertising an assortment of products and services. As the man makes his way through the corridor, he moves them out of his path.

Cut to the man, briefcase in hand, walking out his front door. He rips and kicks his way through a paper poster blocking the door.

SUPER
Put a stop to pop-ups.
Online Protection from SBC Yahoo! DSL.

Cut to hero shot of a computer featuring the sbc yahoo! Online protection dashboard. We see the cursor click on "pop-up blocker."

SUPER
Anti-Virus
Anti-Spyware
Pop-Up Blocker
Parental Controls
Mail Protection

SUPER
SBC [LOGO]
1-866-SBC-YAHOO
sbc.com

When we first received this assignment for SBC Yahoo! DSL, it presented itself as a unique challenge. On the surface, our task seemed pretty simple. After all, Internet pop-up ads are an annoyance that everyone can relate to. The challenge lay in bringing the problem to life in an original and compelling way. We decided the best way to drive home the protective benefit of our SBC's PopUp Blocker was to focus on the intrusive nature of pop-ups. What if pop-up ads weren't merely isolated to our computer screens? What if they were everywhere, literally standing in our way? Would we continue to tolerate it? Probably not.

TKMultiple Winner**

Merit
Television & Cinema
Commercials, TV:
30 Seconds, Single

Merit
Television & Cinema
Commercials, TV:
30 Seconds, Single

CHEESE NIPS OFFICE

Art Director
Izzy Levine
Copywriter
Nathan Goodson, Jon Krevolin
Creative Director
Jon Krevolin, Eric Steinhauser
Director
Rocky Morton
Producer
Jill Rothman, Jennifer Johnson
Production Company
MJZ, Mad River
Editor
Jason MacDonald
Agency
JWT/Lodge 212
Client
Cheese Nips
Country
United States

The objective was to relaunch a
moribund brand. How to make
Cheese Nips relevant. The client
gave it a new form. A new shape.
And poured on the cheese. And
who doesn't love cheese? When in
doubt, focus on the product
attribute. So, we fell in love with the
cheese. And when you love
cheese, damn it, it shows! We also
thought it would be cool to blow up
a bag and spray cheese all over the
place. In fact, I still have some
lodged in my ear.

Merit
Television & Cinema
Commercials, TV:
30 Seconds, Single

CRUSHING

Creative Director
Tor Myhren
Agency
Leo Burnett
Client
Crunch Fitness
Country
United States

Merit
Television & Cinema
Commercials, TV:
30 Seconds, Single

STARBUCKS BLEACHERS

Art Director
Eric Cosper
Copywriter
Adam Alshim
Executive Producer
David Zander, Jeff Scruton
Creative Director
Wayne Best
Director
Tom Kuntz
Editor
Gavin Cutler, Mackenzie Cutler
Producer
Zarina Mak
Production Company
MJZ
Designer
Noel McCarthy, Bart Mialy
Agency
MJZ
Client
Starbucks
Country
United States

Open on the front door of a modest suburban apartment complex. Hank, a young salesman, exits holding rolled-up presentation materials under his arm, and a Starbucks Doubleshot Espresso Drink. He takes a sip of the Doubleshot.

A high energy "Hank" mascot jumps into frame and pumps his fist next to hank, holding a portable stereo playing a high energy, motivating song.

Hank pauses, in mid sip, a bit stunned.

Cut wide to reveal an entire section of gymnasium bleachers, awkwardly sitting on the lawn in front of the apartment complex. In the audience are various people that motivate, or inspire hank.

Cut to hank rising on an escalator. The bleachers are sitting flush against the escalator, the bleacher seats rising at the same angle as hank. He passes various inspirational and motivating audience members shouting words of encouragement.

Cut to hank sitting on the waiting couch of a semi-intimidating corporate reception area. The bleachers are next to him. The audience quietly buzzing.

A receptionist comes through the large doors to the conference room.

RECEPTIONIST
Hank?

Hank stands. The audience stands with him. He takes his first step toward the door, and the crowd explodes.

Cut to title card with a can of Starbucks Doubleshot.

VOICE OVER
Delicious Starbucks Doubleshot Espresso Drink. Bring on the day.

Advertising
104

Open on a girl walking down a hallway in a high school.

A boy exits one of the rooms and comes running after her into the hallway.

BOY
(CONFIDENTLY)
Cheryl, I have something to show you . . .

He walks with her into the room. It's a studio class. He leads her to one of the art tables, where there is something covered by a cloth. The boy lifts up the cloth and reveals a sculpture. It's a bust, made entirely out of Starburst. And it looks exactly like the girl. Next to the bust, there are unwrapped Starburst and there are Starburst wrappers scattered across the table.

BOY
(AS THOUGH IT'S NOT COMPLETELY OBVIOUS)
It's you.

The boy starts waxing poetic about the bust.

BOY
Oh Cheryl. Your lips . . . juicy, like strawberries.

He kisses and licks the Starburst lips.

BOY
Your hair . . . (HE SNIFFS THE HEAD OF THE BUST) . . . fragrant, like fresh lemons . . .

BOY
Your nose . .

He takes a large bite out of the nose, then starts devouring the girl's entire face.

Cut back to the doorway. Cheryl watches in horror as the boy eats the likeness of her face. She leaves.

Cut to Starburst package on title card.

SUPER
Juicy

Merit
Television & Cinema
Commercials, TV:
30 Seconds, Single

STARBURST ART CENTER

Art Director
Scott Vitrone
Copywriter
Ian Reichenthal
Executive Producer
David Zander, Jeff Scruton
Creative Director
Gerry Graf
Director
Rocky Morton
Editor
Dave Koza, Mackenzie Cutler
Producer
Laura Ferguson
Production Company
MJZ
Designer
Duncan Reed
Agency
MJZ
Client
Starburst
Country
United States

TACOMA METEOR

Copywriter
Greg Farley
Chief Creative Officer
Steve Rabosky
Executive Creative Director
Harvey Marco
Creative Director
Steve Chavez
Associate Creative Director
Dino Spadavecchia
Director
Baker Smith
Editor
Paul Martinez, Lost Planet
Producer
Richard Bendetti, Mala Vasan
Production Company
Harvest Films
Agency
Saatchi & Saatchi Los Angeles
Client
Toyota Motor Sales, USA, Inc.
Country
United States

BYSTANDER ONE
(singing) bomp-chik-a-
bomp-wiki-wiki-tiki-bomp

BYSTANDER TWO
Bro, you see that?

BYSTANDER ONE
What?

DISCLAIMER
Dramatization. Access Cab
shown with available TRD
Off-Road Package.

DRIVER
(SCREAMING) Wooooo!
Did you see that!?!

BYSTANDER ONE
Awww, no way!

SUPER
TACOMA
METEOR-PROOF

TITLE CARD
TOYOTA
moving forward
toyota.com

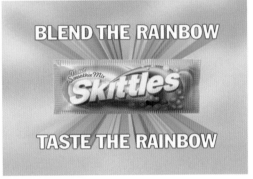

BLEND THE RAINBOW

Skittles

TASTE THE RAINBOW

Merit
Television & Cinema
Commercials, TV:
30 Seconds, Single

SHEEPBOYS

Art Director
Scott Vitrone
Copywriter
Ian Reichenthal
Executive Creative Director
Gerry Graf
Creative Director
Scott Vitrone, Ian Reichenthal
Producer
Nathy Aviram
Director
Martin Granger
Editor
Jun Diaz,
Mackenzie Cutler Editorial
Production Company
Moxie Pictures
Agency
TBWA\Chiat\Day New York
Client
Skittles
Country
United States

Open on two sheepboys. They are part sheep, part boy: each has a sheep-like body and a human face. They are standing together in a field, eating a package of Smoothie Mix Skittles.

SHEEPBOY ONE
Mmm...

SHEEPBOY TWO
These new Smoothie Mix Skittles are delicious.

SHEEPBOY ONE
I know. Two different flavors blended together in each one?

SHEEPBOY TWO
How can they blend together two things as different as anorange and a mango . . . it's unbelievable.

SHEEPBOY ONE
What about peach/pear? A peach blended with a pear? Now that's an unusual combination.

Both sheepboys laugh out loud.

A farmer walks by and yells to them.

FARMER
You two sheepboys . . . stop that jibber-jabbin'!

Cut to Smoothie Mix Skittles end treatment.

SUPER
Blend the rainbow.
Taste the rainbow.

Merit
Television & Cinema
Commercials, TV:
30 Seconds, Single

ERNIE THE KLEPTO

Art Director
Craig Allen
Copywriter
Ashley Davis
Executive Creative Director
Gerry Graf
Creative Director
Scott Vitrone, Ian Reichenthal
Producer
Nathy Aviram
Director
Matt Aselton
Editor
Gavin Cutler, Mackenzie Cutler
Producer
Lora Schulson
Production Company
Epoch Films
Agency
TBWA\Chiat\Day New York
Client
Starburst
Country
United States

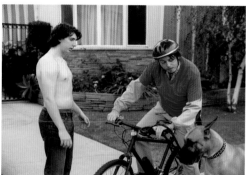

Open on a guy eating
Starburst. He has a dog
and a bike with him. He is
wearing a bicycle helmet.
Another guy, Ernie, walks
up to him.

GUY
Hey aren't you Ernie
the Klepto?

Cut to Ernie. He is now
holding the guy's Starburst.

ERNIE
No. I don't do that anymore.

Cut back to the guy.
He is not holding his
Starburst anymore.

GUY
But you just took my Star-
burst.

Cut to Ernie. He is wearing
the guy's bicycle helmet, and
eating his Starburst.

ERNIE
No I didn't.

Cut back to the guy. He is not
wearing his bicycle helmet
anymore.

GUY:
Oh . . . I thought you did.

Cut to ERNIE, who is now
wearing the guy's shirt.

ERNIE
These are juicy.

GUY
(now shirtless) Yeah.

ERNIE
I gotta go.

ERNIE
Blatantly takes the guy's bike
and leaves with his dog. The
guy watches him leave.

GUY
Thanks.

Cut to a title card with a
Starburst package shot.

TITLE
Blame the juicy goodness.

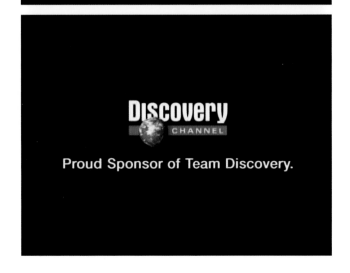

Welcome to the family Lance.

Proud Sponsor of Team Discovery.

Merit
Television & Cinema
Commercials, TV:
30 Seconds, Single

CHOPPER

Art Director
Jay Russell, Andy Mahr
Copywriter
Wade Alger
Creative Director
Wade Alger, Jay Russell
Director
David Cornell
Producer
Flo Babbitt
Agency
TM Advertising
Client
Discovery Channel
Country
United States

The Discovery Channel needed to announce their new @#$%#% bike team. And what better $#@%$ way to "welcome Lance to the family" than by sticking him in a #$%&* room with America's most dysfunctional #$@#%$ family. We're no $#%$# comedic geniuses, but we did know a swearing Lance Armstrong + angry Paul Sr. = *$%#% funny.

Merit
Television & Cinema
Commercials, TV:
30 Seconds, Single

TIGER NERVES

Art Director
Steve Luker
Copywriter
Roger Camp
Creative Director
Steve Luker, Roger Camp
Editor
Peter Wiedensmith
Producer
Ben Grylewicz
Director
Tim Godsall
Production Company
Biscuit Filmworks
Agency
Wieden+Kennedy
Client
Electronic Arts
Country
United States

There was a time when nobody wanted a piece of Tiger Woods. But in the summer of 2003, his once invincible game suddenly became pedestrian. As fate would have it, in the video game Tiger Woods also lost his cojones. Run-of-the-mill gamers were crushing Tiger by 10-15 strokes, and no one was more pissed about it than Tiger Woods himself. So EA Sports went back to the drawing board and added a new dimension—pressure. As in, the kind of pressure you and I would feel playing alongside Tiger…yip, yip, yip.

Open on golfer on green trying to make a shot.

Tiger is a few feet away watching him.

SFX
birds chirping

As he tries to make the shot, he begins shaking uncontrollably.

He steps back to take a break and then tries again.

TIGER
You all right?

MAN
Yeah, I'm fine.

He begins shaking again and steps back.

TIGER
You wanna take a minute?

Man puts up his hand, annoyed.

And tries to make the shot again.

SUPER
Can you handle the pressure?

Cut to game play.

ANNOUNCER
Tiger Woods.
PGA Tour 2006.
Rated E for everyone.

Cut to logo garden.

ANNOUNCER
EA Sports. It's in the game.

Merit
Television & Cinema
Commercials, TV:
30 Seconds, Single

PRESS CONFERENCE

Art Director
James Selman
Copywriter
Mike Byrne
Creative Director
Hal Curtis, Mike Byrne
Editor
Matt Hilber
Agency
Wieden+Kennedy
Client
Nike
Country
United States

We wanted to do something for Lance's last Tour de France. Not just another victory ad. But the most definitive victory ad about the most definitive fight of his life. The one against cancer. So while everyone else was saying goodbye, we were saying hello. Showing the naked truth, the beginning, which made everything possible. Lance is hope. Lance is triumph of the human will. Lance is our reminder that we can be more than we think we can. Lance personifies "Just do it." Press Conference was a quiet but powerful reminder to all of what made Lance, Lance.

Merit
Television & Cinema
Commercials, TV:
30 Seconds, Single

IT'S NOT A MISTAKE

Art Director
Allan Mah
Copywriter
Andrew Bradley
Creative Director
Elspeth Lynn, Lorraine Tao
Sound Designer
Ted Rosnick
Director
Mark Gilbert
Editor
Leo Zaharatos
Producer
Tuula Hopp, Janet Woods
Production Company
Reginald Pike
Agency
ZiG Inc
Client
Ikea Canada
Country
Canada

IKEA wanted new TV advertising to
drive crowds into its stores for the
Winter Sale. "It's Not a Mistake" was
born from the insight that, some-
times, a deal seems just too good to
be legal.

Inside IKEA, a woman is
paying for a few items,
including a lamp. We see
other Customers in line, they
all have various items to
purchase. The co-worker
gives the Woman her receipt.

IKEA CO-WORKER
Here's your receipt.
Have a nice day.

CUSTOMER
Thank you . . .

The customer looks at the
receipt. She seems a little
stunned and walks away
withher purchases, quick-
ening her pace as she does
so. She passes other
customers wheeling their
carts and purchases out. She
walks quickly to the exit then
breaks into a full on sprint.
We see a car parked outside
the IKEA. A man, her
husband, is waiting at the
wheel, casually listening to
the radio. The woman runs
towards the car with her
IKEA bags.

WOMAN
Start the car! Start the car!

SUPER
It's not a mistake.
We're having a sale.

We cut to the woman in the
car with her husband as they
drive away.

WOMAN
Wooo!

SUPER
Up to 50% off selected items.
The IKEA winter sale.

A Volkswagen bug loaded
up with IKEA boxes, wipes
through the frame to

SUPER
IKEA. Fits.

Merit
Television & Cinema
Commercials, TV:
Over 30 Seconds, Single

Also for Hybrid
SEE PAGE 32

MAKING OF IT

Art Director
Scott Kaplan
Copywriter
Tom Christmann
Creative Director
David Lubars, Greg Hahn
Director
Fredrik Bond
Director of Photography
Carl Nilsson
Editor
Rick Russel
Producer
Monica Victor
Production Company
MJZ
Agency
BBDO New York
Client
Ebay
Country
United States

eBay was known as the place to get hard-to-find and used items. Interesting and unique things. Collectibles. But eBay wanted to be the place to get everything. Including everyday stuff and hot new items. They wanted people to think, "whatever it is, you can get it on eBay." We took this sentence literally. We turned the word "It" into a 3-dimensional metaphor for anything you really, really want. "The Making of It" launched the notion in television. The spot shows two inventors coming up with the new hot item everyone in the world wants, represented by a 3-dimensional "It." The viewer wants to know what the item really is. But just as we're about to find out, the end title explains: "Whatever it is you can get it on eBay."

Merit
Television & Cinema
Commercials, TV:
30 Seconds, Campaign

**JETTA TV CAMPAIGN:
KHAKI, DUVET, HOSTA**

Art Director
Julian Newman
Copywriter
Roger Baldacci, Dave Weist
Creative Director
Ron Lawner, Alan Pafenbach,
Dave Weist
Director
Dayton/Faris
Editor
Andre Betz
Producer
Bill Goodell
Production Company
Bob Industries
Agency
Arnold Worldwide
Client
Volkswagen
Country
United States

Usually with humor, you use hyper-
bole or exaggeration to make your
point. In this case, we just wrote
about our actual, sad lives.

We see two men standing on
the lawn in between two
suburban houses. They are
neighbors and are chatting
casually.

The guy just sort of trails off
as both men are distracted
by the sight of something
wonderful. They stare,
transfixed by the sight of
a new VW.

Cut to logo art card.

CARD
newjetta.com
Drivers wanted.

GUY ONE
So I just planted some hosta.

GUY TWO
Yeah, those are nice. Real
hardy. Is that an annual
or perennial?

GUY ONE
Annual. Comes up every year.

GUY TWO
No, I think a perennial is
every year. Comes up per-
annual. Like per-year.

GUY ONE
I think that means it dies
every year and you gotta
replace it. Annual is every
year. Like our annual block
party . . .

We see a husband and wife
coming out of an upscale
shopping plaza right off a
main, busy road. They are
each holding multiple
shopping bags.

The couple is distracted
by the sight of something
wonderful. They stare,
transfixed by the sight of
a new VW.

Cut to logo art card.

CARD
newjetta.com
Drivers wanted

WIFE
Well, that was productive.

HUSBAND
Yeah, that was really good.

WIFE
You don't think the duvet
cover will fight with the
throw pillows do you?

HUSBAND
No. I think the color palette is
pretty much the same.

WIFE
Actually, the piping matches
perfectly.

HUSBAND
Right, forgot about
the piping.

SFX
Sound of car driving, wheels
on asphalt, muffled music
coming from inside the car,
etc.

Merit
Television & Cinema
Commercials, TV:
30 Seconds, Campaign

**THE BIG GAME, LOVE
LETTER, LION**

Art Director
Osamu Sasanuma
Copywriter
Yoshimitsu Sawamoto,
Sohei Okano,
Miwako Hosokawa
Creative Director
Yuya Furukawa
Director
Atsushi Sanada, Chisa Takano
Producer
Keisuke Kayama,
Shigeno Nakada
Production Company
Dentsu Tec, Inc.
Agency
Dentsu Inc. Tokyo
Client
Japan Dairy Council
Country
Japan

This campaign's objective was to
increase milk consumption, which
has been declining over the recent
years. Our strategy focused on a
primary target of the milk category:
teenagers living in Tokyo.

BOY A
Big Game!

BOY B
Then drink.

BOY A
Why?

BOY B
Makes you big.

BOY A
Bigger . . .

BOYS IN OPPOSITE TEAM
Big! Huge! Gigantic!

BOYS
Here. Here. And shoot!

BOYS IN OPPOSITE TEAM
Way too big! Am striking
back! No!

GIRL
Here, big boy! You're so big!

BOY A
Gotta drink this.

SUPER
Ask Milk!

YUKO
That's a lot of milk!

GIRL A
Makes you beautiful.

YUKO
Beautiful . . .

BOY
This is . . .

YUKO
For me?!

BOY
You're beautiful!

YUKO
More . . . love letters?!

GIRL A
Yuko's drowning!

JUN
Yuko!

YUKO
Jun!!

JUN
Are you OK?

YUKO
Mouth to mouth?

JUN
Of course!

YUKO
Gotta drink milk.

SUPER
Ask Milk!

ANTHEM

Art Director
James Clunie
Copywriter
Kara Goodrich, Greg Hahn
Creative Director
David Lubars, Greg Hahn,
Kara Goodrich
Director
Fredrik Bond, Carl Nilsson
Editor
Eric Zumbrennen
Producer
Monica Victor, Chad Garber
Production Company
MJZ
Agency
BBDO New York
Client
Ebay
Country
United States

Everybody knows that you can buy
weird, one-of-a-kind things on eBay.
What they don't know is that there
are tons of new items, too. The goal
of this spot (and the campaign as a
whole) was to make this clear to
everybody—and nothing sums up
"everything" better than the word
"it." This spot simply dimensional-
izes the "it" by putting it into the
context of everyday use. If you can
wear it, throw it, give it, break it,
drive it, you can get it on eBay.

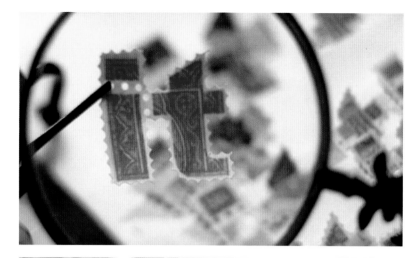

Merit
Television & Cinema
Commercials, TV:
Over 30 Seconds, Single

MEXICAN PUPPET THEATRE

Art Director
Jim Amadeo
Copywriter
Ted Jendrysik
Creative Director
Edward Boches, Jim Amadeo,
Ted Jendrysik
Director
Tommy Means
Editor
Edward Feldman
Producer
Stef Smith
Production Company
Mekanism
Agency
Mullen
Client
GameTap
Country
United States

Open on the exterior of a small Mexican village. Intercut environmental shots of kids hanging out, kids playing, and an older man setting up a crude puppet show.

The puppet master calls kids to the show. Kids everywhere drop what they're doing and come running.

PUPPET MASTER
(In Spanish) Attention children. The show is about to start.

The kids all assemble in front of a homemade puppet theatre resembling a Pac Man video game.

The curtains open and a wooden Pac Man pops up and starts chomping away. The puppet master supplies the audio.

PUPPET MASTER
Wakka-wakka-wakka-wakka . . . Ghosts appear and start chasing Pac Man. The kids all look frightened.

PUPPET MASTER
Woooo. The ghosts are after Pac Man.
A power pellet descends. Pac Man eats it and the ghosts flip around to become bright blue. Pac Man now chases them while the kids cheer.

The camera pans to a Mariachi band who play the Pac Man theme music in celebration.

PUPPET MASTER
Pac Man is victorious.

KIDS
(Cheering)

Cut to GameTap logo

ART
GameTap.
Expand your Playground.

Merit
Television & Cinema
Commercials, TV:
Over 30 Seconds, Single

FUNERAL PYRE

Creative Director
Ari Merkin, Wayne Best
Agency
Fallon
Client
Virgin Mobile USA
Country
United States

VIDEO
Open on a cluttered beach.
We see a small tent with an
audience in front of it.

MAN
My fellow pay-goists . . .

VIDEO
Camera scans in closer
to the tent.

Cut to a man in front of the
audience speaking into a
microphone.

MAN
Rudy.

VIDEO
Cut to Rudy sitting at a
keyboard, playing a few bars.

Cut back to the man with the
microphone.

MAN
Antone.

VIDEO
Cut to a dog.

Cut to a full view of the
audience and the tent.

MAN
Today, we mark the passing of
the evil cell phone contract.

VIDEO
Cut to a ragged, demonic doll
sitting in a boat amongst cell
phone contracts.

Cut to Rudy at the keyboard.

RUDY
Nebuchadnezzer.

VIDEO
Rudy shakes a rattle.

Cut to two women picking
up the boat with the
contracts and throwing it
into the water.

Cut to man.

MAN
No longer shall one suffer
from long-term obligations.

VIDEO
Cut to Rudy, drumming.

RUDY
No more suffering!

VIDEO
Cut to the man.

MAN
Now everybody can save on
every conversation.

VIDEO
Cut to the audience
applauding.

Cut to the man.

MAN
No matter how much you
yack, pay-goism got your
back!

VIDEO
Cut to Rudy, drumming.

Cut to the man.
AUDIENCE
Yes!

MAN
Cause Mr. Evil Contract
Demon, you dead.

AUDIENCE
Hallelujah!

MAN
Rudy.

VIDEO
Cut to Rudy shooting a
burning arrow. The arrow
does not hit the boat.

Cut to the man, looking
embarrassed.

Cut to Rudy looking at the
man. The boat blows up.

Cut back to the man.

SFX
Music up and throughout

MAN
Woo!

VIDEO
Cut to Rudy looking excited.

Cut to a full view of the tent
and audience, dancing.

Cut to a seagull sitting
on a stump.

SEAGULL
Virgin Mobile presents
month to month. A new way
to pay as you go. With
anytime and night and
weekend minutes as low as 4
cents.

Mmmmm...

SUPER/LOGO
Month2Month.

As low as 4¢ per min.

LEGAL
Offer Details

SUPER/LOGO
Virgin Mobile.
Pay As You Go.

Best Buy. Sam Goody.

virginmobileusa.com

Merit
Television & Cinema
Commercials, TV:
Over 30 Seconds, Single

MASKS

Art Director
Storm Tharp
Copywriter
Mark Fitzloff
Creative Director
Mike Byrne, Hal Curtis
Director
Tarsem
Editor
Robert Duffy
Producer
Tommy Murov
Production Company
Radical Media
Agency
Wieden+Kennedy
Client
Nike
Country
United States

Open with a quick montage of six Nike athletes. Tori Hunter, Ladanian Tomlinson, Mariano Rivera, Ben Rothlisberger, Albert Pujols, Brian Urlacher.

Cut to empty stage, camera moves in to reveal Albert Pujols.

Cut Ladanian Tomlinson

Cut to Mariano Rivera

Cut to Brian Urlacher

Cut to Tomlinson

Cut to Tomlinson putting arm through shirt

Cut to Hunter stretching arms

Cut to straight on shot of Hunter

Cut to tight shot of apparel

Cut to wide shot of Rothlisberger

Cut to medium shot of Tomlinson looking into camera

Cut to wide of Hunter

Cut to tight shot of Urlacher

Cut to tight shot of Urlacher putting on shirt

Cut to shot from behind Urlacher, camera moves upwards

Cut to side shot of Urlacher, he crouches down

Cut to front shot of Hunter, he crouches down

Cut to wide shot of Pujols holding bat

Cut to tight shot of Rivera pulling down sleeve

Cut to wide shot of Rivera

Cut to close up of Pujols twirling bat

Cut to wide shot of Pujols hitting foot with bat

Cut to medium shot of Pujols swinging bat, camera pulls out

Cut to medium shot of Rivera throwing ball into glove

Cut to shot of Rothlisberger, camera moves in as Rothlisberger crouches and yells into camera

Cut to Rothlisberger's feet, ball comes into frame

Cut to wide shot of Urlacher in a crouch, he runs forward

Cut to close up of Urlacher

Cut to wide shot of Rothlisberger looking to each side

Cut to Rivera throwing ball in glove

Cut to tight shot of Tomlinson looking into camera

Cut to tight shot of Rothlisberger shouting

Cut to Hunter jumping

Cut to Tomlinson running in place

Cut to wide shot of Tomlinson running in place

Cut ot tight shot of Pujols pulling bat back

Cut to Hunter in the air

Cut to Pujols swinging bat forward

Cut to Rivera throwing ball in glove

Cut to Tomlinson with football going toward him

Cut to Hunter landing

Cut to medium shot of Hunter stretching

Cut to Urlacher

Cut to Pujols swinging bat, camera reveals Pujols wearing a mask

Cut to wide shot of Pujols wearing a mask

Cut to close up of Rothlisberger

Cut to football being snapped

Cut to wide shot of Rothlisberger going back

Cut to Rothlisberger wearing mask

Cut to Rothlisberger turning with mask on

Cut to wider shot of Rothlisberger in mask

Cut to wide shot of Tomlinson with ball moving towards him

Cut to medium shot of Tomlinson, camera moves in

Cut to wide shot of Tomlinson catching ball

Cut to shot of Tomlinson catching ball from behind

Cut to medium shot of Tomlinson sticking hand in camera

Cut to tight shot of Tomlinson sticking hand up

Cut to gazelle running

Cut to wide shot of Tomlinson wearing a mask, camera moves in

Cut to tight shot of Tomlinson wearing mask, camera pulls out

Cut to wide shot of Hunter, he crouches down

Cut to CU of Hunter

Cut to medium shot of Hunter, her looks up

Cut to shot of Venus Fly Trap catching frog

Cut to hunter wearing mask, camera moves around him

Cut to medium shot of Rivera

Cut to wider shot of Rivera looking into camera

Cut to CU of Rivera wearing mask

Cut to shot of scorpion

Cut to tight shot of Rivera in mask

Cut to medium shot of Urlacher, he crouches down

Cut to tighter shot of Urlacher wearing mask

Cut to wrecking ball hitting building

Cut to Urlacher wearing mask, camera snap zooms out

Cut to wide shot of Rothlisberger in mask

Cut to CU of Rothlisberger in mask

Cut to tight shot of Pujols in mask

Cut to wide of Pujols swinging bat in mask

Cut to Hunter in mask, camera moves in

Cut to Rivera's fingers

Cut to ball hitting overhead light

Cut to shot of Rivera from behind

Cut to Tomlinson spinning in mask

Cut to camera moving around Urlacher in mask

Cut to wide shot of Pujols in mask with sparks falling

Cut to Rivera throwing ball towards camera

Cut to product shot with NIKE PRO APPAREL over picture

Dissolve to reveal medium shot of Tomlinson in mask

FOR WARRIORS comes up over picture

Merit
Television & Cinema
Commercials, TV:
Over 30 Seconds, Single

KID TIGER

Art Director
Hal Curtis
Copywriter
Dylan Lee
Creative Director
Hal Curtis
Editor
Peter Wiedensmith,
Corky DeVault
Producer
Andrew Loevenguth
Production Company
Joint
Agency
Wieden+Kennedy
Client
Nike
Country
United States

Crowd at golf tournament

ANNOUNCER
What do you think
here, three wood over
deep for Tiger?

Tiger, as an eight year
old, drives

ANNOUNCER
It probably will be
a three wood . . .

Camera follows
ball onto green

ANNOUNCER
A little to the
right . . . perfect.

Crowd shot

Little boy sitting on father's
shoulders in crowd

Kid Tiger drives

ANNOUNCER
It's been a fascinating week
to be in . . . we're having
glorious weather

Profile shot of Tiger

Tiger on the green being
followed by a caddy

ANNOUNCER
Piece of history being
served up here

Tiger drives

ANNOUNCER
By Tiger Woods in
this moment.

Put goes into hole.

(crowd cheers)

Tiger dances.

Tiger drives.

(crowd cheers)

Put drops near hole.

Aerial view of crowd
coming onto green.

Tiger walking on green
with crowd around him.

Tiger's mother takes
a picture.

Tiger takes flagstick
out of hole.

Photographers take pictures.

Tiger sinks put.

(crowd cheers)

Crowd sitting in stands.

Tiger sinks put.

Tiger retrieved ball
and smiles

Tiger's father standing
and smiling.

Adult Tiger hugs his father.

TITLE CARD
Just do it.

TITLE CARD
Nike logo

The characteristics we associate
with Tiger Woods the professional
golfer were present when he was a
little kid. The smile. The red sweater.
Even the Tiger head cover on his
driver. This spot could not be made
with any other athlete because a).
How many of us look at age three
the way we look now? and b). the
footage simply doesn't exist for
other athletes of his generation.
Tiger was a phenomenon in
Southern California by age three.
Local news stations had done
several extensive stories about him.
He had appeared on the Michael
Douglas Show. But it would be
impossible to make Kid Jordan
winning the NBA Championship or
Kid Lance winning the Tour. Maybe
that's why the spot is interesting.
Because it could be made. Also, we
applaud Nike for taking the chance
of running this during the British
Open. Kind of worked out that Tiger
won.

**COMMUNICATION JUST
GOT EASIER: PIGEON, UFO,
ABORIGINAL**

Art Director
Antero Jokinen
Copywriter
Niklas Lilja
Executive Creative Director
Richard Bullock
Director
Matthijs van Heijningen,
Bonkers B.V., Amsterdam
Editor
Teun Rietveld,
Hectic Electric, Amsterdam
Producer
Peter Cline, Tony Stearns,
Saskia Kok
Production Company
Bonkers B.V., Amsterdam
Agency
180 Amsterdam
Client
Versatel, Gert Post,
Anoeska van Leeuwen
Country
Netherlands

Communication has always been
prone to accidents. A bullroarer
might snap and smack your wife in
the head. You might forget to open
the window before you release a
carrier pigeon. Not to mention the
subtle problems of intergalactic
communication. Happily, communi-
cation just got easier. Focusing on
the history of communication, the
launch campaign of Dutch telecom-
munications company Versatel
never mentioned megabytes or
DSL's. In an acronym-saturated,
jargon-cluttered market, there was
ample space for a call for simplicity.
Somebody had to come along and
make communication easy again.

Man ties note to pigeon and
lets go of pigeon.

Pigeon immediately slams
into window a few feet away.

SUPER
Communication just got
easier. Versatel.

Aboriginal man stands on
rock. He begins swinging his
bullroarer around his head.

The rope snaps and the
bullroarer flies off hitting
his wife.

SUPER
Communication just got
easier. Versatel.

Scientists are trying to
communicate with aliens.

Aliens respond by
blasting the earthlings
with a giant laser.

SUPER
Communication just got
easier. Versatel.

Merit
Television & Cinema
Commercials, TV:
Spots of Varying Length,
Campaign

**FRIDAY, PARKING LOT,
CRAB CLAW**

Art Director
Elvis Chau,
Prayoot Jaturunrasmee
Copywriter
Sarawut Hengsawad,
Salinee Na Ranong
Creative Director
Pinit Chantaprateep,
Prayoot Jaturunrasmee
Director
Thanonchai Sornsriwichai
Editor
Chanarong
Teachaboonsermsak
Producer
Poj Rajkulchai
Production Company
Phenomena Co., Ltd.
Agency
JWT
Client
Thai Asia Pacific Brewery –
Cheers Beer
Country
Thailand

Inside a busy office one worker suddenly realizes it's Friday. The news has an immediate and dramatic effect on everyone. It's the best possible news anyone could want to hear. The workers drop their pens as they emotionally congratulate each other.

SUPER
For every little good thing in life . . . Cheers!

MALE ONE
Delivered already!

MALE TWO
Ake, Need any help?

MALE ONE
The receipt's signed . . . Boi . . . what's today?

MALE TWO
Friday

GROUP
Tomorrow's a holiday?

VOICE OVER
To every little good thing in life, Cheers!

A boy and girl are dining in a seafood restaurant. The waiter places a crab claw noodle dish on the table. The guy rather reluctantly insists the girl take the crab claw. Suddenly he finds a second crab claw hidden among the noodles. Unable to believe his good fortune he holds it up for the other diners to see, shouting 'Another crab claw, another crab claw'. The other diners applaud loudly.

SUPER
For every little good thing in life . . . Cheers!

MALE
Will we ever find a s pace to park?

Hey!

SUPER
For every little good thing in life . . . Cheers!

A bunch of guys are driving around a parking lot looking for an empty space. Suddenly a car in front of them pulls out leaving a vacant spot. The guys can't believe their good fortune – two of the passengers jump out to help guide the car into place, relishing every moment of the operation. Once the task is accomplished, they celebrate jubilantly.

SUPER
For every little good thing in life . . . Cheers!

WAITER
Your steamed Crab Claw with Vermicelli.

WOMAN
There is only one.

MALE
Here...you take it.

WOMAN
Thank you.
It's so delicious.

MALE
CRAB!

SUPER
For every little good thing in life . . . Cheers!

**EVERYONE'S A DELEGATE:
LARRY, ERIC, JEREMY**

Art Director
Regan Warner
**Senior Vice President/
Group Creative Director**
George Dewey
**Executive Vice President/
Group Creative Director**
Steve Ohler
Director
David Shane
Editor
Pete Fritz
Producer
Cori H. Ranzer
Production Company
Hungry Man
Agency
McCann Erickson
Client
United Nations
Country
United States

In September, the United Nations
hosted the 2005 World Summit—the
largest gathering of world leaders in
history. The goal of the advertising
was two-fold. First, the U.N. wanted
to convince skeptical New Yorkers
that the Summit had meaning for
everyone, not just the poor and
disenfranchised in other continents.
Secondly, the U.N. wanted world
leaders to know that regular people
everywhere—even jaded New
Yorkers—wanted them to take
action. The idea for the campaign
was simple: Everyone's a Delegate.
The 2005 World Summit and its
outcome could affect every person
on the planet. So why not have
regular people at the U.N.? And why
not have them address the General
Assembly? And wouldn't that sound
a lot different than the diplomat-
speak we're usually subjected to?
The answer is, of course, yes it
would—especially if it's New
Yorkers doing the talking.

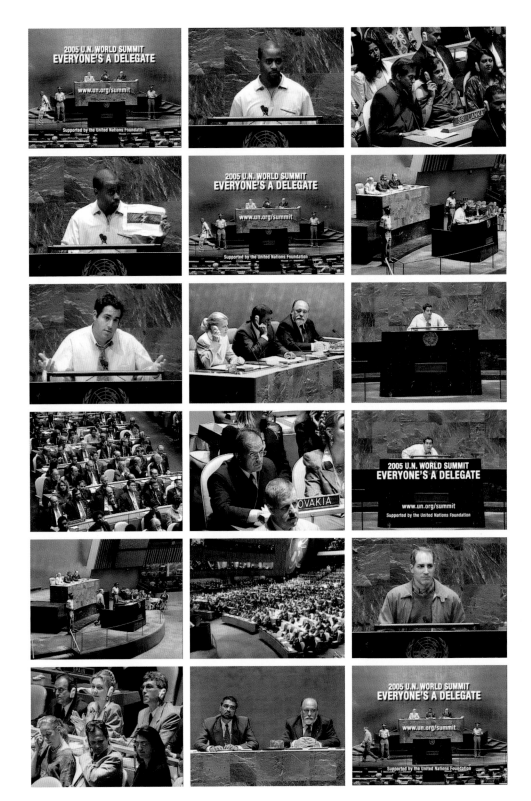

Open inside the U.N.
General Assembly. The room
is packed with dignitaries.
From the podium, we hear
the next speaker announced.

SPEAKER
Now addressing the U.N.,
Larry Kirshcner from
Manhattan . . .

A regular New Yorker in
non-dignified clothing
walks to the podium.

LARRY
Hello. Almost half the world
lives in poverty. That means
they live on less than two
dollars a day. So you should
fix that.

Also, if there's any way you
could avoid Second Avenue
when you come here, that
would be great cause you're
really messing up my
commute. Thanks.

What you want to do is take
the FDR to 42nd street and
then hang a right on First
but . . . totally fix the poverty
thing first. Thank you.

ANNOUNCER
Everyone's a Delegate at the
2005 World Summit.

Because the outcome
affects us all.

Get briefed at
un.org/summit

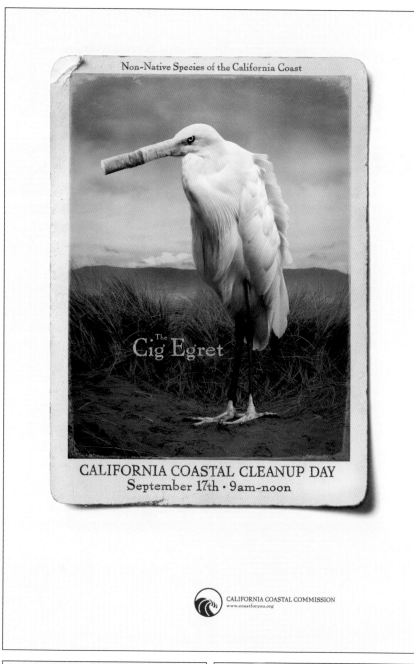

The goals of this campaign were to raise consciousness about the overall litter problem affecting California's coastal environment, and to inform people about the CCC's 21st Annual California Coastal Cleanup Day. Our challenge was to get more people to participate in the cleanup event. The campaign was a success. Participation in 2005 was 45% above the average turnout for the event. Creatively, it was the most daring campaign the CCC has ever done. According to our clients, the "Non-Native Species" campaign was by far the most creative and provocative campaign we've ever run. It cut to the heart of our issues with beautifully spooky, but somehow still whimsical images that elicited strong opinions from everyone who saw them. More importantly, it helped us communicate a message about coastal stewardship to a broader audience than we've ever been able to reach, which is reflected in the numbers. We picked up a record amount of trash this past Coastal Cleanup Day.

The magazine *stern* supports "Exit", a programme that helps people get out of the right-wing extremist scene.

The magazine *stern* supports "Exit", a programme that helps people get out of the right-wing extremist scene.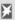

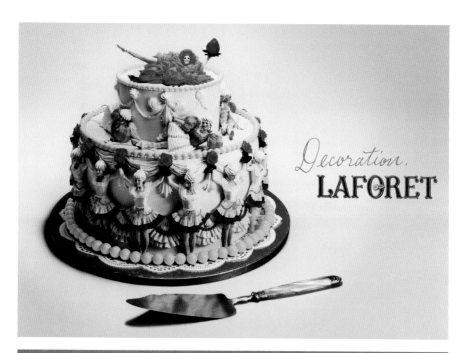

Merit
Posters & Billboards
romotional, Campaign

**DECORATION LAFORET:
BIG CAKE, CAKE PARTS 1, 2**

Art Director
Ryosuke Uehara
Copywriter
Asaji Kato
Designer
Masashi Tentaku,
Ken Okamuro
Photographer
Saori Tsuji
Producer
Wakako Akimoto
Production Company
DRAFT Co., Ltd.
Director
Musubi Aoki
Agency
DRAFT Co., Ltd.
Client
LaForet Harajuku
Country
Japan

Laforet Harajuku is a building housing a lot of apparel stores. This poster was produced for 2005 with the theme of decoration, for the purpose of enlivening the Laforet Harajuku building and the surrounding Harajuku district. Fashion always pushes forward into new trends, but people end up dressing the same without realizing it. This poster shows a cake with a bunch of women all wearing the same clothes. Those who have a strong personality break away from the norm and dress differently from everyone else. This results in more people following suit and dressing differently. I think to live healthy is to feel a connection with people. It is also very healthy to be conscious of the present. To decorate is to perform a fundamental element of fashion. I dream of a world where everyone decorates themselves outside of the norm.

NEW CURRENCY

Art Director
Sabine Frieben
Copywriter
Sepp Baumeister
Creative Director
Eike Wiemann,
Sepp Baumeister
Producer
Andreas Rist
Illustrator
Markus Groepl
Agency
JWT Frankfurt
Client
JWT
Country
Germany

The new positioning of JWT rests on the insight that the time of the consumer is the new currency for which brands really compete—this new positioning provides an opening for generating new business contacts. We contact prospective new business clients by delivering a strongbox filled with the time of the consumer in the shape of specially designed money—three bundles that consist of bills representing the time people spend on relationships, on relaxation and on self-pampering—instead of spending it on the clients brands. Response is by phone—fulfillment is an agency presentation in circumstances that underlines the value of time as the new currency: during the daily commute, on the way to a business meeting, during lunch.

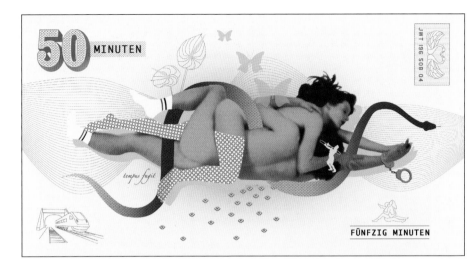

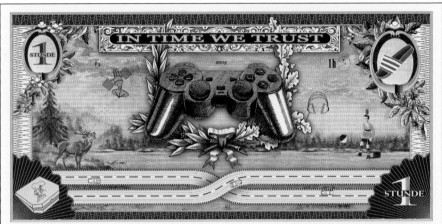

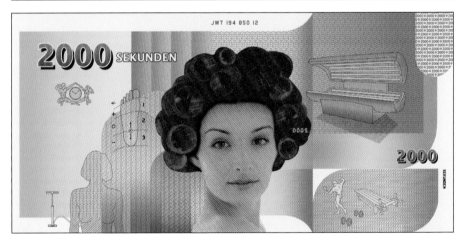

Merit
Television & Cinema
Commercials, Cinema:
Over 30 Seconds, Single

TBS CINEMA

Art Director
Rory Hanrahan
Copywriter
Dave Clark
Creative Director
Linus Karlsson,
Paul Malmstrom
Designer
Rory Hanrahan
Director
Kevin Thomas
Editor
Mike Douglas, Cut + Run, NY
Producer
Margaux Ravis
Production Company
Thomas Thomas, London, UK
Agency
Mother New York
Client
TBS
Country
United States

In order to stay ahead of the curve in the funny business and to help shape the funny of the future, TBS and Mother created the TBS Dept. of Humor Analysis. The Department's First initiative was to conduct the biggest humor survey of all time to determine what Americans think is and is not funny. The department created this recruitment video to demonstrate their important work, and to recruit laypeople to take part in their comprehensive study online.

Open on a shot of the tbs building. A super pops to indicate the location of the department of humor analysis. The camera cuts into the department where john cleese is standing in front of a bustling laboratory.

JOHN CLEESE
The Dept. of Humor Analysis is a major new TBS initiative created to keep TBS ahead of the curve in the funny business.

Cut to a man in his underwear being hit in the head by a ball.

CLEESE
Here, researchers ask, "Where is the funniest place to hit a man with a ball?"

Pan to a test subject is pointing at the briefs of an illustration of a man. The man in his underwear (who resembles the illustration) is immediately hit by a ball in the briefs. Cut to John Cleese walking through a door.

CLEESE
The department has been top secret until just now when I told you about it, however, security remains a top priority.

Cut to John Cleese stepping up to a closed door. John Cleese knocks on the door.

SUPER
knock knock

OFF SCREEN VOICE
Who's there?
CLEESE
John Cleese.
OFF SCREEN VOICE
John Cleese, who?

SFX
drum and cymbal

Cut to a short man with extremely low large bushy eyebrows sitting at the opposing end of a long table from a tidy, tall academic woman with a large forehead with extremely high eyebrows who looks down on him from her high pompous chair with irritation.

CLEESE
In office E-3, the Depts. of Lowbrow and Highbrow humor currently share this desk.

The short man offers the academic woman his finger.

SHORT MAN
Pull my finger.

The academic woman whacks his finger with a pencil. Cut to John Cleese walking in front of an experiment with 2 mimes in a stark white room.

CLEESE
Here, the department attempts to determine which is funnier. A mime pretending to be trapped in a glass box, or a mime actually trapped in a glass box.

Cut to a scientist taking notes as he observes a test subject watching the mimes. The mime trapped in the actual box starts to panic. Cut to Cleese observing the mimes. Cut to members of the field research team running through a field in formation. Cut to them popping out of hiding spots and freezing like the opening of a dramatic cop show.

CLEESE (V.O.)
Here we see the field research team in a field. This dedicated team of researchers immerse themselves in the ordinary world we live in, and they wait.

Cut to a man walking into a glass door.

CLEESE (V.O.)
This is the kind of thing they look for...

Camera pans to two researchers observing the man. Cut to a woman walking into a big hole in the ground.

CLEESE (V.O.)
...and this...

Cut to a Dept. Member in a tree.

DEPT. MEMBER
Here comes a pie.

CLEESE (V.O.)
...and of course, this.

Cut to a man getting a pie in the face. Cut to members of the field research team giving high fives.

CLEESE (V.O.)
Fantastic work, guys.

Cut to John Cleese holding an orange ball.

CLEESE
Help the Dept. with their important work by logging on to tbshumorstudy.com, and telling us what you find funny.

SUPER
www.tbshumorstudy.com

Cut to a nighttime exterior shot of the TBS building. A circle pops over the department's window.

CLEESE (V.O.)
The TBS Department of Humor Analysis...

Cut to the entire department.

DEPARTMENT (IN UNISON):
...putting the "very" in front of "funny."

Cut to TBS logo. Cut to John Cleese standing next to the man who's being hit by the ball. Throwing a ball with all his might at the man before turning to camera.

**NIKE WOMEN'S:
THUNDER THIGHS,
MY LEGS, MY BUTT,
MY HIPS, MY SHOULDERS**

Art Director
Miriam Kaddoura
Copywriter
Kathy Hepinstall
Creative Director
Hal Curtis, Mike Byrne
Illustrator
Stina Persson
Photographer
Max Cardelli
Agency
Wieden+Kennedy
Client
Nike
Country
United States

Nike hadn't developed a branding campaign that talked to women in a while. The main objective was to reconnect with women. Then, maintain an on-going dialogue over a period of 4 months and create intrigue to want to go to www.nike-women.com. We were faced with 3 main challenges. First, we wanted to come up with an idea that inspired all women but also felt like it was speaking to each woman individually. Second, we wanted to talk to women in way that was surprising, entertaining and smart. Then we wanted to visually stand out in fashion magazines. We ended up with a campaign that celebrated being proud of the body you have shaped, which spoke to women in a light-hearted and humorous tone, and looked bold, provocative and beautiful among the hundreds of fashion pages that all start to blend after a while.

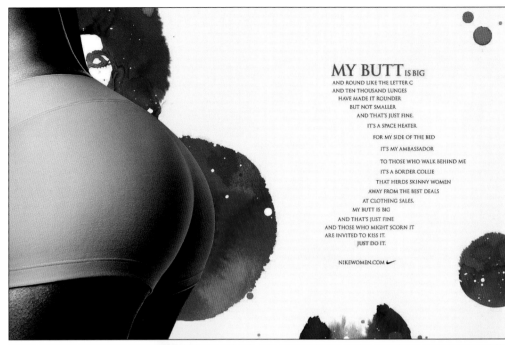

Merit
Television & Cinema
Commercials,
Online Commercial, Single

EXERCISE YOUR MUSIC MUSCLE

Art Director
Rodrigo Butori
Copywriter
Kristina Slade
Creative Director
Court Crandall
Director
Brumby Boylston
Producer
Steiner Kierce,
AnneKatherine Friis
Production Company
National Television
Agency
ground zero advertising
Client
Virgin Digital
Country
United States

Looking to create an experience that would engage people rather than just treat them as passive viewers, we created this viral Brand Essence Video for Virgin Digital with dozens of songs hidden in it. Each character or situation is a visual reference of a song name. The idea was to challenge music fans to find out how many they could spot and "Exercise Your Music Muscle." After it's release on the Virgin Digital website and Virgin Megastores, dozens of blogs, music related websites, and online communities around the world spontaneously promoted it by embracing the challenge. For a while, it was everyone's favorite pastime. The main accomplishment of this piece was that it kept people staring at a commercial for such a long time. To get a consumer to pay attention to your ad is hard, but to get him to spend hours with it is almost impossible.

In this animated trip in the universe of Virgin Digital, we follow the narrative line of famous songs manifested as visual metaphors.

Open on a wide shot. Playing in the background is Serena Ryder's "Sing, Sing." The word "Music" is in the middle of the screen. In the foreground are flowers (Flower – Talking Heads), a butterfly (Butterfly – Crazy Town), and a Hummingbird (Hummingbird – BB King). The "I" in Music hops out of the word and hops over to an old-style, western sheriff and shoots him with a gun. (I Shot The Sheriff – Bob Marley). The sheriff's specter raises from the body and makes its way up to heaven. (Spirit In The Sky – Norman Greenbaum).

We see a tremendous eye crying (Tears In Heaven – Eric Clapton) surrounded by angels. (Angels – Robbie Williams). We follow the tears down through the clouds that are transformed into a purple rain. (Purple Rain – Prince).

We follow the purple raindrops down into the ocean. A glass bottle floats by with a message inside. (Message In A Bottle – The Police) Past the bottle a bird surfs a giant wave. (Surfin' Bird – The Ramones). Camera moves towards the shore to reveal a completely decked-out pimp in a big hat and fur coat (P.I.M.P. – 50 Cent) sitting on a dock. (Sittin' On The Dock Of The Bay – Otis Redding). The pimp is holding a cage with a bird inside. He opens the cage and lets the bird out (Free Bird – Lynyrd Skynyrd) which flies off into the air.

The bird passes a genie flying on a magic carpet through the air. (Magic Carpet Ride – Steppenwolf) The carpet flies past a brick wall. A worker places a brick onto a wall he's building. (Another Brick In The Wall – Pink Floyd).

We look over the wall and see troops marching down the street carrying flags from 7 different countries. (Seven Nation Army – The White Stripes). The camera pans past blank street signs (Where The Streets Have No Name – U2). The camera rests on a queen dancing in an alleyway. (Dancing Queen – ABBA). A giant stone drops from the sky and rolls towards her. (Like A Rolling Stone – Bob Dylan). A hand from the sky reaches down and scoops up the queen in the nick of time. (God Save The Queen – Sex Pistols). The camera continues to pan across a couple of clowns riding on bucking bulls (Rodeo Clowns – Jack Johnson).

The camera rests on Siamese Triplets bellboy(s). On the one huge shirt they share, the word "Me" is on one guy's chest. "Myself" is on another's chest. And "I" is on the last guy's chest. (Me, Myself, And I – De La Soul). The three of them pick up a bag in front of the Hotel California. (Hotel California – The Eagles). A white rabbit (White Rabbit – Jefferson Airplane) is sitting in the foreground smoking two joints. (Smoke Two Joints – Sublime). The smoke from his joint fills the screen. The smoke then dissipates to reveal a very tiny dancer (Tiny Dancer – Elton John) in front of a piano with arms and legs playing itself (Piano Man – Billy Joel).

A blue suede shoe (Blue Suede Shoes - Elvis) steps on the tiny dancer. And we see an egg with legs (Eggman – The Beastie Boys) walk over to a bar. A woman wearing an American flag bikini (American Woman – The Guess Who) is pouring herself a gin and juice. (Gin & Juice – Snoop Doggy Dog and Dr. Dre). Sitting next to her on a bar stool is a dog in a nuclear suit (Atomic Dog – George Clinton).

The camera pulls back to reveal a group of thieves being caught by the police. (Police And Thieves – The Clash). The camera continues to pull back past werewolves wearing mod clothing in front of Big Ben. (Werewolves in London – Warren Zevon). It continues past a video monitor that has fallen on a star-shaped radio (Video Killed The Radio Star – Buggles) and confetti falling on two basketball players celebrating with their trophy. (We Are The Champions – Queen)

The camera pulls back through giant stone letters that read "Exercise Your Music Muscle" that are sitting in front of a pool with the "curtain call" of all the characters we've seen throughout the video. There's also parachutes falling from the sky (Parachutes – Coldplay) and a pink moon. (Pink Moon – Nick Drake). Falling on top of "Exercise Your Music Muscle" is the Virgin Digital logo.

Finally, a man in painter's clothes – in a completely different style of animation – lowers down on a scaffold in the immediate foreground, painting the screen black with a long brush (Paint It Black – The Rolling Stones).

Merit
Television & Cinema Crafts,
Animation, Single

EASY LIFE

Art Director
Alexei Berwitz
Copywriter
Angus Wardlaw
Creative Director
Nick Hastings,
Dominic Gettins, Olly Caporn
Director
Antoine Bardou-Jacquet
Editor
Stephane Pereira
Producer
Franck Montillot
Production Company
Partizan
Agency
Euro RSCG London
Client
Peugeot
Country
United Kingdom

The Peugeot 1007 launched into the
ultra competitive and fragmented
small car market, which targets a
diverse audience with increasingly
diverse needs. With its electronic
sliding doors, tip-tronic gearbox,
interchangeable colored interior and
flexible seating this car appealed to
a unifying desire: to make life easier.
Our campaign needed to deliver
that bold promise whilst being as
innovative, fun and unique as the
car itself. We used a mix of two
worlds: A real life world where
everyday events conspired to make
life difficult and an animated "1007
world" where the problems were
resolved and life is made easier.

An ordinary bloke encoun-
ters lots of everyday difficul-
ties—only to have them
quickly remedied when a
weird animated world kicks-
in. Eventually, we see that he
is the owner of a car that also
makes his life easier...Life
shouldn't be this easy.

DORNIER DO-X

Art Director
Florian Drahorad
Copywriter
Dominik Neubauer
Creative Director
Norbert Herold
Photographer
Ludwig Leonhardt,
Dornier Archiv
Producer
Carsten Horn
Agency
Heye&Partner GmbH
Client
Dornier Cigars
Country
Germany

The German cigar market is a difficult and sensitive area. The newcomer brand Dornier decided to launch his products with the help of a sales folder to create awareness with cigar shop owners. The task for the agency was to bring the myth of the name Dornier to life and connect it to the cigar brand. Dornier was the legendary pioneer of boat seaplanes. The 98cm by 67cm sized and 8-page strong sales folder guarantees a high impact at point-of-sale. Huge two-colored photographs tell about the story and adventures of the legendary seaplanes. The copy covers topics from the history of the boat seaplanes to the tobacco manufactories in South America and the description of the whole product range. The history of the seaplanes merges with the history of the cigars. A legend is born.

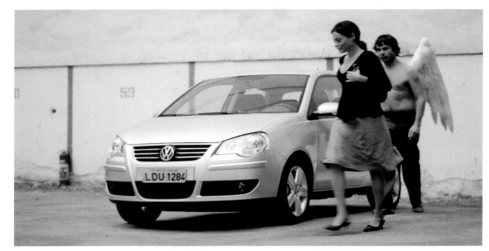

ANGEL'S DAY OFF

Art Director
Dylan Harrison,
Feargal Ballance
Copywriter
Feargal Ballance,
Dylan Harrison
Creative Director
Jeremy Craigen
Director
Frederic Planchon
Producer
Simon Cooper
Production Company
Academy
Agency
DDB London
Client
Volkswagen
Country
United Kingdom

The brief was to bring to life the emotional feeling of protection and safety that Polo drivers feel when driving their car. The ad begins in a city where every individual has a guardian angel looking after him or her. One guardian angel has a day off however, because the woman he normally watches over is driving a VW Polo. The angel passes the time playing pool, visiting a gallery and generally hanging out, watching people go about their busy lives. He knows the Polo will protect her while she's inside it. He makes the most of his time off until the driver he looks after gets out of her Polo and he has to go back to work.

Merit
Television & Cinema Crafts,
Music/Sound Design, Single

BEATBOX FAMILY

Art Director
Mike Long
Copywriter
Kerry Keenan
Designer
Nailgun
Director
Mike Long
Editor
Maury Loeb- P.S.260
Producer
Shelby Ross, Brian Carmody,
Patrick Milling Smith
Production Company
Smuggler
Agency
SKM
Client
MTV Networks
Country
United States

This commercial opens on a comfortable, suburban house. A nervous teenage boy walks up to the door and rings the bell. A conservatively dressed dad opens the door. The boy asks to see "Jennifer" and the dad responds with strange, guttural sounds. He is beat boxing. The boy looks frightened yet follows him into the house. A beat box dialogue ensues between various members of the family as the confused boy looks on. Finally, a young teenage girl hurries down the stairs. But before she can get to her waiting date, her little sister tries to get the boy's attention by thrusting a ferret in his face. Soon, we are in the middle of an all out family beat box battle. The battle ends when the teenage girl grabs her boyfriend and runs out of the house. In the world of MTV, self-expression is cherished. Anyone can be a citizen. Like the end title says, "you just have to learn to speak MTV."

Merit
Collateral Advertising,
Guerrilla/Unconventional,
Campaign

**BIKINI TRIMMER:
BUSHES X 7**

Art Director
Feargal Ballance,
Dylan Harrison
Copywriter
Dylan Harrison,
Feargal Ballance
Creative Director
Jeremy Craigen
Agency
DDB London
Client
Philips
Country
United Kingdom

Our brief was to promote Philips
Bikini Perfect bikini hair trimmer to
women. The bikini area and pubic
hair is not an easy subject to
address, it is not something that
women like to discuss openly. We
needed to get under their radar in a
playful, eye-catching and informa-
tive way. As it was a European
campaign, it also had to be simple
and cross language barriers. Instead
of traditional media, we decided to
make "bushes"—a play on the slang
for pubic hair—trimmed into bikini
area designs. We then placed these
in environments where women were
body conscious—communal areas
and changing rooms in health clubs,
gymnasiums and swimming pools.
We started with the most famous
pubic hair design, "The Brazilian."
After "The Hollywood," we invented
our own designs—"The No Entry,"
"You Are Here," "Charlie Chaplin,"
"Bling" and "Heart." Each bush
demonstrated how versatile, precise
and effective the bikini trimmer is.

'Heart'

'Bling'

'Brazilian'

'No Entry'

'Charlie Chaplin'

'You Are Here'

Merit
Television & Cinema Crafts, Editing, Single

LOYAL

Art Director
John Hobbs
Copywriter
Peter Rosch
Creative Director
Thomas Hayo
Director
Danny Kleinman
Editor
Steve Gandolfi
Producer
Jill Andresevic
Production Company
Kleinman Productions, London
Agency
Cut and Run LA
Client
Levi's
Country
United States

Merit
Newspaper, Consumer, Less Than A Full Page, Campaign

THE ONION CAMPAIGN #2: STORIES THAT HIT HARDER THAN YOUR LAST BOYFRIEND, GIVE THE GIFT THAT WILL MAKE HER SAY… ALL THE THINGS YOU'VE THOUGHT BUT NEVER SAID, LET US PUMP OUR NEWS INTO YOUR KNOWLEDGE HOLE, HELL IS GONNA BE SO COOL

Art Director
Kevin Thoem
Copywriter
Mike Lear, Sara Grunden, Todd Brusnighan
Creative Director
Mike Lear, Mike Hughes
Producer
Melissa Ralston
Agency
The Martin Agency
Client
The Onion
Country
United States

If you think writing ads for The Onion is easy, try doing it as a balding, vertically challenged dyslexic.

Merit
Magazine, Consumer,
Full Page, Single

HITLER

Art Director
Jeff Lable
Photographer
Seth Taras
Creative Director
Court Crandall
Agency
Ground Zero Advertising
Client
A&E History Channel
Country
United States

In our daily life, the events of history are invisible to us—all we can see is the present. In a visually striking way, this campaign reminds us that truly amazing and awful things have happened in our world, and tells us we can still learn about them on The History Channel.

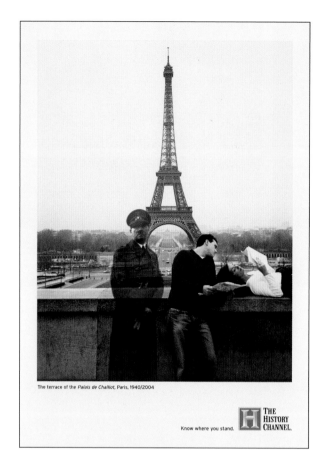

The terrace of the *Palais de Chaillot*, Paris, 1940/2004

Know where you stand.

THE HISTORY CHANNEL.

Merit
Magazine, Consumer,
Multipage, Campaign

**CHAINSAW: BIRDS,
SNAKE, SLOTH**

Art Director
Alexandre Veret
Copywriter
Frederic Sounillac
Creative Director
Sylvain Thirache,
Alexandre Herve
Photo Editor
stock shot
Agency
DDB Paris
Client
Stihl
Country
France

Stihl chain saws are very performant: they cut properly and quickly. And when the chain saw is so fast, animals in the forest don't have the time to get off the tree before the branch gets cut off.

Stihl Chainsaw. Fast. STIHL

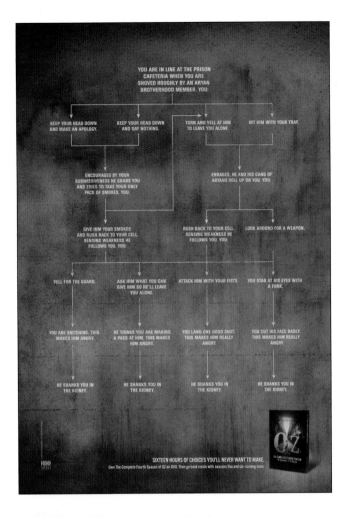

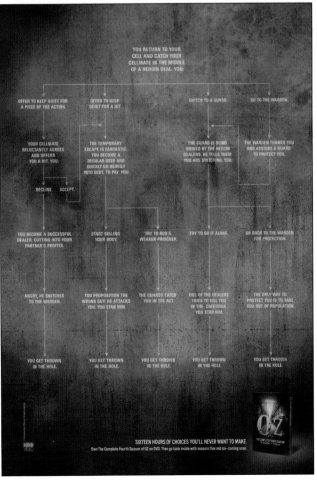

Merit
Magazine, Consumer,
Full Page, Single

HOLE

Art Director
Ray Andrade
Copywriter
James Robinson
Creative Director
Greg Bell, Paul Venables
Agency
Venables Bell & Partners
Client
HBO Home Video
OZ Season 4
Country
United States

A strange thing happens when you watch an episode of Oz. Instead of asking "how will that character get out of this horrific situation?" you find yourself asking "how would I get out of that horrific situation?" Eventually you arrive at the horrible conclusion: You wouldn't. On the show, everyone seems to get thrown into "the hole" at least once, no matter how they tried to avoid it. In fact, the harder they tried to not get thrown in the hole, the more likely it was that they would end up there. While one would think that a break from constant stabbings, beatings and shower-room antics would be appreciated, the characters always emerged from the lightless, naked isolation far worse than they went in. We wanted the ads to convey the same hopeless, horrible, yet somehow entertaining experience.

Merit
Magazine, Consumer,
Full Page, Single

KIDNEY

Art Director
Ray Andrade
Copywriter
James Robinson
Creative Director
Greg Bell, Paul Venables
Agency
Venables Bell & Partners
Client
HBO Home Video
OZ Season 4
Country
United States

After 32 straight hours of Oz episodes my art director and I came to an astounding conclusion: Prison sucks. Every aspect of it sucks to such a degree that the word "sucks" loses all meaning. Every choice the characters made on the show, whether they came from a place of logic, evil or sheer barking madness, ended in tragedy. We wanted the ads to give the viewer the same feeling. Sure it took us 31 hours longer than it should have to reach this conclusion, but once we did we had our starting line: "8 hours of choices you never want to make." After that, it was simply a matter of getting the words "stabbed in the kidney" through the client and finding a euphemism for shower rape. The rest wrote itself.

**THE NOISE PROTECTION
WINDOWS BY WERU:
GARBAGE COLLECTION,
ROCKER, DOGS,
BAND, GLASS CONTAINER**

Art Director
Kay Luebke
Copywriter
Michael Haeussler
Creative Director
Matthias Spaetgens,
Jan Leube
Designer
Anatolij Pickmann,
Liisa-Triin Vurma
Photographer
Ralph Baiker
Agency
Scholz & Friends Berlin GmbH
Client
Weru AG
Country
Germany

This ad was created for Weru to
clarify the effectiveness of Weru
soundproof windows in a surprising
and unseen way. The ad shows a
look out of a Weru soundproof
window: you see things that are
normally big in a very small way. So
they seem to be extremely quiet.

**IN A WORLD WHERE
WHAT IS (COUPLE)**

Art Director
Marcello Serpa, Julio Andery,
Cesar Finamori
Copywriter
Dulcidio Caldeira, Andre Faria
Creative Director
Marcello Serpa
Photographer
Hugo Treu, Fernando Nalon,
Samba Photo,
Stock Photos, Wide
Agency
AlmapBBDO
Client
Volkswagen
Country
Brazil

Our goal was to launch the new
Volkswagen tagline, "Perfect for
your life," translating the new posi-
tioning "Extraordinary cars for ordi-
nary people." The new campaign for
the new Volkswagen positioning
was based on 4 pillars: 1. German
engineering and perfection. 2.
Durable, contemporary design. 3.
Affordability. 4. Authentic, human,
friendly. And for each of the pillars,
we used images capable of commu-
nicating the values of the Volks-
wagen brand today.

Merit
Television & Cinema
Commercials, Cinema:
Over 30 Seconds, Single

THE JUMP

Art Director
Nicole Groezinger
Copywriter
Alex Priebs Macpherson
Creative Director
Thomas Kanofsky,
Eberhard Kirchhoff
Director
Alex Feil
Editor
Alexander Hattendycken
Production Company
Schulten Film
Agency
Saatchi & Saatchi GmbH
Client
A.R.T. Soundstudio
Country
Germany

Merit
Magazine, Consumer,
Spread, Single

**IN A WORLD WHERE
WHAT IS (HAIR)**

Art Director
Marcello Serpa, Julio Andery,
Cesar Finamori
Copywriter
Dulcidio Caldeira, Andre Faria
Creative Director
Marcello Serpa
Photographer
Hugo Treu, Fernando Nalon,
Stockphotos, Wide
Agency
AlmapBBDO
Client
Volkswagen
Country
Brazil

Our goal was to launch the new
Volkswagen tagline, "Perfect for
your life," translating the new posi-
tioning "Extraordinary cars for ordi-
nary people." The new campaign for
the new Volkswagen positioning
was based on 4 pillars: 1. German
engineering and perfection. 2.
Durable, contemporary design. 3.
Affordability. 4. Authentic, human,
friendly. And for each of the pillars,
we used images capable of commu-
nicating the values of the Volk-
swagen brand today.

Merit
Television & Cinema
Commercials, TV:
Public Service/Nonprofit,
Single

CANDLE

Art Director
Philippe Taroux
Copywriter
Benoit Leroux
Creative Director
Erik Vervroegen
Production Company
La Societe du Spectacle
Agency
TBWA\Paris
Client
Amnesty International
Country
France

This spot shows dictators of
the last 40 years, trying to blow
something out. We discover
that they've been trying to
blow out the candle of
Amnesty International's logo.
In spite of their efforts, the
candle stays lit. A logo appears
on screen: Amnesty Interna-
tional. We're here to stay.

Merit
Magazine, Trade,
Full Page, Campaign

Also for Hybrid
SEE PAGE 32

**EBAY IT RETAIL PRINT
CAMPAIGN: BIKE SHOP,
SHOEBOXES, BLENDERS**

Art Director
Chuck Tso
Copywriter
Chris Maiorino
Creative Director
David Lubars, Greg Hahn
Photographer
Craig Cutler
Agency
BBDO New York
Client
Ebay
Country
United States

In 2005, eBay launched their
massive integrated "It" campaign
lauding the breadth of inventory
available on their immensely
popular site. And while the
campaign was hugely successful on
the consumer front, eBay still
needed a way to extend "It" to the
retail industry-particularly small
businesses. We thought it would be
cool to make it real visual and use
negative space to convey the idea
that product was being sold. To tie
the idea into the brand campaign,
we carved "It" letterforms out of the
inventory of some of eBay's most
popular retail categories and twisted
the brand line: "You can get it on
eBay'" to a more retail focused:
"You can sell it on eBay."

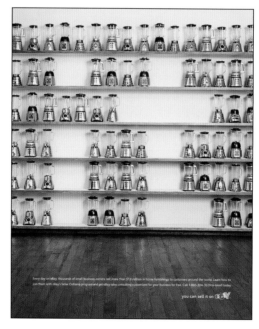

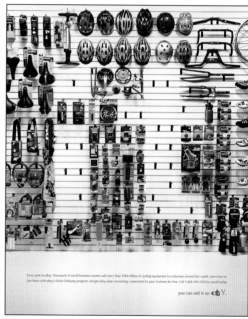

Merit
Television & Cinema
Commercials, TV:
Low Budget (under $100,000),
Single

VIBRATORS

Art Director
Erik Vervroegen
Copywriter
Veronique Sels,
Erik Vervroegen
Creative Director
Erik Vervroegen
Director
Wilfrid Brimo
Production Company
Wanda
Agency
TBWA\Paris
Client
Aides
Country
France

As a little girl grows into a beautiful young woman, she discovers that love isn't always easy. After a series of dating catastrophes, she finally meets the man of her dreams. TAG: Live long enough to find the right one. Protect yourself.

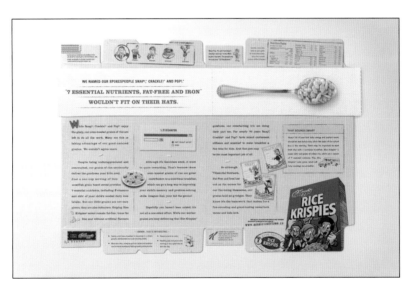

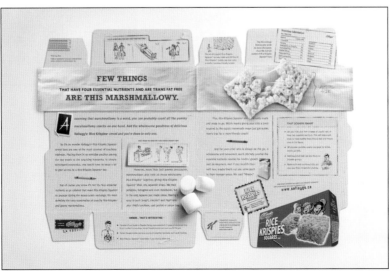

Merit
Magazine, Trade,
Spread, Campaign

**MISSION NUTRITION:
7, FAT FREE AND IRON,
SMART AND GOOD
LOOKING, MARSHMALLOW**

Art Director
Anthony Chelvanathan,
Israel Diaz
Copywriter
Steve Persico, Judy John
Creative Director
Judy John, Israel Diaz
Illustrator
Jim Woo
Photographer
Chris Gordaneer
Producer
Kim Burchiel
Production Company
Image Dynamics
Publisher
Chatelaine
Agency
Leo Burnett Canada
Client
Kellogg's Canada
Country
Canada

We at Starcom MediaVest Group see creative media opportunities in anything and everything. And to prove it, we took this maximum 150-word winner's statement box in this prestigious advertising annual and turned it into an innovative, unexpected and effective media space. Just a friendly reminder that if there's a space, we'll find it.

NUMBERS

Art Director
Alexandre Vilela, Carlos Nunes,
Nando Zenari, Marco Versolato
Copywriter
Emiliano Trierveiler,
Marco Gianelli
Creative Director
Jaques Lewkowicz,
Marco Versolato,
Andre Laurentino
Director
Jarbas Agnelli
Producer
Katia Bontempo Leal
Production Company
AD Studio
Agency
Lew Lara Propaganda
Client
Nokia
Country
Brazil

Our objective was to show the
product as more than just a mobile
phone with a larger, more user-
friendly keyboard. The idea was to
show that words could give a
special meaning to ordinary-looking
numbers. So, it's possible to say
much more if you use words, not
just numbers.

**FIESTA, ART CENTER,
ERNIE THE KLEPTO**

Art Director
Scott Vitrone, Craig Allen
Copywriter
Ian Reichenthal, Ashley Davis
Executive Creative Director
Gerry Graf
Creative Director
Scott Vitrone, Ian Reichenthal
Director
Bryan Buckley, Rocky Morton,
Matt Aselton
Editor
Gavin Cutler, Dave Koza,
Mackenzie Cutler Editorial
Producer
Nathy Aviram, Laura Ferguson,
Lora Schulson
Production Company
Hungryman, MJZ, Epoch Films
Agency
TBWA\Chiat\Day New York
Client
Starburst
Country
United States

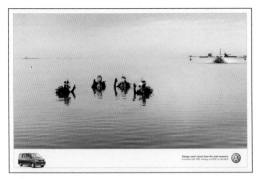

Merit
Magazine, Trade,
Multipage, Campaign

**LES DANGERS:
ELECTRICIAN,
SCRUBBER, PAINTERS,
PLUMBERS, DIVERS**

Art Director
Pierrette Diaz
Copywriter
Matthieu Elkaim
Creative Director
Sylvain Thirache,
Alexandre Herve
Photographer
Jean-Yves Lemoigne
Agency
DDB Paris
Client
Volkswagen
Country
France

Light-hearted and humoristic, right
in the mire of Volkswagen adver-
tising tradition, this campaign volun-
tarily challenges in its form and
content the traditional communica-
tion habits in the utility sector, much
less creative than the private car
sector.

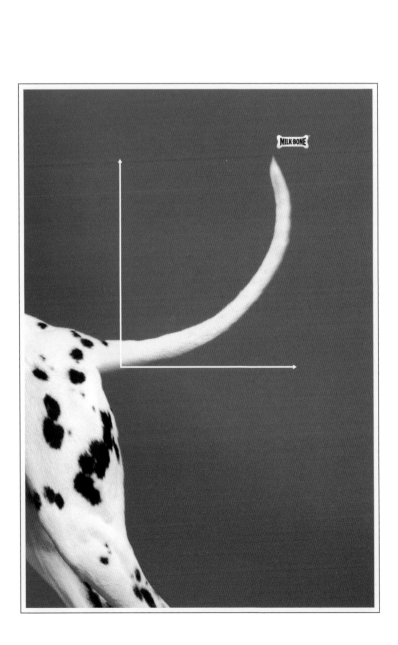

Merit
Posters & Billboards
Promotional, Single

TAIL

Art Director
Daniela Montanez
Copywriter
Matthew Bottkol,
Heidi Hackemer
**Chairman/
Chief Creative Officer**
Chris Becker
Creative Director
Sandy Greenberg, Terri Meyer
Photographer
Stock Photography –
Getty Images, PictureQuest
Agency
Foote Cone & Belding
Client
Kraft/Milk-Bone
Country
United States

Research shows that 99.99% of
dogs can't read. So we opted for a
simple visual approach to remind
dogs how much they love Milk-
Bone. The other .01% of dogs that
do read received a 230-page report
chock full of illuminating pie charts,
competitive analysis, stock earnings
for the year and a detailed history of
the product's genesis entitled, "And
lo! There was Milk-Bone!" The jury is
still out on which approach was
more effective.

TONGUE

Art Director
Daniela Montanez
Copywriter
Matthew Bottkol,
Heidi Hackemer
Chairman/
Chief Creative Officer
Chris Becker
Creative Director
Sandy Greenberg, Terri Meyer
Photographer
Jake Chessum
Agency
Foote Cone & Belding
Client
Kraft/Milk-Bone
Country
United States

Research shows that 99.99% of
dogs can't read. So we opted for a
simple visual approach to remind
dogs how much they love Milk-
Bone. The other .01% of dogs that
do read received a 230-page report
chock full of illuminating pie charts,
competitive analysis, stock earnings
for the year and a detailed history of
the product's genesis entitled, "And
lo! There was Milk-Bone!" The jury is
still out on which approach was
more effective.

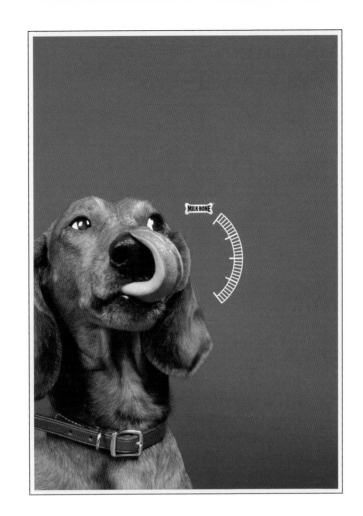

Also for Hybrid
SEE PAGE 32

IT: FUZZY, WOOD, GRASS

Art Director
James Clunie
Copywriter
Kara Goodrich
Creative Director
David Lubars, Greg Hahn
Agency
BBDO New York
Client
Ebay
Country
United States

These posters were part of the
larger eBay "It" campaign. The
idea/end-line is "whatever it is, you
can get it on eBay." Whether it's
made of pink fuzz, glass, grass,
leather, rubber, etc…you can find it
all on eBay.

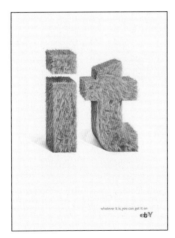
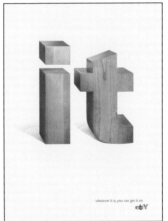
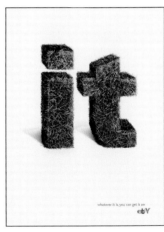

Merit
Posters & Billboards
Promotional, Campaign

MILK-BONE: DROOL, TAIL, TONGUE, JUMPER

Art Director
Daniela Montanez
Copywriter
Matthew Bottkol,
Heidi Hackemer
**Chairman/
Chief Creative Officer**
Chris Becker
Creative Director
Sandy Greenberg, Terri Meyer,
Photographer
Jake Chessum – Tongue;
Stock Photography – Tail,
Drool, Jumper (Getty
Images, PictureQuest)
Agency
Foote Cone & Belding
Client
Kraft/Milk-Bone
Country
United States

Research shows that 99.99% of dogs can't read. So we opted for a simple visual approach to remind dogs how much they love Milk-Bone. The other .01% of dogs that do read received a 230-page report chock full of illuminating pie charts, competitive analysis, stock earnings for the year and a detailed history of the product's genesis entitled, "And lo! There was Milk-Bone!" The jury is still out on which approach was more effective.

Merit
Posters & Billboards
Point-of-Purchase, Campaign

GLOBUS ANIMAL WEEKS: THE LION, THE MOUSE AND THE SPECIAL OFFER, THE CAT, THE OLD MOUSE AND THE SPECIAL OFFER, THE CRANE, THE FROGS AND THE SPECIAL OFFER, THE WOLF, THE LAMB AND THE SPECIAL OFFER

Art Director
Christian Mommertz
Copywriter
Dr. Stephan Vogel,
Christian Mommertz
Creative Director
Christian Mommertz,
Dr. Stephan Vogel
Designer
Nicole Hofer
Agency
Ogilvy & Mather
Werbeagentur GmbH & Co. KG
Client
Globus Market, Germany
Country
Germany

Merit
Radio Advertising,
30 Seconds Or Less, Single

BLEEP

Art Director
Danilo Janjacomo
Copywriter
Adriana Cury
Creative Director
Adriana Cury,
Ana Clèlia Quarto,
Danilo Janjacomo
Director
Ricardo Fleury
Production Company
Lua Nova Sound Productions
Agency
Ogilvy Brasil
Client
Lua Nova
Country
Brazil

The objective of this piece was to divulge the good work done by a sound studio named "Lua Nova." This was done through an unusual and amusing spot where the famous "bleep" (sound signal that censors bad words) is always placed in the wrong place. As a result, all the bad words are perfectly audible and the words that are censured by the "bleep" are absolutely innocent. In the end, it's clear that when a sound producer doesn't do his job correctly, it compromises the work.

BLEEP

SFX
ambient noise - street.
A man is talking to a police officer about the car accident he was just involved in. He says a lot of bad words but the bleep censor keeps covering the wrong ones.

MAN
Officer, I was driving down the street and the light went red. All of a sudden, this BLEEP of a bitch hit the back of my fucking BLEEP. I screamed, "you BLEEP of shit! What're you fucking blind, you cock sucker?" But he got personal. He said, "your mother's a cock sucking whore, why didn't you fucking BLEEP?" He was talking about my mom, I got pissed. BLEEP pissed. I totally lost my BLEEP. My mom, a whore?! I beat the shit out of the BLEEP.

ANNOUNCER
When the sound production isn't done right, your BLEEP ends up like a piece of shit. Lua Nova Productions. We do it right.

MAN
Calling my BLEEP a whore?! Fuck BLEEP shit!!!

Merit
Posters & Billboards
Point-of-Purchase, Single

NIKE- SHARAPOVA: STEEL

Art Director
Johnson Sheng, HaiBo Huang
Copywriter
Lesley Zhou
Creative Director
SheungYan Lo, Bill Chan,
Nick Lim
Illustrator
Lorenzo Petrantoni
Agency
JWT Shanghai
Client
Nike (Suzhou) Sports Co., Ltd.
Country
China

Maria Sharapova is probably one of the most attractive tennis players in the world right now. When everyone is focusing on Sharapova's outlook, we focus on her style of play, which is even more appealing.

you can sell it on ebY.

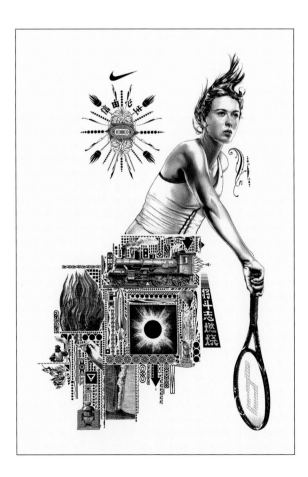

**EBAY IT RETAIL
POSTER CAMPAIGN:
BIKE SHOP, SHOEBOXES,
BLENDERS, JEWELRY, TV**

Art Director
Chuck Tso
Copywriter
Chris Maiorino
Creative Director
David Lubars, Bill Bruce,
Greg Hahn
Agency
BBDO New York
Client
Ebay
Country
United States

In 2005, eBay launched their
massive integrated "It" campaign
lauding the breadth of inventory
available on their immensely
popular site. And while the
campaign was hugely successful on
the consumer front, eBay still
needed away to extend "It" to the
retail industry—particularly small
businesses. We thought it would be
cool to make it really visual and use
negative space to convey the idea
that product was being sold. To tie
the idea into the brand campaign,
we carved "it" letterforms out of the
inventory of some of eBay's most
popular retail categories, and
twisted the brand line: "You can get
it on eBay'" to a more retail focused:
"You can sell it on eBay."

NIKE- SHARAPOVA: FIRE

Art Director
Johnson Sheng, HaiBo Huang
Copywriter
Lesley Zhou
Creative Director
SheungYan Lo, Bill Chan,
Nick Lim
Illustrator
Lorenzo Petrantoni
Agency
JWT Shanghai
Client
Nike (Suzhou) Sports Co., Ltd.
Country
China

Maria Sharapova is probably one of
the most attractive tennis players in
the world right now. When everyone
is focusing on Sharapova's outlook,
we focus on her style of play, which
is even more appealing.

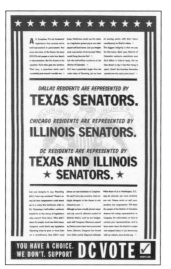
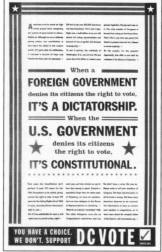
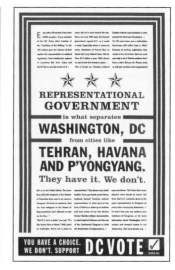

Merit
Posters & Billboards
Public Service/Nonprofit/
Educational, Campaign

OROVERDE MONSTER: I–IV

Art Director
Till Schaffarczyk
Copywriter
Ales Polcar
Creative Director
Helmut Himmler, Lars Huvart
Illustrator
Till Schaffarczyk
Photo Editor
Till Schaffarczyk
Photographer
stock photography
Agency
Ogilvy & Mather
Werbeagentur GmbH & Co. KG
Client
OroVerde Rainforest
Foundation
Country
Germany

Deforestation in the rainforest not
only destroys the ecosystem but
also decimates the invaluable
variety of wildlife and animal species
that live there. The poster campaign
"Monsters" communicates this
important message in order to
inform and activate wildlife lovers.

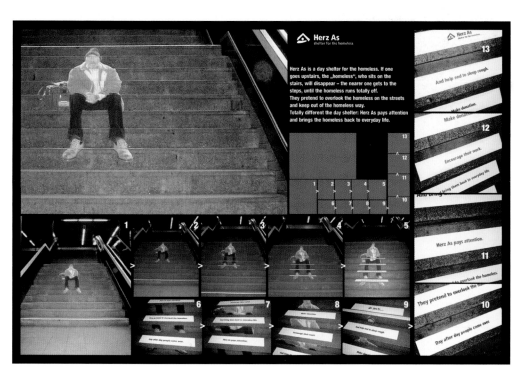

Merit
Posters & Billboards
Public Service/Nonprofit/
Educational, Single

UPSTAIRS

Art Director
Mitoh
Copywriter
Elena Tresnak
Creative Director
Michael Hoinkes
Designer
Mitoh
Agency
He Said She Said
Client
Herz As – Day Shelter
for the homeless
Country
Germany

THE EXPLOSIONS POSTER: CHILD

Art Director
Tim Stuebane
Copywriter
Birgit van den Valentyn
Creative Director
Julia Schmidt,
Matthias Schmidt,
Constantin Kaloff
Designer
Fabian Braun
Illustrator
Carolina Cwiklinska
Agency
Scholz & Friends Berlin GmbH
Client
Aktionsbündnis Landmine.de
Country
Germany

With the help of a technical
exploded drawing, we show how
accurately landmines do their job: a
child, who has been destroyed into
all his individual parts.

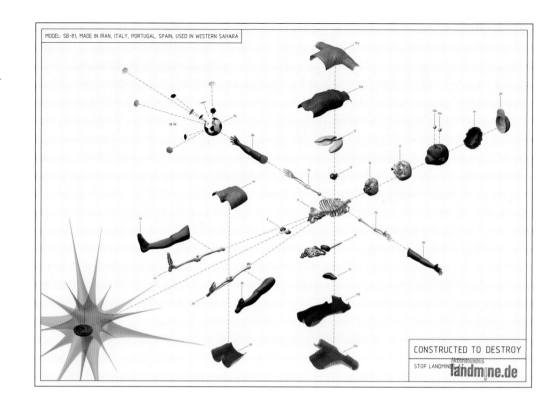

PRISONER

Art Director
Mike Meadus, Kelsey Horne
Copywriter
Mike Meadus
Creative Director
Paul Long
Designer
Mike Meadus, Kelsey Horne,
Brad Connell
Photographer
Ken Woo
Production Company
McGill Production
Agency
MacLaren McCann
Client
Calgary Police
Country
Canada

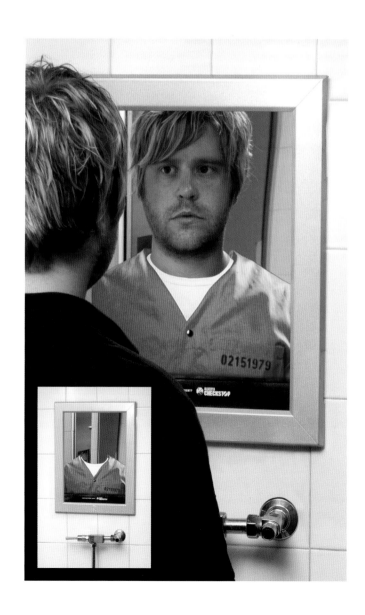

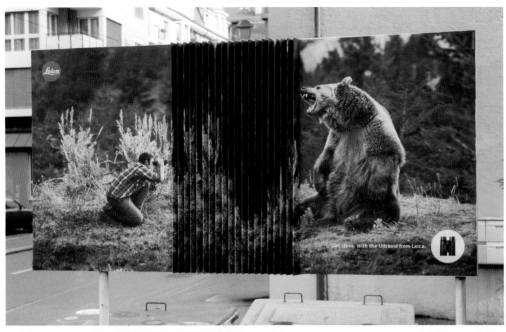

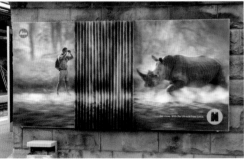

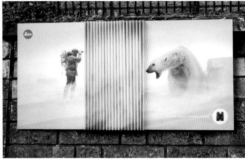

Merit
Posters & Billboards
Outdoor/Billboard, Campaign

LEICA ULTRAVID: GRIZZLY, POLAR BEAR, RHINO

Art Director
Roland Scotoni
Copywriter
Florian Birkner
Creative Director
Urs Schrepfer
Photographer
Stephan Schacher,
Steve Bloom, Ardea, NHPA
Designer
Florian Brand
Agency
Advico Young & Rubicam
Client
Leica Camera AG
Country
Switzerland

We wanted to show that the view through a Leica Ultravid is something exceptional. The quality of the image is so high that it's easy to believe you are standing directly in front of the object you are looking at. The new ad campaign arose from this idea: 5-meter placards were printed and then folded accordion-style to a length of 3 meters. The result is as impressive as it is convincing, and it's come as no surprise that interest in Leica Ultravid has grown. At the moment, the adoption of the campaign throughout Europe is being tested.

Merit
Posters & Billboards
Transit, Single

FOR THAT ANNOYING HEADACHE…

Art Director
Endy Santana
Copywriter
Vinicius Stanzione
Creative Director
Atila Francucci,
Alexandre Soares,
Fernando Nobre, Joao Linneu
Producer
Jomar Farias
Agency
JWT
Client
Bayer
Country
Brazil

Merit
Posters & Billboards
Transit, Single

UNFOLDING DRAMA

Art Director
Chad Burnie
Copywriter
Steve Salibian
Creative Director
Brian Howlett
Agency
Axmith McIntyre Wicht
Client
City of Toronto
Country
Canada

Pedestrian safety is a growing concern on the streets of Toronto. To create awareness of this issue, we put a life-size image of a child on streetcar doors in front of a life-size car. The doors opening and closing create the chilling effect of the child being struck by the car.

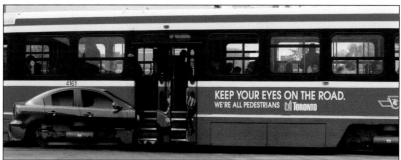

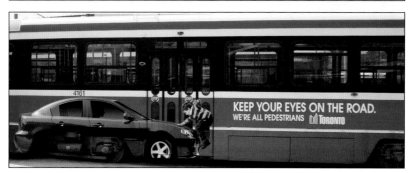

Merit
Television & Cinema
Commercials, Cinema:
30 Seconds, Single

CAMERA PHONE

Art Director
Paul Jordan, Angus Macadam
Copywriter
Paul Jordan, Angus Macadam
Creative Director
Jim Thornton
Director
Chris Palmer
Editor
Paul Watts
Producer
Rupert Smythe
Production Company
Gorgeous Enterprises, UK
Agency Producer
Emma Gooding
Cinematographer
Ian Foster
Agency Producer
Emma Gooding
Agency
Leo Burnett
Client
Department for Transport –
Teen Road Safety
Country
United States

This TV commercial is set on a typical British residential road. It's about a small group of mates (three boys and three girls) who are walking home from school together. It is shot through a mobile phone video camera that one of the girls in the group is holding.

As they walk down the road, we can see that they are all about 14 years old and seem pretty normal teenagers. From the easy and familiar way they're chatting with each other it's clear that they're all close mates.

We see all of the kids messing around in front of the camera in different ways and are having a lot of fun. We focus on each of them and see them playing and laughing naturally.

A girl comes very close to the camera, giggles then turns away. The shot reveals two of the members of the group about to the step into the road and cross to the other side.

The boy at the front of the group, Orlando, at that moment steps out into the street without a change in pace or stopping conversation. He makes a very quick casual glance left and then right but suddenly a car passes through the shot hitting him with a sickening thud and knocking him clean out of the picture. Suddenly there is chaos. The girl with the camera phone forgets about her filming, but in the panic, doesn't stop recording. This means all we see is lots of blurred footage as she runs to where the boy is lying in the road.

Although the camera phone doesn't visually capture all the horror of this accident, we can hear the panic stricken chaos that follows. We hear the friends shouting 'Orlando' and screaming.

We then see at title that says: 55 TEENAGERS A DAY WISH THEY'D GIVEN THE ROAD THEIR FULL ATTENTION.

We then see the 'Think!' logo appear.

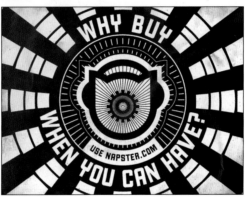

**THE BLACK & WHITE
CAMPAIGN: USE NAPSTER,
OUR TUNES, WHY BUY
WHEN YOU CAN HAVE**

Art Director
Will Uronis, Geoff Lillemon,
Nando Costa, Linn Olofsdotter
Copywriter
Alex Flint, Shane Hutton
Creative Director
Gary Koepke, Lance Jensen
Designer
Geoff Lillemon, Nando Costa,
Linn Olofsdotter
Agency
Modernista
Client
Napster
Country
United States

For the launch of their music
subscription service, Napster
needed an outdoor campaign to
stand out among the clutter. The
brief was to inform people that there
is a new way to enjoy music without
owning it. Striking graphics and
straightforward language were used
to communicate a simple message
and set up a stark contrast between
Napster and the colorful ads of their
main competitor.

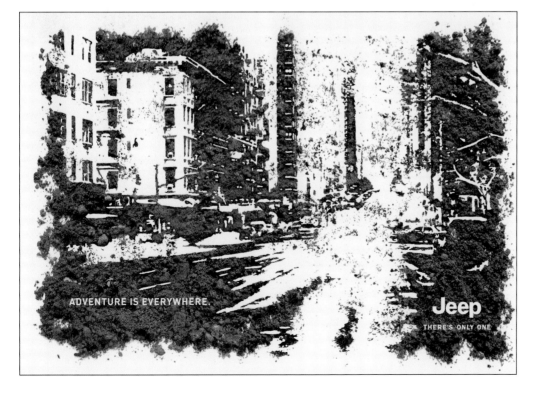

MUD

Art Director
Hanadi Chawaf
Copywriter
Berend Brüdgam
Creative Director
Tim Krink, Niels Holle
Designer
Hanadi Chawaf
Designer
Hanadi Chawaf
Agency
KNSK Werbeagentur GmbH
Client
DaimlerChrysler AG Jeep
Country
Germany

Merit
Posters & Billboards
Outdoor/Billboard, Campaign

**11 NEWS 1 CHANNEL:
BOY, BUSINESS MAN,
HOUSE WIFE**

Art Director
Taya Sutthinun,
Wiboon Leepakpreeda
Copywriter
Nucharat Nuntananonchai,
Passapol Limpisirisan
Creative Director
Chukiat Jaroensuk,
Wibon Leepakpreeda,
Passapol Limpisirisan
Agency
Euro RSCG Flagship Ltd.
Client
11 News 1 Channel
Country
Thailand

11 News 1 Channel positioning is
"fast and accurate." The challenge
for the creative is to visually differen-
tiate this seemingly generic
claim…hence "we bring you to the
real situation."

Merit
Posters & Billboards
Outdoor/Billboard, Campaign

**THE CHARLADY CAMPAIGN:
OPERA, CHESS WORLD
CHAMPIONSHIP, WEDDING**

Art Director
Axel Schilling,
Marc Ebenwaldner
Copywriter
Johan H. Ohlson,
Alexander Schierl
Creative Director
Stefan Setzkorn,
Silke Schneider,
Gunnar Loeser
Designer
Pia Schneider
Photographer
Hiepler, Brunier
Agency
Scholz & Friends
Hamburg GmbH
Client
BSH Bosch und Siemens
Hausgeraete GmbH
Country
Germany

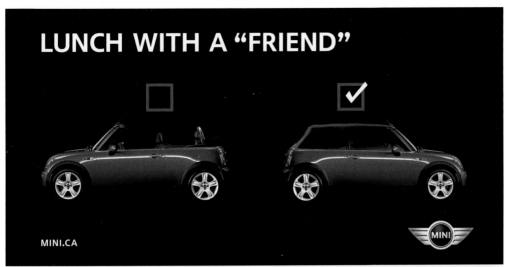

Merit
Posters & Billboards
Outdoor/Billboard, Campaign

**BURRITO, LUNCH,
KAMA SUTRA**

Art Director
Sam Cerullo
Copywriter
Jordan Doucette
Creative Director
Zak Mroueh
Producer
Tracy Haapamaki
Agency
TAXI
Client
MINI Canada
Country
Canada

Hmmm…whether to go top up or top down while performing back seat kama sutra? Thanks to the new MINI convertible campaign, no MINI driver will be left unclear on the appropriate roof position on this, and many other situations they may find themselves in.

Merit
Posters & Billboards
Outdoor/Billboard, Single

SUDUKO

Art Director
Ginny Bracewell
Copywriter
Arthur Tsang, Matthew Nisbet
Creative Director
Tony Peck
Producer
Joe Leung
Agency
OgilvyOne Worldwide (HK)
Client
The Economist
Country
Hong Kong

What could we do with the long-running Economist campaign that would bring a new way to highlight the intelligence of its readers? One bright spark noticed that the word "Economist" had nine letters. And when we remembered that the acclaimed logic puzzle of Sudoku requires players to complete a 9x9 grid with digits, it was natural to put two and two together. Then, all it needed was hours of trying different letter combinations to make it work! Just like Sudoku, The Economist requires intelligence, is strangely addictive and gives you that satisfying "I'm so smart" feeling when you complete it. Even better, the Sudoku grid gave us the white borderline on red background, cleverly substituting for The Economist logo.

Given how incredible extreme sports stunts have become, the word "trick" started to feel too small. So it seemed like a natural question, "At what point do tricks become more than that? At what point do they become miracles?" Has that point already been crossed? We decided to answer the question ourselves by sanctifying the athletes that perform these miracles. And considering that the outdoor boards were located right behind the big air ramp at X Games 11, they served as homage to the athletes as they performed.

Merit
Collateral Advertising,
Direct Mail, Single

SIXTY MAGAZINE

Art Director
Michael Ashley, Diana Tung
Copywriter
Dinesh Kapoor, Michael Ashley
Creative Director
Michael Ashley
Designer
Michael Ashley, Diana Tung
Agency
Arnika
Client
VCU Adcenter
Country
United States

This second edition of VCU Adcenter's annual Sixty magazine is used as a recruiting tool and an opportunity to display some work that the graduating class has created. The creative goal of the magazine has always been to continually try and reinvent the spread, merging student and professional content with art in different ways at every turn of the page. Each 96-page "format-free" issue is compiled and built over an intense 3-week period, and all art and photography is compiled and created in-house using student and agency resources. The end design result is always unique.

Merit
Posters & Billboards
Outdoor/Billboard, Single

FS-MISSIONARY

Art Director
Yue Chee Guan, Key Huang,
Joe Harris, Todd McCracken
Copywriter
Yue Chee Guan, Key Huang,
Joe Harris, Todd McCracken
Creative Director
Yue Chee Guan,
Todd McCracken
Agency
Grey Worldwide Beijing,
Grey Worldwide New Zealand
Client
Australian Therapeutic
Supplies
Country
China

**THE WHAT-DO-YOU-
GET-FROM-F.A.Z.-SIZED-
ADS-BROCHURE**

Art Director
Tim Stockmar
Copywriter
Torsten Lindner
Creative Director
Matthias Spaetgens,
Jan Leube
Designer
Catrin Ciuraj, Claudia Locherer
Photo Editor
appel Grafik Berlin
Photographer
Heribert Schindler,
Ralph Baiker
Agency
Scholz & Friends Berlin GmbH
Client
Frankfurter Allgemeine
Zeitung GmbH
Country
Germany

The "What-do-you-get-from-F.A.Z.-
sized-ads-Brochure" is a direct-
marketing tool that stimulates the
interest in double-page ads in
Germany's biggest quality news-
paper, The Frankfurter Allgemeine
Zeitung (F.A.Z.), by presenting very
big ideas. It convinces potential
advertising clients, such as media
planners and marketing CEO's, that
a double page in the F.A.Z. provides
the space for big brands to stage
their stories.

HATCH

Art Director
Dan Ware
Copywriter
Dave Cerrick
Creative Director
Brian Shembeda, Avery Gross,
G. Andrew Meyer, Noel Haan,
Mark Tutssel
Agency
Leo Burnett
Client
Museum of Science
and Industry
Country
United States

Merit
Collateral Advertising,
Self Promotion, Single

NOT JUST FOR CHRISTMAS

Art Director
Piers North
Copywriter
Erik Enberg
Creative Director
Mark Waites, Robert Saville
Designer
Harrimansteel
Illustrator
Harrimansteel
Photographer
Piers North
Agency
Mother
Client
Mother
Country
United Kingdom

The goal for every agency
Christmas mailer is the same: make
yours the one everyone wants to
keep. So we bought a greyhound
dog, named it "Just For Christmas"
and sent share certificates to
everyone on our mailing list. The
results have been great. "Just For
Christmas" has won four races,
£475 in prize money and now a
place in the ADC Annual, and share-
holders continue to send notes of
thanks and praise. Plus, now we've
got a set of Owner's Passes for the
track. It's the gift that keeps on
giving.

Merit
Posters & Billboards
Outdoor/Billboard, Single

HIGH HEELS

Art Director
Dominik Oberwiler
Creative Director
Petra Bottignole
Photographer
Andrea Vedovo
Agency
Euro RSCG Zurich
Client
Angela Gullè
Country
Switzerland

BUBBLE GIRL

Copywriter
Tom Hudson
Creative Director
Lee Goulding
Designer
Marie Hyon, Marco Spier
Director
Marie Hyon, Marco Spier
Editor
Patrick Burns, Jr.
Producer
Angela Bowen,
Marissa Jennings
Production Company
PSYOP
Agency
PSYOP
Client
Aero
Country
United States

The brief for this spot for Aero was
simply to represent a woman's
blissful experience upon eating the
bubbly chocolate. Aero is famous
for it's bubbles, so the spot is inher-
ently infused with the main brand
attribute. Through painstaking,
carefully crafted animation, the
bubbles form the subtle sensual
nuances of a woman's face as she
enjoys her chocolate, every frame
being beautifully designed.

Music throughout
'Lujon' by Henry Mancini.

This commercial uses
animated bubble circles,
moving in time to the music,
to form the image of a girl
enjoying the blissful experi-
ence of eating Aero.

Open on chocolate
bubbles popping on
in time to the music.

They come together to
form the face of a girl in
a state of bliss.

A dynamic swirl following
the rich sweeping strings of
the music.

It's as if the girl has been
swept away in a kind of
melty chocolate heaven.

The camera moves around
and passes through the
bubbles as they disperse and
reform to show the girl's lips,
eyes, hair etc before ending on
her hand holding a perfectly-
rendered bar of Aero.

We super the line.
HAVE YOU FELT THE
BUBBLES MELT?

FS-DOGGY

Art Director
Yue Chee Guan, Key Huang,
Joe Harris, Todd McCracken
Copywriter
Yue Chee Guan, Key Huang,
Joe Harris, Todd McCracken
Creative Director
Yue Chee Guan,
Todd McCracken
Agency
Grey Worldwide Beijing,
Grey Worldwide New Zealand
Client
Australian Therapeutic
Supplies
Country
China

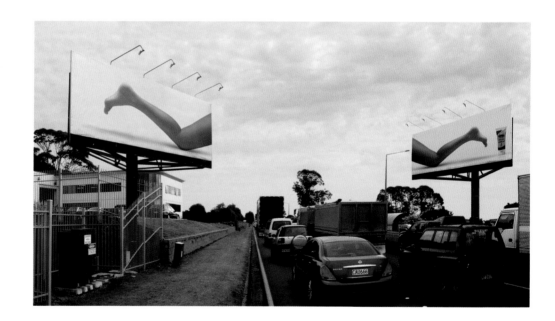

Merit
Collateral Advertising,
Guerrilla/Unconventional,
Single

SHIRT

Art Director
Etienne Zhang
Copywriter
Oscar Leung
Creative Director
Eddie Booth, Stephen Mui,
Murphy Yeung
Agency
Leo Burnett Ltd
Client
P&G
Country
China

Based on the idea of "Wherever the oil stain is, there should be Tide," we leverage an occasion where oil stains could be found most commonly, such as restaurants or local fast food chain stores. With Tide's equity being superior oil stain removal on whites, we set up a tough laundry situation, oil stains on whites, by putting a tray mat (white shirt) onto a tray. The headline was, "With Tide, You Don't Need To Worry About Oil Stains!" The tray mat is printed on paper, die-cut into the shape of a white shirt, and placed on trays at fast food chain stores.

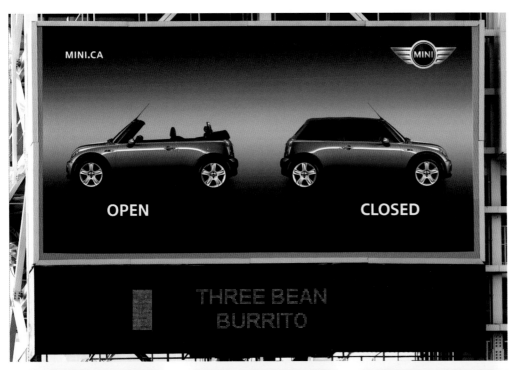

Merit
Posters & Billboards
Electronic Billboard, Single

OPEN OR CLOSED?

Art Director
Sam Cerullo
Copywriter
Jordan Doucette,
Jason McCann, Irfan Khan
Creative Director
Zak Mroueh
Producer
Tracy Haapamaki
Agency
TAXI
Client
MINI Canada
Country
Canada

This digital board used a flashing light to indicate whether a MINI convertible driver should go open or closed depending on the situation. The images above are just a selection from dozens of lines that appeared on this board.

Merit
Collateral Advertising,
Guerrilla/Unconventional,
Single

WHITE OUT

Art Director
Chuck Tso
Copywriter
Eric Schutte
Creative Director
David Lubars, Eric Silver
Agency
BBDO New York
Client
FedEx/Kinko's
Country
United States

FedEx was looking for a bold and innovative idea to announce its new online office supply store, fedexkinkos.com. The result was big. Literally. Oversized sculptures of highlighters, whiteout bottles, and desk lamps were placed in various high-traffic outdoor locations and played off the natural environment. The monstrous highlighter looked as if it had just painted a fresh yellow streak on the curb of a no parking zone, the white-out gave the impression of a freshly painted white cross-walk and the desk lamp was equipped with a sensor that would illuminate areas where people would typically go to read, like a park or an outdoor seating area.

Merit
Collateral Advertising,
Guerrilla/Unconventional,
Single

GIANT COMB

Art Director
Somak Chaudhury
Copywriter
Somak Chaudhury
Creative Director
Chris Chiu, Kumuda Rao,
Sirin Wannavalee
Agency
Leo Burnett
Client
Proctor & Gamble,
Rejoice Conditioners
Country
United States

Merit
Collateral Advertising,
Guerrilla/Unconventional,
Campaign

Also for Graphic Design
Merit
Environmental Design,
Environment, Campaign
SEE PAGE 344

**REAL TOYS: FIRE ENGINE,
GARBAGE TRUCK, DIGGER**

Art Director
Florian Meimberg
Copywriter
Torsten Pollmann,
Claudia Meimberg
Creative Director
Florian Meimberg,
Torsten Pollmann
Photo Editor
Peter Engel
Agency
Grey Worldwide GmbH
Client
Toys "R" Us
Country
Germany

What makes a toy desirable? It has
to look as real as possible. For the
TOYS "R" US Christmas promotion
"Real Toys," real fire engines,
garbage trucks and diggers with
oversized price tags drove through
urban areas in the time before
Christmas. That gave children the
impression of real toys driving
around. Hopefully the kids were not
disappointed when unwrapped the
smaller version at Christmas Eve.

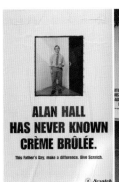
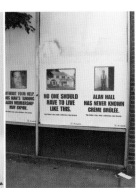
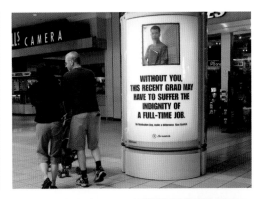
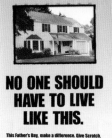
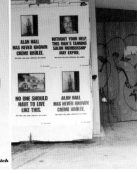
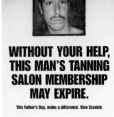
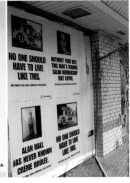

Merit
Posters & Billboards
Wild Postings, Campaign

**GIFT GIVING:
RECENT GRAD, LIVE LIKE
THIS, EVERY NIGHT,
CRÈME BRULEE, WITHOUT
YOUR HELP**

Art Director
Steven Grskovic, Tarsha Hall
Copywriter
Glenn Rockowitz, Greg Lane,
Steven Grskovic
Creative Director
Bob Moore, Rob Rich,
Gethin Stout
Producer
Pete Anderson
Agency
Publicis West
Client
Washington's Lottery
Country
United States

**3 COLORS OF GUINNESS
WILD POSTINGS:
GUINNESS,
SMITHWICKS, HARP**

Art Director
Aaron Adler
Copywriter
Ari Weiss
Creative Director
David Lubars, Eric Silver
Agency
BBDO New York
Client
Guinness
Country
United States

Our task for this campaign was to familiarize the public with the two other beers in the Guinness family: Smithwicks and Harp. The differentiating factor between these three beers immediately became apparent: the color. By creating wild postings with die cuts we were able to introduce these beers to the consumer using the color cues from the environments these ads were placed in.

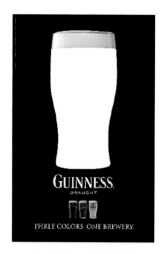
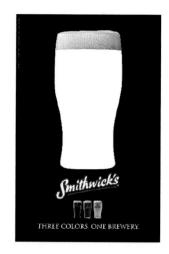

BLACK BELT

Art Director
Marianne Heggenhougen
Copywriter
Markus Ewertz
Creative Director
Kurt Georg Dieckert,
Stefan Schmidt
Designer
Christine Taylor, Melanie Lullies
Producer
Katrin Dettmann
Agency
TBWA\Germany
Client
Sony PlayStation2
Country
Germany

CICERO IS ALIVE

Art Director
Armin Jochum, Joerg Bauer
Copywriter
Andreas Rell
Creative Director
Armin Jochum, Andreas Rell,
Joerg Bauer
Producer
Wolfgang Schif
Production Company
Cicero Werkstudio
Agency
BBDO Campaign
GmbH Stuttgart
Client
Cicero Werkstudio
Country
Germany

The world has seen many famous
typographers come and go, whose
work is still admired today. The work
of Cicero Studio follows this great
calligraphic tradition, but Cicero is
different from all its predecessors in
one respect: Cicero is alive!

Merit
Posters & Billboards
Outdoor/Billboard, Single

GRAFITTI

Art Director
Molly Sheahan
Copywriter
Marty Senn
Creative Director
Ari Merkin
Designer
Cope 2
Producer
Louise Doherty
Agency
Fallon
Client
Time Inc.
Country
United States

With all of TIME's outdoor adver-
tising, the goal was to bring the
content outside of the pages of the
magazine and begin an unbiased
dialogue. This one certainly did that,
and the debate played out on news
programs, radio stations, and even
sparked a very public riff between
Cope 2 and an unhappy city coun-
cilman.

PHOTOGRAPHY

Multiple Winner**

Gold
Book, Single

Also for Graphic Design
Silver
Book Design, Limited Edition,
Private Press or Special
Format Book, Single
SEE PAGE 228

**TSUNAMI: A DOCUMENT
OF DEVASTATION**

Art Director
Giorgio Baravalle
Creative Director
Giorgio Baravalle
Designer
Giorgio Baravalle
Photographer
VII Photo Agency
Publisher
de.MO
Studio/Design Firm
de.MO
Client
de.MO
Country
United States

Tsunami: Document of Devastation
is a document bearing witness to
one of the worst and unprecedented
natural catastrophes of our time.
The disaster's enormity dictates the
large-scale format of this book,
which attempts to capture, in two-
dimensional form, the sweeping
magnitude of this event. Tsunami is
a document -a message in a bottle
to be kept as a unique record. With
proceeds going to Doctors of the
World, Tsunami is a non-profit initia-
tive not only to help the people
affected, but also to raise aware-
ness about the countless people
suffering every day in our world.
TSUNAMI brings to light the reality
of an event that has, and will,
change the face of many nations in
the Indian Ocean region.

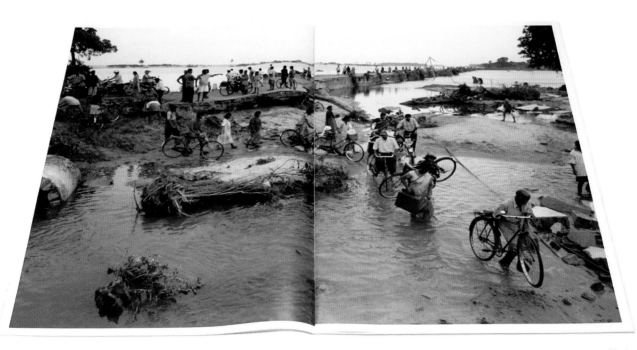

Silver
Magazine Editorial, Campaign

**SELMA BLAIR WITCH
PROJECT**
October 30, 2005,
pages 73–81, Photo Series

Art Director
Arem Duplessis
Creative Director
Janet Froelich
Designer
Jeff Glendenning
Photographer
Roger Ballen
Studio/Design Firm
The New York Times Magazine
Client
The New York Times Magazine
Country
United States

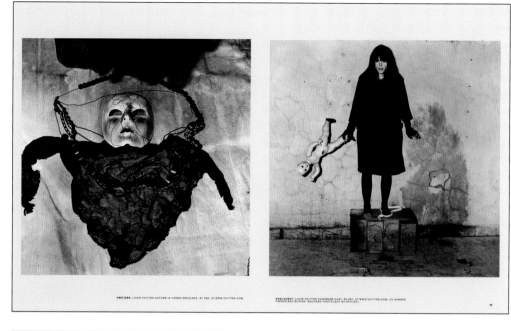

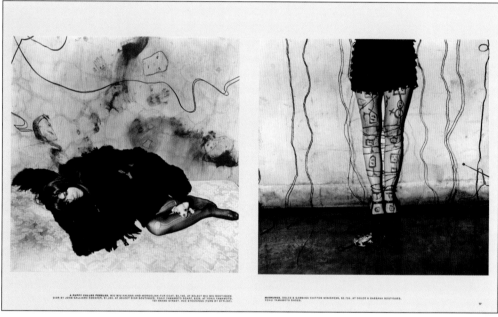

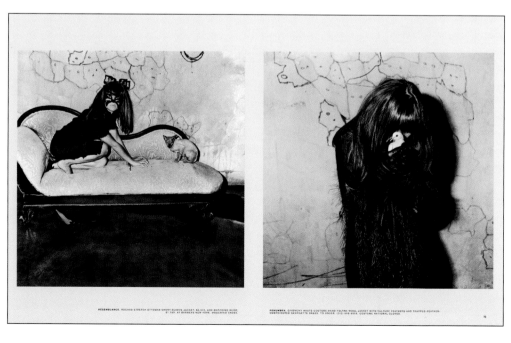

Silver
Magazine Editorial, Campaign

**GHOST TOWN:
GRIM AFTERMATH,
IN A DARK MIRROR,
WOUNDED, WANTED**

Art Director
Arthur Hochstein, D.W. Pine
Photo Editor
MaryAnne Golon
Director of Photography
Michele Stephenson
Photographer
Thomas Dworzak - Magnum
Publisher
TIME, Inc.
Studio/Design Firm
TIME Magazine
Client
TIME Magazine
Country
United States

A photo essay documenting the aftermath of a deserted city, New Orleans, which was destroyed by Hurricane Katrina.

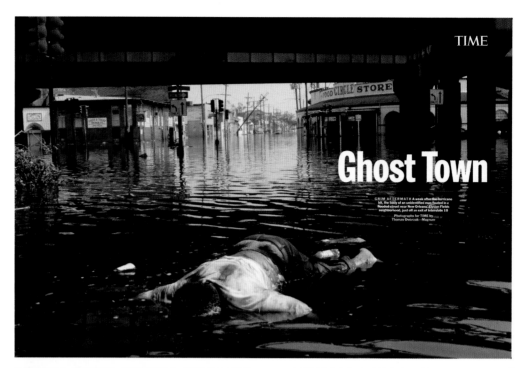

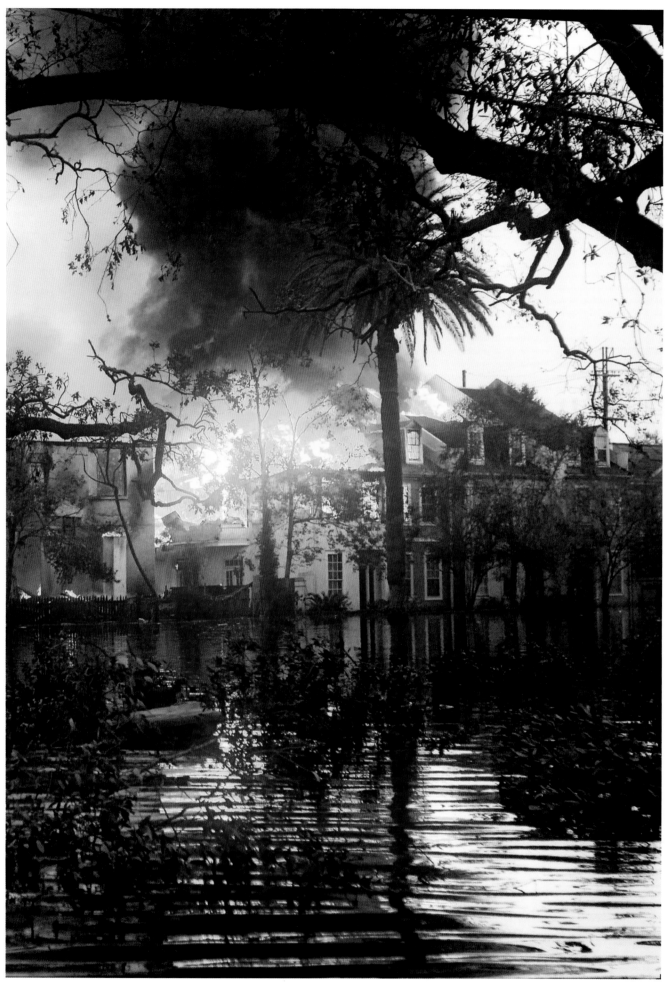

TOWLE SILVER

Art Director
Meredith Schwinder,
Keith Manning
Copywriter
Elizabeth Griffith
Creative Director
Alyssa Toro
Photographer
Joshua Dalsimer
Production Company
Viewfinder Productions
Studio/Design Firm
Dalsimer Photography
Client
Towle Silver
Country
United States

These ads were created for maga-
zine and trade publications. We were
trying to put a new, fun face on what
traditionally has been a rather uptight
industry. We had a lot of fun casting
these and pairing up the right people
to go with the right objects.

Silver that reflects you.

TOWLE
SILVERSMITHS

Silver that reflects you.

TOWLE
SILVERSMITHS

Distinctive Merit
Magazine Editorial, Campaign

A PILGRIM'S JOURNEY:
POPE JOHN PAUL II,
THE GLADIATOR,
REACHING OUT,
THE TRAVELER, IN PRAYER

Art Director
Arthur Hochstein, D.W. Pine
Photo Editor
MaryAnne Golon
Director of Photography
Michele Stephenson
Publisher TIME, Inc.
Photographer
Gianni Giansanti
(Corbis/Polaris),
Joel Stettenheim (Corbis),
James Hill (Contact)
Studio/Design Firm
TIME Magazine
Client
TIME Magazine
Country
United States

A photo essay remembering some
of the defining moments that made
Pope John Paul II.

A Pilgrim's Journey

POPE JOHN PAUL II
1920-2005

Photograph by
Gianni Giansanti—Corbis

Reaching Out
John Paul II, here greeting
a bishop in Uganda in 1993,
once said, "To have communion
with the people, that's the
most important thing."

Photograph by
Joel Stettenheim—Corbis

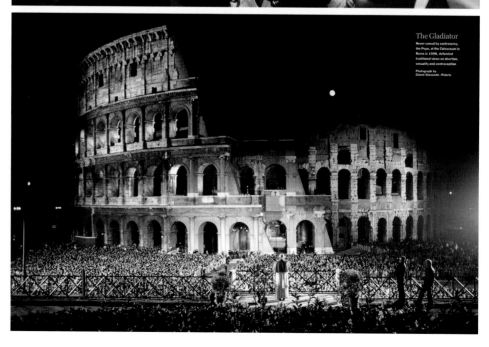

The Gladiator
Never cowed by controversy,
the Pope, at the Colosseum in
Rome in 1996, defended
traditional views on abortion,
sexuality and contraception

Photograph by
Gianni Giansanti—Polaris

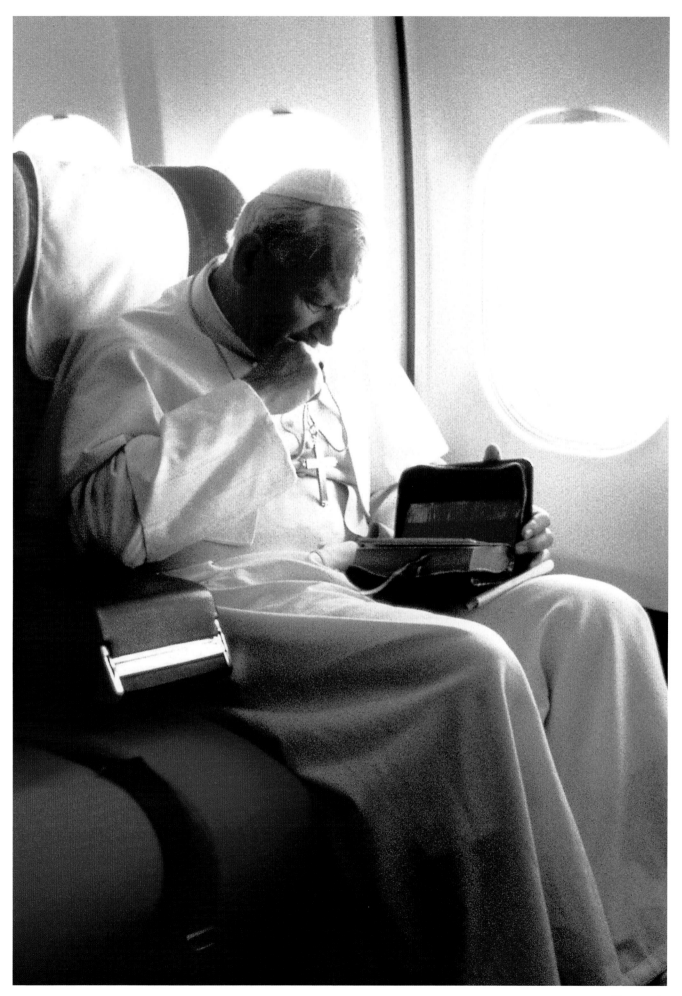

**AN AMERICAN TRAGEDY:
FIRST BIRTHDAY,
A DROWNED CITY,
A HERO'S PAIN,
LAW AND DISORDER,
AN ANGRY EXODUS**

Art Director
Arthur Hochstein,
Cynthia A. Hoffman, D.W. Pine
Photo Editor
MaryAnne Golon
Director of Photography
Michele Stephenson
Photographer
Matt Rourke (Austin
American-Statesman/WPN),
Smiley N. Pool (Dallas
Morning News),
Chris Usher,
Khampha Bouaphank
(Fort Worth Star-Telegram/
KRT/Abaca),
Michael Ainsworth
(Dallas Morning News)
Publisher
TIME, Inc.
Studio/Design Firm
TIME Magazine
Client
TIME Magazine
Country
United States

A photo essay documenting one of
the worst natural disasters to ever
hit the United States.

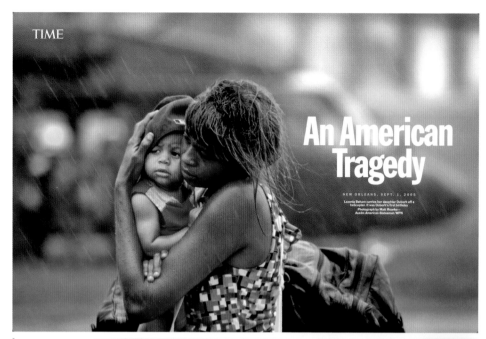

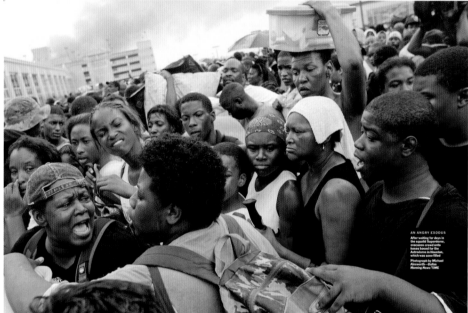

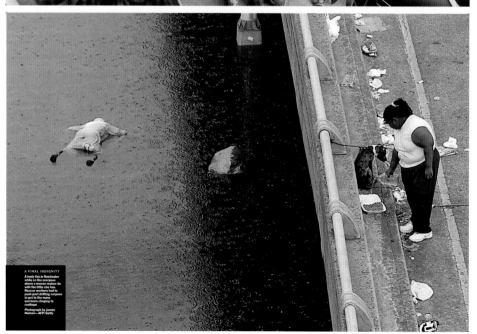

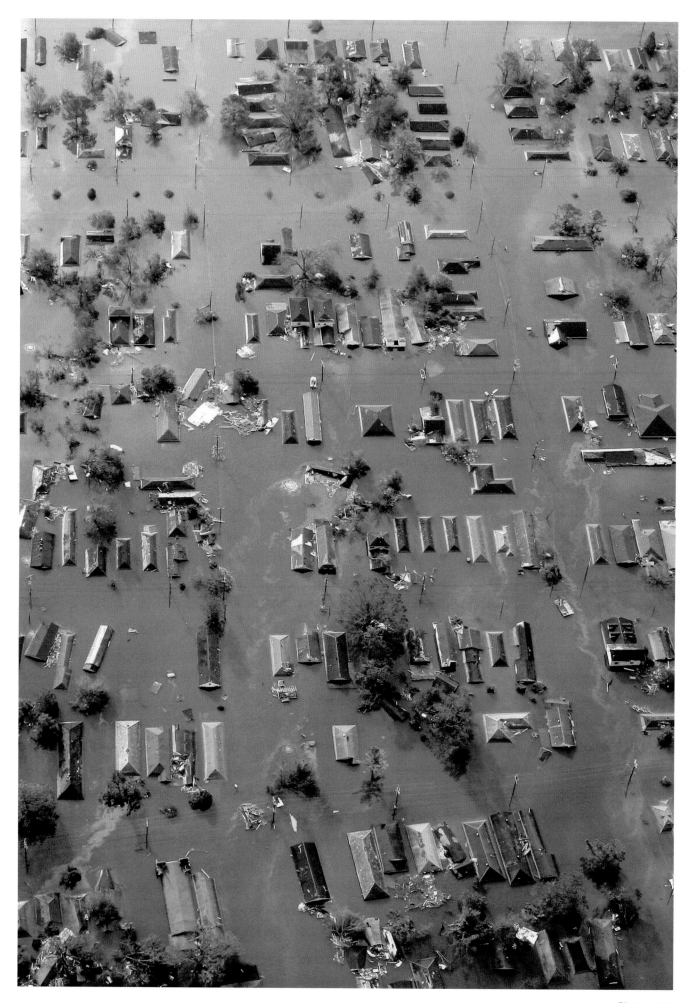

Distinctive Merit
Magazine Editorial, Campaign

SEA OF SORROW:
THAILAND, INDIA,
SRI LANKA

Art Director
Arthur Hochstein,
Cynthia A. Hoffman
Photo Editor
MaryAnne Golon,
Alice Gabriner
Director of Photography
Michele Stephenson
Photographer
Joanne Davis (AFP/Getty),
Gurinder Osan (AP),
John Stanmeyer (VII),
Andrew Wong (Getty)
Publisher
TIME, Inc.
Studio/Design Firm
TIME Magazine
Client
TIME Magazine
Country
United States

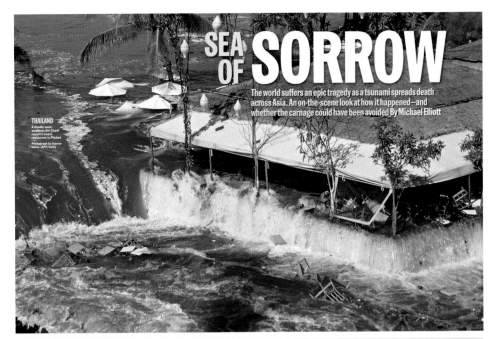

SEA OF SORROW

The world suffers an epic tragedy as a tsunami spreads death across Asia. An on-the-scene look at how it happened—and whether the carnage could have been avoided By Michael Elliott

THAILAND
A deadly wave swallows the Chedi resort's beach restaurant in Phuket
Photograph by Joanne Davis—AFP/Getty

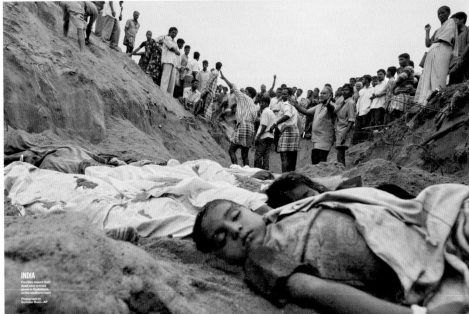

INDIA
Families mourn their dead near a mass grave in Cuddalore, on the southern coast
Photograph by Gurinder Osan—AP

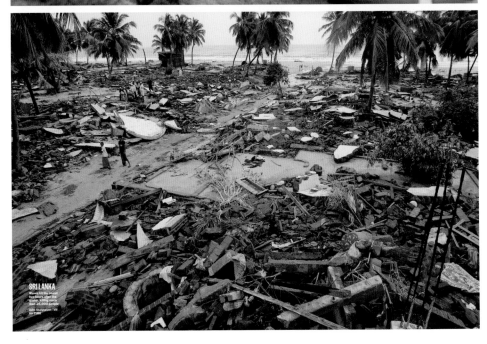

SRI LANKA
Waves hit the island two hours after the quake, killing more than 25,000 people
John Stanmeyer—VII for TIME

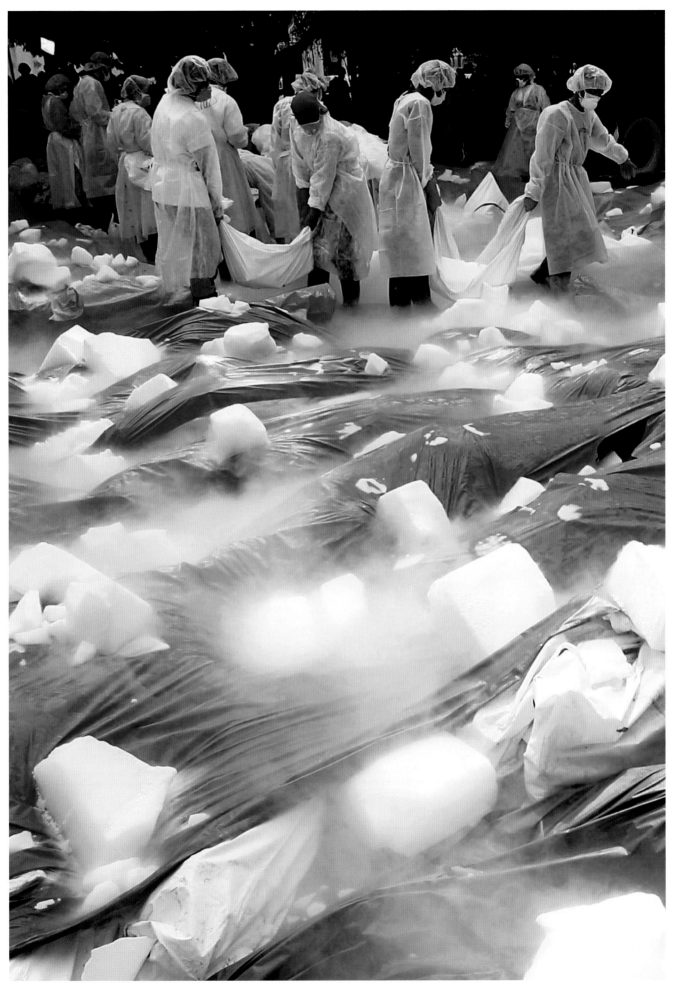

Distinctive Merit
Book, Single

DISFARMER

Art Director
Edwynn Houk, Michael Mattis
Designer
Edwynn Houk, Michael Mattis
Photo Editor
Edwynn Houk, Michael Mattis
Photographer
Mike Disfarmer
Publisher
powerHouse Books
Creative Director
Edwynn Houk, Michael Mattis
Studio/Design Firm
powerHouse Books
Client
Edwynn Houk Gallery
Country
United States

Distinctive Merit
Miscellaneous, Campaign

TOKYO II

Art Director
Todd Cornelius, BBDO
Photographer
Michael Graf
Producer
Dolores Salken
Studio/Design Firm
graf studios
Client
Hasselblad
Country
Canada

This is an exploration of the underground culture of Japanese love hotels. Shot over two weeks in Osaka and Tokyo, with a cast of over twenty people, we glimpsed into the stories of people who frequent these establishments.

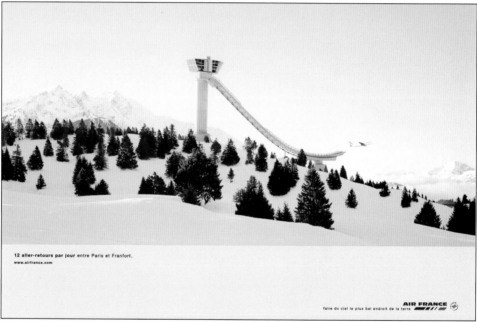

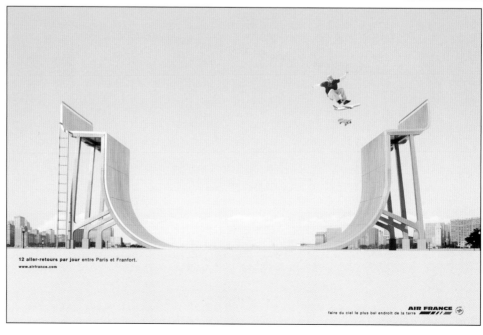

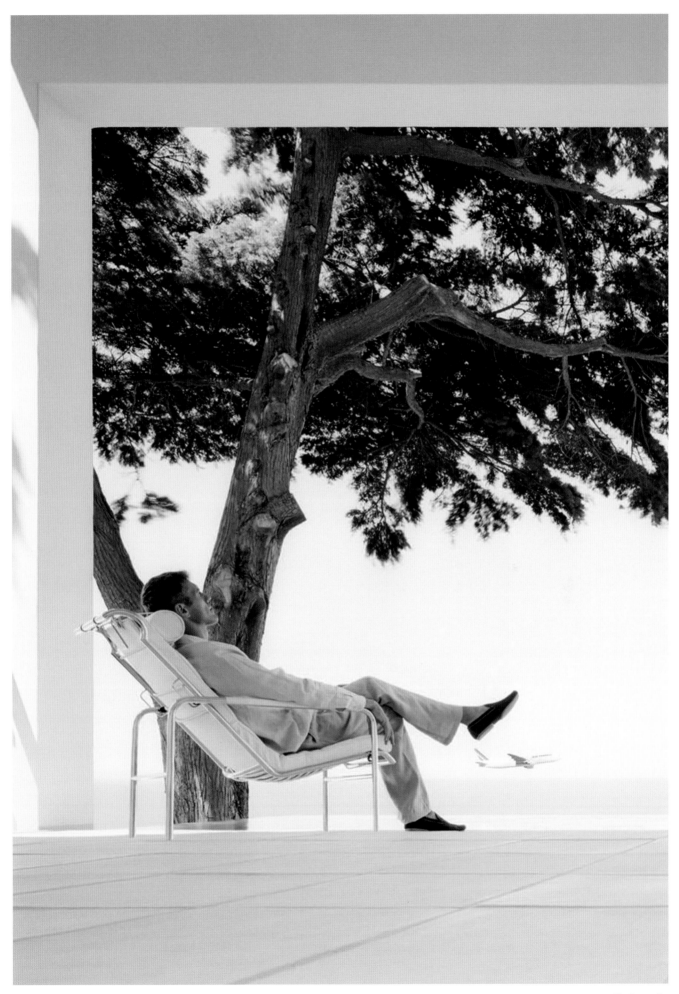

Merit
Magazine Advertisement,
Campaign

**WI-FI: BIRDS, TOW TRUCK,
WASHING LINE, FENCE**

Art Director
Roger Leebody
Copywriter
Gillian Glendinning
Creative Director
Dan Mawdesley
Photographer
Olaf Veltman
Photo Editor
Stephan Lesger, Magic
Studio/Design Firm
ADK Europe BV
Client
Nikon
Country
Netherlands

Nikon introduced two digital
cameras last year with wire-
less technology. This facilitated the
transfer of images between camera,
printer and PC without cables or
chords. It was important that this
technological leap forward was
marked with a suitably epic feeling
announcement campaign that
supported the brand as much as the
products featured. The filmic, "big
production" style of photography
was also essential to create the right
visual tone and give it a slight David
Lynch feel. There were few photog-
raphers we felt could achieve this
and it was as though the campaign
had almost been created for Olaf
Veltman's beautifully crafted, eerily
timeless images. We shot the
campaign on a variety of locations in
Texas, California and New Mexico.
And the resulting landscapes and
sky plates were meticulously
melded together by Stephan Lesger
at Magic in Amsterdam.

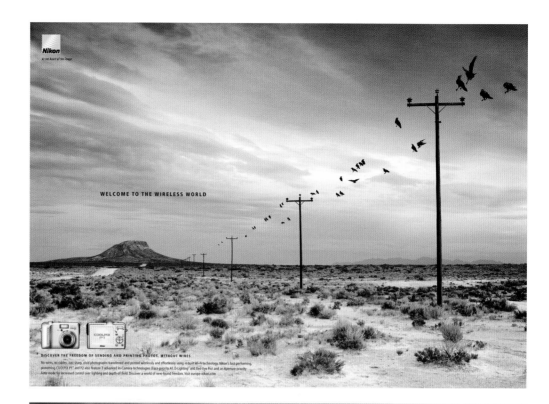

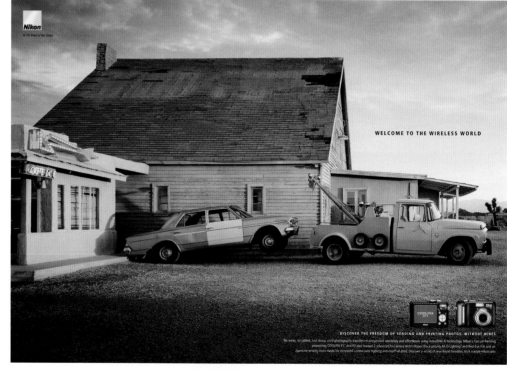

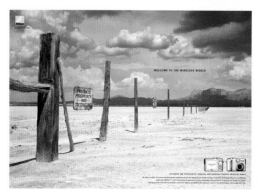

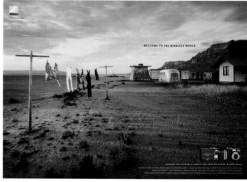

Merit
Corporate/Institutional, Single

**THE MEISSEN PORCELAIN
FOR ADULTS ONLY
BROCHURE**

Art Director
Anje Jager
Copywriter
Stephan Deisenhofer
Creative Director
Martin Pross,
Raphael Puettmann,
Mario Gamper
Photo Editor
Andreas Freitag
(BerlinPostproduction),
appel Grafik Berlin
Photographer
Attila Hartwig c/o Nerger Mao
Producer
Anikó Krueger
Studio/Design Firm
Scholz & Friends Berlin GmbH
Client
Staatliche Porzellan-
Manufaktur Meissen GmbH
Country
Germany

To support the sales of Meissen
Porcelain figurines and fight their
image as dust catchers, we devel-
oped the brochure "Meissen Porce-
lain for adults only." It shows the
200 years old figurines in a surpris-
ingly modern way, making them as
attractive and sexy as pin-up girls in
a magazine "for adults only." A
quick and easy response card was
enclosed for all those who wanted
to get to know one of the beautiful
ladies a little better.

Merit
Magazine Advertisement,
Campaign

**THIS MORNING:
EGG, BUNS, BAUBLES,
SECATEURS**

Art Director
Tiger Savage
Copywriter
Paul Pickersgill
Creative Director
Graham Fink
Typographer
Rob Wilson
Photographer
Donna Trope
Studio/Design Firm
M&C Saatchi
Client
ITV
Country
United Kingdom

What struck us about this brief was
the uniqueness of the program.
There are very few shows that,
within a matter of minutes, move
from a light hearted discussion on
weeding to an operating theatre in
which a live vasectomy is being
carried out. It was this range of
serious to not so serious topics that
inspired the creative idea. By
creating a visual that can be inter-
preted at either end of the spectrum
the onus is on the viewer to take out
what they will. It is the detail and
elegance of the photography that
dramatizes this creative so success-
fully and makes it so very engaging.

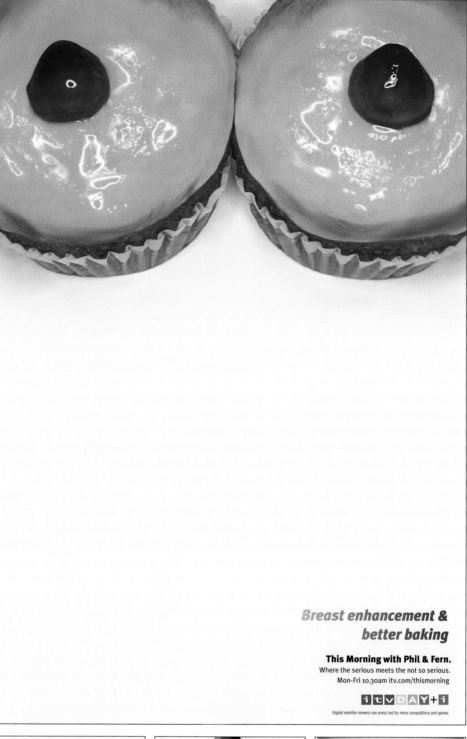

*Breast enhancement &
better baking*

This Morning with Phil & Fern.
Where the serious meets the not so serious.
Mon-Fri 10.30am itv.com/thismorning

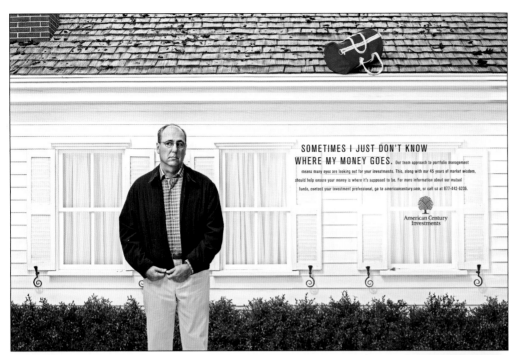

SOMETIMES I JUST DON'T KNOW WHERE MY MONEY GOES. Our team approach to portfolio management means many eyes are looking out for your investments. This, along with our 45 years of market wisdom, should help ensure your money is where it's supposed to be. For more information about our mutual funds, contact your investment professional, go to americancentury.com, or call us at 877-442-6236.

American Century Investments

Merit
Magazine Advertisement,
Campaign

**ACI CAMPAIGN:
POOL, ROOF, BAG, COUCH**

Art Director
Meg Sewell, Matt Sorrell
Copywriter
Jenny McGuinness,
Paul Bartow
Creative Director
Matt Elhardt, Joel Rodgriguez
Art Producer
Amy Zimmerman
Photographer
Zachary Scott
Producer
Berns Rothchild
Studio/Design Firm
TBWA\Chiat\Day New York
Client
American Century Investments
Country
United States

The goal with this campaign was to show that ACI understands investors' unique emotional relationships with their money. In the real world, no two people's investments are alike. So we used different tote bags to distinguish each investor's stash and give them unique personalities. This also helped us get around using cliché iconography like charts, graphs, or green dollar bills.

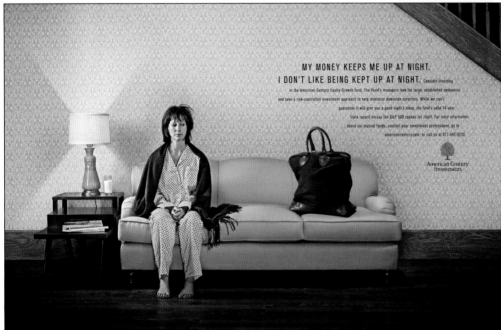

MY MONEY KEEPS ME UP AT NIGHT. I DON'T LIKE BEING KEPT UP AT NIGHT. Consider investing in the American Century Equity Growth fund. The Fund's managers look for large, established companies and take a risk-controlled investment approach to help minimize downside surprises. While we can't guarantee it will give you a good night's sleep, the fund's solid 14-year track record versus the S&P 500 speaks for itself. For more information about our mutual funds, contact your investment professional, go to americancentury.com, or call us at 877-442-6236.

American Century Investments

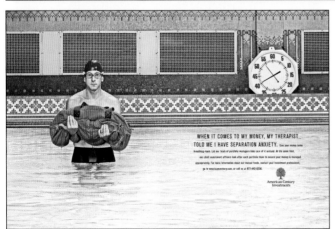

WHEN IT COMES TO MY MONEY, MY THERAPIST TOLD ME I HAVE SEPARATION ANXIETY. Love your money junior Breathing room. Let our team of portfolio managers take care of it instead. At the same time, our client investment officers look after each portfolio team to ensure your money is managed appropriately. For more information about our mutual funds, contact your investment professional, go to americancentury.com, or call us at 877-442-6236.

American Century Investments

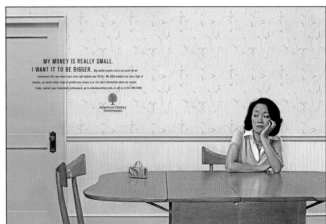

MY MONEY IS REALLY SMALL. I WANT IT TO BE BIGGER. Big mighty supply starts out small. So we recommend that you invest more often and behind your 401(k). We offer products for every type of investor, no matter what type of growth your money is in. For more information about our mutual funds, contact your investment professional, go to americancentury.com, or call us at 877-442-6236.

American Century Investments

Photography
193

Merit
Calendar or Appointment
Book, Campaign

**SHARE MOMENTS:
GLACIER, ROCKS,
MEADOW, SPIT OF
LAND, DESERT 1**

Designer
Norbert Waning
Photographer
Christian Schmidt
Publisher
Kodak GmbH Stuttgart,
Germany, Claudia Leiendecker
Production Company
Recom Christian Schemer,
Recom Thomas Saalfrank,
Recom Thomas Fritz,
Recom Grit Hackenberg
Studio/Design Firm
Christian Schmidt Photodesign
Client
Kodak GmbH, Stuttgart
Germany
Country
Germany

The journey made by a small
balloon, drifting around the world,
crossing boarders, timeless and
weightless, peaceful, traveling all
continents.

Merit
Book, Single

**FLOR GARDUÑO
SILENT NATURES**

Art Director
Theredbox
Communication Design
Designer
Paolo Jannuzzi,
Alberto Bianda, Sidi Vanetti
Photographer
Flor Garduño
Publisher
Gabriele Capelli Editore
Director
Paolo Jannuzzi, Alberto Bianda
Studio/Design Firm
Gabriele Capelli Editore
Client
Comune di Chiasso
Country
Switzerland

The types become an image that
contains forms that breaks to evoke
the surrealistic visions of the photo-
graphic work.

HEKMAG CUT & POSE

Art Director
Christian Feldhusen
Creative Director
Andrè Aimaq
Editor in Chief
Andrè Aimaq
Editor
Christopher Knipping,
Ulrike Miebach
Photographer
Michael Baumgarten
Production Company
Aimaq·Rapp·Stolle
Werbeagentur GmbH
Publisher
Hekmag Verlag
Studio/Design Firm
Aimaq·Rapp·Stolle Werbr
GmbH
Client
Andrè Aimaq
Country
Germany

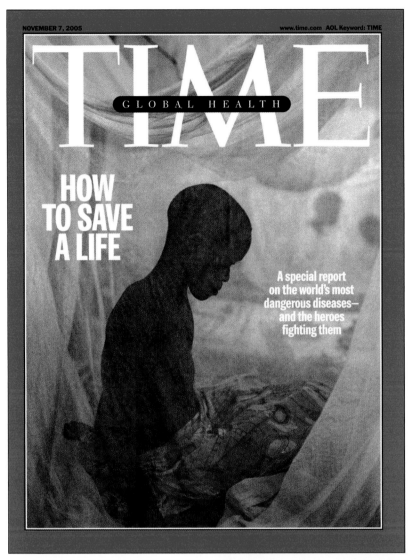

Merit
Magazine Editorial, Campaign

GLOBAL HEALTH 2005:
A TOUCH OF EMPATHY,
A TINY BREAK IN A
HARD WAR, DEATH
BY MOSQUITO, A YOUNG
SON GRIEVES, REST
AND RECOVERY

Art Director
Arthur Hochstein,
Janet Michaud
Photo Editor
MaryAnne Golon
Director of Photography
Michele Stephenson
Photographer
James Nachtwey (VII)
Publisher
TIME, Inc.
Studio/Design Firm
TIME Magazine
Client
TIME Magazine
Country
United States

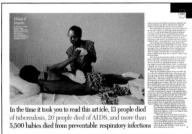

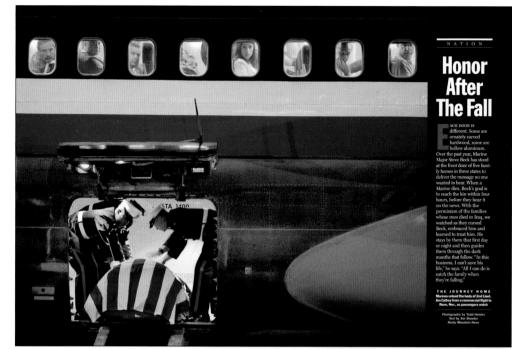

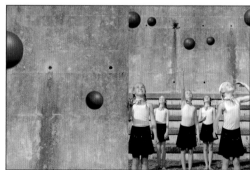

Merit
Magazine Editorial, Campaign

RAGE ATTACK

Art Director
Mike Meirè, Florian Lambl
Creative Director
Mike Meirè
Designer
Esther Gebauer
Editor
Catrin Hansmerten
Photo Editor
Ann-Katrin Weiner
Photographer
Achim Lippoth
Publisher
Kid's Wear Magazine,
Achim Lippoth
Studio/Design Firm
Achim Lippoth Photographer
Client
Kid's Wear Magazine
Country
Germany

Merit
Magazine Editorial, Campaign

THE LIGHT STUFF
Design Spring 2005, April 3,
2005, pages 126–131

Art Director
David Sebbah
Creative Director
Janet Froelich
Photographer
Raymond Meier
Designer
Janet Froelich
Editor
Stephano Tonchi, Pilar Viladas
Studio/Design Firm
T: The New York Times
Style Magazine
Client
T: The New York Times
Style Magazine
Country
United States

Merit
Magazine Editorial, Campaign

GREAT PERFORMERS
February 27, 2005,
pages 54–59, 62–63, 68–69,
Photo Series

Art Director
Arem Duplessis
Creative Director
Janet Froelich
Designer
Guillermo Nagore
Photo Editor
Kathy Ryan, Kira Pollack
Photographer
Inez van Lamsweerde,
Vinoodh Matadin
Studio/Design Firm
The New York Times Magazine
Client
The New York Times Magazine
Country
United States

Merit
Magazine Editorial, Single

YOUNG SCIENTISTS

Art Director
Mike Meirè, Florian Lambl
Creative Director
Mike Meirè
Designer
Esther Gebauer
Editor
Catrin Hansmerten
Photo Editor
Ann-Katrin Weiner
Photographer
Achim Lippoth
Publisher
Kid's Wear Magazine,
Achim Lippoth
Studio/Design Firm
Achim Lippoth Photographer
Client
Kid's Wear Magazine
Country
Germany

A new cigarette filter may make smoking a lot less harmful. But is that a good thing? *Incendiary Device*

By Jon Gertner

Photomontages by Tom Schierlitz

Merit
Magazine Editorial, Single

A NEW CIGARETTE FILTER

Art Director
Arem Duplessis
Creative Director
Janet Froelich
Designer
Guillermo Nagore
Photo Editor
Kathy Ryan
Photographer
Tom Schierlitz
Studio/Design Firm
The New York Times Magazine
Client
The New York Times Magazine
Country
United States

DESIGN SPRING 2005

Merit
Cover, Newspaper/Magazine,
Single

DESIGN SPRING 2005

Art Director
David Sebbah
Creative Director
Janet Froelich
Photographer
Raymond Meier
Editor
Stephano Tonchi, Pilar Viladas
Studio/Design Firm
T: The New York Times
Style Magazine
Client
T: The New York Times
Style Magazine
Country
United States

**THE DESTRUCTION OF
LOWER MANHATTAN**

Art Director
Danny Lyon
Copywriter
Danny Lyon
Photo Editor
Danny Lyon
Photographer
Danny Lyon
Publisher
powerHouse Books
Creative Director
Danny Lyon
Studio/Design Firm
powerHouse Books
Client
Danny Lyon
Country
United States

Merit
Book, Single

**THE FACE OF
FORGIVENESS,
SALVATION AND
REDEMPTION**

Editor
Daniel Power
Photographer
Steven Katsman
Publisher
powerHouse Books
Studio/Design Firm
Steven Katsman
Client
powerHouse Books
Country
United States

Merit
Miscellaneous, Campaign

ESCAPE: BUBBLE BOY, SIAMESE TWIN, WHEEL CHAIR

Art Director
Mark Puchala, Zig
Photographer
Michael Graf
Producer
Genvieve Martel
Studio/Design Firm
graf studios
Client
Nintendo
Country
Canada

This was shot over 2 days in an abandoned hospital in north Toronto. The emptiness of the hospital made for the perfect eeri-ness on set.

Merit
Poster or Billboard
Advertisement, Campaign

PEPSI LIGHT

Creative Director
Carsten Bolk, BBDO
Photographer
Peer Brecht
Art Director
Fabian Kirner, BBDO
Studio/Design Firm
Peer Brecht Photodesign
Client
Pepsi
Country
Germany

ILLUSTRATION

Gold
Magazine Editorial, Campaign

**THE FUNNY PAGES:
BUILDING STORIES,
10/2, 10/23, 11/27, 12/4,
12/11**

Art Director
Arem Duplessis
Creative Director
Janet Froelich
Designer
Arem Duplessis,
Nancy Harris Rouemy,
Guillermo Nagore
Illustrator
Chris Ware
Studio/Design Firm
The New York Times Magazine
Client
The New York Times Magazine
Country
United States

Illustration
206

Building Stories
PART 3 By Chris Ware

Illustration
207

Silver
Magazine Editorial, Single

SILENT NIGHT

Art Director
Françoise Mouly
Editor
David Remnick
Illustrator
Anita Kunz
Publisher
The New Yorker
Studio/Design Firm
Anita Kunz, Ltd.
Client
The New Yorker
Country
Canada

As an illustrator I am grateful to the New Yorker Magazine for continuing to publish thought-provoking and often controversial art. For this cover I wanted to convey how soldiers must feel after endless tours of duty, but I wanted to find a visual clue so as not to be didactic. The interesting thing is that although I made up this idea, I actually heard from soldiers who did exactly the same thing, that is to count off days with marks until the marks made interesting shapes.

Illustration
208

Distinctive Merit
Cover, Newspaper/Magazine,
Single

CUPID'S ARROWS

Art Editor
Françoise Mouly
Illustrator
Richard McGuire
Studio/Design Firm
The New Yorker Magazine
Client
The New Yorker
Country
United States

Illustration
209

Distinctive Merit
Cover, Newspaper/Magazine,
Single

BURSTING WITH PRIDE

Art Editor
Françoise Mouly
Illustrator
J.J. Sempè
Studio/Design Firm
The New Yorker Magazine
Client
The New Yorker
Country
United States

Illustration
210

Distinctive Merit
Magazine Editorial, Single

TILLEY BUG

Art Director
Françoise Mouly
Editor
David Remnick
Illustrator
Anita Kunz
Publisher
The New Yorker
Studio/Design Firm
Anita Kunz, Ltd.
Client
The New Yorker
Country
Canada

This was just a little idea that was a take off of the Eustace Tilley character. Understanding that the New Yorker prints a wide variety of art, I proposed this visual pun simply for humor's sake.

Illustration
211

HONKY TONK PARADE

Designer
Paul Davis
Illustrator
Paul Davis
Publisher
Overlook Press
Studio/Design Firm
Paul Davis Studio
Client
Overlook Press
Country
United States

Illustration
212

Illustration

213

**ANTHROPOMORPHIC ABC:
V IS FOR VIXEN, Q IS FOR
QUAIL, C IS FOR CAT**

Art Director
Ben Hogan
Creative Director
Lionel Gadoury, Andy Strote
Illustrator
Anita Kunz
Production Company
Context Creative
Publisher
Fiber Magazine
Studio/Design Firm
Anita Kunz, Ltd.
Client
Fiber Magazine
Country
Canada

I was very pleased the Fiber part-
ners chose my Anthropomorphic
ABC to use to showcase in their
oversized magazine Fiber. The
alphabet was a fanciful exploration
of hybrids based upon the idea that
animals (especially chimpanzees)
and humans share a significant
amount of similar genetic material.

Illustration
214

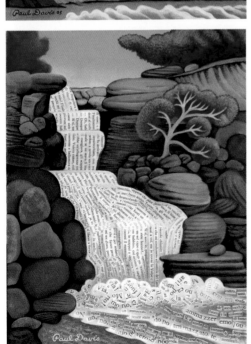

Distinctive Merit
Calendar or Appointment
Book, Single

2006 CALENDAR

Illustrator
Paul Davis
Publisher
Cartiere Marchi
Studio/Design Firm
Paul Davis Studio
Client
Cartiere Marchi
Country
United States

Illustration
215

**MIYABE MIYUKI
BONKURA/HIGURASI**

Art Director
Jiro Aoki
Copywriter
Takashi Saito
Creative Director
Takashi Saito
Designer
Ysuo Enokida
Studio/Design Firm
Adk
Client
Kodansha
Country
Japan

In portraying the crow with a simple illustration, my aim was to create a poster that immediately tugs on the heartstrings. Perhaps I also succeeded in expanding the world of fiction by giving Can-Crow lines that do not appear in the book.

**7 TRANSFORMATIONS
OF LEADERSHIP**

Art Director
Karen Player
Designer
Kaajal S. Asher
Illustrator
Brian Cronin
Publisher
Harvard Business School
Publishing
Editor
Tom Stewart
Studio/Design Firm
Harvard Business School
Publishing
Client
Harvard Business Review
Country
United States

The article discusses how leaders are constantly developing. With time and experience, they go through what are known as the 7 levels of leadership. The way they see and portray their actions changes with every level they conquer. These skills they have learned in their earlier levels can also be used and are interchangeable in the later levels as shown in the illustration.

Illustration

人間のことを
つい、好きに
なってしまった。

Merit
Poster or Billboard, Single

BAD DRIVER

Art Director
Ted Forbes
Designer
Ted Forbes
Illustrator
Brad Holland
Studio/Design Firm
Brad Holland
Client
Dallas Society of
Visual Communications
Country
United States

This picture began life as a spot illustration for Joe Kimberling at LA Magazine. Nobody paid much attention to it in that incarnation, but restored to adult size, it's had a second life. It's a picture about driving in Los Angeles, which we've all done even if we haven't been to LA. In my original sketch, the car was a stretch limo pulling through an intersection and you couldn't see the driver's face. But after Joe okayed the sketch, things began to change and this version pretty well drew itself. I called Joe to warn him that the thing was morphing. It was OK with him.

Illustration
217

**EXHIBITION OF KIDA
YASUHIKO, DAILY PRAYER:
FUDO OR ACALA, THE GOD
OF FIRE: YELLOW FUDO,
BLACK FUDO, RED FUDO,
BROWN FUDO**

Art Director
Yasuhiko Kida
Creative Director
Yasuhiko Kida
Designer
Yasuhiko Kida,
Kazuhiro Shinzato
Illustrator
Yasuhiko Kida
Producer
Yasuhiko Kida
Production Company
Epson Piezograph Laboratory,
Neo Works
Studio/Design Firm
Fuuraibo Corp.
Client
Furaibo
Country
Japan

Yasuhiko KIDA is renowned in
Japan for his woodcut prints and
paintings. This exhibition mainly
consists of paintings done in the last
several years. Fudo or Acala, the
God of Fire, is one of the most
frequent Buddhist motifs explored
by KIDA. The poster for this exhibi-
tion is a reproduction of four indi-
vidual Fudo oil paintings.

**THE OTHER
STEM-CELL DEBATE**

Art Director
Arem Duplessis
Creative Director
Janet Froelich
Designer
Kristina DiMatteo
Illustrator
Marco Ventura
Studio/Design Firm
The New York Times Magazine
Client
The New York Times Magazine
Country
United States

Illustration
218

Merit
Magazine Editorial, Single

NEW YORK SEX

Art Director
Kate Elazegui
Illustrator
Yuko Shimizu
Publisher
New York Magazine
Creative Director
Luke Hayman
Studio/Design Firm
Yuko Shimizu
Client
New York Magazine
Country
United States

New York Magazine called me to illustrate a double page spread for the opener of this article about new sex drug that is supposed to drive New Yorkers sex crazy. They wanted me to draw almost Bosch like surrealistic scene of people having sex everywhere. The challenge was, how to do that without losing class, and within the range of what you can show in a newsstand magazine.

Merit
Magazine Editorial, Single

SEVEN DEADLY DISASTERS

Art Director
Tom Staebler
Designer
Rob Wilson
Illustrator
Yuko Shimizu
Publisher
Playboy Enterprises
International, Inc.
Studio/Design Firm
Playboy Enterprises
International, Inc.
Client
Playboy Magazine
Country
United States

Illustration
219

Merit
Cover, Newspaper/Magazine,
Single

HOT SPOT

Art Editor
Françoise Mouly
Illustrator
J.J. Sempè
Studio/Design Firm
The New Yorker Magazine
Client
The New Yorker
Country
United States

Merit
Cover, Newspaper/Magazine,
Single

**A BUTTERFLY FLAPS
ITS WINGS**

Art Editor
Françoise Mouly
Illustrator
Chris Ware
Studio/Design Firm
The New Yorker Magazine
Client
The New Yorker
Country
United States

Illustration
220

Merit
Cover, Newspaper/Magazine, Single

DEBUT ON THE BEACH

Art Editor
Françoise Mouly
Illustrator
Ana Juan
Studio/Design Firm
The New Yorker Magazine
Client
The New Yorker
Country
United States

Merit
Cover, Newspaper/Magazine, Single

PLEASE HOLD

Art Editor
Françoise Mouly
Illustrator
Ian Falconer
Studio/Design Firm
The New Yorker Magazine
Client
The New Yorker
Country
United States

Illustration
221

Merit
Cover, Newspaper/Magazine,
Single

FOOD BOWLS

Art Editor
Françoise Mouly
Illustrator
Wayne Thiebaud
Studio/Design Firm
The New Yorker Magazine
Client
The New Yorker
Country
United States

Merit
Cover, Newspaper/Magazine,
Single

BLACK IS BACK

Art Editor
Françoise Mouly
Illustrator
Lorenzo Mattotti
Studio/Design Firm
The New Yorker Magazine
Client
The New Yorker
Country
United States

Illustration

data security

Weaknesses in internal storage processes and policies can expose your company's data to risk. By Dick Benton

hidden threats to data

ANY ORGANIZATIONS HAVE A GOOD HANDLE ON EXTERNAL RISK. They've implemented disaster recovery (DR), business continuance and security measures to protect their data and applications. On the internal security front, companies have instituted systems that limit physical and digital access to critical systems to reduce the likelihood of a disgruntled or unauthorized employee purposely or accidentally damaging/absconding with crucial data. But while focusing on these obvious perils, firms may overlook the seemingly mundane—but potentially more damaging—dangers that can arise due to lax administration and procedures.

Merit
Magazine Editorial, Single

HIDDEN THREATS TO DATA

Art Director
Mary Beth Cadwell
Illustrator
Yuko Shimizu
Publisher
Storage Magazine Tech Target
Studio/Design Firm
Yuko Shimizu
Client
STORAGE Magazine
Country
United States

For this article about how important data leaks from where you don't expect, and how to prevent that from happening, Storage Magazine did not want to see any 1) businessmen 2) computers or monitors, because they are tired of seeing them. It was probably one of the most conceptual illustrations I created last year.

Merit
Poster or Billboard, Single

GIRL

Creative Director
Paul Silburn, Susan Treacy
Designer
Aesthetic Apparatus
Illustrator
Aesthetic Apparatus
Studio/Design Firm
Fallon
Client
Nordstrom
Country
United States

Illustration
223

GRAPHIC DESIGN

JIANIANHUA CENTER

Designer
Michael Duncan, Lonny Israel,
Brad Thomas, Kye Archuleta,
Alan Sinclair, Patricia Yeh
Studio/Design Firm
SOM – Skidmore,
Owings & Merrill LLP
Client
Chongqing Financial
Street Real Estate, LTD
Country
United States

Jianianhua Center is a new mixed-
use retail and office complex in the
heart of Chongqing, a port city in
southwest China. To counteract the
grayness of the region and to
respond to the intense visual activity
of the city center, Jinianianhua
elevates the potential of environ-
mental graphics as a civic art form.
Using a standard triad signage
system, the building's entire eight-
story retail component becomes a
6055-square-meter slow-moving
choreographed graphic. Enclosing
this dynamic billboard behind the
glass skin diminishes its commer-
ciality and transforms the architec-
ture. The client commissioned the
first super-graphic to celebrate
Chinese New Year. The scheme—an
urban flower box—celebrates the
New Years acknowledgement of the
approach of spring and captures the
ultimate symbol of good fortune in
Chinese culture-100 simultaneously
blooming flowers. This concept is
visualized through a seemingly infi-
nite combination of abstract pattern
and color sequences through the
programmed rotation of the 148
individual panels.

Multiple Winner**

Silver
Book Design, Limited Edition,
Private Press or Special
Format Book, Single

Also for Photography
Gold
Book, Single
SEE PAGE 170

**TSUNAMI: A DOCUMENT
OF DEVASTATION**

Art Director
Giorgio Baravalle
Creative Director
Giorgio Baravalle
Designer
Giorgio Baravalle
Photographer
VII Photo Agency
Publisher
de.MO
Studio/Design Firm
de.MO
Client
de.MO
Country
United States

"Tsunami: Document of Devasta-
tion" is a document bearing witness
to one of the worst and unprece-
dented natural catastrophes of our
time. The disaster's enormity
dictates the large-scale format of
this book, which attempts to
capture, in two-dimensional form,
the sweeping magnitude of this
event. Tsunami is a document—a
message in a bottle to be kept as a
unique record. With proceeds going
to Doctors of the World, Tsunami is
a non-profit initiative not only to help
the people affected, but also to raise
awareness about the countless
people suffering every day in our
world. Tsunami brings to light the
reality of an event that has, and will,
change the face of many nations in
the Indian Ocean region.

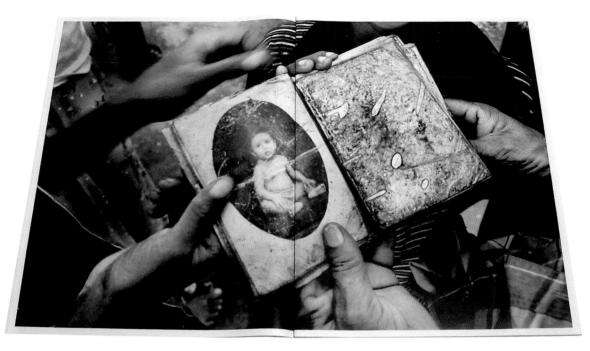

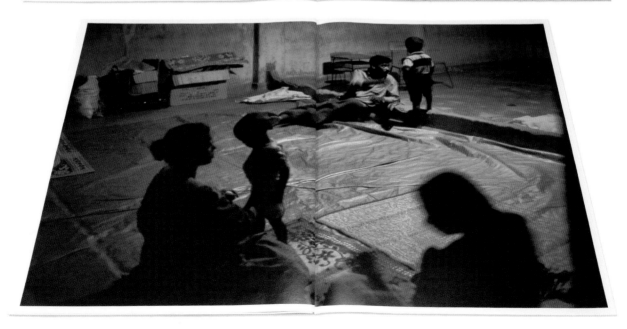

Multiple Winner**

Silver
Television & Cinema Design,
Art Direction, Campaign
Distinctive Merit
Television & Cinema Design,
Animation, Campaign

**VW FOX SHORT CUTS:
PULP FICTION, SHINING,
TITANIC**

Art Director
Jennifer Shiman,
Christian Brenner
Copywriter
Tim Jacobs, Sandra Illes
Creative Director
Jennifer Shiman, Amir Kassaei,
Eric Schoeffler
Director
Jennifer Shiman
Editor
Jennifer Shiman
Producer
James Strader
Production Company
Angry Alien Productions/
Los Angeles, VCC/Dusseldorf
Studio/Design Firm
DDB Germany
Client
Volkswagen AG
Country
Germany

The Fox is the smallest Volkswagen.
Its positioning is "Short but fun."
Our target group is young people
and beginners. Our objectives were
two: to find a communication that
matches this positioning perfectly.
And to get the target group excited
about the car. Our solution: We
recreated the famous Hollywood
blockbusters TITANIC, PULP
FICTION and THE SHINING—
animated, 30 seconds long and with
a cast of bunnies. Because these
clips are exactly like the Fox: short
and fun.

Short but fun.

The new Fox.

Silver
Television & Cinema Design,
Art Direction, Campaign

———————————————

**THE ACTION POETRY
SERIES: BUDAPEST,
FORGETFULNESS,
SOME DAYS**

Creative Director
Toby Barlow
Director
Julian Grey
Producer
Sue Riedl, Anthony Garetti
Production Company
Head Gear Animation
Studio/Design Firm
Head Gear Animation,
JWT New York
Client
Sundance Channel
Country
Canada

**FLESH & BLOOD:
BLACK, RED, FLESH**

Art Director
Wabisabi
Designer
Ryohey Wabi Kudow,
Kazushi Sabi Nakanishi
Production Company
Home, Inc.
Publisher
Wabisabi
Studio/Design Firm
Home, Inc.
Client
Home, Inc.
Country
Japan

Wabisabi is the design team of
Ryohey "Wabi" Kudow and Kazushi
"Sabi" Nakanishi. "Flesh and
Blood" was made by using our
original font, Hormon, which
creates a unique expression by
piling up the words. This is an
homage to "Fantastic Plastic
Machine," Japanese music group.

FANTASTIC PLASTIC MACHINE ©2005

Silver
Book Design, Special
Trade Book, Single

VITAMIN D

Art Director
Julia Hasting
Creative Director
Julia Hasting
Designer
Julia Hasting
Publisher
Phaidon Press, Inc.
Studio/Design Firm
Phaidon Press, Inc.
Client
Phaidon Press, Inc.
Country
United States

My approach was to find a design that did not overpower the delicate and subtle beauty of the drawings, but at the same time I tried to find a typographic solution that underlined their handmade character. The typewriter font Everson Mono suited this approach well since it has a spontaneous and unrefined look without appearing too mechanical. I tried to enhance this by adding hand-drawn elements to the font, such as hand-drawn circles and underlines to highlight names and headers. The cover illustration resulted from examining the chemical structure of actual Vitamin D and the idea to feature all 109 artists' names on the cover. The model structure was drawn by hand to look more organic. I chose a paper (Asian creamy wood-free/uncoated) that looked as if the artworks were drawn directly onto it. The deckle edge further emphasizes this idea of the book as portfolio.

Multiple Winner**

Distinctive Merit
Editorial Design, Magazine,
Consumer, Cover, Single
Merit
Editorial Design, Magazine,
Consumer, Full Issue, Single

THE LIVES THEY LIVED

Art Director
Arem Duplessis
Creative Director
Janet Froelich
Designer
Nancy Harris Rouemy
Photo Editor
Kathy Ryan
Illustrator
Deanne Cheuk
Studio/Design Firm
The New York Times Magazine
Client
The New York Times Magazine
Country
United States

Nixon's Real Enforcer
Before she went down in history as the hapless secretary, she was a power-ful force in the White House.
By Francis Wilkinson

Photograph by Richard Avedon

Frank Perdue b.1920

Chicken Hawker
When consumers bought his chickens, they were really buying him.
By Joseph Nocera

True Believer
Frank Perdue was convinced that his chickens really were better than anybody else's.

Our Cereal Hero
Forget Toucan Sam and Cap'n Crunch. Tony the Tiger was the star.
By Elizabeth McCracken

Thurl Ravenscroft b.1914

G-r-r-r-e-a-t!
Who knew? Thurl Ravenscroft's voice was everywhere, but it was as Tony the Tiger that he became that unforgettable echo in our minds.

34

PERDUE: PERDUE FARMS. TONY THE TIGER: KELLOGG COMPANY. 35

what I said, what I did, what I thought, really had an effect on the state of affairs of my world," he would later reflect.

Stockdale retired from the Navy in 1979 to become president of the Citadel, a civilian military college in South Carolina, but quit a year later when the board blocked his efforts to rein in the school's out-of-control culture of hazing. ("When you've been tortured by professionals, you do not have to put up with amateurs," he told a friend, explaining his abrupt decision to resign.)

Then came Stockdale's ill-fated foray into politics. His friend Ross Perot had assured him that he would be only a placeholder until he could find a suitable running mate for the 1992 presidential election — a couple of weeks, Perot told him. Stockdale had spent longer blindfolded, naked on the floor, with an untreated broken leg in his cell in Vietnam. He figured he could get through this fine.

He didn't. After delivering the unforgettable opening line in the vice presidential debate — "Who am I? Why am I here?" — Stockdale was reduced to a national laughingstock. Even then there was a whiff of tragedy, a sense that he deserved better, but he disappeared from the public stage before much more could be said about him. He was last seen by many Americans in the person of Phil Hartman on "Saturday Night Live."

The former fighter pilot found solace in the world of ideas. He was inevitably pulled back to Hoa Lo, and to a better understanding of the qualities that enable certain men to stand up and tom their world around — "the rising of the few," as he called it. For guidance, Stockdale turned to the writings of other ex-prisoners: Viktor Frankl, Aleksandr Solzhenitsyn, Fyodor Dostoyevsky. Stockdale gradually came to see heroism not as a matter of consistent good judgment but as a single act, or series of acts, performed in a particular context. And he came to see heroes not as people who had carried out their duty with distinction but as individuals who had, like himself, done something no reasonable person would ever have felt justified asking them to do. ∎

Eugene Record b. 1940 Luther Vandross b. 1951

Soul Men

Two singers who weren't afraid
to wear their voices on their sleeves.
By Rob Hoerburger

It was the season of Shaft, of macho guys who patrolled the movie screen and the airwaves in big cars and big shoes, of soul on steroids. While Shaft and Superfly's musical counterparts enforced a tough urban sound with the thwack of a guitar or the hiss of a high-hat, around the corner another man was settling onto a park bench, probably around dusk, drawing up his collar to ward off the chill. And slowly, quietly, the words fell from his lips like drowsy autumn leaves: "One month ago today, I was happy as a lark. . . ."

This was the voice of Eugene Record, lead singer and songwriter of the Chi-Lites, proponents of Chicago soul, which had less drive than Motown or Stax but was also more elegant. With its sophisticated instrumentation and harmonies, it was R&B dressed in its Sunday best. And the persona he created on this song, "Have You Seen Her?" was as far from Shaft as Andy Griffith. Record was one of pop music's all-time sad sacks, Job in an Afro and a tux. Other singers, like Smokey Robinson and Curtis Mayfield in his pre-"Superfly" days, sang with remorse and exposed wires, their pleas were often camouflaged come-ons. Even Roy Orbison, for all his rampant paranoia, got the girl about half the time. For Record, whose laments could suddenly turn into a desperate yowl, there was no hope. The woman was gone, having slipped away while he wasn't looking, because of some unknowable transgression or simply because she wasn't that into him anymore, and now she was never to be retrieved. A few months after "Have You Seen Her" reached the Top 10, the group released what would become its biggest hit, "Oh, Girl." The song was almost a prequel: the relationship wasn't even but Record was already mourning it, resigned to life after love, to loneliness without parole. It reached No. 1 on the pop and R&B charts a few weeks before the Watergate break-in and became an unwitting anthem for the beginning of uncertain times.

Record's purview extended beyond romance. "(For God's Sake) Give More Power to the People," one of the group's funkier numbers, begged not for revolution but for a reasoned redefinition of life in the ghetto, as did "I'm Ready (If I Don't Get to Go)," which starts as a song about a child dreaming of a better school but ends as a parable about surviving in a world of broken promises and dashed hopes. This was music of deep despair but also of swelling humanity. Though the Chi-Lites never had another hit after 1973, lost as they became in the reduction of soul to disco and then hip-hop, Record's cris-de-coeur would influence singers for decades.

One man who heard them was Luther Vandross. He was already a backup singer in heavy demand by the mid-70's, and what instantly set him apart was that he sang like a girl — or rather three very strong "girls": Dionne

Love Power
Never suited to play it Superbad, Vandross (above, 1986) and Record (opposite, second from right, 1971) drew strength from self-doubt, loneliness and, above all, romance. **Online:** Video testimony from fellow R&B singers on Luther Vandross's music and life is at nytimes.com/magazine.

Warwick, Aretha Franklin and Diana Ross, the idols of his New York youth. It took him almost another decade and several tweakings of his musical image, though, before his breakthrough, "Never Too Much," as accomplished a record as was released in 1981. It had Warwick's lithe musicianship, Franklin's gospel surge and Ross's sexy pout all rolled into one. But a crucial element had been added: practically every line had a slight quiver to it, a trill or melisma that lasted half a beat too long. It was as if this man who could sing circles around anyone on the charts — that's how he described himself to me once — suddenly wasn't so sure of himself. In an era when music was becoming more and more mechanized and digitized (Vandross was duking it out on the charts with the likes of Duran Duran), the spasms of self-doubt within his muscular voice appealed to listeners who still liked their pop on the warmblooded side. Even Vandross's epic battle with his weight, waged from album cover to album cover, endeared him to millions alienated by the rail-thinness of MTV, which hit the streets the same month as "Never Too Much."

By the time "Dance With My Father" was released in 2003, two months after the stroke that ended his career and, ultimately, his life, Vandross's voice was as full and generous as ever, but always with that look over the shoulder, that moment of wondering why. He had become the reigning if occasionally reluctant king of soul, and voices like his and Record's could be heard not just in modern R&B crooners like John Legend but also in other emotional vein openers who followed, both heavy (Kurt Cobain and Dave Grohl) and light (John Mayer). These men seemed to understand the difference between courage and bravado. Sure, they were sensitive, vulnerable guys. But in making pop music a safer place for men to question themselves, they were also manly as hell. Shaft, retired now and working the occasional security gig, probably has them on his iPod between Usher and 50 Cent. ∎

40 VANDROSS. PHOTOGRAPH BY SCOTT WIENER/RETNA 41

Every weekday at 10 a.m. for more than 30 years, the comedian Gene Baylos left his West 56th Street apartment for his daily walk to the Friars Club. Sonny, his building's doorman, was the first to see the day's comic routine. The walk took a good two hours, because Baylos made stops along the way. Sometimes he would visit Raphael Serrur at his jewelry store on 57th and entertain the customers. Other times, he'd go chat with Kim at Simon Lock and Key, or go to a men's clothing store where he would joke with the clerk. On the way home, at 2:30, he would deliver a sandwich to a homeless man he knew, and each winter Baylos made sure the man had a coat. One day, a friend accompanied Baylos and offered to bring the homeless man some hand-me-downs. "Get your own bum," Baylos said.

Comedians graduate loosely in classes, and many of those in Baylos's fraternity — Red Buttons, Henny Youngman, Shecky Greene — got their legs in the Catskills and made their livings in the big-city clubs following World War II. Whether he was circulating among the tables in the 1930's at the Theatrical Pharmacy (a hangout for Variety performers), antically shoving butter packets and rolls into his pockets for laughs (he also was notoriously cheap) or doing zany physical gags backstage at the Riviera as he waited to open for Dinah Shore, Gene Baylos cracked up the comics. But while his peers went on to national fame in the golden age of television, Baylos's career stalled.

"People who didn't have half his ability went on and on," says the comedian Norm Crosby. "All the comics thought he was brilliant, creative and innovative." Over the years, Baylos's friend the comedian Jan Murray gave him advice he didn't heed: "You're making me, Jerry Lewis, Milton Berle laugh. For heaven's sake, why don't you do these things onstage?"

Murray says he thinks Baylos didn't because he was "scared to die" (to bomb, in contemporary parlance). The most talented comedians struggle with the irresolvable dilemma of getting laughs and pushing the audience to hear their real comedy, their true voice. Fame can expand the parameters of what a crowd will tolerate, but for a comic who wants steady work, it's a balancing act. Despite Baylos's skilled physical performance and the novel way he could work a show-biz crowd, he tended to rely on straight-up jokes for civilian audiences. One, for which Baylos is best known, involved rushing onstage as if he were late. "I've just returned from the dentist," he would explain breathlessly.

As he praised the dentist's work, white Chicklets spewed forth from his mouth. "Jokes are much safer than being unique," Murray told me.

As in music, in comedy originators don't necessarily get their rightful credit. Sometimes it can be hard to distinguish between inspiration and imitation, but those who benefit the most often have the luck of timing or the savvy to make the too-now palatable.

Baylos said he felt he had been robbed. It was the late 40's, the high season of his career. He had finished a long, successful stint, which Walter Winchell had plugged, at the popular Mother Kelly's in Miami; he had married a beauty, Cyrile Seiden; he was working another Florida gig at the Five O'Clock Club. One night, he wandered over to the Beachcomber to congratulate Dean Martin, an old friend. Martin and Lewis were headlining. After watching the show, Baylos left irate.

Many years later, in an interview with the writer Nick Tosches, who was researching a biography of Martin, Baylos said that Lewis had lifted his physical moves. "He stole my body," Baylos told Tosches. "I asked Dean to tell him to stop, and he didn't. I didn't talk to Dean for five years."

Meanwhile, things declined for Baylos when the club scene died and comedy migrated to TV. There were a few commercials, appearances on "The Dean Martin Show," "Car 54, Where Are You?" a role in "The Love Machine" as Shecky Greene's sidekick, and one in "The Family Jewels" with Jerry Lewis, perhaps offered as a truce.

But a comedian's routine is a kind of fitness, and the hard-core take work where they find it. They need an audience to stay alive. Toward the end of his life, as his peers got cameos and worked cruises, Baylos circulated among the tables in the dining room of his second home, the Friars Club. Frank Capitelli, the headwaiter, would lead him to his corner seat, Table 24, below LeRoy Neiman's painting of him. Joey Adams, who was the best man at his wedding, would sit at his own table to Baylos's left. Baylos might or might not eat his scrambled eggs and bacon, but he always, always worked the room. His table shtick from the old days — before anyone was famous — had been adjusted to amuse his aging celebrity friends. As he bragged about being overwhelmed by a wash of coming bookings — Leno, Caesars Palace — he would pocket a baked potato or a chicken breast. Or he would open the saltshaker, upend it on his head, hold his nose and say, "It was so cold in Alaska." ∎

Gene Baylos b. 1906

Mr. Shtick

He performed better offstage than on.
By Adrian Nicole LeBlanc

Hanging Himself Gene Baylos saved his best comedy routines for friends and colleagues.

52 PHOTOGRAPH FROM THE COLLECTION OF CYRILE BAYLOS

Graphic Design

239

Distinctive Merit
Editorial Design,
Magazine, Consumer,
Spread, Multipage, Single

THE LITERARY DARWINISTS

Art Director
Arem Duplessis
Creative Director
Janet Froelich
Designer
Jeff Glendenning
Illustrator
Alan Dye
Studio/Design Firm
The New York Times Magazine
Client
The New York Times Magazine
Country
United States

The Literary Darwinists

Can evolutionary principles shed new
light on the literary canon? And why, as a species,
do we read anyway? **By D.T. Max**

Illustrations by Alan Dye

74

Jane Austen first published "Pride and Prejudice" in 1813. She had misgivings about the book, complaining in a letter to her sister that it was "rather too light, and bright, and sparkling." But these qualities may be what make it the most popular of her novels. It tells the story of Elizabeth Bennet, a young woman from a shabby genteel family, who meets Mr. Darcy, an aristocrat. At first, the two dislike each other. Mr. Darcy is arrogant; Elizabeth, clever and cutting. But through a series of encounters that show one to the other in a more appealing light — as well as Mr. Darcy's intervention when an officer named Wickham runs away with Elizabeth's younger sister Lydia (Darcy bribes the cad to marry Lyd-

Distinctive Merit
Editorial Design,
Magazine, Consumer,
Full Issue, Single

INFLUENCE MAGAZINE

Art Director
Garland Lyn, Art Director
Executive Design Director
Michael Ian Kaye
Designer
Soohyen Park, John Moeller,
Nobi Kashiwagi
Editor
Jan-Willem Dikkers,
Kristin M. Jones
Publisher/Editorial Director
Raul Martinez
Executive Editor/
Director of Photography
Gil Blank
Photo Editor
Avena Gallagher,
Editor of Inspiration Images
Producer
Libra Balian, Producer
Production Company
AR
Studio/Design Firm
AR
Client
Influence magazine
Country
United States

Influence was a labor of love. It was
a project generated with the sole
purpose of exploring where art inter-
sects with popular culture. It was
created to inspire creatives and
stimulate a discourse around
aesthetics.

"What are we to do when we wish to describe a wave? We usually end up by producing a stagnant pool. When we try to describe the light we can describe it accurately only by putting it out. Therefore do not let us attempt to describe it. But you cannot not attempt to describe it, because that means to stop expressing, and to stop expressing is to stop living. For these romantics, to live is to do something, to do is to express your nature. To express your nature is to express your relation to the universe. Your relation to the universe is inexpressible, but you must nevertheless express it. This is the agony, this is the problem. This is the yearning, this is the reason why we must go to distant countries, this is why we seek for exotic examples, this is why we travel in the East and write novels about the past, this is why we indulge in all manner of fantasies. This is the typical romantic nostalgia." —Isaiah Berlin

ARE OUR PICTURES OF EACH OTHER FOREVER BOUND UP IN LONGING?

TEN YEARS AGO, EVE FOWLER MADE A SERIES OF PICTURES SIMILAR IN FORMAT TO WHAT YOU MIGHT EXPECT FROM ANY GRADE SCHOOL PHOTOGRAPHER OR COMMERCIAL. PORTRAIT studio. There was the standard mottled canvas background and the plain, bright studio lighting; she even had the photos printed in frame-ready five by sevens and wallet sized multiples. Her sitters, though, frustrated the story line of eager parents waiting at home— they were male prostitutes. For a recent series, she's begun to photograph sitters whose most distinctive characteristic is, paradoxically, the ambiguity of their appearance. Neither documentary essay nor personality caricature, Fowler's work addresses subjects fraught with connotation, but only as stand-ins for more indirect questions. When I discussed individual images with her, names were rarely ever mentioned. In time, I completely lost track of which story was attached to which portrait, a drift towards obscurity that seems not unrelated to Fowler's project, itself an amalgam of the preferences we maintain of our personal histories.

GIL BLANK Tell me a bit about what led to your consistent engagement with portraiture. Were you at all interested in using it as a way of understanding certain people, or was it much more a consciously controlled act of surveillance, a premeditated artistic and conceptual process, where the subjects, or their sense of identity, were somewhat secondary to your own motivations and questions?
EVE FOWLER When I started photographing hustlers in 1993, I was taking photographs on the street. I wouldn't say that work was conceptual. But after two years I had the idea that I was attracted to the hustlers because of some things

we had in common. The experience was like a return to some feelings I had from when I was growing up. I would say there was something nostalgic about my affinity for the people I was photographing. "Nostalgia" translated directly from its Greek root implies "home," or the pain of its loss, and I decided to try to get that into the pictures. I figured that my nostalgia was for the seventies, because that was the time when whatever made me the way I am was making the hustlers the way they were. I thought making traditional, wallet sized school portraits would give the viewer a feeling of nostalgia, both good and bad. I didn't want

FOWLER, Eve
Eve Fowler is an artist living and working in Los Angeles. Her work is in the collection of the San Francisco Museum of Modern Art, The New Museum and The Smithsonian. She is currently producing a number of photographic series with Editions Fawbush, New York, previews of which can be seen at www.fawbush.com.

(p. 161) FOWLER, Eve
Untitled, 2000–2004. C-print print © Eve Fowler, courtesy the artist.

Säde: Portrait of a Synchronized Skater

A STORY BY ROSA LIKSOM

I WAS BORN INTO SUCH A NORMAL MIDDLE CLASS FAMILY THAT THE MOST SIGNIFICANT INCIDENT IN MY CHILDHOOD was that at the age of three my foreigner was squeezed between the playroom door and my nail turned out half black. Even that I can't remember myself but that's the story I've been told. My life was so plain that nothing stands out of it. I don't even remember whether I ever played with dolls or not.

I learned to skate at the age of three and finally ended up a typical Sunday skater. Well, it was okay, but somehow I just couldn't believe that was all there was to it. Was that really the life I wanted to live? I had this feeling that there must be something more to discover, something bigger and greater than figure skating, but I just couldn't figure out what it could be.

It was a Sunday. The fifth of March, when I was visiting aunt

Arla at Tampere along with the rest of the family. When I woke up in the morning my dad told me he had a surprise for me. He had purchased tickets for us to a local ice show. So we ended up sitting amongst other spectators at Tampere Ice hall without having a clue what would happen next. And... oh my god! Twenty girls took to the ice, skating in a row with awesome costumes, and then started performing this thing I had never seen before. I couldn't breathe because I felt this was what I had been waiting for my whole life. These skaters went forward with such magnificent speed in those paillette outfits, and they made wild formations: the circle became two lines in a fracture of seconds, and that turned out to be a two line parallel wheel, and then a 4-spoke wheel....

After the performance there was only one thing circulating in my

(p. 165 all images) FREGER, Charles
Winter Face, 2000. Type C print © Charles Fréger, courtesy the artist.

(p. 169 all images) FREGER, Charles
Winter Face, 2000. Type C print © Charles Fréger, courtesy the artist.

(p. 170) FREGER, Charles
Winter Face, 2000. Type C print © Charles Fréger, courtesy the artist.

FREGER, Charles
Since 1999, Charles Fréger (born in Bourges, France in 1975) has been photographing young people in groups contexts that require a uniform code of dress. Some of the subjects he has based his series on include sporting (Suiho swimmers, factory workers, and French naval recruits. *Winter Face,* the series published here, can be found in *Steps,* his book of portraits of teenagers on synchronized ice dancing teams.

mind: this is what I want. At home I told mom and dad that I wanted to become a synchronized skater. I can't say they were thrilled about the idea because it really isn't what you could call an expensive hobby, but when they realized how much I wanted it, they gave in. Since I could do all the basics – skate forwards and backwards and the simplest jumps and spins – I was accepted into a synchronized skating team. I was very motivated right from the beginning. I skated for the team for a year, and weird things happened to me. I learned everything; some steps, the single jumps except for the axel, the spirals and the three turns and a bunch of spins.

Next summer I got the opportunity to attend a camp. On my first day I was on the ice for a couple of hours, after which the coach came to ask me if I would like to try out for the team. I was like... *siki* Is this real? And I burst out crying. It was the best thing

that had happened to me in my life. I'd just turned eleven.

I became a member of the Sun Ice Team. We were a total of 24 even though only 20 could gain a place on the competing team. I was instantly placed amongst others in the line and the coach started yelling. I was panicking, which way should I go... help! But slowly I got more and more sucked inside the team and I learned what each cheer meant. I learned the ways of the team: doing the make-up, putting up your hair, how to squeeze all your fat inside the push-in training outfit, taking care of your competing costumes, sewing the paillettes, warming up...

I was very happy, even though I was in total panic for the first few months. I was terrified of whether I could follow the rest of the team or not, but I had a strong feeling inside of me that this was my life. Here and now. The feeling was so powerful that I

LIKSOM, Rosa
Rosa Liksom was born in 1958 in Lapland and now lives in Helsinki. She is a painter, a photographer, and writer. One *Night Stands,* a collection of written portraits of young male rough is uncomplicated that are alternately comic, brutal, and poignant, was published in 1994.

KAMAITACHI

Designer
Tadanori Yokoo, Ikko Tanaka
Editor
Lesley A. Martin
Illustrator
Tadanori Yokoo
Photographer
Eikoh Hosoe
Publisher
Aperture Foundation
Studio/Design Firm
Aperture Foundation
Client
Aperture
Country
United States

Aperture's 2005 edition of Eikoh
Hosoe's groundbreaking book,
Kamaitachi, is an homage to the
creativity and craftsmanship of the
original object. This new, deluxe
edition has been printed by Toppan
Printing Co., Ltd., Tokyo, as a tri-
tone book on an offset press and is
enclosed in a clamshell box
designed exclusively for this edition
by Tadanori Yokoo, a longtime
collaborator with Eikoh Hosoe. The
first edition of Kamaitachi was first
published in 1969 in a limited edition
of 1,000 copies. This exquisite
volume was never widely available
outside of Japan and has long been
out of print. The new, deluxe Aper-
ture edition is limited to 500
numbered copies signed by the
photographer. A Japanese edition of
500 copies was published simulta-
neously by Seigensha, Kyoto. The
Seigensha edition does not include
the clamshell box.

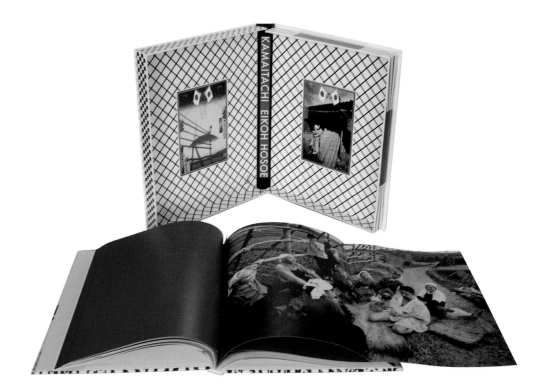

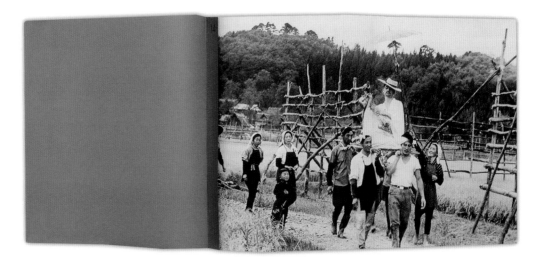

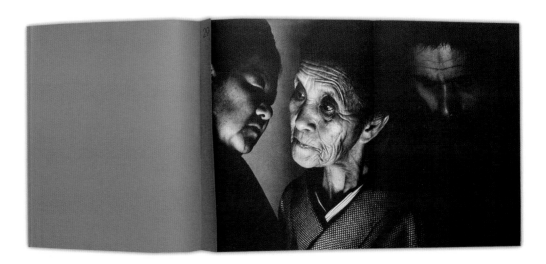

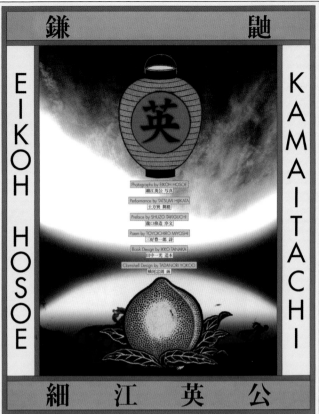

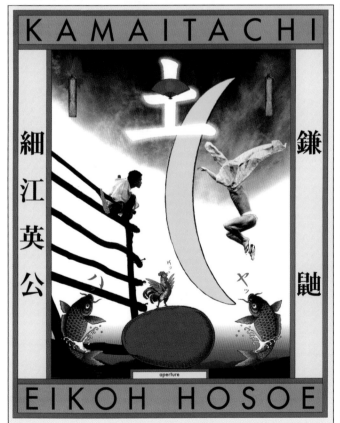

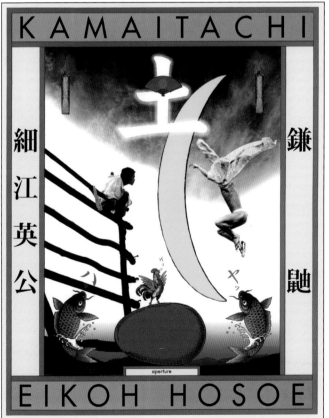

SENIOR LIBRARY 2004

Art Director
Carin Goldberg, Richard Wilde
Copywriter
Akiko Busch
Creative Director
Carin Goldberg, Richard Wilde
Designer
Carin Goldberg
Photo Editor
Carin Goldberg Design
Photographer
Jason Fulford
Production Company
A to A Graphics, Inc.
Studio/Design Firm
School of Visual Arts
Client
School of Visual Arts
Country
United States

Distinctive Merit
Book Design, Museum,
Gallery or Library Book, Single

CRY OUT FOR JOY, YOU LOWER PARTS OF THE EARTH

Art Director
Sybren Kuiper
Copywriter
Italo Calvino, Anton Brink,
Wouter Prins, Erla Nordfjord,
O.B. Saxinger, Meta Knol
Designer
Sybren Kuiper, Karin van Dam
Illustrator
Karin van Dam
Photo Editor
Sybren Kuiper, Karin van Dam
Producer
Flevodruk, Harderwijk
Publisher
Artimo, Amsterdam
Studio/Design Firm
-SYB- graphic design
Client
Karin van Dam
Country
Netherlands

Artist Karin van Dam makes giant installations that can be best described as "futuristic cities," which are large enough to dwell in. This catalogue is not only a history of her past work, but also an artifact that fits seamlessly in her oeuvre. Tactility, choice of materials, printing, die-cuts and binding-techniques are a logical consequence of her work. The book, like her work, is predominantly black (including the edges of the pages). Die-cut and varnished texts can also be seen inside. The drawings are printed in black and silver to suggest the graphite pencil tones. The photos of her installations are ordered in such a way that the reader gets the impression of dwelling through them. The pop-up on the inside back-cover is an original work by Karin van Dam especially made for this book.

In Ersilia, to establish relationships that sustain the city's life, the inhabitants stretch strings from the corners of the houses, white or grey or black or white according to whether they mark a relationship of blood, of trade, authority, agency.

When the strings become so numerous that you can no longer pass among them, the inhabitants leave: the houses are dismantled; only the strings and their supports remain.

From a mountainside, camping with their household goods, Ersilia's refugees look at the labyrinth of taut strings and poles that rise in the plain. That is the city of Ersilia still, and they are nothing. They rebuild Ersilia elsewhere. They weave a similar pattern of strings which they would like to be more complex and at the same time more regular than the other. Then they abandon it and take themselves and their houses still farther away.

Distinctive Merit
Book Design, Museum,
Gallery or Library Book, Single

**THE BEST DUTCH BOOK
DESIGNS '04**

Art Director
Sybren Kuiper
Copywriter
Just Enschede
Designer
Sybren Kuiper
Editor
Just Enschede
Photo Editor
Sybren Kuiper
Photographer
Nederlof Repro bv, Cruquius
Producer
Alwin van Stein
Production Company
Grafische Cultuurstichting,
Amsterdam
Publisher
The Best Dutch Book Designs
Studio/Design Firm
-SYB- graphic design
Client
The Best Dutch Book Designs
Country
Netherlands

Catalogues like these tend to repro-
duce the nominated books pretty
small, in order to show a lot of
spreads on a relatively small number
of pages. Essential graphic design
features, like the real feel of a book,
the typography etc…gets lost this
way. This catalogue tries to give the
readers the sensation that they
open the nominated books them-
selves. At least for a moment. To
achieve this, all books are repro-
duced at 100% of their actual size. If
the reproduced book is bigger than
the catalogue itself, the reproduc-
tion bleeds off the pages, showing
only a part of a spread. Each book is
reproduced on eight picture pages.
These are inserted in eight smaller
text pages. These smaller pages
help to navigate from book to book.
The Dutch texts and the English
translations are ordered fully
symmetrically around the picture-
pages. Only on the back do the two
languages meet without translation:
"BO K."

BO K

DE BEST
VERZORGDE
BOEKEN
04

Distinctive Merit
Corporate & Promotional
Design, Annual Report, Single

**STEDELIJK MUSEUM
AMSTERDAM 2003/2004**

Art Director
Ben Laloua, Didier Pascal
Designer
Ben Laloua, Didier Pascal
Photo Editor
Ben Laloua, Didier Pascal
Producer
Printer Die Keure Brugge,
Binder Hexspoor
Publisher
Stedelijk Museum Amsterdam
Editor
Jelle Bouwhuis
Studio/Design Firm
Ben Laloua, Didier Pascal
Client
Stedelijk Museum Amsterdam
Country
Netherlands

The Stedelijk Museum Amsterdam
is one of the most significant
museums in Europe. Beside their
collection of modern art, there is
also a collection of applied art, and
a weekly program of readings and
film screenings. The goal of the
design of this annual report was to
create an image for all activities of
the museum, in other words, to
create a visual essay for high profile
as well as more trivial activities. The
use of gentle tactile material
ensures that the annual report has a
pleasant and desirable image.

Distinctive Merit
Corporate & Promotional
Design, Annual Report, Single

**INSINGER DE BEAUFORT
ANNUAL REVIEW 2004**

Art Director
Tirso Francès, Sybren Kuiper
Copywriter
Louise Hide, Charlie Errington
Designer
Dirkjan Brummelman
Photographer
Vincent van de Wijngaard
Production Company
Dietwee Communicatie
en Vormgeving
Publisher
Bank Insinger de Beaufort N.V.
Studio/Design Firm
Dietwee Communicatie
en Vormgeving
Client
Insinger de Beaufort
Country
Netherlands

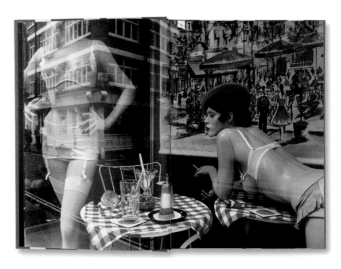

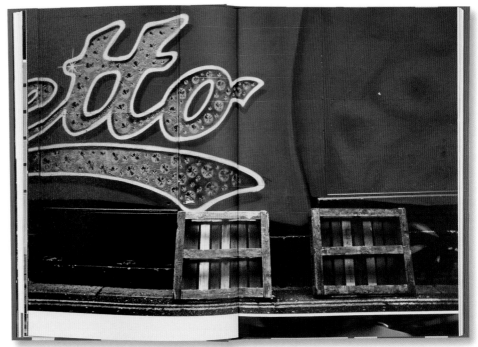

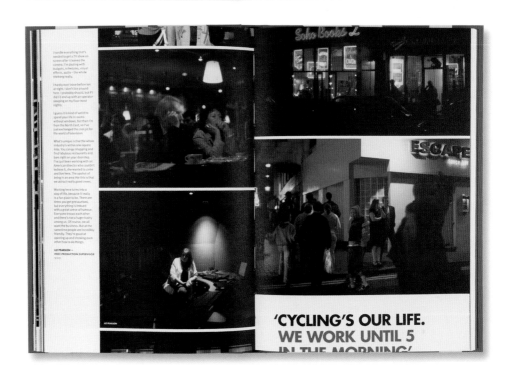

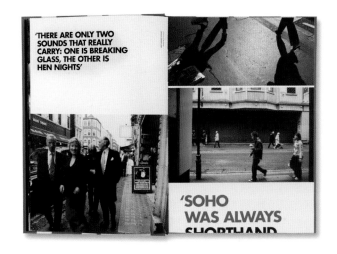

VANISHING

Art Director
Giorgio Baravalle
Copywriter
Michael Persson
Creative Director
Giorgio Baravalle
Designer
Giorgio Baravalle
Photographer
Antonin Kratochvil
Publisher
de.MO
Studio/Design Firm
de.MO
Client
de.MO
Country
United States

Vanishing is a tour through endangered life forms and ruined environments, human catastrophes and destruction, resulting in vanishing cultures. Vanishing speaks on behalf of life, despite man's ever-threatening presence. This body of work offers nothing in the way of answers, neither is it a sermon in hopes of brighter days. Vanishing gives those who go about their business, living their lives, a chance to look beyond their worlds and into others. Traditional typography is altered and interspersed with current technology to capture the book's concept of natural forms changed by modern development. The book was originally meant to be horizontal in format but was eventually designed as a traditional vertical book but treated as a horizontal to once again emphasize the book's primary concern of traditional forms altered by modern conventions.

**GOETHE OF ONE STUDY:
ORANGE, GREEN, PURPLE**

Art Director
Ryosuke Uehara
Creative Director
Satoru Miyata
Designer
Ryosuke Uehara,
Ken Okamuro
Producer
Minako Nakaoka
Production Company
DRAFT Co., L td.
Studio/Design Firm
DRAFT Co., Ltd.
Client
D-BROS
Country
Japan

There are two structural devices in
these notebooks. One is to use
visual tricks through the mixture of
colors. Another is to vary page
lengths through the book so that the
edges of the pages on the unbound
side are offset in such a way that art
can be displayed even when the
book is closed. These three note-
books are printed to display the
words Orange, Purple, and Green,
using two of three primary colors
(cyan, magenta, yellow) in various
combinations. A plain notebook
gets the creative juices flowing.
Color drives imagination. The goal
with these notebooks is that the
expression of the words Orange,
Green, and Purple in this way
becomes food for the imagination.

Distinctive Merit
Corporate & Promotional
Design, Complete Press/
Promotional Kit, Single

NIKE CONSIDERED KIT

Art Director
Ryan Dunn
Creative Director
Michael Shea
Designer
Todd St. John, Gary Benzel
Director
Todd St. John
Production Company
HunterGatherer
Illustrator
Todd St. John, Gary Benzel
Studio/Design Firm
HunterGatherer
Client
Nike
Country
United States

We were contacted to create
artwork and housing to be sent to a
few hundred people introducing
Generation 2 of Nike's sustainable
line, Considered. The kit abstractly
illustrates the 13-word Considered
manifesto. It contains a set of 13
silk-screened postcards, 3 silk-
screened prints, 2 t-shirts, and DVD
containing an original animation. It
was sent as a targeted promotion in
very limited numbers with the idea
that people would want to keep it.
The box was made of a single piece
of cardboard, with graphics printed
in one-color directly on the card-
board. The interior tray held the
prints, postcards, shirts and DVD. It
was designed to be sent through the
mail with no additional packaging
necessary.

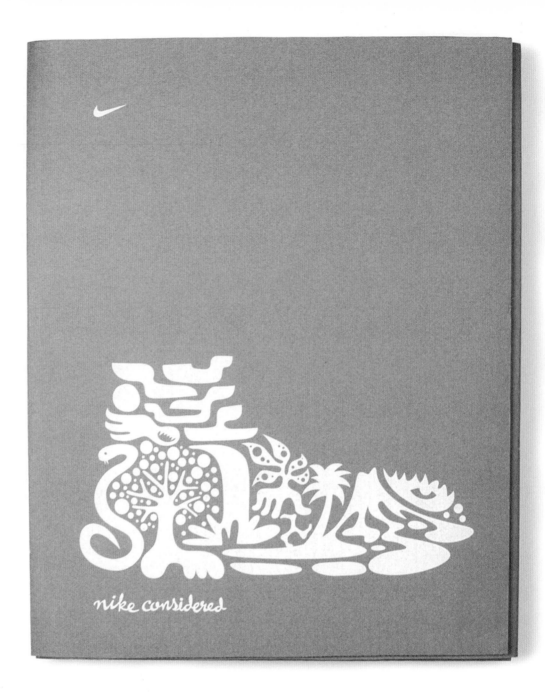

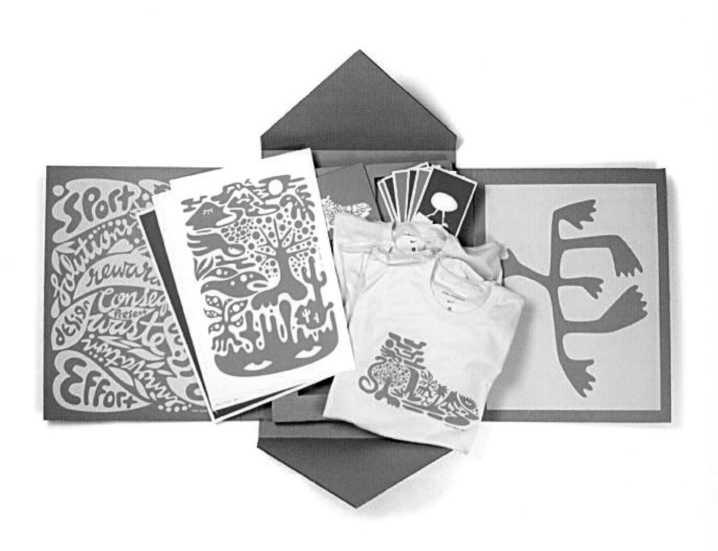

Distinctive Merit
Corporate & Promotional
Design, Calendar or
Appointment Book, Single

PAPER JAM

Art Director
Ryosuke Uehara
Creative Director
Satoru Miyata
Designer
Ryosuke Uehara, Ken
Okamuro
Production Company
DRAFT Co., Ltd.
Producer
Minako Nakaoka
Studio/Design Firm
DRAFT Co., Ltd.
Client
D-BROS
Country
Japan

This calendar is printed on two sides
and is composed of six pieces. First,
we designed normal calendars, then
tore them up and reassembled them
in interesting ways. It was a very
cumbersome process. First, I set
up a scenario in which I pretended
to be blocking traffic, and froze
the scene like that. The point was
to express that my progress
throughout the year had been
blocked by someone. I want the
D-BROS calendar to mean some-
thing special for the buyer. I'm
hoping that people treat every
day as an important experience
they can't forget, turning the pages
of time happily forward, willing to
move beyond the past, although
sometimes reluctantly.

Distinctive Merit
Poster Design,
Public Service/Nonprofit/
Educational, Campaign

HEROMOISM

Creative Director
Tommy Li
Designer
Choi Kim Hung, Joshua Lau
Photographer
Larry Hou
Art Director
Tommy Li
Copywriter
Tommy Li
Studio/Design Firm
Tommy Li Design
Workshop Ltd.
Client
Tommy Li Solo
Exhibition@MTR ARTtube
Country
Hong Kong

Viewable at www.adcglobal.org

This page could not be printed in mainland China due to content restrictions.

HEROMOISM

Creative Director
Tommy Li
Designer
Choi Kim Hung, Joshua Lau
Photographer
Larry Hou
Art Director
Tommy Li
Copywriter
Tommy Li
Studio/Design Firm
Tommy Li Design
Workshop Ltd.
Client
Tommy Li Solo
Exhibition@MTR ARTtube
Country
Hong Kong

It's hard to understand what is
"Mao" in Hong Kong today. Hong
Kong is a metropolis with eastern
culture mix with western capitalism.
Definition of "Hero" for most of the
youngster today means comic char-
acters instead of "Mao" or
"Communism." Playful means
everything. This poster still banned
in China for any exhibition or design
competition entry. Thus, any inter-
national recognition awarded by this
poster is very important to expose in
Mainland China because it is the
best way to let them know Hong
Kong still reserve creative freedom.

Distinctive Merit
Television & Cinema Design,
Animation, Campaign

**SUNDANCE POETRY:
THE DEAD, BUDAPEST,
FORGETFULNESS**

Art Director
Toby Barlow
Copywriter
Billy Collins
Creative Director
Toby Barlow
Designer
Julian Grey, Isaac King,
Philippe Blanchard
Director
Julian Grey, Juan Delcan
Producer
Anthony Garetti, Sue Riedl,
Graciela Del Toro
Production Company
Headgear, Spontaneous
Editor
Julian Grey
Studio/Design Firm
JWT/Lodge 212
Client
Sundance Channel
Country
United States

We want people to spend more time with our clients. But this doesn't have to happen through ads for the Sundance Channel. We created actual programming making the Sundance Channel more interesting so that people wanted to spend more time with the channel.
12 short films based on poems of Billy Collins.

Distinctive Merit
Corporate & Promotional
Design, Self-Promotion:
Print, Single

PROTO TYPE FONT

Art Director
Toshiyasu Nanbu
Copywriter
Toshiyasu Nanbu
Designer
Toshiyasu Nanbu
Illustrator
Yumeto Nanbu, Toshiyasu
Nanbu
Publisher
Taste, Inc.
Studio/Design Firm
Taste, Inc.
Client
Taste, Inc.
Country
Japan

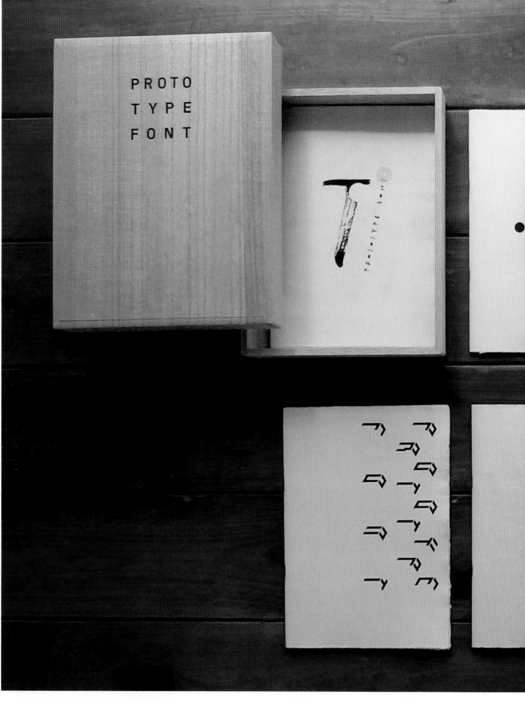

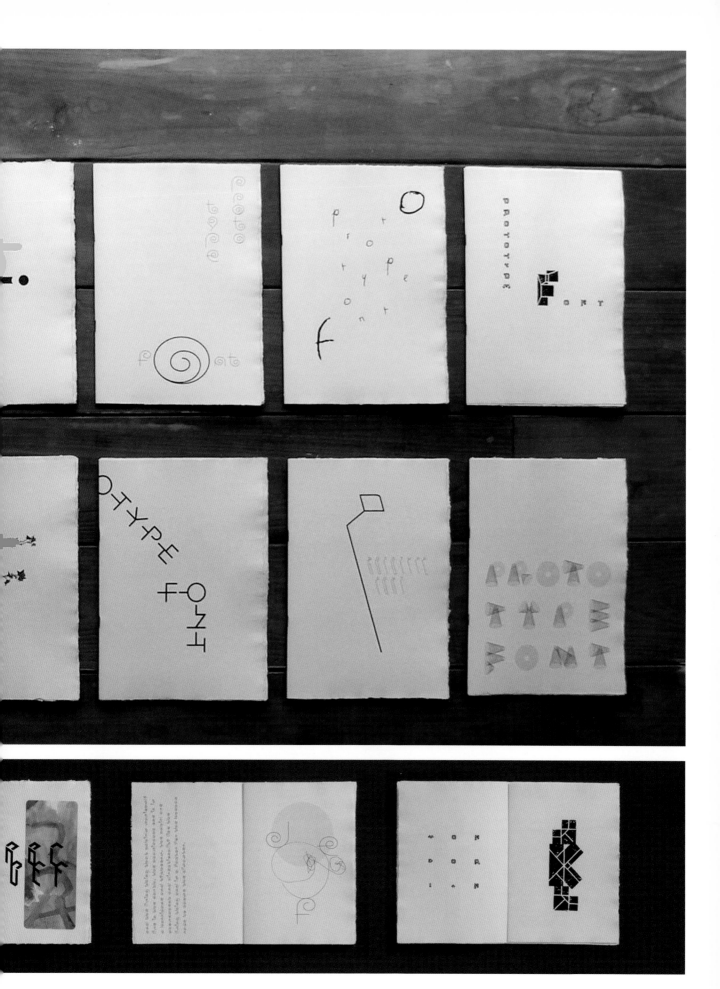

SEVEN EXHIBITION

Art Director
Hideki Nakajima
Designer
Hideki Nakajima
Photo Editor
cache
Studio/Design Firm
Nakajima Design
Client
Hong Kong Arts Centre
Country
Japan

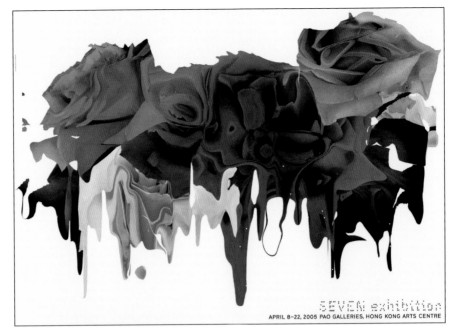

MADE IN CHINA–ADIDAS

Art Director
Jun He
Copywriter
Jun He
Creative Director
Jun He
Designer
Jun He
Director
Jun He
Illustrator
Yan Qu
Studio/Design Firm
Mewe D A
Country
China

The posters of "MADE IN CHINA" series are designed by MEWE DESIGN ALLIANCE for the theme "IN CHINA" of the exhibition "GRAPHIC DESIGN IN CHINA 05." The posters are made up of the logo of "MADE IN CHINA" and the logo of "MEWE DESIGN ALLIANCE." Many people have visited the Silk Market in China. The peddlers there usually stick the logo of "NIKE," "adidas," etc…on their merchandise to show their goods are not fake and shift off inspection. Actually, both of the buyer and seller are tacit, which shows the embarrassing condition of the name brand in China.

WATER FOR LIFE

Art Director
Kenji Umetani
Designer
Kenji Umetani
Illustrator
Yusuke Tanaka
Photographer
Shintaro Shiratori
Production Company
ADK, Inc.
Studio/Design Firm
ADK
Client
JAGDA inc.
Country
Japan

The theme of this series of posters is "Water For Life." Water is a precious essence of life for any living organism on earth. Water would be a source of flesh-and-blood of living forms, breathe life into them, and rotting away in the end. Water evaporation from a living organism that has fallen into decay infuses new breath into other organism.

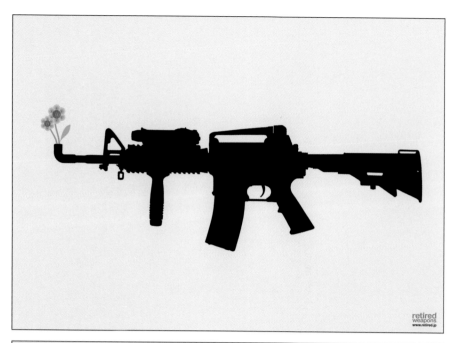

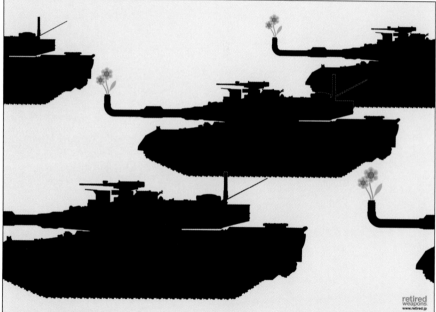

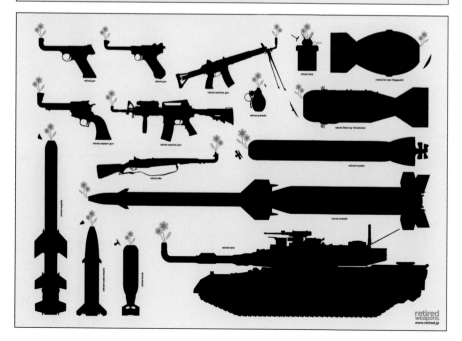

**RETIRED WEAPONS
SERIES:
RETIRED WEAPONS,
RETIRED TANK,
RETIRED MACHINE GUN**

Art Director
Yuji Tokuda
Creative Director
Yuji Tokuda, Junya Ishikawa
Producer
Junya Ishikawa
Studio/Design Firm
junya-ishikawa .com
Client
Retired Weapons
Country
Japan

The 20th century was a century of
the invention of materials. The 21st
century needs to be a century of the
invention of dialogue. We wish our
art to be a dialogue starter among
people and create little steps
towards the goal of this new
century.

Distinctive Merit
Package Design, Product
Graphics, Single

EARTH GARBAGE BAG

Art Director
Kenjiro Sano
Creative Director
Kenjiro Sano
Designer
Koichi Kosugi
Studio/Design Firm
Hakuhodo, Inc.
Client
Fuji Television Network, Inc.
Country
Japan

As people in the design industry,
we are convinced that whenever
possible, it is our essential mission
to contribute to making this world
a better place through our own
work. "Earth garbage bag"
has been designed to raise
environmental awareness and
is now in use in municipal
governments all over Japan.

**ANNI KUAN BROCHURE:
GOLD, PINS, PENCIL**

Art Director
Stefan Sagmeister
Copywriter
Stefan Sagmeister
Creative Director
Stefan Sagmeister
Designer
Richard The,
Ariane Spiranni,
Izabella Bielawska
Illustrator
Richard The, Ariane
Spiranni, Izabella Bielawska
Photographer
Richard The, Ariane Spiranni,
Izabella Bielawska
Producer
Kim Printing, New York
Publisher
Anni Kuan Design
Studio/Design Firm
Stefan Sagmeister
Client
Anni Kuan
Country
United States

These are three newsprint cata-
logues for New York fashion
designer Anni Kuan. Utilizing the
supplied pins, one catalog can be
taken apart and pinned up—
revealing lovely Anni as a pin-up. On
the other, the entire catalog spells
out: "Material luxuries can best be
enjoyed in small doses" which is
one of the items on a list taken from
my diary entitled: "things I have
learned in my life so far." And yes,
that is real, actual gold on the front
cover (albeit a small dose).

Distinctive Merit
Environmental Design,
Environment, Campaign

**PLAYSTATION PORTABLE:
WHITE, BLACK,
WHITE, BLACK**

Art Director
Kenjiro Sano
Copywriter
Kenji Saito, Taku Tsuboi
Creative Director
Masaru Kitakaze
Designer
Koichi Kosugi, Eri Honda
Studio/Design Firm
Hakuhodo, Inc.
Client
Sony Computer
Entertainment, Inc.
Country
Japan

Distinctive Merit
Television & Cinema Design,
TV Identities, Openings,
Teasers, Campaign

**PARAMOUNT COMEDY
REBRAND IDENTITIES:
BUMCHEEK MONKEY,
TALKING HEADS, SQUIRREL**

Creative Director
Richard Holman
Copywriter
Claire Lambert
Designer
Chris Turner, Sam Tootal,
Matt Bauer
Illustrator
Al Murphy, Paul Bower,
Mikko Rantanen
Producer
Charlotte Dale
Production Company
devilfish
Studio/Design Firm
devilfish
Client
Paramount Comedy
Country
United Kingdom

Paramount Comedy had lost signifi-
cant audience share in a short time.
In part this was due to the program-
ming but it was also due to a tired
and formal identity. The channel felt
sterile and uninspired. Our brief was
to create an identity that was 1.
Funny 2. Entertaining 3. Full of the
spontaneity, misrule and creativity
that makes great comedy great. We
were also charged with creating a
durable aesthetic that could be
developed over time and across
other media. And we were asked to
concentrate on a young demo-
graphic. Since the re-brand the
channel has gone from 15th to 10th
in the ratings, 16-34's are up 39%
and ABC1's up 26%.

CICERO IS ALIVE

Art Director
Armin Jochum, Joerg Bauer
Copywriter
Andreas Rell
Creative Director
Armin Jochum, Andreas Rell,
Joerg Bauer
Producer
Wolfgang Schif
Production Company
Cicero Werkstudio
Studio/Design Firm
BBDO Campaign
GmbH Stuttgart
Client
Cicero Werkstudio
Country
Germany

The world has seen many famous
typographers come and go, whose
work is still admired today. The work
of Cicero Studio follows this great
calligraphic tradition, but Cicero is
different from all its predecessors in
one respect: Cicero is alive!

NOT ACTUAL SIZE

American movie candy goes under the magnifying glass

Photographs Marko Lavrisha Art Direction Houman Pirdavari

Merit
Editorial Design,
Magazine, Consumer,
Spread, Multipage, Single

MOVIE CANDY

Art Director
Houman Pirdavari
Copywriter
Houman Pirdavari
Creative Director
Houman Pirdavari
Designer
Houman Pirdavari
Photographer
Marko Lavrisha
Publisher
A. Ghanbarian
Studio/Design Firm
freelance
Client
SOMA Magazine
Country
United States

Appearing in a special issue dedicated to cinema, this seven-page piece was no accident. The publisher was adamant from the outset that the objective of these pages was to make the reader feel like they were in a movie theater, in the body of an insect.

Merit
Editorial Design,
Magazine, Consumer,
Spread, Multipage, Single

**HOW NOW VOL. 12,
SPRING 2005**

Art Director
Deb Bishop
Creative Director
Eric A. Pike
Designer
Robin Rosenthal, Tina Chang,
Jennifer Dahl
Editor
Kelly Smith Killian
Illustrator
Jessie Hartland
Photo Editor
Heloise Goodman,
Rebecca Donnelly,
Lina Watanabe
Photographer
Victor Schrager
Publisher
Lauren Stanich
Studio/Design Firm
Martha Stewart Living
Omnimedia
Client
Kids: Fun Stuff To Do Together
Country
United States

"How Now" is a special, interactive section in Kids: Fun Stuff To Do Together that's just for kids. In each issue we feature an animal and a secondary theme related to that animal. We include games, crafts, activities, and stories. We select a single illustrator to illustrate each "How Now," use large type throughout, and print on uncoated paper to give the section a story book feel and to differentiate it from the rest of the magazine. In the Spring 2005 issue, we featured cows and ice cream, weaving photographs and drawings of cows with those of ice cream. We always connect the two themes. Milk comes from cows, which in turn is used to make ice cream. This way, children learn while they also enjoy the activities.

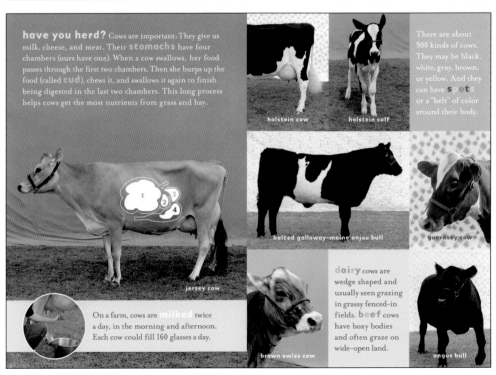

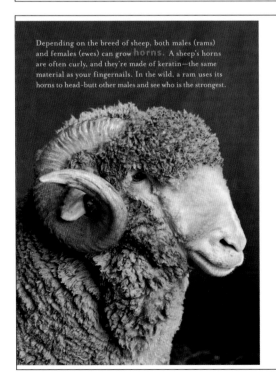

Merit
Editorial Design,
Magazine, Consumer,
Spread, Multipage, Single

**HOW NOW VOL. 15,
WINTER 2005**

Art Director
Robin Rosenthal
Creative Director
Eric A. Pike
Designer
Tina Chang, Jody Churchfield
Editor
Kelly Smith Killian
Illustrator
Greg Clarke
Photo Editor
Heloise Goodman,
Rebecca Donnelly, Mary Cahill
Photographer
Victor Schrager
Publisher
Lauren Stanich
Studio/Design Firm
Martha Stewart Living
Omnimedia
Client
Kids: Fun Stuff To Do Together
Country
United States

"How Now" is a special, interactive
section in Kids: Fun Stuff To Do
Together that's just for kids. In each
issue we feature an animal and a
secondary theme related to that
animal. We include games, crafts,
activities, and stories. We select a
single illustrator to illustrate each
"How Now," use large type
throughout, and print on uncoated
paper to give the section a story
book feel and to differentiate it from
the rest of the magazine. Here, the
themes were sheep and sleep: A
sleeping sheep "counts people" as
he tries to sleep. This is juxtaposed
with photos of actual sheep and the
children who own them. Again,
every installment is a chance to
learn as well as enjoy the games
and activities.

Merit
Editorial Design,
Magazine, Consumer, Spread,
Multipage, Campaign

**WILLIAM SAFIRE SERIES:
SEPTEMBER 25,
OCTOBER 2, OCTOBER 9,
OCTOBER 30, DECEMBER 4,
2005, NEW DESIGN SERIES**

Art Director
Arem Duplessis
Creative Director
Janet Froelich
Designer
Kristina DiMatteo
Illustrator
Marian Bantjes,
Tamara Shopsin, Ed Fella,
Julia Hasting,
Ashley Snow Macomber
Studio/Design Firm
The New York Times Magazine
Client
The New York Times Magazine
Country
United States

9.25.05

ON LANGUAGE BY WILLIAM SAFIRE

Rising above yuck, yecch, bleah and ew.

Today's scholarly linguistic dissertation deals with embodied cognition. (That should clear the room of readers searching for the prurient, offensive and scatological.)

Early last month, the Los Angeles Daily News columnist Bridget Johnson noted that "some recent Hollywood bits that have raised conservative ire include hailing Alfred Kinsey, Nicole Kidman sharing her bathtub with a boy in 'Birth,' euthanasia glorified in 'Million Dollar Baby' and 'The Sea Inside.' Regardless of

The face we make with *yuck* and *ick* is an expression that refers to the spontaneous act of disgust."

End of imitative *ick-factoring*. You can now wipe that awful expression off your face.

Blame-Game Finger-Pointing

10.2.05

ON LANGUAGE BY WILLIAM SAFIRE

This *raunch* has no dressing.

"Fluent in *raunch*" is how Ariel Levy, 30, describes her critique of post-feminism. Her shocking book, "Female Chauvinist Pigs," is subtitled

the noun *sleaze*. Its usage exploded in 1980 into the political "age of *sleaze*," a phrase for petty corruption that replaced a previous genera-

12.4.05

ON LANGUAGE BY WILLIAM SAFIRE

Computerlingo needs a murder board.

At last month's annual conference of the Computer Security Institute, the keynote speaker was one of those privacy nuts who exhorts businesses to tighten up their software and databases lest they threaten

software. The lexicographer Charles Levine calls them "analogical formations" (on the analogy of *analogy*), often with a switch on one-half of the word: the Free Software Foundation grants reuse and reproduction

10.9.05

ON LANGUAGE BY WILLIAM SAFIRE

Bad guys, real and unisex.

"You're such a *guy*," says the woman to her man, imputing either that he is thrillingly red-blooded or too pigheaded to ask for directions.

In olden times — a period from the 17th-century terrorist named

think we're desperate for a plural 'you' in contemporary English," says Robin Lakoff, professor of linguistics at U.C. Berkeley. "The South has *y'all* and some New Yorkers have *youse*, but the rest of us have

Merit
Editorial Design, Magazine,
Consumer, Full Issue, Single

**KID'S WEAR
SPRING/SUMMER '05
NO. 20**

Art Director
Mike Meirè, Florian Lambl
Copywriter
Vito Avantario,
Thomas Edelmann,
Edgar Heinelt, Michael Kröger,
Sven Lager, Elke Naters,
Heiko Schulz
Creative Director
Mike Meirè
Designer
Esther Gebauer
Editor
Catrin Hansmerten
Illustrator
Manu Burghart,
Esther Gebauer, Maria Holch,
Jasper Kröger,
York&Zec Meirè,
Julia Schonlau
Photo Editor
Ann-Katrin Weiner
Photographer
Roberto Badin, Ute Behrend,
Beate Geissler,
Takashi Homma,
Achim Lippoth,
Jason Mcglade, Mike Meirè,
Yoichi Nagano, Martin Parr,
Oliver Sann, Annelies Strba,
Bruce Weber
Publisher
Kid's Wear Magazine,
Achim Lippoth
Studio/Design Firm
Achim Lippoth Photographer
Client
Kid's Wear Magazine
Country
Germany

Merit
Editorial Design, Magazine,
Consumer, Full Issue, Single

**THE TSUNAMI ISSUE:
NOVEMBER 27, 2005,
ENTRIE ISSUE, PAGES 46-67**

Art Director
Arem Duplessis
Creative Director
Janet Froelich
Designer
Jeff Glendenning
Photo Editor
Kathy Ryan
Studio/Design Firm
The New York Times Magazine
Client
The New York Times Magazine
Country
United States

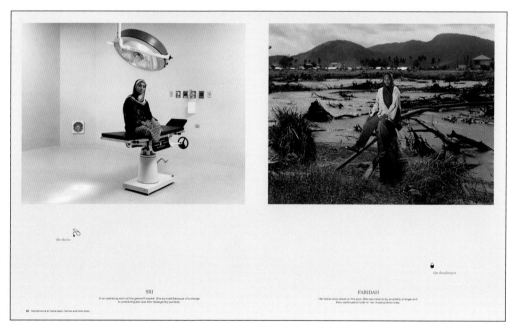

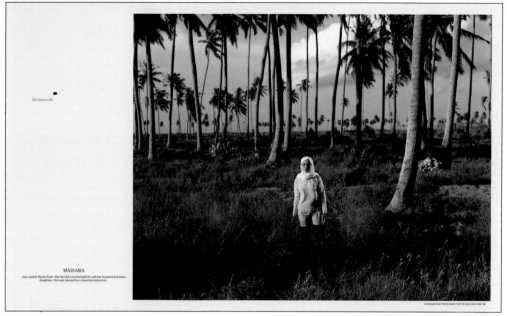

Merit
Editorial Design, Magazine,
Consumer, Full Issue, Single

PREFIX PHOTO 12

Art Director
Fidel Peòa, Claire Dawson,
Scott McLeod
Copywriter
various
Creative Director
Fidel Peòa, Claire Dawson
Designer
Fidel Peòa, Claire Dawson
Editor
Scott McLeod
Photographer
various
Publisher
Prefix Institute of
Contemporary Art
Studio/Design Firm
Underline Studio
Client
Prefix Institute of
Contemporary Art
Country
Canada

Prefix Photo is an engaging maga-
zine that presents contemporary
Canadian photography in an inter-
national context. Characterized by
innovative design and outstanding
production values, it features
photography portfolios and critical
essays, providing a complement of
intelligent texts and breathtaking
visuals.

Merit
Editorial Design, Magazine,
Consumer, Full Issue, Single

LIGHTER

Art Director
Wang Xu
Creative Director
Wang Xu
Designer
Wang Xu
Editor
Wang Xu
Producer
WX-design
Production Company
Output Centre, Fortune DTP
Compugraphic, Ltd.
Publisher
Exchange Publish House
Studio/Design Firm
Wang Xu & Associates Ltd.
Client
Exchange Publish House
Country
China

City West
Campus
Adelaide

John Wardle
Architects +
Hassell
Architects in
Association

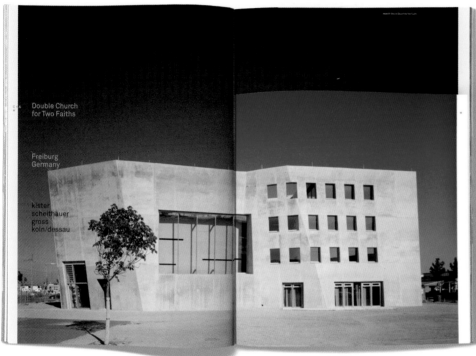

Double Church
for Two Faiths

Freiburg
Germany

kister
scheithauer
gross
koln/dessau

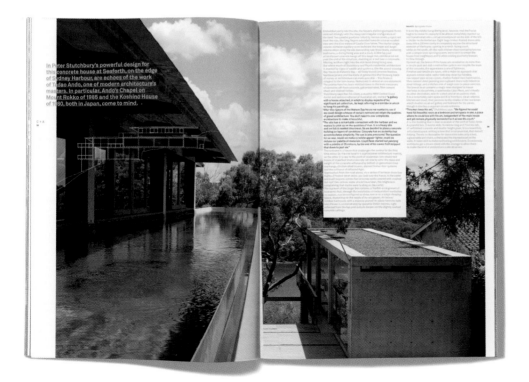

In Peter Stutchbury's powerful design for this concrete house at Seaforth, on the edge of Sydney Harbour, are echoes of the work of Tadao Ando, one of modern architecture's masters. In particular, Ando's Chapel on Mount Rokko of 1985 and the Koshino House of 1980, both in Japan, come to mind.

Merit
Editorial Design, Magazine,
Trade, Full Issue, Single

C+A MAGAZINE

Art Director
Tim Murphy
Copywriter
Joe Rollo
Creative Director
Garry Emery
Designer
Tim Murphy
Editor
Joe Rollo
Photographer
Trevor Mein,
Christian Richters,
Michael Nicholson, Fritz Kos
Publisher
Cement Concrete &
Aggregates Australia
Production Company
emerystudio
Studio/Design Firm
emerystudio
Client
Cement Concrete &
Aggregates Australia
Country
Australia

C+A magazine is a new international magazine of concrete architecture for an industry association, with qualities of a memorable and collectible folio, unlike any other industry magazine, using bold texts and photography as well as architectural drawings to describe each project published. The magazine is designed to be inspirational and to promote concrete as a material of choice in architecture. It aims to become a much anticipated, indispensable and sought after resource for architects and design professionals. The design approach is direct and rational.

Merit
Editorial Design, Magazine,
Trade, Full Issue, Single

CIRCULAR: ISSUE 13

Art Director
Domenic Lippa
Copywriter
Domenic Lippa. Peter Bain,
Fiona Ross,
Sallyanne Theodosiou,
John Belknap, Mukesh Parmar
Creative Director
Domenic Lippa
Designer
Domenic Lippa
Director
Domenic Lippa
Editor
Domenic Lippa, Bruno Maag,
James Alexander,
Sallyanne Theodosiou
Production Company
The Typographic Circle
Publisher
The Typographic Circle
Studio/Design Firm
Lippa Pearce Design
Client
The Typographic Circle
Country
United Kingdom

The objective for issue 13 of the
Typographic Circle's magazine,
Circular, is the same objective we
have with every issue: How to create
an eclectic publication that reflects
the Circle's aims and aspirations?
Published only once a year, we are
not under the same continuity
issues as other magazines. In fact,
our past issues have all had different
designs, often based on different
formats and binding methods.
The Biggest challenge is to produce
something that visually excites the
most demanding of audiences—
designers and typographers!
The solution rested in the interplay
with the different personalities'
initials, which we turned into typo-
graphic monograms. Using just
black and red as our primary color
palette, the magazine uses a playful
mix of different paper stocks all
left unbound.

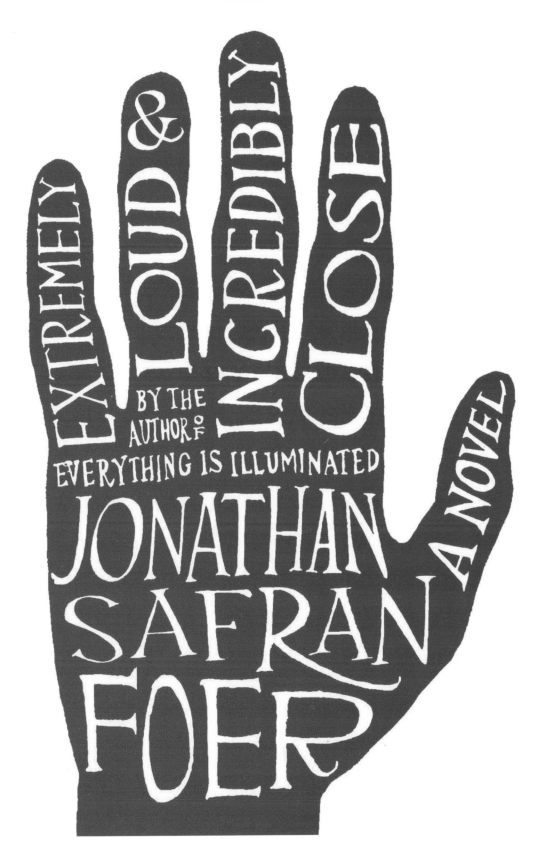

Merit
Book Design,
Book Jacket, Single

**EXTREMELY LOUD &
INCREDIBLY CLOSE**

Art Director
John Hamilton,
Michaela Sullivan
Designer
Jonathan Gray
Illustrator
Jonathan Gray
Publisher
Penguin Books,
Houghton Mifflin
Studio/Design Firm
gray318
Client
Penguin Books,
Houghton Mifflin
Country
United Kingdom

The authors' previous book had
quite a bold graphic cover. I wanted
this cover to be a continuation, but
to stand up in it's own right. The text
contains a lot of beautiful and
striking imagery, so I already had a
lot to work with. One such image is
a pair of hands with the words "yes"
and "no" written on each palm. With
his previous book, I tried to get the
type to push at the edges of the
cover. This time, I thought it would
be great to have it pushing at the
edges of another form: the hand. It's
also always nice to fight with the
rectangular format of a book, so by
placing all the type within the silhou-
ette, the rectangle hopefully
becomes irrelevant.

Graphic Design
289

Merit
Book Design,
Book Jacket, Single

**AMERICAN
PHOTOGRAPHY 21**

Art Director
Michael J. Walsh
Designer
Michael J. Walsh
Director
Mark Heflin
Photographer
Allesandra Petlin,
Hans Neleman
Publisher
Amilus, Inc.
Copywriter
Peggy Roalf
Studio/Design Firm
School of Visual Arts
Client
American Photography
Country
United States

This book takes a yearly pulse of
the photography world. The work
displayed covers the spectrum of
emotions, ranging from heart-
breaking news to contemplative
art, sometimes shocking, some-
times humorous, always beautiful
and personal.

Merit
Book Design, Special Trade
Book, Single

SELIGER BOOK

Photographer
Mark Seliger
Art Director
Fred Woodward
Designer
Ken DeLago
Publisher
Rizzoli
Studio/Design Firm
GQ Magazine
Client
Mark Seliger
Country
United States

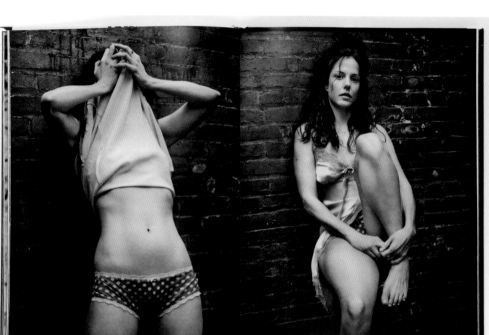

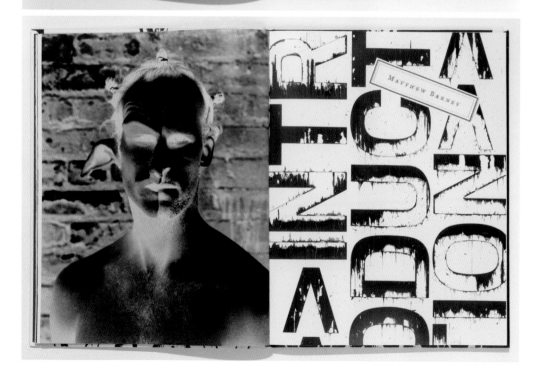

Merit
Book Design, Special Trade
Book, Single

SAMPLE

Art Director
Julia Hasting
Creative Director
Julia Hasting
Designer
Julia Hasting
Publisher
Phaidon Press, Inc.
Studio/Design Firm
Phaidon Press, Inc.
Client
Phaidon Press, Inc.
Country
United States

My approach was to find a design that did not overpower the delicate and subtle beauty of the drawings, but at the same time I tried to find a typographic solution that underlined their handmade character. The typewriter font Everson Mono suited this approach well since it has a spontaneous and unrefined look without appearing too mechanical. I tried to enhance this by adding hand-drawn elements to the font, such as hand-drawn circles and underlines to highlight names and headers. The cover illustration resulted from examining the chemical structure of actual vitamin d and the idea to feature all 109 artists' names on the cover. The model structure was drawn by hand to look more organic. I chose a paper (Asian creamy wood-free/uncoated) that looked as if the artworks were drawn directly onto it. The deckle edge further emphasizes this idea of the book as portfolio.

A
R
A
K
I

PHAIDON

Merit
Book Design, Special Trade
Book, Single

**NOBUYOSHI ARAKI:
LIFE, DEATH, SELF**

Designer
Sonya Dyakova
Photographer
Nobuyoshi Araki
Publisher
Phaidon Press, Inc.
Studio/Design Firm
Phaidon Press, Inc.
Client
Phaidon Press, Inc.
Country
United States

Nobuyoshi Araki is one of Japan's greatest living photographers, and certainly its most controversial. Over the last forty years he has published more than 250 books, bearing testimony to his inexhaustible creative energy. His work often challenges social taboos surrounding sex and death. The brief was to create the definitive book on Araki, which would provide the most comprehensive overview of his prolific career. A luxurious object, it had to be the one book to own. The book includes a wide selection of Araki's writings, often revealing a very different person from his public persona. Intimate and unashamedly honest, they inspired me to portray the duality of Araki's personality: the conflict between his narcissistic facade and his more private and sensitive side. I chose two typefaces to express this juxtaposition, one of which (Bauer Bodoni) has a sense of monumentality, while the other (Cottonwood) is mischievous and playful.

Merit
Book Design, Public Service/
Nonprofit Book, Single

COLOR YOUR DAY

Art Director
Käthi Dübi, Saskia Wierinck,
Hèlëne Bergmans
Designer
Käthi Dübi, Saskia Wierinck,
Hèlëne Bergmans
Illustrator
Frèderiek Westerveel
Producer
Drukkerij ANDO Bv
Production Company
Drukkerij ANDO Bv,
Binderij Hexspoor
Creative Director
Käthi Dübi, Saskia Wierinck,
Hèlëne Bergmans
Studio/Design Firm
Barlock bv
Client
Ando bv
Country
Netherlands

The theme of this diary is "Color
your day." The diary gives you a very
colorful and refreshing feeling by
using different types of paper, a
special binding and the design. The
cover is printed on linen with a silk-
look. There is one week per spread,
full of inspiring color experiences
that take you by surprise and take
your mind off stressful days! Extra
special finishing techniques will
keep you busy, such as thermo
printed fortune cookies, sexy die-
cuts, stickers, color charts and
good wine stains. This diary will
color your days in 2006!

Merit
Book Design, Public Service/
Nonprofit Book, Single

COLLECTED WORK

Art Director
De Designpolitie
Copywriter
Utrecht School of the Arts
Creative Director
De Designpolitie
Designer
De Designpolitie
Photographer
Diverse
Producer
Lenoir Schuring
Publisher
Utrecht School of the Arts
Studio/Design Firm
De Designpolitie
Client
Utrecht School of the Arts
Country
Netherlands

Merit
Book Design, Public Service/
Nonprofit Book, Single

**FONS HICKMANN–
TOUCH ME THERE**

Art Director
Fons Hickmann
Copywriter
Fons Hickmann
Creative Director
Fons Hickmann
Designer
Carolin Hansen,
Sabine Kornbrust,
Verena Petrasch, Annik Troxler,
Franziska Morlock,
Fons Hickmann
Editor
Fons Hickmann
Illustrator
Gesine Grotian-Steinweg
Photographer
Simon Gallus, Frank Goeldner,
Fons Hickmann, Markus Steur,
Jens Nieth, Nicola Schudy
Producer
Fons Hickmann m23
Production Company
Engelhard & Bauer,
Schumacher AG
Publisher
Die Gestalten Verlag
Studio/Design Firm
Fons Hickmann m23
Client
Fons Hickmann m23
Country
Germany

This book is the missing link
between art, design and theory.
Within 472 pages in eight printed
colors, Fons Hickmann introduces a
world of graphic design, photog-
raphy, illustration and rock 'n' roll.
The result is intelligent design that is
conceptual and political, always
transcending the limits of its
content. That's why the studio Fons
Hickmann m23 is one of the most
award-winning teams in the world.

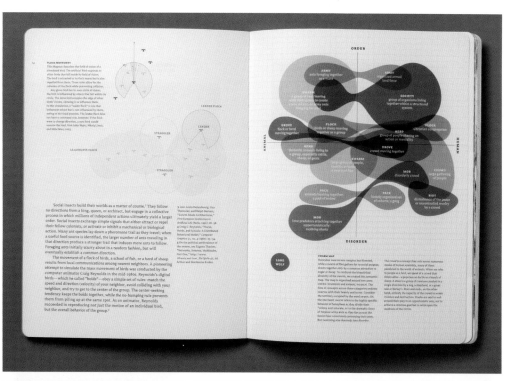

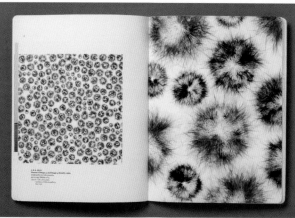

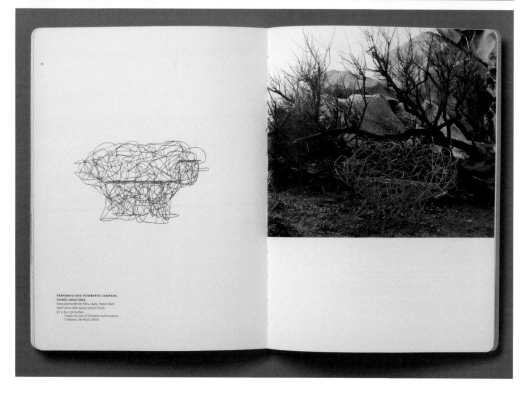

Merit
Book Design, Museum, Gallery
Or Library Book, Single

SWARM

Art Director
Abbott Miller, Ellen Lupton
Copywriter
Marion Boulton Stroud,
Abbott Miller, Ellen Lupton,
William Smith
Designer
Abbott Miller, Ellen Lupton,
Kristen Spilman
Editor
Ellen Lupton, Abbott Miller
Publisher
The Fabric Workshop
and Museum
Studio/Design Firm
Pentagram Design, Inc.
Client
The Fabric Workshop
and Museum
Country
United States

"Swarm" was an exhibition we
organized as guest curators for the
Fabric Museum and Workshop in
Philadelphia. The show brought
together work that expressed
swarming as a social effect gener-
ated by masses of objects, images,
data or organisms. The artists and
designers exhibited included the
Bouroullec and Campana brothers,
Felix Gonzalez-Torres, Julie
Mehretu, Sarah Sze, Fred Tomaselli,
and Yukinori Yanagi, among others.
The "Swarm" publication is
modeled on a field guide, particu-
larly in its Singer-sewn binding,
rounded edges and journal-like
format. Reproductions of artwork in
the show alternate with beautifully
rendered information graphics. The
cover of the publication features the
graphic signature for "Swarm,"
made of letters that coalesce from
minute circles. The visual and tactile
qualities of the publication situate
swarming as something both
visceral and analytical, futuristic but
also ancient and primal.

TIM HAWKINSON

Designer
Omnivore,
Alice Chung, Karen Hsu
Director
Rachel de W. Wixom
Editor
Kate Norment, Thea Hetzner
Production Company
Whitney Museum
of American Art
Publisher
Whitney Museum
of American Art
Studio/Design Firm
Whitney Museum
of American Art
Client
Whitney Museum
of American Art
Country
United States

The design process first began with
a visit to the artist's studio to see
and hear him talk about his work.
Taking cues from the artist's trans-
formation of everyday materials, the
book is wrapped in ordinary brown
packing paper with the cover typog-
raphy embossed on one side and
debossed on the other, lending the
impression that the type had been
pushed through a solid form. The
interior typography utilized a
mechanical typewriter typeface in a
single setting throughout the book,
while each section was composed
on its own grid to create subtle
distinction.

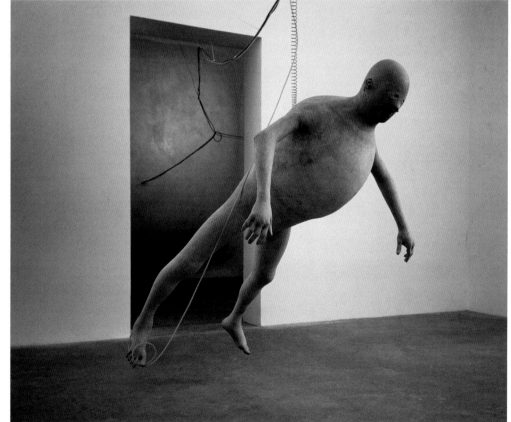

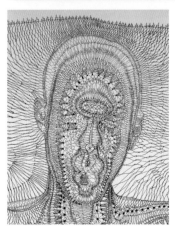

Merit
Book Design, Museum,
Gallery or Library Book, Single

TURN TO THE TITLE PAGE

Designer
Makiko Ushiba
Director
Rachel de W. Wixom
Editor
Thea Hetzner
Photo Editor
Professional Graphics
Production Company
Whitney Museum
of American Art
Publisher
Whitney Museum
of American Art
Studio/Design Firm
Whitney Museum
of American Art
Client
Whitney Museum
of American Art
Country
United States

For Raymond Pettibon's commissioned project at the Whitney Museum, we presented the artist's new animation—only the second that he has developed—as well as a collection of recent drawings that address both the long-term aspect of his influence and his ongoing effect on contemporary artists. In addition to these gallery components, and created as an integral aspect of the exhibition, we also organized "Turn to the Title Page," a catalogue/artist book that draws from his decades of involvement with artist's books, 'zines and other ephemeral visual media. The book makes Pettibon's vision uniquely accessible to a wide audience, and as a complement to the gallery installation, the selection of work highlights his facility with and experimentation across media, evident throughout his career. For the book, the artist created seventy new drawings arranged in a loosely narrative format—referencing the comic books and pulp novels, among other media, by which he is consistently inspired. Unlike a traditional exhibition catalogue, this format presented its own set of challenges. In order to capture the layers of collage, ink, watercolor and other media the artists employed, it was critical to use the original artwork to produce appropriately high-resolution scans for the layout. While the Museum provided the artist with a full book map and formatted page stock on which to work, our designer nevertheless had to very carefully translate the composition of the unique mock-up that Pettibon created into a printable format, all without compromising the integrity of the original object. Lastly, one of the most critical components was sending a member of the Whitney staff to the printers to directly oversee the proofing process, allowing for color correction of the design proofs to be done directly against the artist's original drawings—a rare circumstance that provided for such rich and accurate color translation.

Merit
Book Design, Museum,
Gallery or Library Book,
Campaign

**ARCHIGRAM:
EXPERIMENTAL
ARCHITECTURE
1961–1974**

Art Director
Masayoshi Kodaira
Designer
Masayoshi Kodaira,
Namiko Otsuka
Editor
Contemporary Art Center,
Art Tower Mito
Images
Archigram Archives
Photographer
Kozo Takayama,
Hiroki Nakashima
Publisher
Pie Books
Studio/Design Firm
Flame, Inc.
Client
Pie Books
Country
Japan

Merit
Corporate & Promotional
Design, Booklet/Brochure,
Campaign

**2005 GANGGU
PAPER ALBUM**

Art Director
Jun He
Copywriter
Jun He
Creative Director
Jun He
Designer
Jun He
Photographer
Li An, Meng Duan
Producer
Mewe Design Alliance
Studio/Design Firm
Mewe D A
Client
Beijing East Ganggu Paper
Trading Company Limited
Country
China

"Wrapper" is a propaganda album
designed for Ganggu paper in 2005.
It is made up of twelve pieces of
handcraft work made by twelve of
Ganggu's stuff and twelve pieces of
design work from twelve designers
correspondingly. Meanwhile, it is
also an advertisement of Ganggu's
paper products, including the paper
product with difficult promotion.
Naming it "Wrapper" has a double
meaning. One is the concept of
wrapping paper. The album intro-
duces twelve kinds of wrapping
paper, which are common but easy
to ignore; then, wrap them in
airproof way, which brings contrast
between new and old. Finally, pull
them apart to emphasize the
concept of wrapping paper. The
other is the meaning of a jacket. The
jacket and paper inside are printed
in the same printing plate, and cut in
different ways to produce the
distinction between jacket and
paper inside. No cost increase, but
twelve patterns of a unique jacket is
the real meaning of "Wrapper."

**MOJO PROMO MATERIALS:
CASE STUDY, BROCHURE,
DVD CASE, ENVELOPE**

Art Director
Sally Morrow
Copywriter
David Brooks
Creative Director
Sally Morrow
Designer
Sally Morrow, Shanin Andrew
Illustrator
Gina Triplett, Scott McGregor
Producer
Spike Selby
Studio/Design Firm
Sandstrom Design
Client
Mojo Pictures + Sound
Country
United States

The objective was to create mate-
rials that would engage an audience
that has little time; create materials
that would convey the unique nature
of Mojo Pictures + Sound. As a
company with a large roster of
capabilities (film, video, docu-info-
commercials, strategy, writing,
etc…), we created a combination
brochure and folder that focused on
their most significant capability:
storytelling. And the magic (mojo)
that can happen as a result.

Merit
Corporate & Promotional
Design, Booklet/Brochure,
Single

TGP GIFT HANDBOOK 2006

Copywriter
Dan Philips
Creative Director
Beth Elliott, James W Moore
Designer
Beth Elliott, James W Moore,
Rebecca McFarland
Editor
Denise Martin
Photographer
Terry Sutherland
Publisher
The Grateful Palate
Studio/Design Firm
Beth Elliott Design
Client
The Grateful Palate
Country
United States

WILBERFORCE

Art Director
Andrew Lawrence
Copywriter
Jayne Workman
Creative Director
Richard Scholey
Designer
Andrew Lawrence
Director
Simon Preece
Photo Editor
Tim Leonard
Producer
Jo Todd
Studio/Design Firm
Elmwood Design
Client
Hull City Image
Country
United Kingdom

Hull Cityimage wanted to create a brand that would position Hull as the lead city for the 2007 bicentenary of the abolition of the slave trade by "son of Hull" William Wilberforce. It also had to communicate Hull's aspiration to bring about positive change for its residents and in the wider world. The identity for this new brand presented a significant creative challenge: to reflect Wilberforce's history and principles within the context of modern slavery, and the renaissance of Hull itself as a city. It also had to have relevance beyond the 2007 bicentenary. Our solution avoided clichéd images of slavery and created a modern identity more in keeping with an organization dedicated to preserving human rights. Wilberforce 2007 Hull will be a highly visible brand promoted around the world. With involvement of world statesmen such as Archbishop Desmond Tutu, it will be at the forefront of raising awareness about an issue that most people believe has been confined to history.

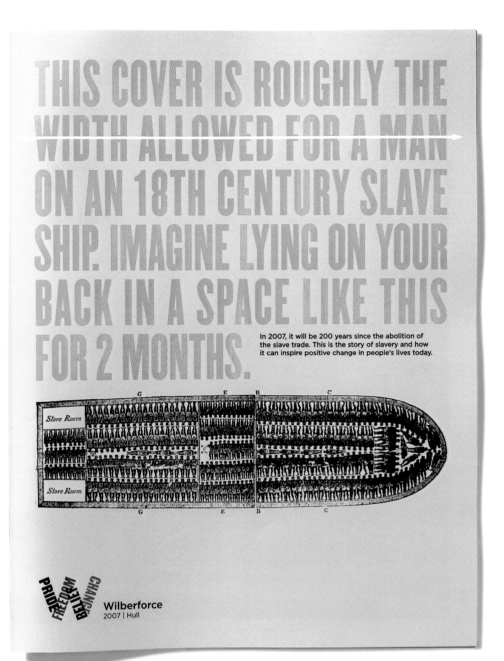

THIS COVER IS ROUGHLY THE WIDTH ALLOWED FOR A MAN ON AN 18TH CENTURY SLAVE SHIP. IMAGINE LYING ON YOUR BACK IN A SPACE LIKE THIS FOR 2 MONTHS.

In 2007, it will be 200 years since the abolition of the slave trade. This is the story of slavery and how it can inspire positive change in people's lives today.

Wilberforce
2007 | Hull

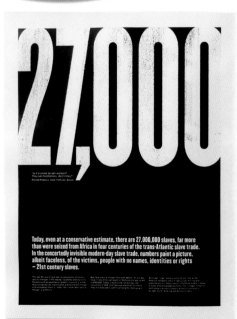
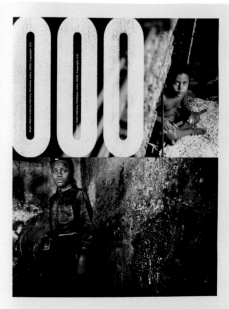

27,000 000

Today, even at a conservative estimate, there are 27,000,000 slaves, far more than were seized from Africa in four centuries of the trans-Atlantic slave trade. In the concertedly invisible modern-day slave trade, numbers paint a picture, albeit faceless, of the victims, people with no names, identities or rights — 21st century slaves.

Merit
Corporate & Promotional
Design, Booklet/Brochure,
Single

CACP

Art Director
Carlos Segura
Creative Director
Carlos Segura
Designer
Carlos Segura, Chris May
Photographer
Assorted
Printer
Sioux Printing,
Rohner Letterpress
Studio/Design Firm
Segura, Inc.
Client
Corbis
Country
United States

This letter-pressed/offset piece was
created to introduce Corbis' new
"Assignment and Commissioned
Photography" (CACP). Twenty-three
award-winning photographers who
are available for assignment. Corbis
represents some of the industry's
most renowned names, and is an
international collection of talent
spanning fashion, lifestyle, adver-
tising, journalism and portraiture.
Corbis is the new source for today's
most compelling and provocative
photographers.

Merit
Corporate & Promotional
Design, Booklet/Brochure,
Single

DARFUR FLIP BOOK

Art Director
Alice Ann Wilson
Copywriter
Tonia Simon
Creative Director
Marty Cooke
Designer
Alice Ann Wilson,
Shelly Bevilaqua,
Gemma Mitchell
Production Company
Ad Arts
Studio/Design Firm
SS+K
Client
Genocide Intervention Fund
Country
United States

The form of the flipbook is a way to
express the urgency of the genocide
happening in Sudan. A subtractive
population map shows the rapid
killing and evacuation of a single
Darfurian village over a period of
days. The population marks rapidly
disappear, forming the word
"GENOCIDE" before vanishing.
Designed for distribution at an anti-
genocide fundraising event, this
book became a mobile fundraising
tool which people were encouraged
to take and pass along to anyone
else who may be moved to
contribute or get involved.

Merit
Corporate & Promotional
Design, Newsletter, Journal,
or House Publication, Single

BELOW THE FOLD

Art Director
William Drenttel,
Jessica Helfand, Geoff Halber
Creative Director
William Drenttel,
Jessica Helfand
Designer
William Drenttel,
Jessica Helfand, Geoff Halber
Publisher
Winterhouse Institute
Studio/Design Firm
Winterhouse
Client
Winterhouse Institute
Country
United States

Merit
Corporate & Promotional
Design, Corporate Identity
Program, Campaign

**NEON CHESTERFIELD:
DINING MENUS,
CHECK HOLDERS,
WINE MENU, GIFT CARD
AND ENVELOPE**

Creative Director
Jorgen Olofsson
Designer
Karin Asplund
Director
Linda Bjork
Studio/Design Firm
Amore
Client
Tre Hotell i Gamla Stan
Country
Sweden

The visual identity for Leijontornet
was created in relation to an
inherent challenge: The dining area
houses the remains of a Stockholm
fortress wall from medieval times
and is the place where Sweden's
largest silver treasure was found.
This is an innovative world-class
restaurant situated in a 5-star hotel
and was in need of a thorough revi-
talization. We aimed for a visual
identity with a dynamic, unexpected
expression placed in contrast with
the museum-like history in the
restaurant.

Restaurang Leijontornet, Lilla Nygatan 5 Gamla Stan, 111 28
Stockholm, Sweden, P+46 8 506 400 80, F+46 8 506 400 85
info@leijontornet.se, www.leijontornet.se Mats Bengtsson
Owner, Dir +46 8 506 400 02, mats@leijontornet.se

Leijontornet

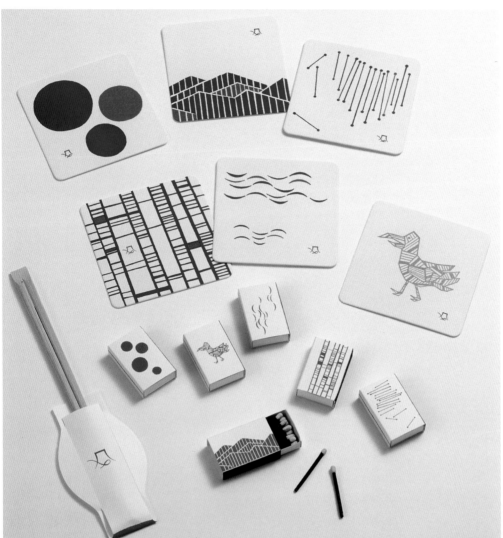

Merit
Corporate & Promotional
Design, Corporate Identity
Program, Campaign

**GO-FU-JYU-U
CORPORATE IDENTITY:
SHOP CARD, PAPER
COASTER, MATCH BOX,
DM (POSTCARD),
WRAPPING PAPER**

Art Director
Atsuki Kikuchi
Designer
Atsuki Kikuchi
Illustrator
Atsuki Kikuchi
Production Company
GO-FU-JYU-U
Studio/Design Firm
Bluemark, Inc.
Client
GO-FU-JYU-U
Country
Japan

"GO-FU-JYU-U" is an old Japanese
house renovated into a restaurant.
Therefore, I designed visual identity
for the image that had both oldness
and newness.

Merit
Corporate & Promotional
Design, Corporate Identity
Program, Campaign

**EFFENAAR VISUAL
IDENTITY**

Art Director
Renè Toneman
Creative Director
Renè Toneman
Designer
Serge Scheepers
Studio/Design Firm
Fabrique
Client
Effenaar
Country
Netherlands

The Eindhoven pop venue Effenaar
recently moved to a new building.
Fabrique developed a completely
new visual identity that is perfectly
in line with the ambience of this
building. The groundbreaking
programming at Effenaar is
extremely varied, and Fabrique
therefore developed a flexible house
style, with room for various forms of
cultural expression. The letter E
plays a key role and, thanks to the
use of different elements, is given a
different look each time. Grids and
shading give the letter a raw, indus-
trial and stylistic look, while the use
of colors creates a kaleidoscopic
effect that is completely in line with
Effenaar's unorthodox nature. Along
with the visual identity, Fabrique
also developed the recently
launched website www.effenaar.nl,
all correspondence materials,
publicity material and internal and
external signposting. Fabrique
designed an exclusive poster espe-
cially for the opening, which could
be given as a business gift to the
invited guests.

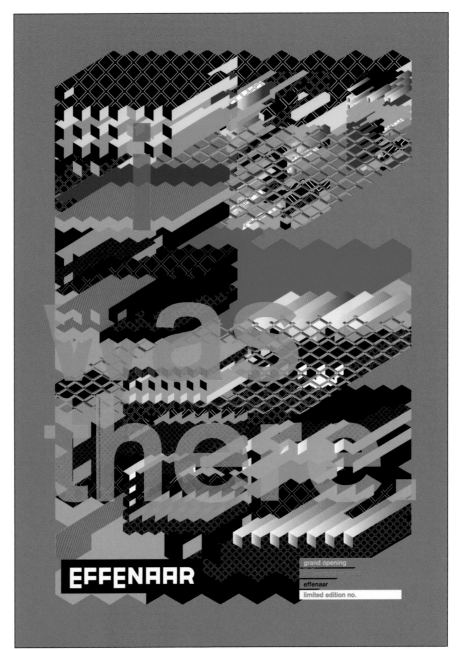

Merit
Corporate & Promotional
Design, Corporate Identity
Program, Campaign

**COUNTRY IDENTITY
AND PROMOTION: IDENTITY
SYSTEM, COASTER,
MENU, DOOR KNOB MENU,
SERVICE MENU**

Art Director
Andrea Brown
Creative Director
Matteo Bologna
Designer
Andrea Brown
Studio/Design Firm
Mucca Design Corp.
Client
Country Restaurant
Country
United States

With master chef Geoffrey Zakarian
at its helm, Country is a Manhattan
restaurant that serves sophisticated
contemporary dishes featuring
locally grown and organic ingredi-
ents. Located in the historic Carlton
hotel, the restaurant's interior design
revolves around a diverse mix of
original architectural details and
mid-century modern furniture.
Zakarian turned to Mucca for help in
developing a brand identity that was
uniquely representative of the
restaurant's eclectic character. We
used the C in Country as a basis for
the logo. To make it more dynamic
we overlapped different faces,
creating new shapes for every appli-
cation. On the menu we printed one
of the C's upside down so it can be
read both ways when it's flipped
open. Variously shaped and hued
C's are mixed randomly in each
instance of the logo to convey the
warm and whimsical spirit of the
restaurant. By creating an infinite
number of variations for it, the logo
can be visibly displayed throughout
the restaurant without ever feeling
overused.

THE NATIONAL
GALLERY IDENTITY

Designer
Kevin Lan, James Harvey
Art Director
Robert Ball
Copywriter
Robert Ball, John Simmons,
Jim Prior
Director
Jim Prior
Studio/Design Firm
The Partners Design
Consultants
Client
The National Gallery
Country
United Kingdom

The brief was to create a consistent
identity that helped promote a
reappraisal of the gallery in people's
minds. The solution lay in creating
intrigue through storytelling and
evocative language. Painting
pictures with words, and showing
paintings as glimpses, we called the
idea the "Gallery of the Mind."

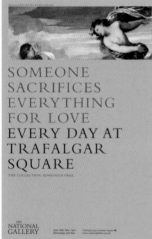

SOMEONE
SACRIFICES
EVERYTHING
FOR LOVE
EVERY DAY AT
TRAFALGAR
SQUARE

THE COLLECTION. ADMISSION FREE.

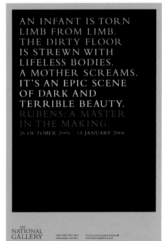

AN INFANT IS TORN
LIMB FROM LIMB.
THE DIRTY FLOOR
IS STREWN WITH
LIFELESS BODIES.
A MOTHER SCREAMS.
IT'S AN EPIC SCENE
OF DARK AND
TERRIBLE BEAUTY.
RUBENS: A MASTER
IN THE MAKING.
26 OCTOBER 2005 – 15 JANUARY 2006

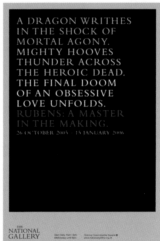

A DRAGON WRITHES
IN THE SHOCK OF
MORTAL AGONY.
MIGHTY HOOVES
THUNDER ACROSS
THE HEROIC DEAD.
THE FINAL DOOM
OF AN OBSESSIVE
LOVE UNFOLDS.
RUBENS: A MASTER
IN THE MAKING.
26 OCTOBER 2005 – 15 JANUARY 2006

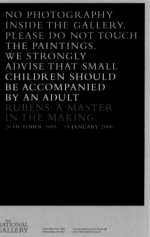

NO PHOTOGRAPHY
INSIDE THE GALLERY.
PLEASE DO NOT TOUCH
THE PAINTINGS.
WE STRONGLY
ADVISE THAT SMALL
CHILDREN SHOULD
BE ACCOMPANIED
BY AN ADULT
RUBENS: A MASTER
IN THE MAKING.
26 OCTOBER 2005 – 15 JANUARY 2006

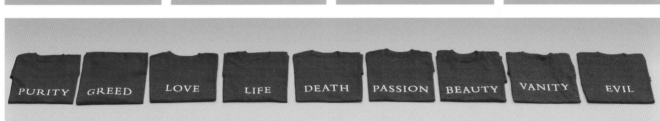

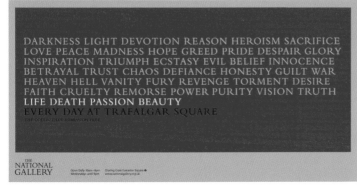

DARKNESS LIGHT DEVOTION REASON HEROISM SACRIFICE
LOVE PEACE MADNESS HOPE GREED PRIDE DESPAIR GLORY
INSPIRATION TRIUMPH ECSTASY EVIL BELIEF INNOCENCE
BETRAYAL TRUST CHAOS DEFIANCE HONESTY GUILT WAR
HEAVEN HELL VANITY FURY REVENGE TORMENT DESIRE
FAITH CRUELTY REMORSE POWER PURITY VISION TRUTH
LIFE DEATH PASSION BEAUTY
EVERY DAY AT TRAFALGAR SQUARE

THE COLLECTION. ADMISSION FREE.

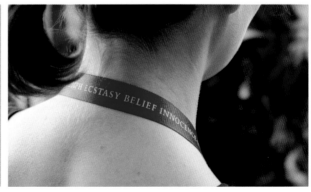

Merit
Corporate & Promotional
Design, Stationery, Campaign

**'05 SHENZHAN BIENNALE
OF URBANISM
ARCHITECTURE VISUAL
IDENTIFICATION SYSTEM**

Art Director
Yu Guang
Copywriter
Xiaohong Li, Juan Du,
Jia Zhang, Huiyang Zhang
Creative Director
Yu Guang
Designer
Yu Guang
Director
Yu Guang
Editor
Xiaohong Li, Juan Du,
Jia Zhang, Huiyang Zhang
Producer
Shenzhen City Government
Production Company
'05 Shenzhan Biennale
of Urbanism Architecture
Organizer Committee
Studio/Design Firm
MEWE Design Alliance
Client
'05 Shenzhan Biennale
of Urbanism Architecture
Organizer Committee
Country
China

The Visual Identification System is
designed based on the logical
concept of structuring Kanji. All
objects that can be described by
Kanji can also be illustrated by the
set of a new font, which is a core
feature of the biennale's Visual Iden-
tification System. The patterns that
appeared in the envelope, letter
paper, invitation, handbag, brochure
and CD cover etc. are repeated
placements of each object's name
written in the new font. Under the
principle of "identifiable," the
diamond shape is the most space-
efficient structural element to form a
Kanji. The concept and relationship
of a spot expanding to a large
dimension indicates the relationship
between architecture and the city.

Merit
Corporate & Promotional
Design, Complete Press/
Promotional Kit, Single

PBI/EPOM PRESS KIT

Art Director
Manabu Mizuno
Copywriter
Noriaki Yoshida
Designer
Yuta Akimoto, Takahiro Furuya
Creative Director
Manabu Mizuno
Production Company
Good Design Company
Publisher
Seven & I Holdings Co., Ltd.
Studio/Design Firm
Good Design Company
Client
Seven & I Holdings Co., Ltd.
Country
Japan

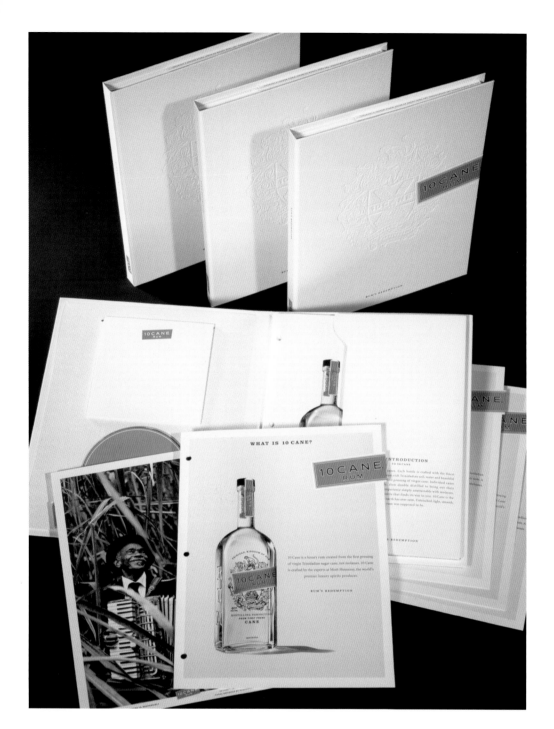

Merit
Corporate & Promotional
Design, Complete Press/
Promotional Kit, Single

Also for Hybrid
SEE PAGE 34

10 CANE LAUNCH KIT

Art Director
Sharon Werner
Copywriter
Todd Lamb
Creative Director
Linus Karlsson
Designer
Sharon Werner, Sarah Nelson
Illustrator
Elvis Swift
Photographer
Lars Toppelman
Studio/Design Firm
Werner Design Werks, Inc.
Client
Mother NY
Country
United States

10 Cane is a luxury rum made for
mixing top quality rum cocktails.
Alchemy is the underlying posi-
tioning of both the product and the
package. The mixing of the elegant
and classic crest with the irreverent
placement of the label, the raw
beauty of Trinidad with the sophisti-
cation of France—it's the redemp-
tion of the classic cocktail. The kit
conveys all of these things, and
above all, a sense of quality and
distinction. It looks clean and fresh.
It's compact and easy for sales-
people to carry, and has all the infor-
mation they need to tell the 10 Cane
story right at their fingertips.

Merit
Corporate & Promotional
Design, Self-Promotion:
Print, Single

**EXPLANATION OF
DEFEATED IDEA BOOK**

Art Director
Nishi Katsunori
Designer
Nishi Katsunori,
Sakuma Yoshimi,
Kariatsumari Miho,
Harada Yuko, Hoshino Chiiko,
Tanaka Aya
Illustrator
Nishi Katsunori,
Sakuma Yoshimi,
Kariatsumari Miho,
Harada Yuko, Hoshino Chiiko,
Tanaka Aya
Publisher
Honolulu, Inc.
Studio/Design Firm
Honolulu, Inc.
Client
Honolulu, Inc.
Country
Japan

The one that idea regrettably
defeated in business was made
into a collection book. It was
distributed as a corporate profile
in fiscal year 2006.

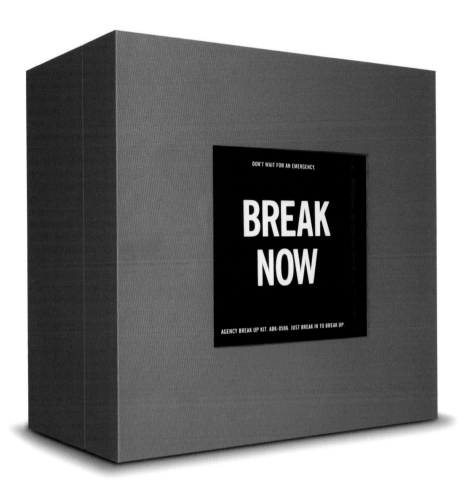

BREAK NOW

Art Director
Philip Pitcher
Creative Director
Rob Taylor, Peter Rogers
Studio/Design Firm
Like A River
Client
Like A River
Country
United Kingdom

What we wanted to do here was to
encourage new business prospects
to "Break Now" from their agency
and try us out. The concept is based
on a UK style fire alarm. The key
message is "Break Now before your
brand gets burnt." We included a
(safety style) guidebook with useful
phrases, postcards showing our
work (a cruel but fun way to sack
their agency), Dutch Courage,
even tissues to console broken
hearted executives!

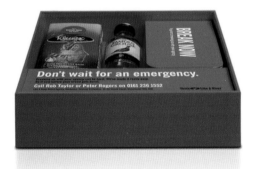

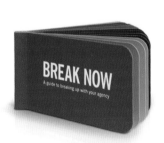

Merit
Corporate & Promotional
Design, Self-Promotion:
Print, Single

LE GRAND LIVRE DES NAPPERONS

Art Director
Renè Clèment
Creative Director
Louis Gagnon
Designer
Renè Clèment
Studio/Design Firm
Paprika Communications
Client
Transcontinental Litho-Acme
Country
Canada

Paprika was mandated by
Transcontinental Litho Acme to
create a unique piece that would be
distributed as Christmas gifts to
clients of both firms. The main chal-
lenge was to impress and please, as
well as promote the expertise of
both companies in their fields of
excellence: design and printing.
Paprika created a book of table
paper mats with an exclusive selec-
tion of 8 series of mats. The Big
Book of Table Mats was offered as
Christmas gifts to clients, suppliers,
artists, and friends of Paprika
Design and Transcontinental Litho
Acme printing.

Merit
Corporate & Promotional
Design, Self-Promotion:
Print, Single

**2005 VALENTINE'S DAY
CARD**

Copywriter
Alison Illies
Designer
Joe Cecere
Creative Director
Joe Cecere
Project Director
Kris McCoy
Printer
Shapco Printing
Studio/Design Firm
Rachel Meier
Client
Little & Company
Country
United States

Little & Company designs and
produces an annual Valentine's Day
card for clients, partners, & friends—
the card is a love fest, an opportunity
to reconnect and let them know how
much we love and appreciate them.
Most importantly, our Valentine is an
opportunity to give back to our
local and global communities with
charitable donations.

Merit
Corporate & Promotional
Design, Self-Promotion:
Print, Single

**BFA PHOTOGRAPHY
PORTFOLIO**

Art Director
Michael J. Walsh
Creative Director
Silas H. Rhodes
Designer
Brankica Kovrlija
Photo Editor
Stephen Frailey,
Department chair
Studio/Design Firm
School of Visual Arts
Client
School of Visual Arts
Country
United States

Merit
Corporate & Promotional
Design, Promotional Apparel,
Single

FEDEX T-SHIRT

Art Director
Chuck Tso, Eric Schutte
Creative Director
David Lubars, Eric Silver
Studio/Design Firm
BBDO New York
Client
FedEx
Country
United States

In an effort to maintain visibility
amongst the sea of delivery
personnel, FedEx challenged us to
come up with a way to keep their
brand top-of-mind when it comes to
package delivery. This promotional
shirt has a unique wraparound
design, giving the impression of a
FedEx envelope being carried by its
wearer. The shirts were handed out
in and around major delivery hubs
around the country.

FRONT

BACK

Merit
Corporate & Promotional
Design, Promotional Apparel,
Single

ARBOR DAY TOTE BAG

Creative Director
Helicopter
Designer
Helicopter
Art Director
Helicopter
Copywriter
Helicopter
Illustrator
Helicopter
Production Company
Helicopter:
Andrew Ackermann
Studio/Design Firm
Helicopter
Client
Self Promotion
Country
United States

We want to be better citizens of the
world. We combined our Christmas
gift and promotional package into
this Arbor Day package. The idea
was to give the recipients of the gift
an opportunity to participate in envi-
ronmentalism without subjecting
them to guilt or feelings of inade-
quacy. Its simple: use tote, plant
tree. For the adventurous, there are
links to make donations. All profits
from bag sales were donated to the
Environmental Defense Fund.

Merit
Corporate & Promotional
Design, Postcard, Greeting
Card, or Invitation Card, Single

MIXER

Art Director
Cathy Solarana,
Michah Schmiedeskamp,
Randall Myers
Creative Director
Marty Amsler
Designer
Cathy Solarana
Studio/Design Firm
Bailey Lauerman
Client
Bailey Lauerman
Country
United States

Concepting in a construction zone
with paint fumes may have been
partially responsible for the invita-
tion to our cocktail reception
unveiling our newly renovated office.
When every nail was in place and
every inch of paint had dried, it was
time to celebrate with clients and
colleagues. So we came up with a
simple invite to honor the occasion.
And on a sunny Friday afternoon,
we gathered in Marty's garage out in
suburbia, armed with supplies—two
boxes of paint stirrers, 3 gallons of
paint, 9 bags of clothes pins, some
rope and, of course, a cooler of
beer. The result was 400 hand-
dipped invitations in the colors of
our new office and a garage floor
that will never be the same.

Merit
Corporate & Promotional
Design, Postcard, Greeting
Card, or Invitation Card, Single

MOHAWK SHOW 6 INVITE

Art Director
Joshua C. Chen
Creative Director
Joshua C. Chen
Designer
Max N. Spector
Studio/Design Firm
Chen Design Associates
Client
Mohawk Paper Mills
Country
United States

A good party often has a pervading
sense of abundance. This invitation
attempts to reflect the character of
the event by portraying it in such an
atmosphere. The number six refer-
ences the name of the party
(Mohawk Show Six), but more
significantly provides a basis for
exaggeration. Each picture presents
six items, which is more than
expected (more fingers, more olives,
more towers on the Golden Gate
bridge, etc…). With complementary
food and drinks, the message was
far from an exaggeration.

Merit
Corporate & Promotional
Design Postcard, Greeting
Card, or Invitation Card, Single

TISCHLEIN DECK DICH

Creative Director
Annette Häfelinger,
Frank Wagner
Designer
Jenny Heinecker,
Adelgund Janik,
Markus Kirsch, Viviana Tapia
Studio/Design Firm
Häfelinger+Wagner Design
Client
Häfelinger+Wagner Design
Country
Germany

**WITH THE PERSON,
WITH THE TREE**

Art Director
Go Kato
Copywriter
Norihumi Yamagami
Creative Director
Fujiko Shirataki,
Norihumi Yamagami
Designer
Syugo Takeuchi
Photographer
Yoshiyuki Ikuhara
Illustrator
Tansetsu Ogino
Studio/Design Firm
Daiko Advertising, Inc.
Client
Nishigaki Lumber, Inc.
Country
Japan

Nishigaki Lumber, Inc. has been
developing and preserving precious
old traditions such as manual crafts-
manship, while valuing the coexis-
tence of nature and humans without
being overwhelmed by a shift in
social trends. The Nishigaki Lumber
calendar was produced as a tool to
represent such thoughts toward
nature, through the motto "Inspira-
tional visual arts, conveying thought
and feelings to the viewers." With the
theme of "trees and humans," the
project aims to show humans and
trees as being blessed by Mother
Nature just like all living things, as
well as the fascinating figurative
aspect of resemblance, by showing
the survival power shared by humans
and trees alike. This is expressed in
contrasting dynamic photos.

Merit
Corporate & Promotional
Design, Calendar or
Appointment Book, Single

**EVERLASTING ADHESIVE
CALENDAR**

Art Director
Ivana Vucic, Orsat Frankovic
Copywriter
Ivana Vucic, Orsat Frankovic
Creative Director
Ivana Vucic, Orsat Frankovic
Designer
Ivana Vucic, Orsat Frankovic
Production Company
Laboratorium
Producer
Laboratorium
Publisher
Laboratorium
Studio/Design Firm
Laboratorium
Client
Laboratorium
Country
Croatia

It has always been hard to find
something good enough to give to
people you care about, and on the
other hand, something good
enough to represent the studio.
After coming up with the idea of the
Everlasting Calendar, we do not
have that problem anymore. It will
work as everlasting gift.

**THE WRONG WORKING
ENVIRONMENT:
COFFEE DISPENSER,
CASH MACHINE,
PHOTO BOOTH**

Art Director
David Fischer
Copywriter
Axel Tischer
Creative Director
Matthias Spaetgens,
Jan Leube
Designer
Inga Schulze,
Sara dos Santos Vieira
Producer
Soeren Gessat
Photographer
Hans Starck
Studio/Design Firm
Scholz & Friends Berlin GmbH
Client
jobsintown.de
Country
Germany

The task was to increase the brand
awareness of Jobsintown.de and to
communicate it as a serious chal-
lenger to the established employ-
ment agencies. Regarding the small
media budget, we had to reduce
losses due to non-selective adver-
tising to a minimum, by exactly
targeting people who are willing to
change their job or employer. We
reached this goal by providing a
surprising insight into cash
machines, photo booths and coffee
dispensers. Full-sized posters on
the sidewalls of these service
machines show people working
under hair-raising conditions instead
of the expected machinery. With this
unusual positioning and the involve-
ment of the environment we reveal
how terrible it could be to have the
wrong job in a striking way. We
especially chose service machines,
which were situated on highly
frequented subway stations and
their nearby environments. Thus we
could reach our primary target
group effectively: commuters on
their way to work.

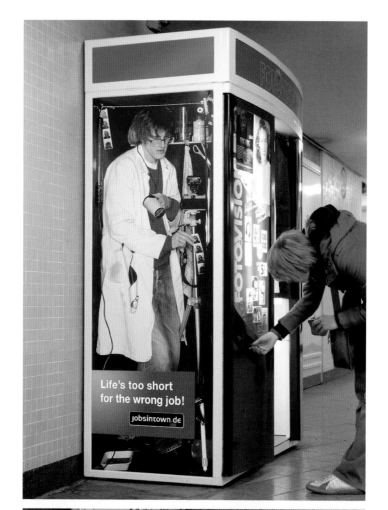

IT CONSOLIDATES

Art Director
Jesus de Francisco,
Mark Kudsi, Stacy Milrany
Copywriter
Will Elliot
Creative Director
Mathew Cullen, John Norman,
Hunter Hindman, Rick Condos
Designer
Paulo de Almada, Kaan Atilla,
Earl Burnley, John Clark,
Mathew Cullen,
Jesus de Francisco,
Gabe Dunne, Jesse Franklin,
Christopher Janney,
Chris De St Jeor,
Linas Jodwalis, Mark Kudsi,
Mark Kulakoff, Mark Lai,
Chris Leone, Vi Nguyen,
Robyn Resella, Kirk Shintani,
Mike Slane
Director
Motion Theory
Editor
Jeff Consiglio
Producer
Javier Jimenez, Scott Gemmell
Production Company
Motion Theory
Studio/Design Firm
Motion Theory
Client
HP
Country
United States

The complications of everyday life whimsically simplify in "It Consolidates," a :30 HP spot that communicates the power of the company's newest enterprise server. Motion Theory integrated live-action and animation techniques to meld art and film, creating a unique style that illustrates the message in myriad everyday solutions. Over the course of the spot, a tangle of freeways becomes a unified highway, a messy cubicle cleans itself, a chaotic office folds into its most organized form and more. The runaway consolidation ends in the server room, where the HP enterprise server tames and unruly tangle of server wires. Illustration infuses the spot with a lighthearted tone, giving the sense that the consolidating power of the HP server extends well beyond everyday technology, and brings business chaos under control.

Merit
Corporate & Promotional
Design, Calendar or
Appointment Book, Campaign

UNA DIARY 2006

Designer
Will de l'Ecluse,
Tim Baumgarten
Photographer
Andrè Thijssen
Creative Director
Will de l'Ecluse
Photo Editor
Andrè Thijssen
Producer
UNA (Amsterdam) designers
Production Company
UNA, Mart Spruijt,
Grafisch Papier, AKS,
Hexspoor, Andrè Thijssen
Publisher
UNA, Mart Spruijt,
Grafisch Papier, AKS,
Hexspoor, Andrè Thijssen
Studio/Design Firm
UNA (Amsterdam) designers
Client
UNA (Amsterdam) designers
Country
Netherlands

When you leaf through this publica-
tion you see a book of blank and
colored pages. On closer examina-
tion, you see image pages with the
month, week and days indicated, a
diary. We know them all, those
everyday situations; everybody can
see them but only a few give them a
second glance. In just such
everyday situations André Thijssen
sees comic, absurd or puzzling
images, which he captures and
names. Sometimes you need some-
body to give you a hand to see
things or to see them differently.

**NONPLUSULTRA –
WALL CALENDAR 2006**

Art Director
Kirsten Dietz,
Jochen Raedeker
Creative Director
Kirsten Dietz,
Jochen Raedeker
Designer
Susanne Hoerner,
Felix Widmaier
Illustrator
Susanne Hoerner
Production Company
Grafisches Zentrum
Drucktechnik, Ditzingen-
Heimerdingen
Studio/Design Firm
strichpunkt
Client
Papierfabrik Scheufelen
GmbH+Co. KG
Country
Germany

For its 2006 calendar, strichpunkt
used 150-year-old chromo-lithogra-
phies from the Kurt Weidemann
collection—and to tremendous
effect: complemented by contem-
porary designs in white-on-white in
various finishes, the Scheufelen
calendar is the non-plus-ultra in
state-of-the-art papermaking,
reproduction and printing.

THE FAN CALENDAR

Art Director
Marcin Baba
Copywriter
Dennis Lueck
Creative Director
Suze Barrett, Tobias Holland
Photo Editor
Metagate GmbH, Hamburg
Studio/Design Firm
Scholz & Friends
Hamburg GmbH
Client
FC Schalke '04
Supporters Club e.V.
Country
Germany

Merit
Corporate & Promotional
Design, Miscellaneous,
Campaign

**CHRISTCHURCH ART
GALLERY TATTOOS:
ART IS FUN, EYE SPY,
ARTY FARTY, ART ATTACK,
ART ROCKS**

Art Director
Guy Pask, Douglas Maclean
Creative Director
Guy Pask, Douglas Maclean
Designer
Justine Holmes
Studio/Design Firm
Strategy Advertising & Design
Client
Christchurch Art Gallery
Country
New Zealand

The brief was to create a series of
children's giveaways that would
make the Art Museum more acces-
sible and fun for younger visitors.
A specific font was created as a
branding device for the Christchurch
Art Gallery and this was used to
create "faces" that became tempo-
rary tattoos, highlighting awareness
and the more light-hearted side of
art. Particularly popular with children
were the "arty-farty" tattoos. These
tattoos were primarily aimed at 4–12
year old children, either coming to
the gallery with parents, or as part
of school visits.

Merit
Poster Design, Promotional,
Campaign

FRF X LEVI'S

Art Director
Takeshi Yamamoto, Jiro Aoki
Copywriter
Takahiro Nozaki
Creative Director
Takeshi Yamamoto
Designer
Jiro Aoki
Studio/Design Firm
ADK
Client
Levi Strauss Japan K.K.
Country
Japan

By printing this poster on tough
denim fabric, I created a highly
versatile poster that works as a
shelter against rain, a cloak against
cold, or a leisure sheet for seating.
What's more, in producing a keep-
sake that will outlast the event, my
aim was to create something that
will cement the bond between its
owner and Levi's.

Merit
Television & Cinema Design,
TV Identities, Openings,
Teasers, Single

NOGGIN ANTHEM

Art Director
Matthew Duntemann
Copywriter
Dixie Feldman
Designer
Melinda Beck
Editor
Naree Song – Bunko Studios
Producer
Clark Stubbs
Production Company
NOGGIN Brand Comm.
Studio/Design Firm
MTV Networks
Client
NOGGIN Brand COMM.
Country
United States

Target Audience: Preschoolers and
their parents. We wished to create
a rousing song (sung by our very
popular navigational character
Moose E. Moose) that was imbued
with a great nationalistic fervor and
served as a rallying cry for our
NOGGIN audience. One of our
primary challenges was how to
make NOGGIN stand out in a world
saturated with pre-school
content/media. What has made
NOGGIN so successful is that most
everything we do (including this
song) entertains parents while still
being totally accessible to their little
preschoolers. Parents are just as
delighted as their children by our
song campaigns because we are
able to write and direct the creative
(design/animation/story) in such a
way that we give a sly ironic wink to
the parent while at the same time
delighting small children. Parents
love us and their kids do too!!!

Merit
Poster Design, Promotional,
Campaign

TAMAKI POSTER

Art Director
Osamu Misawa
Designer
Osamu Misawa, Maiko Takeda
Studio/Design Firm
Osamu Misawa Design
Room Co., Ltd.
Client
Tamaki
Country
Japan

SUGAHARA GLASSWORKS INC.
797 fujishita kujukuri-machi
sanbu-gun, chiba. 283-0112
tel:0475-76-3551 www.sugahara.com
info@sugahara.com

SUGAHARA GLASSWORKS INC.
797 fujishita kujukuri-machi
sanbu-gun, chiba. 283-0112
tel:0475-76-3551 www.sugahara.com
info@sugahara.com

Merit
Poster Design, Promotional,
Campaign

HANDMADE

Art Director
Koji Iyama
Designer
Koji Iyama
Illustrator
Koji Iyama
Production Company
Iyama Design
Studio/Design Firm
Iyama Design
Client
Sugahara Glassworks Inc.
Country
Japan

These posters are for a handmade
glassmaker, Sugahara. To empha-
size their commitment to the hand-
made craft, I drew their products in
aqueous ink. I also wrote every
single block letter by hand to further
emphasize their delicate work of art.

Merit
Package Design,
Food/Beverage, Single

SHIELD OIL CAPSULE

Art Director
Xiaoming Zhang
Designer
Xiaoming Zhang
Illustrator
Huzi & Xiaoming Zhang
Creative Director
Xiaoming Zhang
Director
Shengguan Ma
Studio/Design Firm
Coidea Design Consultants
Client
The Sino-American
Joint Ventuse,
Ningxia Biology Food Co., Ltd.
Country
China

To support the new actions and
measures launched by Ningxia
Zhicheng Biotic Food Engineering
Co., Ltd, we have designed, for its
major product—Holy Shield Oil
Capsule, a series of packages, which
are designed with a view to expati-
ating our common understanding
on the healthy products industry
and on the consuming philosophy
nowadays by using pure graphic
and color-based language without,
however, following the commercial-
ization trend prevalent in current
healthy products package design.

Merit
Poster Design, Promotional,
Campaign

**YASEI JIDAI: STYROFOAM,
POST-IT, CURSIVE,
JAPANESE PAPER**

Art Director
Norito Shinmura
Designer
Yuka Watanabe,
Kousuke Niwano
Photographer
Kiyofusa Nozu
Creative Director
Norito Shinmura
Production Company
Shinmura Design Office
Publisher
Kadokawa Shoten Co., Ltd.
Studio/Design Firm
Shinmura Design Office
Client
Kadokawa Shoten Co., Ltd.
Country
Japan

These posters were created for the
promotion of Yasei Jidai, a monthly
publication showcasing the writings
of various authors. The purpose of
this series was to express the content
of the publication graphically, using
various kinds of materials.

Merit
Poster Design, Promotional,
Campaign

**THIS MUST BE THE PLACE:
RED, GREEN, BLUE**

Art Director
Claire Dawson, Fidel Peòa
Creative Director
Claire Dawson, Fidel Peòa
Designer
Claire Dawson, Fidel Peòa
Studio/Design Firm
Underline Studio
Client
InterAccess Electronic Media
Arts Centre
Country
Canada

This campaign for the electronic arts
gallery invites audiences to examine
their relationships with interactive
artworks. The posters were placed
on the streets of Toronto, and the
distance from that spot to the new
location of the gallery was hand-
written by volunteers, informing
viewers of their relative distance (in
time) to the gallery, "the place."

Merit
Poster Design, Promotional,
Single

TOKYO-BERLIN EXHIBITION

Art Director
Manabu Mizuno
Designer
Yui Takada, Chiaki Aizawa
Creative Director
Manabu Mizuno
Production Company
good design company co,. inc.
Publisher
Mori Art Museum
Studio/Design Firm
good design company co., inc.
Client
Mori Art Museum
Country
Japan

Merit
Poster Design,
Public Service/Nonprofit/
Educational, Single

MADE IN CHINA–NIKE

Art Director
Jun He
Copywriter
Jun He
Creative Director
Jun He
Designer
Jun He
Director
Jun He
Illustrator
Yan Qu
Studio/Design Firm
Mewe D A
Country
China

The posters of "Made In China"
series are designed by Mewe
Design Alliance for the theme "In
China" of the exhibition "Graphic
Design In China '05." The posters
are made up of the logo of "Made In
China" and the logo of "Mewe
Design Alliance." Many people have
visited the Silk Market in China. The
peddlers there usually stick the logo
of "Nike," "adidas," etc…on their
merchandise to show their goods
are not fake and ward off inspection.
Actually, both the buyer and seller
are tacit, which demonstrates the
embarrassing condition of the name
brand in China.

Merit
Poster Design, Promotional,
Campaign

CAFE CHARAN PORAN

Art Director
Kenichi Sato
Designer
Kenichi Sato
Production Company
Terashima Design Co.
Studio/Design Firm
Terashima Design Co.
Client
Cafe Charan Poran
Country
Japan

I made lips using coffee beans for
coffee lovers.

Merit
Package Design, Gift/Specialty
Product, Campaign

**KIMONO ROSE PACKAGING:
CANDLE, PERFUME,
BATH SALTS**

Creative Director
Dan Olson
Designer
Brad Surcey
Copywriter
Lisa Pemrick
Studio/Design Firm
Duffy & Partners
Client
Thymes
Country
United States

The introduction of a new line from
the Thymes that redefines femi-
ninity. With a sparkling and lyrical
design, Kimono Rose is
unabashedly feminine, beautifully
layered with an undercurrent of
intrigue. A sheer, sensuous floral
scent finished with a kiss of smooth,
silken vanilla and encased by a
unique closure representing features
of a kimono. Delicate but dynamic,
soft-spoken, yet striking, it is a
modern reflection of who you are,
and who you want to be, all
wrapped up in one truly lovely
creation.

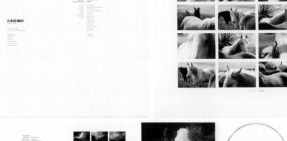
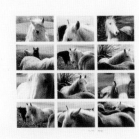

Merit
Package Design,
Entertainment, Campaign

MARC HELLNER EP AND LP:
MARC HELLNER CD EP,
VINYL EP, CD, LP, VINYL LP

Art Director
Hans Seeger
Photographer
Cedric Buchet
Studio/Design Firm
Hans Seeger
Client
Peacefrog Records
Country
United States

Merit
Environmental Design,
Trade Shows, Campaign

BARONET 2005

Art Director
Sebastien Bisson,
Louis Gagnon
Creative Director
Louis Gagnon
Designer
Sebastien Bisson
Studio/Design Firm
Paprika Communications
Client
Baronet
Country
Canada

Baronet is a high-end furniture
manufacturer known for superb
craftsmanship and distinctive
design. For the design of our Fall
2005 showroom, we decided to
focus on the tradition and the history
of the company. We created a series
of illustrations inspired by the actual
plan and archives documents.

DIALOG IN THE DARK 2005

Art Director
Manabu Mizuno
Designer
Yui Takada
Creative Director
Manabu Mizuno
Production Company
Good Design Company
Publisher
TBS Radio &
Communications, Inc.
Studio/Design Firm
Good Design Company
Client
TBS Radio &
Communications, Inc.
Country
Japan

Merit
Television & Cinema Design,
Title Design, Single

KISS KISS, BANG BANG

Designer
Danny Yount,
Stephen Schuster,
James Choi
Director
Danny Yount
Producer
Phyllis Weisband-Fibus
Production Company
Prologue
Studio/Design Firm
Prologue
Client
Silver Pictures
Country
United States

Using crime novels from the 60s as
a central theme, we developed a
number of ideas ranging from a
photographic tabletop shoot to
graphic solutions that were stylisti-
cally similar to titles Saul Bass had
done in that era. The story was to be
kept organic in the sense that
certain metaphors, like those pulled
from the novels, would direct it but
not give away the plot. At times the
sequence nods to scenes within the
film, and other times it plays out
abstractly, interweaving representa-
tions of the film's characters with
parts of urban LA and the Holly-
wood Hills. Fortunately, the music fit
the mood of the concept, so we let it
drive the animation and design.

Merit
Environmental Design,
Gallery Museum Exhibit/
Installation, Campaign

**DOVE PRESENTS:
WOMEN PHOTOGRAPHERS
ON BEAUTY, EXHIBIT 1-4**

Art Director
David Israel
Executive Creative Director
Brian Collins
Designer
Leigh Okies,
Nathalie Hennequin,
Satian Pensathapon,
3rd Uncle
Studio/Design Firm
Ogilvy & Mather
Client
Dove
Country
United States

The Brand Integration Group (BIG) in New York helped DOVE create an international photo exhibition to explore the question What is beauty? Many of the world's foremost women photographers contributed their work to the exhibit Beyond Compare. The photos in the exhibit reflect Dove's belief that beauty comes in all shapes, sizes, colors, and ages. More than 80 percent of the visitors stayed for 30 minutes or more, and 95 percent of the women polled said the exhibit was successful in helping them see and think about beauty in a new way.

Merit
Package Design,
Entertainment, Campaign

ART STAR

Art Director
Masayoshi Kodaira
Designer
Masayoshi Kodaira
Artist
Yoshitomo Nara,
Kenji Yanobe, Takashi Homma,
Noriyuki Tanaka
Producer
Masaki Asano
Production Company
FLAME, Inc.
Publisher
TOPPAN Printing Co., Ltd.
Studio/Design Firm
FLAME, Inc.
Client
TOPPAN Printing Co., Ltd.
Country
Japan

Merit
Poster Design, Promotional,
Single

IRENE SCHWEIZER

Art Director
Niklaus Troxler
Designer
Niklaus Troxler
Studio/Design Firm
Niklaus Troxler Design
Client
Jazz in Willisau
Country
Switzerland

Merit
Package Design, Gift/Specialty
Product, Campaign

**FILIGREE PACKAGING:
BODY CRÈME, BATH SALTS,
BAR SOAP, CANDLE**

Creative Director
Dan Olson
Designer
Esther Mun
Copywriter
Lisa Pemrick
Studio/Design Firm
Duffy & Partners
Client
Thymes
Country
United States

With an approachable sophistica-
tion that manages to be both classic
and contemporary, this evocative
collection is poetic, elemental, and a
celebration of individual unique-
ness. Clean and lovely, Thymes Fili-
gree captures the elusive nuance
and subtlety that can be found all
around us, if only we know where to
look. The rich brown against the
embossed leaf pattern, unique
closures and die-cuts all add up to a
true reflection of the sophistication
of the collection and the artistic
nature of Thymes. The customized
laser-cut lace wrapped around the
neck of the bottles brings forward
the poetry of the fragrance and
delivers a unique quality, enhancing
the gift-ability of the collection.

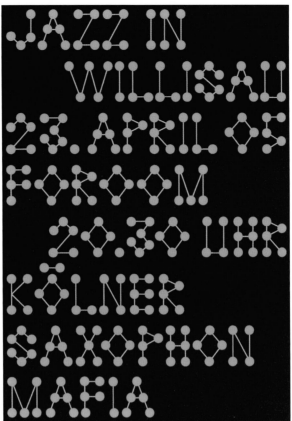

Merit
Poster Design, Promotional,
Single

**KOELNER SAXOPHON
MAFIA**

Art Director
Niklaus Troxler
Designer
Niklaus Troxler
Studio/Design Firm
Niklaus Troxler Design
Client
Jazz in Willisau
Country
Switzerland

Merit
Package Design, Gift/Specialty
Product, Single

RING PACKAGE

Art Director
Yoshie Watanabe
Copywriter
Yayako Uchida
Creative Director
Satoru Miyata
Designer
Yoshie Watanabe
Illustrator
Yoshie Watanabe
Producer
Toshihide Nishio
Studio/Design Firm
DRAFT Co., Ltd.
Client
Nagahori Corporation
Country
Japan

These books are designed to serve
as packages to hold an engagement
ring and wedding ring. They feature
a scene where the window in the
house casts a shadow with the
frame partially blocking incoming
light. The great attention to detail
forced on the project by having to
meet rigorous specifications for the
design of the box, such as making it
easy to place and remove the ring
and keeping it firmly in place, ended
up being a credit to the quality of the
accomplishment. It would make me
very happy if married couples open
up the book years later and are
reminded of the wonderful memo-
ries of their wedding day.

Merit
Environmental Design,
Environment, Campaign

Also for Advertising
Merit
Collateral Advertising,
Guerrilla/Unconventional,
Campaign
SEE PAGE 165

**REAL TOYS: FIRE ENGINE,
GARBAGE TRUCK, DIGGER**

Art Director
Florian Meimberg
Copywriter
Torsten Pollmann, Claudia
Meimberg
Creative Director
Florian Meimberg,
Torsten Pollmann
Studio/Design Firm
Grey Worldwide GmbH
Client
Toys "R" Us
Country
Germany

What makes a toy desirable? It has
to look as real as possible. For the
TOYS "R" US Christmas promotion
"Real Toys", real fire engines,
garbage trucks and diggers with
oversized price tags drove through
urban areas in the time before
Christmas. That gave children the
impression of real toys driving
around. Hopefully the kids were not
disappointed when they'll unwrap
the smaller version at Christmas Eve.

Merit
Poster Design,
Public Service/Nonprofit/
Educational, Campaign

INTRO TECH MUSIC PARTY

Art Director
Bai Zhiwei
Creative Director
Bai Zhiwei
Designer
Bai Zhiwei
Photographer
Bai Zhiwei
Production Company
SoundFilter
Studio/Design Firm
Bai Zhiwei Graphic studio
Client
SoundFilter
Country
China

This is a group of performance
posters of an Electronic Band called
"Intro tech." They are well known for
their multiplex style.

Merit
Poster Design,
Public Service/Nonprofit/
Educational, Campaign

PEACE POSTERS:
1-4, NESSIM HIGSON

Art Director
Nessim Higson
Copywriter
George W Bush
Designer
John Finnell, Nessim Higson
Studio/Design Firm
IAAH/iamalwayshungry
Client
The One Show of NY
Country
United States

I speak for both John and I in that one of the most important aspects in having the Peace posters featured in the 85th Annual Art Directors show is the fact that the posters can be seen and heard by more people than was originally intended. The One Club of NY asked for something for their upcoming show on Political Propaganda. The rest—as they say—fell in place. It seemed like the smartest thing we could do was utilize the administration's voice against itself. A big shout out to George W for the invaluable material. Please contact us for posters.

Merit
Poster Design,
Public Service/Nonprofit/
Educational, Single

NINTENDO 2006
NEW GRADUATE
RECRUITMENT POSTER

Art Director
Takashi Maeda
Creative Director
Shin Kojo
Designer
Takashi Maeda
Production Company
Nintendo Co., Ltd.
Publisher
Nintendo Co., Ltd.
Studio/Design Firm
Nintendo Co., Ltd.
Client
Nintendo Co., Ltd.
Country
Japan

We wanted to turn heads. Even draw attention from those who do not have the slightest interest in joining Nintendo. We emphasized impact, lucidity, and humor because we are a company that provides "fun." In order to show Nintendo's commitment to creativity, we used dense offset printing on a Japanese paper to make it look as though it was painted.

**THE DOLPHINS
IN THE NET PROMOTION**

Art Director
Cathrin Ciuraj
Copywriter
Edgar Linscheid,
Christian Ole Puls,
Katharina Psczolla
Creative Director
Matthias Spaetgens,
Jan Leube
Producer
Sabine Baesler, Anikó Krueger,
Anne Gabriel
Studio/Design Firm
Scholz & Friends Berlin GmbH
Client
WDCS Deutschland
Country
Germany

WDCS wants to strengthen public
awareness of their work: the conser-
vation of whales and dolphins. The
organization wants to call attention to
the problem of catching dolphins in
fishing nets, and they want to inspire
people to adopt endangered
dolphins from the North Sea. A card
with a reply card was created. On the
back it says "you too can save
dolphins." On the front it shows a
dolphin. The card was put in seat
back pockets of buses and trains. By
taking the dolphin card out of the
pocket the passengers symbolically
free the animals out of the fishing net.

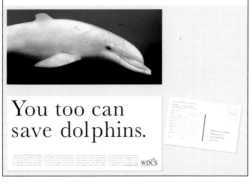

DAZER

Art Director
Takashi Miyake
Copywriter
Tetsu Suzuki
Creative Director
Takashi Miyake
Designer
Takashi Miyake,
Yumiko Shimada, Asuka Yagi
Production Company
Trademarks, Inc.
Studio/Design Firm
Trademarks, Inc.
Client
Neway Japan
Country
Japan

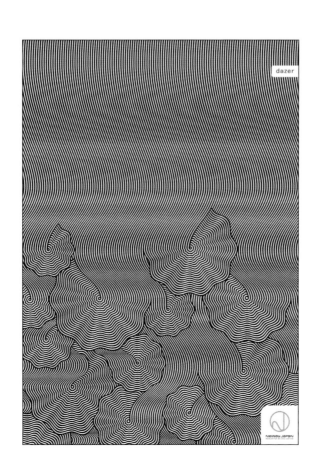

Merit
Poster Design,
Public Service/Nonprofit/
Educational, Campaign

THEATER BRAVA!

Art Director
Shinnoske Sugisaki
Designer
Shinnsuke Suzuki,
Chiaki Okuno
Production Company
Shinnoske, Inc.
Creative Director
Mikio Uno
Studio/Design Firm
Shinnoske, Inc.
Client
Mainichi Broadcasting System
Country
Japan

This is a poster for a multi-purpose theater mainly used for dramas. "Brava!" is a eulogy for women, in Italian. The logo is a visualization of cheers and applause featured in the letters "Brava!" The visual identity system can be transformed in various compositions to modify purposes and applications.

Merit
Corporate & Promotional
Design, Calendar or
Appointment Book, Single

BOOK COVER CALENDAR

Art Director
Tomoki Furukawa, Jun Ogita
Designer
Jun Ogita, Tomoki Furukawa
Producer
Tempro Co., Ltd.
Studio/Design Firm
Safari, Inc.
Client
Tempro Co., Ltd.
Country
Japan

INTERACTIVE

**UK PAVILION,
AICHI EXPO '05**

Copywriter
Katie Edwards
Creative Director
Peter Higgins
Designer
Robin Clark
Producer
Shirley Walker
Production Company
Ten Alps Events
Programmer
Plant
Art Director
Robin Clark
Agency
Land Design Studio
Client
UK Government, Foreign
and Commonwealth Office
Country
United Kingdom

This project comprises seven inter-
active installations at the UK
pavilion for the Aichi Expo in Japan
Presented in an immersive interior
space each showcases striking
technological innovations that have
been inspired by the natural world.
Within each, the narrative content is
transformed from complex
concepts into simple engaging
digital installations using semiotic
sensory interfaces. The protocol
enables both user and a
surrounding group to quickly under-
stand the basic concept which is
supported by dynamic text, graphic
panels and ultimately the website.
This system enables a very effective
communication strategy and maxi-
mizes visitor throughput. (3,000,000
visitors to the pavilion in a six-month
period). Extensive evaluation has
shown that visitors leave the
pavilion with a higher perception of
the value and use of technology
within the UK, which is implicitly
embedded within the communica-
tion media.

Silver
Product/Service Promotion,
Single

DREAMKITCHEN

Art Director
Anders Eklind, John Bergdahl
Copywriter
Fredrik Jansson, Anders
Hegerfors
Web Director
Mathias Appelblad
Designer
Mikko Timonen,
Nina Andersson, Jerry Wass,
Viktor Larsson
Producer
Eva Råberg, Åsa Jansson,
Magnus Kennhed
Production Company
Sammarco Productions,
Kokokaka, Sto.pp
Agency
Forsman & Bodenfors
Client
IKEA Sweden
Country
Sweden

It all began with a seemingly simple
brief: present IKEA's kitchen designs
in an irresistibly inspiring way, while
educating consumers that they are
of great quality, highly functional,
and available at incredibly low
prices. In addition, we needed to
demonstrate that IKEA offers serv-
ices to make the complex
purchasing and installation process
smooth and convenient. We quickly
concluded that only the web offers
the tools to fulfill this complex
communication need. The main
visual, six different dream kitchens
with real-life scenes that you can
move around in on a 3D track,
inspire with great design and show
the overall effect that a beautiful
kitchen has on the home. The
unique visual treatment provides a
level of entertainment that made
people stay at the site for an
average of four minutes! Sub-
sections and links provide details
such as step-by-step pricing, a
planning tool, an explanation of the
IKEA Kitchen Help services, and an
overview of IKEA quality testing. The
site helped increase the total market
for home kitchens, and strength-
ened IKEA's already well-estab-
lished position even further.

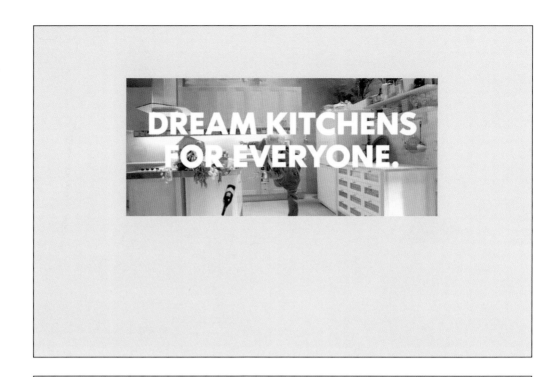

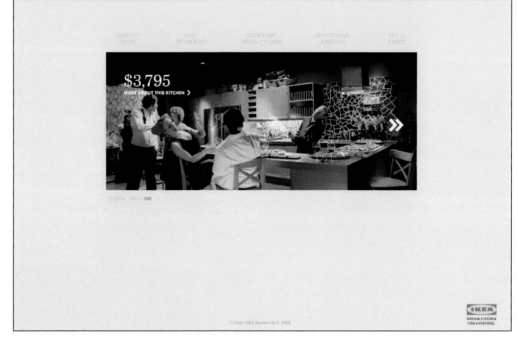

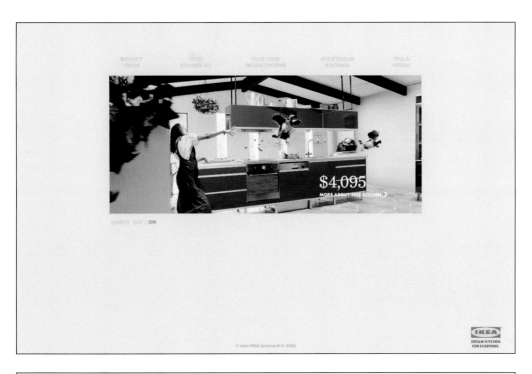

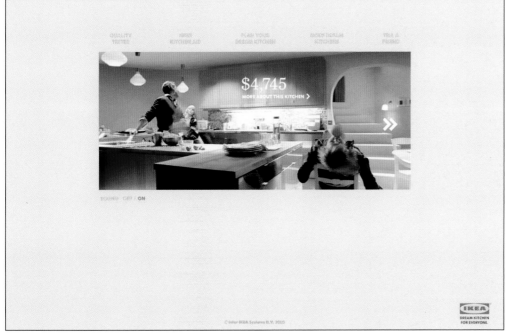

Silver
Hybrid/Art/Experimental,
Single

GLOBAL RESEARCH SHOW

Art Director
Yugo Nakamura,
Takashi Kamada
Designer
Takashi Kamada,
Takayuki Fukatsu
Producer
Ryouhei Mitsuhashi,
Masao Nakajima
Production Company
Tha, Tohokushinsha Film
Corporation, Maxmouse, Inc.
Programmer
Keita Kitamura
Creative Director
Aco Suzuki, Yugo Nakamura
Agency
Dentsu, Inc.
Client
Tokyo FM Broadcasting
Co., Ltd.
Country
Japan

We made an experimental voice-
blog system for a radio program
broadcasted by TokyoFM. This is a
kind of enhanced podcasting site.
All entries are provided by text and
voice-sound data, which are played
with synchronized motion. Posted
sound data is analyzed in the server
and its volume history is visualized
to Avatar's motion. User can throw
their comments on each entry, then
computer voice is generated on
server-side text-to-speech system.
I hope you will know the particular
atmosphere of this communication
system.

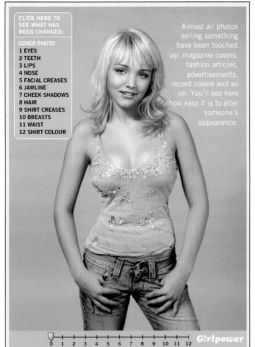

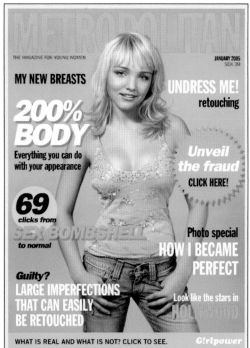

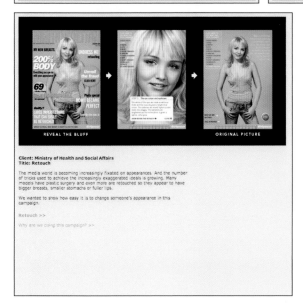

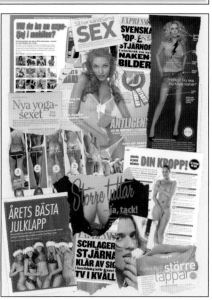

Client: Ministry of Health and Social Affairs
Title: Retouch

The media world is becoming increasingly fixated on appearances. And the number of tricks used to achieve the increasingly exaggerated ideals is growing. Many models have plastic surgery and even more are retouched so they appear to have bigger breasts, smaller stomachs or fuller lips.

We wanted to show how easy it is to change someone's appearance in this campaign.

Retouch >>

Why are we doing this campaign? >>

Distinctive Merit
Public Service/Nonprofit/
Educational, Single

RETOUCH

Art Director
Silla Öberg
Copywriter
Jacob Nelson
Designer
Lars Jansson, Viktor Larsson
Production Company
Itiden
Web Director
Martin Cedergren
Agency
Forsman & Bodenfors
Client
Ministry of Health
and Social Affairs
Country
Sweden

The media world is becoming increasingly fixated on appearances. And the number of tricks used to achieve the increasingly exaggerated ideals is growing. We wanted to show how easy it is to change someone's appearance. And by doing so, make the girls understand that they should not to compare themselves with what they see.

Multiple Winner**

Distinctive Merit
Minisite, Single
Distinctive Merit
Product/Service Promotion,
Single

SNICKERS SATISFIES.COM

Art Director
Brett Simon, Ron Lent,
Elena Fridman
Copywriter
John Heath, Tina Divino,
Aaron Adler, Richard Ardito,
Tom Christmann,
Scott Cooney, Adam Kanzer,
Scott Kaplan, Dan Kelleher,
Jerome Marucci,
Steve McElligott,
Jamie Overkamp,
Grant Smith, Ari Weiss
Creative Director
Andreas Combuechen,
Eric Silver, Arturo Aranda
Designer
Donovan Goodly
Producer
Dave Kurman
Programmer
Steve Longbons, Henry Cho
Developer
Cesar Munoz, Fatima Osman,
Katy Walker
Agency
Atmosphere BBDO
Client
Masterfoods USA
Country
United States

Snickers and Atmosphere BBDO
have developed an online program
designed to re-engage (and
increase market-share) among
teens and young adults. The
program consists of short, interac-
tive animations that give users
moments of "satisfaction." In
keeping with the brand voice and
attitude, the tone of these anima-
tions are humorous, outrageous,
and often have unexpected twists.
In order to keep users coming back
to the site and to connote the idea
of "freshness" (associated with the
brand), every day a new animation is
launched on the site. The program
relies on viral marketing to drive
traffic and to generate awareness;
there is no online advertising driving
traffic, but a viral component
encourages users to be brand
ambassadors and spread the word
about the site.

Distinctive Merit
Minisite, Single

Also for Hybrid
Silver
Multi-Channel, Campaign
SEE PAGE 22

**FEATURE FILMS
WEB CAMPAIGN 1**

Art Director
Colin Jeffery
Copywriter
Dave Weist
Creative Director
Ron Lawner, Alan Pafenbach,
Dave Weist, Colin Jeffery
Producer
Amy Favat
Production Company
Brand New School, Brickyard,
LOBO, Curious Pictures
Programmer
Roy Wetherbee
Agency
Arnold Worldwide
Client
Volkswagen
Country
United States

In the new Passat FEATURE FILMS
campaign, every feature had its own
story to tell. These examples are no
exception. They're unique to them-
selves and create (as a package) a
certain collage effect. We wanted
them to take you from one world to
the next, if watched back to back,
so we used different as many
different artists and techniques as
budgets would allow.

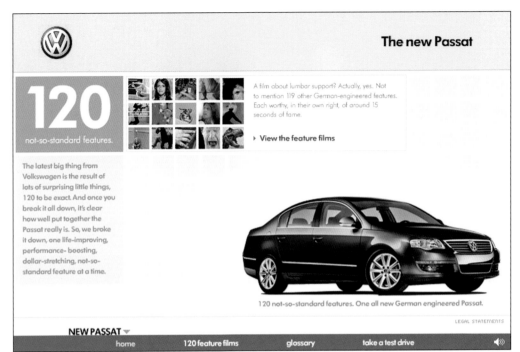

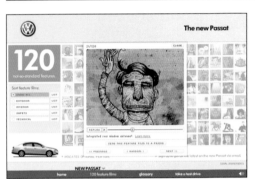

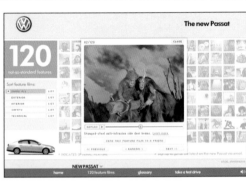

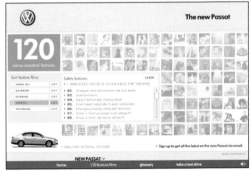

Distinctive Merit
Minisite, Single

ABSOLUT METROPOLIS

Art Director
Max Larsson Von Reybekiel
Copywriter
Kristoffer Triumf
Creative Director
Ted Persson
Designer
Fredrik Karlsson,
Jens Eriksson
Editor
Magnus Wålsten
Producer
Johan Magnusson
Production Company
Great Works
Programmer
Fredrik Karlsson,
Oskar Sundberg,
Jocke Wissing
Agency
Great Works
Client
V&S Absolut Spirits
Country
Sweden

ABSOLUT VODKA has, with its heritage in art, fashion and music, always been looking for new creative forms to reach the right people. The main challenge for this activity was also to re-position the ABSOLUT brand from being aspirational to being more inclusive, in order to rejuvenate the brand. The ABSOLUT METROPOLIS concept does by focusing on real people and their individual style, instead of focusing on established artists or fashion designers. The website invites the visitor to a journey in Tokyo's underground world where eleven of the cities most colorful and vivid people showcase their individual style. The result: An electric collection clothes—documented by photographer Nadav Kander under creative supervision from Japanese underground legend Pyuupiru. Thanks to a high level of experience level and close collaboration with a limited number of design and fashion blogs, ABSOLUT METROPOLIS is one of the most well visited campaigns produced for ABSOLUT.

Merit
Interactive Kiosk/Installation,
Single

**SAMSUNG WELCOME
EXPERIENCE**

Art Director
The Imagination Group
Copywriter
The Imagination Group
Creative Director
The Imagination Group
Designer
The Imagination Group
Editor
The Imagination Group
Producer
The Imagination Group
Production Company
The Imagination Group
Programmer
The Imagination Group
Agency
Imagination (USA) Inc.
Client
Samsung
Country
United States

The Welcome Experience is an inter-
active exhibit within the Samsung
Experience at New York City's Time
Warner Center. The Welcome Expe-
rience changes periodically to
reflect current New York interests,
events and ideas. The challenge of
this iteration of the Welcome Experi-
ence was to create an engaging and
immersive digital experience that
would connect to visitors interests
and lives with a theme focused on
well being (both physical and
mental) while communicating the
Samsung brand. The experience
needed to connect to the lifestyle of
the Samsung target audience—a
visitor who is interested in tech-
nology, interested in high-design
and loves to live life to its fullest. To
this end, Imagination developed a
dynamic 3D environment of New
York City's famous Central Park
depicting four well-known areas
within the park: the Conservatory,
Sheep's Meadow, the Reservoir and
the Zoo. The content for each of the
four environments includes scenes
of people using Samsung products.
Each scene balances the Samsung
brand experience and values with
specific product details. The overall
impression is that the consumers'
recreational, sporting, business and
entertainment experiences are
enhanced as they interact with
Samsung handheld and wireless
products. Note: Imagination devel-
oped the Original Welcome Experi-
ence Installation in collaboration
with Matthew Mohr and the Parsons
School of Design.

Merit
Product/Service Promotion,
Single

ANYFILMS.NET

Art Director
Chris Bradley
Copywriter
Josh Rogers, Neil Powell,
Dan Shefelman, Jenny Lee
Creative Director
Neil Powell
Designer
The Barbarian Group,
Mark Sloan
Editor
Outside Editorial/NY
Producer
Stacy Suplizio,
The Barbarian Group
Production Company
Villans, Berwyn/NY,
The Barbarian Group
Programmer
The Barbarian Group
Agency
MargeotesFertittaPowell
Client
Samsung
Country
United States

Brief: MargeotesFertittaPowell was
challenged to create an online pres-
ence that would position Samsung
as an innovator in product/content
development, and also as the leader
in bringing 4G-technology and
entertainment based content to
today's consumers. The solution
was anyfilms.net. Rationale: In a
first-of-its-kind online experience,
visitors can solve the mystery within
the site's multi-perspective story,
using some 11, 000 story variations.
Completed films could then be
emailed to cellular phones as video.
The complexity of the site,
combined with the multiple techno-
logical venues, affirmed Samsung's
commitment to providing
consumers cutting-edge tech-
nology. Target: MFP initially focused
its push toward those typically
young, tech-savvy consumers.
However, through blogs, news-
groups and word-of-mouth, a more
general and global audience
emerged. Which ultimately created
a groundswell of interest in a rela-
tively short amount of time, with an
average visit of five minutes, and
nearly a million unique visitors.

Merit
Product/Service Promotion,
Single

**RED BULL COPILOT:
DOWNHILL**

Creative Director
Tim Barber, David Bliss,
Jacquie Moss
Art Director
Ammon Haggerty,
Michael E. Cole
Copywriter
Tim Barber
Designer
Gino Nave, Scott Runcorn
Producer
Kevin Townsend, Rebecca Hill
Production Company
Odopod, Science + Fiction,
Ocean Watch
Programmer
Ammon Haggerty,
Michelangelo Capraro
Agency
Odopod
Client
Red Bull
Country
United States

This is the third episode in the Red
Bull Copilot series of broadband
websites. The goal for the Copilot
series has always been to take the
audience off the sidelines and
involve them in the action with the
athletes. This installment delves into
the pinnacle of Alpine sports, down-
hill skiing. It is a story of man vs.
mountain and features world cham-
pion downhill skier Daron Rahlves in
action on the racecourse at
Mammoth Mountain, CA. The site is
structured in four chapters: The
Course, The Gear, The Skier, and
The Race. See what it takes to
survive an 80 MPH descent down
an icy mountain. The story is told
through interviews and live action
footage along with interactive tech-
nical illustrations. Chapter four, The
Race, puts the user in control of the
race action with multiple selectable
camera angles, audio tracks, and
data feeds.

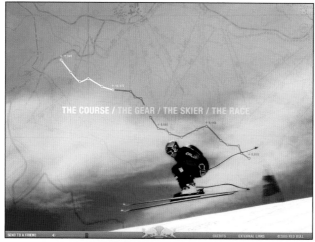

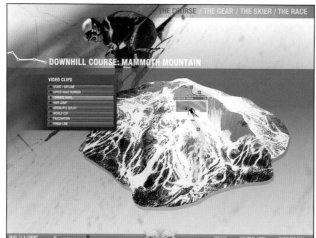

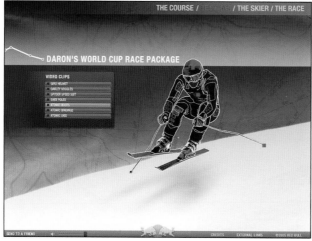

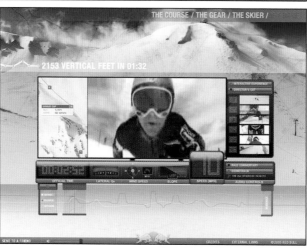

Interactive
362

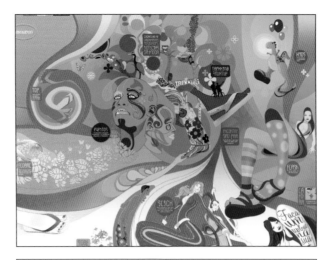

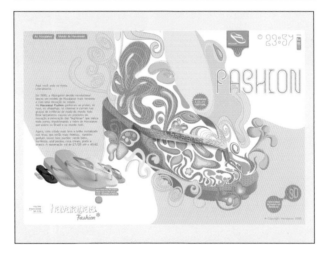

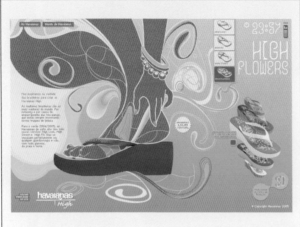

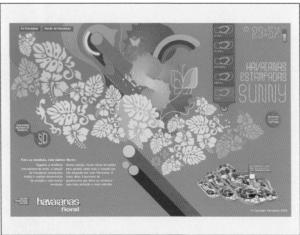

Merit
Product/Service Promotion,
Single

HAVAIANAS

Art Director
Adhemas Batista
Copywriter
Luciana Haguiara
Creative Director
Marcello Serpa,
Sergio Mugnaini
Designer
Ricardo Martins
Producer
Ana Maria Machado, Lua Web
Programmer
Fabricio Zuardi, Flavio Ramos,
Raphael Carvalho
Agency
AlmapBBDO
Client
Alpargatas
Country
Brazil

The goal was to show the Havaianas
product line while speaking the
fashion lingo. On the homepage, a
progressive loading system allows
for the website to be loaded while
users navigates through a section,
making the website quicker. The
pages show each model's lifestyle
and follow a guideline that is almost
imperceptible, since every one has
totally different, custom made illus-
trations. Each model's attitude was
the theme for the illustrations, colors
and animations. A common jingle
had different arrangements
according to the correspondent
sandal model theme. Because of
that, the user navigates through the
Havaianas World and hears the
same song, but in different rhythms
and styles. All that to show that
Havaianas are universal sandals that
match everything and everybody.

Merit
Public Service/Nonprofit/
Educational, Single

HOPE

Art Director
Cassiano Saldanha
Copywriter
Moacyr Netto
Creative Director
Marco Antonio de Almeida
Designer
Felipe Mahalem, Felipe Lima
Producer
Fernando Zomenhan
Programmer
Felipe Mahalem, Flavio Silva
Editor
Elaine Thompson
Agency
OgilvyOne Comunicação Brasil
Client
GRAACC
Country
Brazil

GRAACC is a Brazilian NGO that gives support to poor children with cancer. During our first visit to GRAACC, we faced quite a different atmosphere than we expected to find. The hospital has the look and feel of an amusement park. Through providing a fun and gratifying experience by means of games and light-hearted activities, GRAACC manages to offer the children a balance to the difficult treatment of cancer, thus reducing future traumas. Back to the agency, we believed our biggest challenge was to make people feel what we felt during our visit: at first, awkwardness regarding what we could find, followed by a big relief. So we had the idea of showing a patient getting his hair shaved and, at the end of the piece, we reveal the kid has been cured. Results: drive to GRAACC's site was 35% higher and the amount of donations increased 28%.

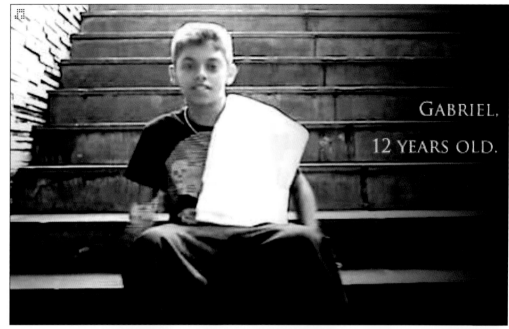

Merit
Product/Service Promotion,
Single

KPF WEBSITE

Creative Director
Vas Sloutchevsky
Producer
Jeremy Berg
Programmer
Joon Yong Park, Gicheol Lee
Designer
Vas Sloutchevsky
Agency
Firstborn
Client
Kohn Pedersen Fox Architects
Country
United States

Kohn Pedersen Fox, one of the
world's leaders in architecture and
planning, asked Firstborn to design
and develop a website that illustrates
in a visual way their unique approach
to contemporary architecture, show-
casing hundreds of projects in an
engaging and tactile way. The means
to explore the site and imagery are
unique in their own right, making this
website a thoroughly rewarding and
educating online experience. The
idea for this explorative interface
stems from KPF's work itself—the
site's navigation structure resembles
floors with stairwells between them.
In addition, each page of the site acts
like a mini-case study allowing the
user to get familiar with KPF's work
while reading any piece of informa-
tion. By adding a few minimalist
interface elements we conveyed the
feeling of precision and modernity of
KPF's architecture.

Merit
Product/Service Promotion,
Single

**HAKUHODO & HAKUHODO
DY MEDIA PARTNERS
RECRUIT 2007**

Art Director
Katsuhiko Sano,
Hironobu Tsuchiya
Copywriter
Mariko Ogata
Designer
Katsuhiko Sano, Tatsuro Oe,
Ryuhei Nakadai
Producer
Kyoko Kochi,
Teruaki Tomikawa,
Hiroyuki Murayama
Production Company
Hakuhodo i-studio, Inc.
Programmer
Tatsuro Oe
Creative Director
Yutaka Sugiyama
Agency
Hakuhodo i-studio, Inc.
Client
Hakuhodo, Inc.
Country
Japan

The site, Musubi, literally means to
tie together. The objective was to
bring potential candidates to this
recruiting site developed for the
clients, Hakuhodo and Hakuhodo
DY Media Partners. This project
brought us closer to the client, and
more importantly, brought together
users with client. It brings us a
tremendous sense of accomplish-
ment that our product helped facili-
tate the Musubi of people and rela-
tionships. And ultimately the intri-
cate tying together of people, rela-
tionships and objectives made this
project a success. Finally, I strongly
believe that Musubi happened again
by winning this award.

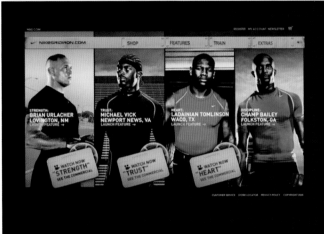

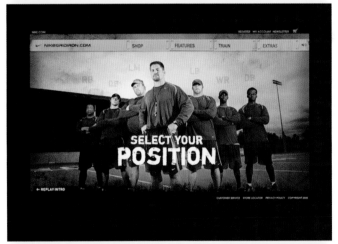

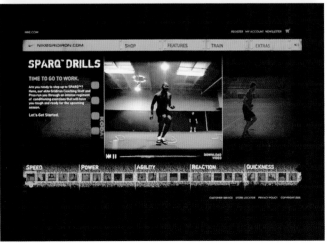

Merit
Product/Service Promotion,
Single

NIKE GRIDIRON

Designer
David Hyung, Troy Kooper,
Jeremiah Simpson,
Lian Chang, Matt Walsh
Editor
Can Misirlioglu, Tim Speece
Producer
Winston Binch,
Harshal Sisodia, Matt Howell
Programmer
Sean Lyons, Nick Coronges,
Kumi Tominaga, Sarah Grant,
Lee Walling, Noel Billig,
August Yang, Michele Roman
Copywriter
Joshua Bletterman,
Thomas Pettus,
Micheal Spiegel
Agency
R/GA
Client
Nike
Country
United States

From summer workouts to state
championships, NikeGridiron.com
helps high school football players
prepare for the season with innova-
tive training tools and video drills.
They can perform the same drills as
Tom Brady with a comprehensive
training log called THE PROGRAM.
They can check out the high school
careers of All-Pros with ICONS, a
series of hometown video features.
And they can train by position with
video coaches in POSITION CAMP.
A new training tool even allows
users to compare their speed and
strength against Michael Vick's high
school stats. The site spotlights new
products, like the Zoom Air Vick III,
with performance-driven features.
An elevated design sensibility
combines with a no-nonsense copy
tone to inspire young players to train
like champions.

LIFE ON BOARD PROJECT

Art Director
Marcus Alkemade,
Vivian Walsh, Matt Page
Copywriter
Sicco Beerda, Lorenzo de Rita,
Marc Williams,
Christa Larwood
Creative Director
Sicco Beerda, Lorenzo de Rita
Designer
Hert Zollner
Producer
Roman Coppola,
Lance Bangs, Remy Belveaux,
Zoran Bihac
Programmer
Mario Piepenbrink
Agency
Euro RSCG 4D
Client
Volvo
Country
Netherlands

Take an interesting person with an
amazing life story. Then take another
interesting person they've never met
before. Put them in a car and ask
them to share their stories and talk
about life in general as they drive
through inspiring locations across
the world. This is the Life On Board
Project: a series of short documen-
tary films that reflect the richness of
everyday life as people experience it
in their cars. Through the unscripted
conversations that take place, these
films explore and investigate themes
of beauty, courage, innovation,
sharing and everything that Volvo
considers when creating a car "For
Life." The website is a journey in
itself. Visitors enter the 3D world of
the Project in which they are invited
to wander and fly through all
hundreds of pieces of rich media
content that where produced or
used during the seven production
months of this project.

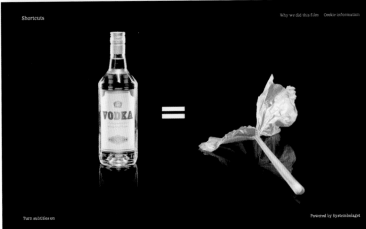

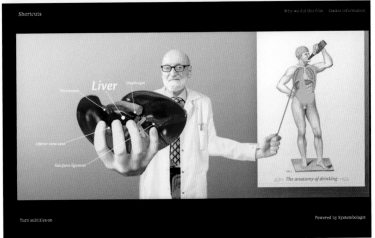

Merit
Public Service/Nonprofit/
Educational, Single

BARROSO

Art Director
Joakim Blondell
Copywriter
Johan Olivero,
Anna Qvennerstedt
Web Director
Martin Cedergren
Designer
Lotta Dolling
Producer
Charlotte Most
Production Company
EFTI, B-Reel
Agency
Forsman & Bodenfors
Client
Sveriges Television
Country
Sweden

This site was part of a campaign aimed at one person, EU president Josè Manuel Barroso. The campaign began with an ad in the Financial Times, telling M.r Barroso what the EU stands to gain by taking alcohol-related problems more seriously, citing recent findings by the World Health Organization. The ad ended by telling Mr. Barroso that we had made a website exclusively for him, with a "crash course" on the subject. The main purpose of the campaign was to increase support for the Swedish Alcohol Retail Monopoly, which has limited alcohol-related problems in Sweden the last 50 years but needed stronger popular support to survive in the long run. Since the campaign wasn't propaganda aimed directly at Swedes, but a "crash course" for EU politicians, we could convey some basic facts that most Swedes didn't know about, and make a lot of them listen.

Merit
Game/Entertainment, Single

MUSICA STAFF INDUCTION

Art Director
Paul Tooze
Copywriter
Brett Netherton
Creative Director
Ross Chowles
Designer
Dylan Jones
Editor
Graham Merril
Producer
Ashley Joyce
Production Company
Wireframe, B&S Studios
Programmer
Brendan Goosen
Agency
The Jupiter Drawing Room,
Cape Town South Africa
Client
Musica
Country
South Africa

Musica is one of South Africa's
largest entertainment retailers, and
wanted something funkier than
PowerPoint presentations to train
their new staff. Working around their
product range of music, movies and
games, this CD-Rom takes
inductees through an interactive
game that covers Vision and
Mission statements, Values, HR
policy, Operating Procedures and
Merchandising. Frank L Baum's
"The Wizard Of Oz" provided the
basic storyline: players need to
solve problems and riddles to reach
the Wizard who, in this case, is
Ozzie Osbourne. On the way, they
discover that they have the heart,
the brain, the courage and the
determination to reach the top in the
company.

Interactive
370

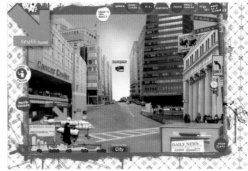

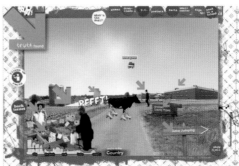

Merit
Public Service/Nonprofit/
Educational, Single

TRUTH FOUND

Art Director
Meghan Siegal
Copywriter
Marc Einhorn
Creative Director
Ron Lawner, Pete Favat,
Alex Bogusky, John Kearse,
Tom Adams
Designer
Meghan Siegal, Neal Bessen,
Chris Valencius, Cindy Moon
Producer
Barry Frechette,
AnneMarie Lambert
Programmer
Ebbey Mathew,
Adam Buhler, Chris Teso
Agency
Arnold Worldwide
Client
American Legacy Foundation
Country
United States

Big Tobacco permeates our daily
lives way more than most of us
realize. It's everywhere, in all of our
cities, towns and neighborhoods.
So, we thought it would be a good
idea to build a world on
thetruth.com that shows people if
they look a little deeper, these facts
about the tobacco industry and it's
deadly products are there to be
revealed. So, with truth found we
use a big old orange arrow to point
out some of the people and places
affected by Big Tobacco.

Merit
Minisite, Single

OLYMPUS

Art Director
Rolf Borcherding
Creative Director
Olaf Czeschner
Designer
Rolf Borcherding,
Andrè Bourguignon
Programmer
Heiko Schweickhardt
Editor
Katharina Schlungs
Agency
Neue Digitale
Client
Olympus
Country
Germany

MY LIFE AS A 10

Art Director
Miguel Calderon
Copywriter
Ivan Gonzalez
Creative Director
Ulises Valencia,
Miguel Calderon
Designer
Francisco Roman,
Cesar Moreno
Editor
Roberto Espero,
Jezreel Gutierrez,
Sebastian Mariscal
Producer
Miguel Calderon,
Ulises Valencia
Production Company
Grupo W
Programmer
Homero Sousa, Raul Uranga
Agency
Grupo W
Client
Nike
Country
Mexico

When we started the project, we were hired just to produce the website. A few weeks after we defined the prototypes, Nike asked us to create the animated film. With the original script from Weiden+Kennedy we change some scenes and started the casting for sets, actors, voices, etc. All with a Brazilian esthetic but developed all in Mexico. Two months ago, and after a lot of midnight work we were on time to publish the final product.

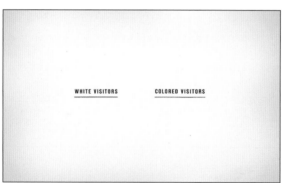

COLORED/WHITES

Art Director
Ray Page, Jason Stanfield
Copywriter
Keith Anderson
Creative Director
John Livengood, Eric Gutierrez
Designer
Ray Page
Programmer
Mike Swartz
Agency
DDB Seattle
Client
remembersegregation.org
Country
United States

This project is a reminder of why we celebrate the MLK holiday. We were fascinated by imposing the arcane notion of segregation upon the modern medium of a web page. We hoped to shock viewers into remembering an ugly part of our nation's history, and inspire a new generation to continue fighting for civil rights.

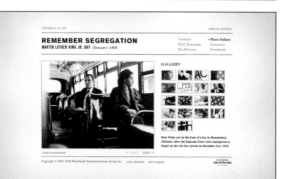

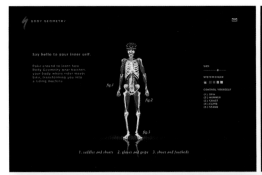

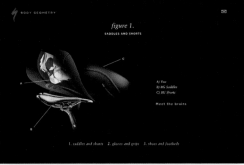

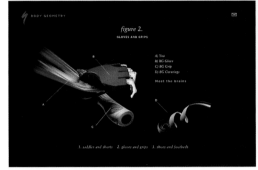

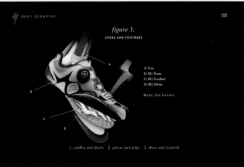

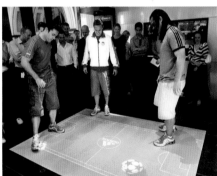

Merit
Minisite, Single

SPECIALIZED BODY GEOMETRY MICROSITE

Art Director
Aaron Dietz
Copywriter
Mandy Dietz
Creative Director
Keith Anderson, Albert Kelly,
Steve Mapp
**Director of
Interactive Production**
Mike Geiger
Producer
Carey Head
Production Company
EGG
Agency
James Taylor
Client
Specialized
Country
United States

Science class meets cycling in this site for Specialized Body Geometry products. Users "poke around" to learn how BG gear works with the body from the inside out. Graphic dissections (complete with squishy sound effects) are served up throughout the site to make learning gross again.

Merit
Interactive Kiosk/Installation,
Single

ADIDAS_1 INTERACTIVE STORE

Creative Director
Liz Sivell
Producer
Sarah Barry, Keith Pinney
Programmer
Ian Tilley
Agency
OneDigital
Client
adidas
Country
Australia

OneDigital set about to create the world's most intelligent, interactive retail environment. We Created a totally "immersive' in-store brand experience for the launch of the adidas_1 Intelligent Shoe. The environment was a series of interactive and digital in-store installations, applied to the retail environment of the Adidas Store in Sydney's Queen Victoria Building during April 2005. The shoe itself is revolutionary. It's the first sports shoe that is microprocessor controlled. It responds to the wearer's style and to the terrain over which the wearer is moving, so we designed a store that changes in response to the visitor. You would never see the store the same way twice. Every visit offered the customer something new, involving and fun.

SEEDS OF IMAGINATION

Art Director
Ron Lent
Copywriter
John Heath
Creative Director
Andreas Combuechen,
Arturo Aranda
Designer
Sacha Reeb,
Peggy Pi-Yu Chuang
Producer
Jeremy Villano
Agency
Atmosphere BBDO
Client
GE
Country
United States

A virtual garden where people can
experience the central idea behind
GE's Ecomagination effort: Imagina-
tion is our only limitless resource. By
thinking in more creative ways
about energy and the environment,
we can make the world greener.
Nurture a seed with your imagina-
tion and grow a flower unique to
your thoughts and ideas. Type in
words related to the environment or
gardening and the flower will thrive.
You can change its size, color and
shape; alter the weather; and affect
the ecology it lives in. There are
even hidden animations and
rewards if the gardener is thinking
outside of the flower box. As your
flower grows, you're rewarded with
seeds to pass along to your friends
via email. Then you can view their
progress and your flower's other
descendants in a "family tree" and
community garden gallery.

PRISONER

Art Director
Luiz Risi, Veni Cury
Copywriter
Rodrigo Senra
Creative Director
Suzana Apelbaum
Designer
Veni Cury
Programmer
Rogerio Nogueira
Agency
JWT
Client
Fundacao SOS Mata Atlantica
Country
Brazil

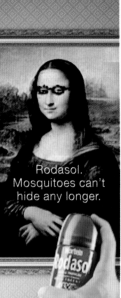
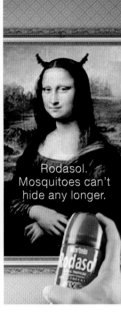
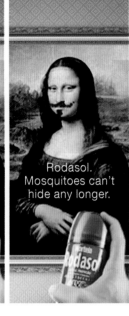

Merit
Banners, Single

MONALISA

Art Director
Valter Klug
Copywriter
Fabio Pierro
Creative Director
Alon Sochaczewski,
Marcio Paiva
Designer
Euro RSCG 4D
Editor
Euro RSCG 4D
Producer
Euro RSCG 4D
Production Company
Euro RSCG 4D
Programmer
Euro RSCG 4D
Agency
Euro RSCG 4D
Client
Reckitt Benckiser
Country
Brazil

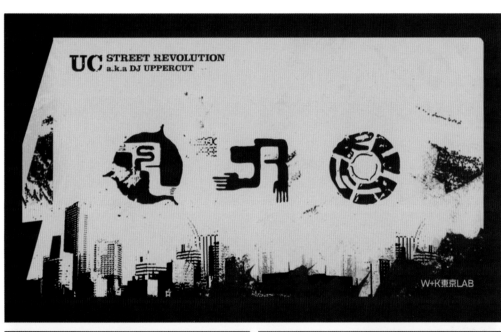

Merit
Wireless (PDA, Mobile Phone,
Other Devices), Single

**DJ UPPERCUT STREET
REVOLUTION MICROSITE**

Designer
+cruz, woog, Shane Lester
Art Director
+cruz, Shane Lester
Creative Director
John C Jay, Sumiko Sato
Production Company
Wieden+Kennedy Tokyo Lab
Copywriter
+cruz, Shane Lester
Editor
Shane Lester
Producer
+cruz
Programmer
Shane Lester
Agency
W+K Toyko
Client
DJ Uppercut
Country
Japan

UC's "Street Revolution" is a call-to-action, challenging the current state of hip-hop across the globe, urging the masses to evolve and create new hip-hop, inspiring revolutions within us. We created a bold visual manifesto using raw and iconic imagery, broadcasting our message with raw street immediacy. The website is like a pirate broadcasting station, transmitting UC's audio-graphic manifesto to the masses, a message of taking hip hop back to its original roots of raw, pure and eclectic street expression. The online propaganda pumps out a series of audio-visual content, dynamic online expressions of the UCSR movement, including episodic interactive and video content, evangelizing Street Revolution.

Merit
Self-promotion, Single

ASYLUM WEBSITE

Art Director
Edwin Tan
Creative Director
Christopher lee
Designer
Edwin Tan
Agency
Asylum Creative Pte. Ltd.
Client
Asylum
Country
Singapore

The Asylum website is an extension of our personality online, we wanted to show our humor and irreverence so that the viewer can feel our brand and our spirit rather than have a practical website. The real store is about discovery and inspiration so I think that experience cannot be represented fully online. Someone actually wrote to us and commented that the experience is like heavy metal vs. nursery. Surreal! We like that.

Multiple Winner**

Merit
Game/Entertainment, Single
Merit
Minisite, Single

COMCASTIC.COM

Art Director
Will McGinness
Copywriter
Toria Emery
Creative Director
Will McGinness,
Keith Anderson, Toria Emery
Designer
Devin Sharkey,
Keytoon Animation Studio
Director of
Interactive Production
Mike Geiger
Producer
Amanda Kelso, Dora Lee
Production Company
The Barbarian Group,
Natzke Design,
Branden Hall, Number 9
Illustrator
Brian Taylor
Sound Design
Gino Nave, Chris Ewen,
Sean Drinkwater
Agency
James Taylor
Client
Comcast
Country
United States

Comcastic.com was designed to be entertaining. Immersive experiences involving three-dimensional, talking puppets and a pentathlon of skill tests also happen to highlight several Comcast products, but the primary goal was to have users visit the site and say: That's Comcastic!

Interactive
376

Merit
Product/Service Promotion,
Single

**NIKE BASKETBALL ZOOM
LEBRON III**

Designer
Shu Zheng Li,
Joseph Cartman,
Yu-Ming Wu
Producer
Harshal Sisodia
Programmer
Joseph Cartman,
Michele Roman
Copywriter
Omid Fatemi,
Joshua Bletterman
Production Company
Stardust
Agency
R/GA
Client
Nike
Country
United States

When presented with the task of
showcasing Nike's latest signature
shoe, the Zoom LeBron III, R/GA
concentrated on a forward-thinking
display with an aesthetic as innova-
tive as the shoe itself. The user jour-
neys into a world of motion graphics
and 3-D modeling, complete with
narration and music, that show-
cases the ingenuity of LeBron
James and the shoe he inspired.
Upon entering the site, users are
submerged into this virtual video
world for a uniquely engaging take
on a product-driven narrative.

Merit
Product/Service Promotion,
Single

BECK

Art Director
Florian Schmitt
Designer
Tommi Eberwein, Carl Burgess
Producer
Nicky Cameron
Production Company
Hi-ReS!
Creative Director
Florian Schmitt
Agency
Hi-ReS!
Client
Beck/Interscope, US
Country
United Kingdom

Our brief was to create a new online
home for Beck, without tying the
site into a specific album release.
Taking its origin from the 19th
century Viennese Theatre (where flat
panels on stage could be flipped to
create a new stage scene), we
developed a virtual mechanical
version of it, using our own photog-
raphy of sculptures made up of
tapes and CD cases.

STUDENT

Graphic Design

Gold
Book Design, Limited Edition,
Private Press or Special
Format Book, Single

CLASS MATTERS

Designer
Elizabeth Yerin Shim
School
Yale University School of Art
Country
United States

The objective was to take the New
York Times articles from the series
"Class Matters" and treat them with
an interpretive conceptual umbrella.
The biggest challenges were finding
a fresh perspective on the issue, a
way to address the nature of the
articles themselves, and a formal,
structural metaphor of that perspec-
tive. The solution was to twist the
conventions of hierarchy and to use
fragments to reveal the essence.
The quotes from the interviewees
were separated and set in the main
area as the raw commentary. The
rest of the article, commentary from
the writer, runs in the footnotes. The
third area, marginalia, contains
readers' commentary from the
online forum. At the threshold waits
a discovery, the subheads printed
on the back of the page. When the
reader turns a page it is pulled and
stays in the air, not knowing where
to fall, uncomfortably, just like the
issue of class.

Advertising

Distinctive Merit
Magazine, Consumer,
Spread, Campaign

CARDS

Art Director
Susann Goerg
Copywriter
Katharina Trumbach
School
Miami Ad School Europe
Client
American Red Cross
Country
Germany

Donations only work when you have
a lot, especially in the massive
destruction that happened to the
areas of the tsunami wave. So we
created this postcard campaign
because it is flexible in terms of
where you place it. It is supposed to
become a collector's item or at least
travels around and does not stay on
one billboard or in one magazine.
It's an active campaign because you
do something with it. It shows you
what "power" this one coin has, and
because of the pictures you actually
do something with it on your own.
By showing the reality, you feel
involved and closer to the victims.

Slow Down Atlanta

Advertising

Distinctive Merit
Collateral Advertising,
Guerrilla/Unconventional,
Campaign

SLOWDOWN ATLANTA

Art Director
Maari Thrall
Copywriter
Miller Jones
School
The Creative Circus
Country
United States

Graphic Design

Distinctive Merit
Corporate & Promotional
Design, Self-Promotion:
Print, Single

**YOSHINOTONE CUSTOM
CHIPS UNCOVERED**

Designer
Yoshino Sumiyama
Photographer
Yoshino Sumiyama
Instructor
Kim Maley
School
School of Visual Arts
Country
United States

The concept was to document what
I have now in 2005. I focused on my
clothes because they are the only
things I have managed well for a
long time. Also, I think the selection
of the clothing represents who I am.
While pursuing this project, I real-
ized that I have chosen these items
largely because of color. The colors
in my wardrobe range from primary
to secondary colors, as well as
black and white. Showing all the
items of clothing in the color chip
format helps communicate the
concept. The guidebook contains
explanatory descriptions for each
item. This work is not just a
contrivance to look at, but also
something to have fun with by
tearing the actual chips off.

Interactive

Distinctive Merit
Self-Promotion, Single

OKAY DAVE

Designer
Dave Werner
Programmer
Dave Werner
School
The Portfolio Center
Country
United States

Okaydave.com is an attempt to create a portfolio that was less of a thumbnail click-through and more of a narrative experience. The diverse range of featured projects includes an interactive novel, a 150-pound metal chair, a design-themed rap parody of Kanye West's "Heard Em Say" and an annual report. Using short films to tell the stories behind the projects (and promoting explo-ration and discovery through secret projects hidden in the environment), the end result is a self-promotional hybrid of design skills, conceptual thinking, personality and presenta-tion. This was Dave Werner's final student portfolio from Portfolio Center in Atlanta, GA.

Interactive

Merit
Public Service/Nonprofit/
Educational, Single

SMOKELESS

Designer
Kenny Chan Yew Choong
School
The One Academy
Of Communication Design
Client
Malaysia Government Project
Country
Malaysia

Advertising

Merit
Magazine, Consumer,
Full Page, Campaign

INNOVATORS

Art Director
Jannik Davidsen,
Mathieu Garnier
School
Miami Ad School
Client
Business 2.0 Magazine
Country
Denmark

The objective was to create a
campaign in the tone of voice of the
new generation of CEO's. A big
challenge was to tell the story in a
fresh way that celebrated the natural
talent of tomorrows CEO's, and still
keep the executions smart and
innovative.

Let us do the talking.

Cardeology
cardeology.com

Let us do the talking.

Cardeology
cardeology.com

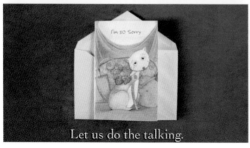

Let us do the talking.

Cardeology
cardeology.com

Advertising

Merit
Television & Cinema
Commercials, TV:
30 Seconds, Campaign

CARD TV SPOTS

Art Director
Eric Rojas
Copywriter
Alicia Dotter
Director
Stephan Gill
School
The Creative Circus
Client
Cardeology
Country
United States

We wanted to show the real reasons
people need greeting cards.
Because let's face it, they're safer
than using your own words. So to
avoid putting your foot in your
mouth, put a card in your hand.

Merit
Magazine, Trade,
Multipage, Campaign

**TITANIUM STAPLES,
SURPRISINGLY STRONG:
SHIRT, LEASH, WEDGIE**

Art Director
Vladislav Ivangorodsky
Copywriter
Vladislav Ivangorodsky
Creative Director
Vladislav Ivangorodsky
Designer
Vladislav Ivangorodsky
Photographer
Vladislav Ivangorodsky
Producer
Vladislav Ivangorodsky
Production Company
OMS (one man show)
School
Pratt Institute
Client
Swingline
Country
United States

Swingline's new titanium staples are
stronger than the standard ones.
The reader will not know what the
ad is for—or that it is an ad until the
page is flipped. A real staple is put
through the page. (No people or
animals were severally hurt during
the photo shoot.)

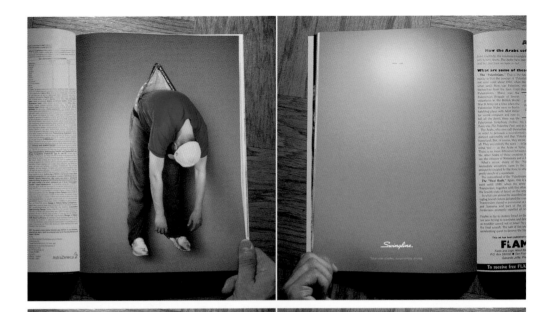

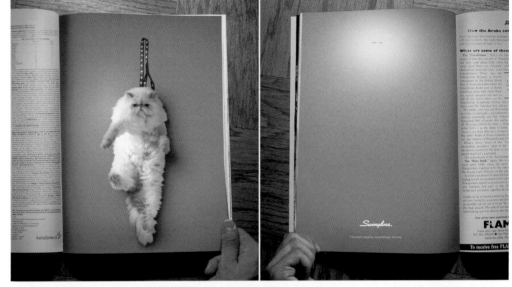

Graphic Design

Merit
Poster Design, Promotional,
Campaign

**THE DEAD BODY
OF MY POSTER**

Copywriter
Jiwon Lee
Designer
Jiwon Lee
School
California Institute of the Arts
Client
Jiwon Lee, Mina Park
Country
United States

I feel weird about out-dated posters. Even though they are good archival artifacts of an event and graphic style, they are not living, but are fossils. I couldn't shake the idea that the posters are dead. This poster series is designed to show the concept of death and re-birth of practical art. The geometric shapes on the black layer are a set of Chinese characters that translate to, "Here lies the dead body of my poster."

Graphic Design

Merit
Poster Design,
Public Service/Nonprofit/
Educational, Single

DJ SPOOKY:
REBIRTH OF A NATION

Art Director
Shelley Stepp,
Jae-Hyouk Sung
Designer
Jason Mendez
Illustrator
Jason Mendez
Publisher
California Institute of the Arts
Office of Public Affairs
Creative Director
Jason Mendez
School
California Institute of the Arts
Client
REDCAT (Roy and Edna
Disney/CalArts Theater)
Country
United States

The DJ Spooky: Rebirth of A Nation
performance at REDCAT was a
multi-media piece remixing D.W.
Griffith's 1915 film, Birth of a Nation.
The restricted color palette refer-
ences the time period as well as the
seriousness of the piece. The
combination of hand and digital
lettering illustrates the mixing of
mediums and cultures.

Graphic Design

Merit
Poster Design, Promotional,
Campaign

**LIMINAL:
A SENSORY THRESHOLD:
PLACE, UNITED,
HOME, FREEDOM, TIME**

Studio/Design Firm
a minor variant
Client
Undergraduate Thesis
Country
United States

Sometimes within the course of a design process, I find that there is a point where all the parts of a project seem to fall into place and a solution becomes clear. There is a moment within our consciousness where information morph's into meaning. This space can be pregnant with meaning and potential, but it can also contain a sense of tension as one state is destroyed to create the next. The liminal moment doesn't happen with every project. It does not predispose success. But it does happen. And when it does, it is different. It's a moment where success and failure have an equal footing. A space that is pre-context, pre-meaning, and pre-design. With this project I hoped to articulate the idea of a liminal space and attempt to orchestrate this moment of tension. I hope to represent the character of this theoretical space, and in so doing, elongate what is primarily a fleeting moment. PLACE: This piece was created by listing every city and state in which I have lived, or to which I have traveled. These names were collapsed upon themselves, then extruded and manipulated using lighting effects. They are transformed into singular objects that contain vast amounts of information. UNITED: This poster uses a 256 color "index" of each frame of a sequence showing the second plane striking the south tower on 9/11. HOME: This is a street map of San Francisco whose city blocks have been vectorized and broken apart forming thousands of singular objects. The larger, yellow, objects are the city blocks on which I have lived. Urban residences tend to identify strongly with their locations and in a way, this can stand as a map of my life in San Francisco. FREEDOM: two opposing documents, the Bill of Rights and 10 articles from the Patriot Act, have been transmitted into a wholly symbolic space to show their fragility. The text from each document has been replaced with 26 colors so that the information has been encoded but still resides. TIME: This poster uses class photos of myself from grades 1-12 which have been transformed, using a 26 color "index" of each photo, into a succession of rings. The rings are set against a grid of numbers, the grades 1-12, to show that even within this tight grid of rules an individual can grow. The size and location of each ring is connected to my memories of each year.

PLACE
01

TIME TRAVLER
05

FREEDOM
04

HOME
SAN FRANCISCO
03

Graphic Design

Merit
Book Design, Limited Edition,
Private Press or Special
Format Book, Single

4:3:ME

Art Director
Martin Venezky
Copywriter
Jessica D'Elena
Creative Director
Jessica D'Elena
Designer
Jessica D'Elena
Editor
Jessica D'Elena
Illustrator
Jessica D'Elena
Photo Editor
Jessica D'Elena
Photographer
Jessica D'Elena
Publisher
Jessica D'Elena
School
California Institute of the Arts
Country
United States

4:3:ME is an encyclopedia of a
personal event: the author's 1976
televised birth. As an encyclopedia,
the document takes into account
the social, cultural, and physical
forces that both lead to the event, as
well as those that were influenced
because of it. Since it is an account
that is media centric in nature, the
book looks at how both the author
and greater cultural realms have
been changed by, and have
changed media. The book's primary
objective was to begin with the
specificity of a single event and then
be able to expand beyond this to
include greater cultural signifiers.
The solution to this goal was
resolved by dividing the book into
chapters based on the immediate
"players" involved in the initial
event. MOTHER, CAMERA, ME,
AUDIENCE became the system for
expanding a televised birth to the
matrilineal history, the camera as a
third parent for shaping social iden-
tifications and signifiers, the shaping
of my own personal ideologies
through a video/televisionary driven
social space, and finally, the perma-
nence and viral qualities new media
has established as not just speaker
to audience but audience member
itself.

Graphic Design

Merit
Poster Design,
Public Service/Nonprofit/
Educational, Single

CREATIVE MUSIC FESTIVAL

Art Director
Shelly Stepp,
Jae-Hyouk Sung
Creative Director
Colin Graham, Justin O'Brien
Designer
Colin Graham, Justin O'Brien
Illustrator
Colin Graham, Justin O'Brien
Publisher
California Institute of the Arts
Office of Public Affairs
School
California Institute of the Arts
Client
REDCAT (Roy and Edna
Disney/CalArts Theater)
Country
United States

The poster for the Creative Music
Festival featuring Wadada Leo
Smith probably had something to
do with "Ankhrasmation." Maybe
that's why it has that one shape that
I can't quite remember what its
called, but it has something to do
with ancient Egypt or something in
it. It doesn't have any moms or dads
but it does have a head, if you look
hard enough. Two out of three isn't
that bad.

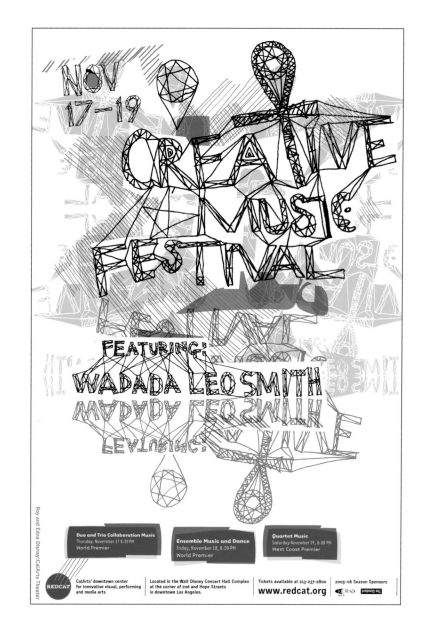

Graphic Design

Merit
Television & Cinema Design,
Title Design, Single

**AMERICAN SPLENDOR
MOVIE**

Art Director
Joe Mullen
Copywriter
Joe Mullen
Creative Director
Joe Mullen
Designer
Joe Mullen
Director
Joe Mullen
Editor
Joe Mullen
Producer
Joe Mullen
School
California Institute of the Arts
Country
United States

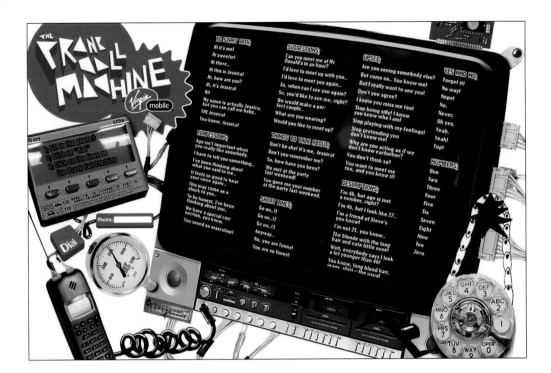

Interactive

Merit
Product/Service Promotion,
Single

PRANK CALL MACHINE

Art Director
Joakim Thörn
Copywriter
Linda Börjesson
Designer
Emil Oldberg
School
Berghs Scholl
of Communication
Client
Virgin Mobile
Country
Sweden

This campaign is based on a well-known and entertaining phenomenon—prank calls—and created a Prank Call Machine. The customers will get a text message which invites them to log on to the website and use the machine to make a prank call to one of their friends. After the call, the friend will get a text message with an explanation and an invitation to get even. The prank call will be recorded, and can be sent by e-mail to others. It can also be listened to and rated on the website. The prank calls with the highest rates can in a later stage be used as radio commercials. Our belief is that by involving the customers, the advertising becomes more efficient.

Graphic Design

Merit
Poster Design,
Public Service/Nonprofit/
Educational, Single

CALARTS VIEW AT REDCAT

Art Director
Shelley Stepp,
Jae-Hyouk Sung
Creative Director
Julene Bello, Haezeline Go
Designer
Julene Bello, Haezeline Go
Publisher
California Institute of the Arts
Office of Public Affairs
School
California Institute of the Arts
Client
REDCAT (Roy and Edna
Disney/CalArts Theater)
Country
United States

CalArts View at REDCAT was a
weeklong event featuring new
works by CalArts students, encom-
passing their diverse programs. One
of CalArts' idiosyncrasies is its
architectural structure. We wanted
to hint at the origin of the perform-
ance work both in its process and
environment, by using abstract
shapes and lines that displayed
multi-levels and an interconnected
structure simultaneously—from the
strings of a guitar and ribbons of a
film to the lines formed by a writer's
handwriting.

Illustration

Merit
Self-Promotion, Single

HUNTING

Illustrator
Hyejeong Park
School
School of Visual Arts
Country
United States

This illustration was for self-promo-
tion. The broken mirror reflects
outwards. The girl is looking at the
same things reflected in the mirror.
The red eye in the little tree is also
looking at the same things. Now, the
preparation is over and they are
ready to hunt. Just like me.

Graphic Design

Merit
Poster Design,
Public Service/Nonprofit/
Educational, Single

**DAMIÁN ORTEGA:
THE BEETLE TRILOGY
AND OTHER WORKS**

Art Director
Shelley Stepp,
Jae-Hyouk Sung
Creative Director
Jerry De La Rosa Jr.
Designer
Jerry De La Rosa Jr.
Illustrator
Jerry De La Rosa Jr.
Publisher
California Institute of the Arts
Office of Public Affairs
School
California Institute of the Arts
Client
REDCAT (Roy and Edna
Disney/CalArts Theater)
Country
United States

The REDCAT poster featuring
Damian Ortega encapsulates the
artist's heritage and the spirit of his
work. The exhibition was open
November through January, so the
language of the papel picado was
chosen for its wide use in many
Mexican festivals at the end of the
year. I wanted the poster to be fun,
eye-catching and have a Mexican
feel. Using random elements from
the traditional papel picado forms
with the illustrated parts of the Volk-
swagen Beetle made for an inter-
esting design challenge.

Graphic Design

Merit
Television & Cinema Design,
TV Identities, Openings,
Teasers, Single

**PALINDROMES
TEASER TRAILER**

Designer
Jeremy Landman
School
CalArts
Country
United States

A recently abandoned swing set
suggests the transition from child-
hood to adolescence. The back and
forth motion of the swings mirrors
the reversible character of palin-
dromes. Several palindromes echo
the swinging motion and hint at the
plot of Todd Solondz's film. The final
palindrome, "Aviva," is the name of
the film's thirteen-year-old main
character. I created this teaser trailer
in an advanced motion graphics
class instructed by David Vegezzi.

HALL OF FAME

ADC
HALL OF FAME

1972
M. F. Agha
Lester Beall
Alexey Brodovitch
A.M. Cassandre
René Clark
Robert Gage
William Golden
Paul Rand

1973
Charles Coiner
Paul Smith
Jack Tinker

1974
Will Burtin
Leo Lionni

1975
Gordon Aymar
Herbert Bayer
Cipes Pineles Burtin
Heyworth Campbell
Alexander Liberman
L. Moholy-Nagy

1976
E. McKnight Kauffer
Herbert Matter

1977
Saul Bass
Herb Lubalin
Bradbury Thompson

1978
Thomas M. Cleland
Lou Dorfsman
Allen Hurlburt
George Lois

1979
W. A. Dwiggins
George Giusti
Milton Glaser
Helmut Krone
Willem Sandberg
Ladislav Sutnar
Jan Tschichold

1980
Gene Federico
Otto Storch
Henry Wolf

1981
Lucian Bernhard
Ivan Chermayeff
Gyorgy Kepes
George Krikorian
William Taubin

1982
Richard Avedon
Amil Gargano
Jerome Snyder
Massimo Vignelli

1983
Aaron Burns
Seymour Chwast
Steve Frankfurt

1984
Charles Eames
Wallace Elton
Sam Scali
Louis Silverstein

1985
Art Kane
Len Sirowitz
Charles Tudor

1986
Walt Disney
Roy Grace
Alvin Lustig
Arthur Paul

1987
Willy Fleckhaus
Shigeo Fukuda
Steve Horn
Tony Palladino

1988
Ben Shahn
Bert Steinhauser
Mike Tesch

1989
Rudolph de Harak
Raymond Loewy

1990
Lee Clow
Reba Sochis
Frank Zachary

1991
Bea Feitler
Bob Gill
Bob Giraldi
Richard Hess

1992
Eiko Ishioka
Rick Levine
Onofrio Paccione
Gordon Parks

1993
Leo Burnett
Yusaku Kamekura
Robert Wilvers
Howard Zieff

1994
Alan Fletcher
Norman Rockwell
Ikko Tanaka
Rochelle Udell
Andy Warhol

1995
Robert Brownjohn
Paul Davis
Roy Kuhlman
Jay Maisel

1996
William McCaffery
Erik Nitsche
Arnold Varga
Fred Woodward

1997
Allan Beaver
Sheila Metzner
B. Martin Pedersen
George Tscherny

1998
Tom Geismar
Chuck Jones
Paula Scher
Alex Steinweiss

1999
R.O Blechman
Annie Leibovitz
Stan Richards

2000
Edward Benguiat
Joe Sedelmaier
Pablo Ferro
Tandanori Yokoo

2001/2002
Rich Silverstein
Giorgio Soavi
Edward Sorel

2003
Michael Bierut
André François
David Kennedy

2004
Jerry Andelin
Jay Chiat
Louise Fili
Al Hirschfeld
Tibor Kalman
Bruce McCall
Duane Michals

2006
Janet Froelich
Issey Miyake
Nancy Rice
Art Spiegelman
Bert Stern

HALL OF FAME
EDUCATORS AWARD

1983
Bill Bernbach

1987
Leon Friend

1988
Silas Rhodes

1989
Hershel Levit

1990
Robert Weaver

1991
Jim Henson

1996
Steven Heller

1998
Red Burns

1999
Richard Wilde

2001
Philip Meggs

2003
Richard Saul Wurman

2004
Muriel Cooper
Edward Tufte

2006
Nicholas Negroponte

Everyday, we reimagine, rethink, and redesign, constantly striving to produce fresh images and new ideas. But begin to peel back the layers of our work and one can trace the lineage of our design influences. As designers and creators, we rely on inspiration for our livelihood, and often draw it from the rich history of artists who came before us. ⁜ Since 1972, the Art Directors Club Hall of Fame has honored excellence in our field, creating a living record of the preeminent art directors and designers of the 20th and 21st centuries. Through their creative expression, these individuals influence what we see and remember of our world and our times. Their images unite us as a creative community by providing shared ideas and memories. ⁜ By recognizing the singular perspectives of these individuals, we celebrate the vast history of remarkable talents who have shaped our work and visual culture. It is my privilege to congratulate this year's inductees on their place in this extraordinary history and thank them for their unparalleled contributions to the legacy of our profession.

—Ann Harakawa

Chair, 2006 Hall of Fame Selection Committee

**ADC
HALL OF FAME
SELECTION
COMMITTEE**

Ann Harakawa
Chair, ADC Board Member;
Principal, Two Twelve Design

Paul Lavoie
President, ADC Board
of Directors; Chairman
and CEO, TAXI New York

George Lois
ADC Hall of Fame; Past
President, ADC Board

Tony Palladino
ADC Hall of Fame

Paul Davis
ADC Hall of Fame; Past
ADC Board member

Eileen Hedy Schultz
Past President, ADC Board

Gael Towey
ADC Board Member;
Chief Creative Officer,
Martha Stewart Omnimedia

Andy Hirsch
ADC Member; Principal,
Merkley & Partners

Cheryl Heller
Past ADC Board Member;
Principal, Heller
Communications, Inc.

Peter Cohen
Past ADC Board Member;
Creative Director

Richard Wilde
ADC Hall of Fame Educator;
Chair, Advertising and
Graphic Design Department,
School of Visual Arts

Janet
Froelich

THIS PAGE: *The New York Times Style Magazine,* Cover, Spring, 2005. OPPOSITE PAGE, CLOCKWISE FROM TOP LEFT: *The New York Times Style Magazine,* Cover, Fall, 2004; *The New York Times Magazine,* Cover, November 30, 2003; *The New York Times Magazine,* Cover, September 23, 2001; *The New York Times Style Magazine,* Women's Fashion Issue, Cover and Spread, Fall, 2005; *The New York Times Magazine,* September 8, 2002.

To me, Janet Froelich isn't a magazine art director. Don't get me wrong: she is an art director, and a great one (having won more than 60 gold and silver awards from graphic design organizations, for one thing), and I have known my share of art directors, and let's leave it at that. But Janet—who officially is the creative director of the *New York Times Magazine,* overseeing the look of not only the weekly magazine, but of *T,* our new style magazine and *Play,* our even newer sports magazine—she's something else, in so many ways, but most crucially in this one way: she's a journalist.

She starts the day like a journalist, and has for the twenty years she has worked at the *Times,* reading the paper, really reading the paper. She works like a journalist, understanding that every decision is a bit of a group decision, and thus not Art. (She trained as a painter, and began her career as a painter, so she knows what it is to make Art, and how making a magazine is something not

quite Art). She has the temperament of a journalist, that combustible admixture of curiosity, impatience, righteousness and a keen desire to get things right and true. And like a journalist she sees the world—absorbs the world, laments the world, marvels at the world—through stories.

A story: One airliner, and then another, are piloted into the Trade Center towers. The lamentable world is raining ash and bodies on the marvelous world of lower Manhattan (where Janet has happened to live since her Artist days), and within hours, we in the magazine offices on the 8th floor of the Times Building are completely ripping up an issue set to close in seventy-two hours and beginning to plan instead, or beginning to imagine if we can plan—amid panicked calls to spouses and kids and friends and what not—a 9/11 issue. Amid the many other riddles of that terrible day, our riddle: How to conceive a cover that will not be conceived by every other

magazine doing approximately what we are doing, a cover that will memorialize the event but somehow get beyond it, a cover that will tell a story—a story not just of the awful event but of our feelings about it? In meetings, and there were many meetings that day, Janet listened, questioned, jotted, interrupted, noted (she's a journalist). Then while my colleagues and I on the editorial side talked to writers, she talked to artists downtown. Among the artists were two, Paul Myoda and Julian LaVerdiere, who had been working in a studio on the 91st floor of the north tower, conceiving a light sculpture for the building. The cover she coaxed out of them so quickly, a simple and not so simple digital manipulation of a photograph by *Times* photographer Fred Conrad, is called "The Phantom Towers," and became not only an icon of the tragic attack but inspired a real-world, scaled-up doppelganger: actual lights projected upwards, ghost-limb-like, from Ground Zero, just like our

cover. Our most memorable cover. Ever.

A journalist, doing with concepts and photographers and illustrations and type treatment what we editors do with words: that's how I have always thought of Janet. A rarity, but maybe not forever. So many young designers have passed through our art department in the years we have worked together, and so much has rubbed off on them. Janet mentors like a journalist, too. Among those she has mentored, along with so many young art directors around town, is me. She's taught me how to think and edit visually. Now the two of us—the art director who's a journalist, the journalist who's learned to think like an art director—now we are able to speak a common language. How many editors can say that about their magazine's art director?

Gerald Marzorati
Editor-in-Chief
The New York Times Magazine

DESIGN FALL 2004

The New York Times Magazine

NOVEMBER 26, 2002 / SECTION 6

+ + +

=

See Page 71

Inspiration

Where does it come from?

The Annual Design Issue

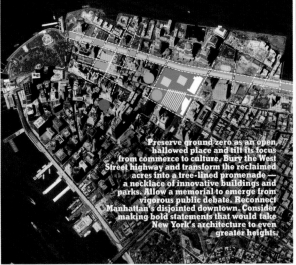

Don't Rebuild. Reimagine.

Now is the time for New York to express its ambition through architecture and reclaim its place as a visionary city.

By Herbert Muschamp

Preserve ground zero as an open, hallowed place and tilt its focus from commerce to culture. Bury the West Street highway and transform the reclaimed acres into a tree-lined promenade — a necklace of innovative buildings and parks. Allow a memorial to emerge from vigorous public debate. Reconnect Manhattan's disjointed downtown. Consider making bold statements that would take New York's architecture to even greater heights.

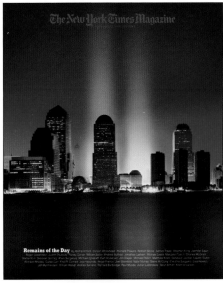

The New York Times Magazine

Remains of the Day

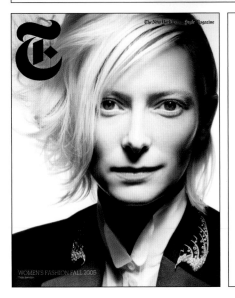

WOMEN'S FASHION FALL 2005

The New York Times Style Magazine

White Mischief

ONE MINUTE, SHE'S THE ARCHANGEL GABRIEL, AND THE NEXT, MARILYN MANSON. TILDA SWINTON, AS LYNN HIRSCHBERG DISCOVERS, IS A WOMAN OF EXTREMES.

Photographs by Raymond Meier

THIS PAGE: Issey Miyake, "Making Things," Installation View at Fondation Cartier pour l'art contemporain,1999. OPPOSITE PAGE, CLOCKWISE FROM TOP: Issey Miyake, "Making Things," Installation View at Fondation Cartier pour l'art contemporain,1999; Issey Miyake, "Making Things," Installation View at Ace Gallery, New York, 1999; "Nannano? A-POC Making: Issey Miyake + Dai Fujiwara," Installation View at AXIS Gallery, Roppngi, Tokyo, 2003; "A-POC Making: Issey Miyake + Dai Fujiwara," Installation View at Vitra Design Museum, Berlin, 2001; Issey Miyake, "Making Things," Installation View at Fondation Cartier pour l'art contemporain,1999.

Issey
Miyake

Issey Miyake was born in Hiroshima in 1938. He graduated from the Tama University, Tokyo in 1963 with a degree in graphic design. In 1965, he left for Paris to study at the École de la Chambre Syndicale de la Couture Parisienne. From 1966-1969 he worked for different fashion houses in Paris and New York.

The most significant effect of this period upon Miyake's work was a schism with traditional couture. Miyake's vision to create clothing for everyone and his subsequent exploration of the relationship between clothing and the body set him apart. His touchstone eventually became creating clothing from a single piece of cloth.

Miyake returned to Tokyo and established the Miyake Design Studio in 1970. It has evolved into a research laboratory dedicated to attracting and nurturing diverse talent, a studio with a team mentality.

In 1973, Miyake presented his first fashion show in Paris,

defying tradition and trend, surprising those assembled with his avant-garde and architectural vision. In 1978, he published *East Meets West,* a seminal book in which he chronicled his experiments making clothing from "one piece of cloth" that transcended the boundaries of East/West traditions and innovations. In 1979, Miyake was invited to the International Design Conference in Aspen, CO. to present Issey Miyake: East Meets West as the Conference finale.

In 1986, Miyake began a 10-year collaboration with photographer Irving Penn, culminating in the 1999 *Irving Penn Regards the Work of Issey Miyake* designed by late Tanaka Ikko.

Miyake's quest for clothing that could be universal was realized when Frankfurt Ballet director William Forsythe came to him to request for costumes for his dancers. Miyake's "garment pleating" is a revolutionary new process by which, instead of pleating fabric first, an outsize piece of fabric is cut and sewn

and then sandwiched between layers of paper, then fed through a heat press. When the paper is cut away, a perfectly sized finished pleated garment is ready to wear. In 1992, the Pleats Please Issey Miyake line was born.

In 1997, Miyake presented the result of a new experiment using digital technology at his show in Paris. "Just Before", a continuous roll of knit tubes from which the wearer could cut around lines of demarcation to extrude a fully-finished dress and then customize it, was the earliest evolution of what was to become A-POC (A Piece of Cloth). In 1999, Miyake turned the Issey Miyake line over to an associate so that he could return to his first love, research. Developed with Fujiwara Dai, A-POC is a technological process by which fabric, texture, and the components for a fully finished garment are made in a single process and which has unlimited possibility and applications to other areas of design.

A-POC has been featured

prominently in Issey Miyake "Making Things," an exhibition in Paris, New York, and Tokyo in 1998, "A-POC Making" at the Vitra Museum in 2001; and "Nannano? A-POC" at the Axis Gallery Tokyo in 2003.

The Miyake Issey Foundation was established in 2004 and in 2007, Miyake-brainchild, 21_21 Design Sight will open in Tokyo as a space in which to explore how all medium of design affects our daily lives.

Miyake has received numerous awards, including The Order of Commandeur of the Decoration of Art and Culture of France, from the French Government (1991), Shiju-hosho, Medal with the Purple Ribbon, from the Japanese Government (1997), Designated as Bunka Kourousha, the Person of the Cultural Merits, from the Japanese Government (1998), Awarded the 11th Wexner Prize from the Wexner Center, Ohio State University (2004), The Praemium Imperiale Sculpture Prize from the Japan Art Association (2005).

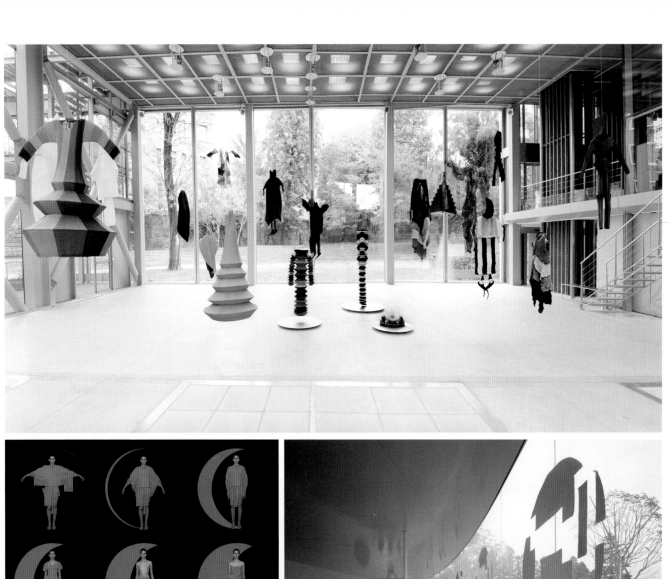

THIS PAGE: Client, *Rolling Stone,* 1986; OPPOSITE PAGE, CLOCKWISE FROM TOP LEFT: Client, Episcopal Ad Project, 1986; Client, International Hairgoods, 1989; Client, ITT Life Insurance Corporation; Client, Herman Miller; Client, Weight Watchers; Client, *Successful Farming,* 1989; Client, Episcopal Ad Project, 1986; Client, Gold'n Plump.

Nancy
Rice

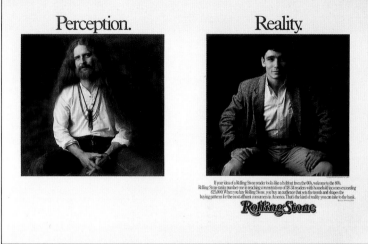

Nancy Rice is one of the legends of advertising, having held senior creative management posts with the likes of Knox Reeves, Bozell & Jacobs Mpls., DDB Needham Chicago, Ogilvy & Mather Chicago, BBDO Mpls., and Rice & Rice. In 1981, she was a founding partner in Fallon McElligott Rice, which, within three years of its founding, was named "Agency of the Year" by *Ad Age.* While there, Rice was named first runner-up for "Ad woman of the Year" by *Adweek.* In 1986, the Hall of Fame Committee of the New York Art Directors Club named her "Art Director of the Year." That year, she was also featured in the *Esquire Register* as one of the "Men and Women Under 40 Who are Changing the Nation." In 1989, *Adweek* and the One Club chose her "Perception/Reality" campaign for *Rolling Stone* magazine as one of the 10 Best Campaigns of the Decade. In 1997, she was showcased by British Design and Art Direction in *The Art Direction Book,* featuring twenty-eight of the world's

best art directors (only six from the USA).

In addition to winning creative awards, Ms. Rice has also been a sought-after judge, speaker and columnist for the advertising industry, the graphic design field and education. She has been a Trustee for two terms for her alma mater, the Minneapolis College of Art and Design, where she was a commencement speaker representing 100 years of MCAD alumni. Rice was also honored with a one-woman show in New York at the Herb Lubalin Gallery at Cooper Union. In 2001, Nancy's dedication to education and the future of the communications industry led Nancy full-circle to her position as Worldwide Creative Director of Miami Ad School and Director of Miami Ad School Minneapolis. While there, her mission was to assure the quality level of teachers, students, and their work. Nancy continues to teach now as full-time faculty at MCAD. There she focuses her efforts

on the restructuring of the school's undergraduate Advertising Degree Program as the Program's Coordinator. She also continues to mentor her many students worldwide, and to be involved in creating new experiences in curriculum, continuing her commitment to the future of the industry. Nancy is a single parent and grandmother, proud mother of two 30-year old daughters, both artists.

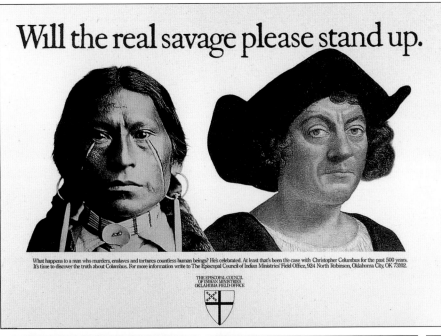

Will the real savage please stand up.

What happens to a man who murders, enslaves and tortures countless human beings? He's celebrated. At least that's been the case with Christopher Columbus for the past 500 years. It's time to discover the truth about Columbus. For more information write to The Episcopal Council of Indian Ministries' Field Office, 924 North Robinson, Oklahoma City, OK 73102.

THE EPISCOPAL COUNCIL
OF INDIAN MINISTRIES
OKLAHOMA FIELD OFFICE

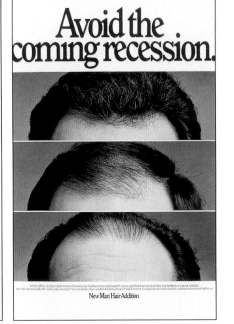

Avoid the coming recession.

New Mari Hair Addition

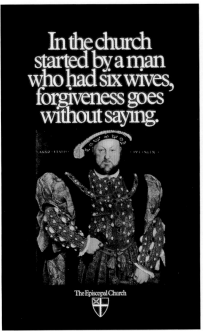

In the church started by a man who had six wives, forgiveness goes without saying.

The Episcopal Church

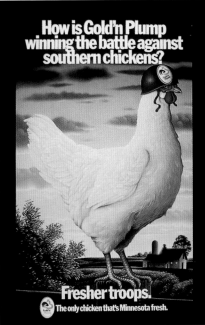

How is Gold'n Plump winning the battle against southern chickens?

Fresher troops.
The only chicken that's Minnesota fresh.

HOW MUCH IS IT COSTING YOU TO IGNORE YOUR LIFE INSURANCE?

ITT Life Insurance Corporation

"Even the pigs know when Successful Farming comes. It's the only time of the month they get fed late."

WE HELP YOU TO LOSE WEIGHT THE SAME WAY YOU PUT IT ON:

WITH A KNIFE AND FORK.

WEIGHT WATCHERS

Now Herman Miller fills your dealership with something just as important as furniture.

Art
Spiegelman

Art Spiegelman has, according to *LA Weekly,* almost single-handedly brought comic books from the toy closet to the literature shelves. In 1992 he won the Pulitzer Prize for his Holocaust narrative *Maus,* portraying Jews as mice and Nazis as cats. Translated into over 25 languages, *Maus* was chosen by New York Public Library and *The New York Times Book Review* as among the 100 most significant books of the last century. His comics are renown for shifting graphic styles, formal complexity, and controversial content. He sees in our post-literate culture the importance of the comic rising, for "comics echo the way the brain works."

Art Spiegelman was born February 15, 1948 in Stockholm, Sweden. His family immigrated to America in 1951, settling in Rego Park, New York. Rejecting his parents' aspirations for him to become a dentist, Spiegelman found cartooning early, drawing professionally at age 16. He went on to study art at Harpur College before joining the San Francisco-based under-

ground comics movement of the late 1960s and '70s. He and Bill Griffith co-edited the seminal underground comix anthology *Arcade* between 1975 and 1977, and in 1977 Belier Press published *Breakdowns,* a hardcover volume collecting Spiegelman's underground work.

Creative consultant for Topps Bubble Gum Co. from 1965-1987, Spiegelman designed Wacky Packages, and Garbage Pail Kids, and taught history and aesthetics of comics at the School for Visual Arts in New York from 1979 to 1986.

In 1980, Spiegelman co-founded *Raw,* an avant-garde comics magazine, with his wife, Françoise Mouly. For eleven years, *Raw* presented ground-breaking work from contemporary cartoonists and serialized *Maus* in chapter-length installments. The two volumes of *Maus,* published by Pantheon in 1986 and 1991 respectively, were published together as *The Complete Maus* in 1996. Between 2000 and 2003

Spiegelman and Mouly co-edited *Little Lit,* a series of three children comics anthologies published by HarperCollins. An anthology of that work is due from Puffin in late 2006.

Art Spiegelman's work has frequently appeared in *The New Yorker,* where he was a staff artist, writer and cover artist from 1993 to 2003. In 2004 he completed a two-year cycle of broadsheet-sized color comics pages, *In the Shadow of No Towers,* first published in several European newspapers and magazines as well as *The Forward.* These highly political works, published together by Pantheon in the United States, made many national bestseller lists and was selected by *The New York Times Book Review* as among the 100 Notable Books of 2004.

Spiegelman's work has been displayed in numerous solo and group exhibitions, including "The Comic Art Show" at the Whitney Museum of American Art (1983) and "Making *Maus*" at the Museum of Modern Art (1991).

A major exhibition of his work was recently shown at the Los Angeles Museum of Contemporary Art and the Milwaukee Art Museum as part of the "Masters of American Comics" exhibit, for which he was a senior consultant (November 2005 to August 2006).

Spiegelman's many awards include the *LA Times* Book Prize for Fiction and an Honorary Doctorate of Letters from SUNY Binghamton. In 2005, he was made a Chevalier de l'Ordre des Arts et des Lettres in France, named a Fellow of the American Academy of Arts and Sciences, and was among *Time Magazine*'s 100 Most Influential People of 2005.

He is currently working on a comix format memoir, *Portrait of the Artist as a Young !@##$%!,* incorporating his most significant early underground comix work, and is assembling a book about the making of *Maus,* entitled *Meta-Maus.*

Bert
Stern

Bert Stern, one of the legendary figures in contemporary photography, personified the commercial photographer as cultural hero in the 1960s. Hugely successful in the worlds of fashion and advertising photography, in the late 1960s he operated a studio, not unlike Andy Warhol's Factory, from which he created countless award-winning ads, editorial features, magazine covers, films, and portraits. His name is firmly associated with the golden age of advertising, and many of his images are classics.

Stern's meteoric rise in the 1960s advertising world is represented by such images as his vodka advertisement in which an Egyptian pyramid is seen inverted in a martini glass. Besides working for such clients as IBM, *Vogue, Glamour, LIFE,* Revlon, and Smirnoff, he was highly acclaimed for his portraits of celebrities including Gary Cooper and Louis Armstrong. His portraits of stars ranging from Elizabeth Taylor and

Audrey Hepburn to Drew Barrymore, including the spellbinding 1962 "last sitting" photographs of Marilyn Monroe, form a gallery of the most beautiful women of our time. In the 1960s, he became the American prototype of the fashion photographer as media star, and his pictures of models from Twiggy to Iman have become icons to a new generation of photographers. In all Stern's works can be seen the remarkable graphic simplicity of his photographic art, as well as his extraordinary rapport with his subjects.

Born in Brooklyn, New York and self-taught in photography, Stern began his career as assistant to art director Hershel Bramson at *Look* magazine from 1946 to 1948. Between 1949 and 1951, he was art director at *Mayfair* magazine, after which he rejoined Bramson at L.C. Gumbiner advertising agency, and helped create the modern advertising photograph. In 1954, he opened the first of four studios in New York, the last closing in

1971. Between 1971 and 1975, Stern lived in Spain. Since 1976, he has continued working in New York on personal as well as commercial assignments.

Hall of Fame

graphis **74**

NaturalClassic.

THE RAINBOW OF SMIRNOFF SUMMER DRINKS There's no end to the cool, refreshing drinks you can make with vodka. And there's no vodka like Smirnoff for making them taste perfect to the last delicious drop. It's so easy! Just add a jigger of Smirnoff to your favorite fruit juice, mixer or soft drink. Smirnoff has no liquor taste. It *lures itself completely* in your Screwdriver or Bloody Mary, Vodka Collins or Highball . . . leaving their familiar flavors freshened, but unchanged. Always ask at bars for Smirnoff, the vodka you drink at home.

the vodka of vodkas

Smirnoff THE GREATEST NAME IN **VODKA**

THE MARTINI WITH THE MARVELOUS TASTE

They say a taste for Martinis, like olives, must be cultivated. Perhaps that's why the most cultivated tastes insist on the driest, smoothest, subtlest Martini of all . . . the smart Martini . . . the Vodka Martini. This much is sure: if your taste in Martinis is dry . . . really dry . . . your search is ended. Make your next Martini just as you always make it—with one simple, but vital difference. Use dry, mellow Smirnoff Vodka instead of gin!

it leaves you breathless . . .

Smirnoff THE GREATEST NAME **VODKA**

LONG, COOL SMIRNOFF, DRINKS FOR LONG, HOT SUMMER DAYS!

There's no end to the tall, refreshing drinks you can make with Smirnoff Vodka. They're all so easy to prepare . . . and wonderful to taste. So, this summer, why quench your thirst with anything that's not delicious? Add a jigger of Smirnoff to any mixer, fruit juice or soft drink. Smooth, flavorless Smirnoff has no liquor taste or "breath." It leaves itself in your favorite flavor, adds gusto to just about anything that pours!

it leaves you breathless

Smirnoff THE GREATEST NAME **VODKA**

Nicholas
Negroponte

Nicholas Negroponte is founder and chairman of the One Laptop per Child non-profit association. He is currently on leave from Massachusetts Institute of Technology, where he was co-founder and director of the MIT Media Laboratory, and the Jerome B. Wiesner Professor of Media Technology. A graduate of MIT, Nicholas was a pioneer in the field of computer-aided design, and has been a member of the MIT faculty since 1966. Conceived in 1980, the Media Laboratory opened its doors in 1985. He is also author of the 1995 best seller, *Being Digital,* which has been translated into more than 40 languages. In the private sector, Nicholas serves on the board of directors for Motorola, Inc. and as general partner in a venture capital firm specializing in digital technologies for information and entertainment. He has provided start-up funds for more than 40 companies, including *Wired* magazine.

THIS PAGE: One Laptop Per Child concept image by fuse-project. OPPOSITE PAGE, FROM TOP: Green Machine Prototype concept images by Design Continuum; Blue Machine and Yellow Machine concept images by fuse-project.

ADC
Administration

EXECUTIVE DIRECTOR
Myrna Davis

Director of Operations
Olga Grisaitis

Marketing &
Development Associate
Laura Des Enfants

Annual Awards Manager
& Editor, ADC Publications
Emily Warren

Interactive Manager
& ADC Young Guns
Coordinator
Jenny Synan

Education Coordinator
Kate Farina

Assistant to
the Executive Director
Chris Reitz

Membership Administrator
Ann Schirripa

Awards Program Associate
Glenn Kubota

Awards Program Associate
Kimberly Hanzich

Facilities Associate
Jen Griffiths

Web Intern
Adam Nguyen

Financial Consultant
Tony Zisa

Certified Public Accountant
Winnie Tam & Co., P.C.

Waitstaff
Margaret Busweiler
Patricia Connors

ADC
Board of Directors 2005–06

PRESIDENT
Paul Lavoie
TAXI NYC

OFFICERS

Vice President
Brian Collins
Brand Integration Group,
Ogilvy & Mather

Second Vice President
Jeroen Bours
Hill, Holliday New York

Secretary
Chee Pearlman
Chee Company

Treasurer
Michael Donovan
D/G2, Inc.

Assistant Secretary
& Treasurer
Gael Towey
Martha Stewart Living
Omnimedia

BOARD

Ken Carbone
Carbone Smolan Agency

Ann Harakawa
Two Twelve Associates

Doug Jaeger
The Happy Corp. Global

Linus Karlsson
Mother

Gary Koepke
Modernista!

Rick Kurnit
Frankfurt, Kurnit, Klein & Selz

Clement Mok
CMCD | Visual Symbols Library

Ty Montague
J. Walter Thompson

Neil Powell
Margeotes, Fertitta, + Powell

Lisa Strausfeld
Pentagram

Jakob Trollbäck
Trollbäck and Company

Kevin Wassong
Minyanville

EMERITUS

Rick Boyko
VCU Adcenter

Jon Kamen
@radical.media

Parry Merkley
Merkley + Partners

ADVISORY BOARD
PRESIDENT

Robert Greenberg
R/GA

ADC
Past Presidents

Richard J. Walsh, 1920–21
Joseph Chapin, 1921–22
Heyworth Campbell, 1922–23
Fred Suhr, 1923–24
Nathaniel Pousette-Dart, 1924–25
Walter Whitehead, 1925–26
Pierce Johnson, 1926–27
Arthur Munn, 1927–28
Stuart Campbell, 1929–30
Guy Gayler Clark, 1930–31
Edward F. Molyneuz, 1931–33
Gordon C. Aymar, 1933–34
Mehemed Fehmy Agha, 1934–35
Joseph Platt, 1935–36
Deane Uptegrove, 1936–38
Walter B. Geoghegan, 1938–40
Lester Jay Loh, 1940–41
Loren B. Stone, 1941–42
William A. Adriance, 1942–43
William A. Irwin, 1943–45
Arthur Hawkins Jr., 1945–46
Paul Smith, 1946–48
Lester Rondell, 1948–50
Harry O'Brien, 1950–51
Roy W. Tillotson, 1951–53
John Jamison, 1953–54**
Julian Archer, 1954–55
Frank Baker, 1955–56
William H. Buckley, 1956–57**
Walter R. Grotz, 1957–58
Garrett P. Orr, 1958–60
Robert H. Blattner, 1960–61
Edward B. Graham, 1961–62
Bert W. Littman, 1962–64
Robert Sherrich Smith, 1964–65
John A. Skidmore, 1965–67
John Peter, 1967–69
Wiilliam P. Brockmeier, 1969–71
George Lois, 1971–73**
Herbert Lubalin, 1973–74
Louis Dorfsman, 1974–75**
Eileen Hedy Schulz, 1975–77**
David Davidian, 1977–79**
William Taubin, 1979–81
Walter Kaprielian, 1981–83**
Andrew Kner, 1983–85**
Edward Brodsky, 1985–87**
Karl Steinbrenner, 1987–89
Henry Wolf, 1989–91
Kurt Haiman, 1991–93**
Allan Beaver, 1993–95**
Carl Fischer, 1995–97**
Bill Oberlander, 1997–2000**
Richard Wilde, 2000–2002**
Robert Greenberg 2002-2005**

Advisory board**

ADC
Hall of Fame

SPECIAL THANKS

Invitation &
Booklet Cover Design
Two Twelve Associates

Exhibit Design
Scott Ballum/Sheepless

Booklet Design
Giampietro+Smith

he ADC is known for the prestigious Gold Cubes it bestows upon the most talented creatives in our industry. In addition to the Annual Awards, ADC offers a wide variety of programming throughout the year—portfolio reviews, speaker events, workshops for high school students, traveling exhibitions, parties and symposia. Our diverse array of events helps fulfill ADC's mission to celebrate and inspire creative excellence and encourage young people coming into the field. Founded in 1920 as the worlds first Art Directors Club, the ADC is the premier organization for visual communications. Our mandate is to provide a forum for creative leaders in Advertising, Graphic Design and Interactive Media, and to address the growing integration among those industries. ADC Now features the highlights of our year, at our own gallery and throughout the world.

September 2005

September 9–10
SEMI-PERMANENT

The ADC was pleased to help bring the Semi-Permanent world tour to New York City, hosting their VIP party on the 9th in the ADC Gallery.

September 14–30
DUTCH TOUCH FASHION EXHIBITION

This exhibition of works by Dutch fashion photographers, designers and artists gave insight into the process of bridging individual creative thinking with commercial assignments.

September 28–October 28
ACT EXHIBITION

The ADC Gallery hosted the Advertising Community Together (ACT) exhibition, "Great Ads for a Better Future." This year ACT's exhibition focused on sustainability, and celebrated campaigns developed for NGOS, non-profit groups, and government agencies from around the world. ACT is an AdForum initiative.

September 29
BIG BRAND TALKS

For this year's Big Brand Talks Bill Gardner of Gardner Design, Joe Duffy of Duffy and Partners, and Katherine Stone of Engage Consulting shared their wisdom on logo design trends, brand development, and experiential marketing techniques.

TOP, MIDDLE & BOTTOM LEFT: The Dutch Fashion Foundation presented two shows as participants in New York's Fashion Week.

October 11

CITIES PROJECT

"Starchitecture and the City:
Toronto's Bilbao Effect."
Architects Will Alsop, Jack
Diamond, Bruce Kuwabara,
and Daniel Libeskind
discussed their Canadian
projects with architect/design
journalist Andrew Blum and
grappled with how the archi-
tecture of cultural institutions
impacts the social and
economic life of a city.

October 27

**PHOTOGRAPHY
PORTFOLIO REVIEW**

For the ADC's 6th annual
Photography Portfolio Review
100 established and emerging
photographers were seated
with their portfolios for
review by area creatives in
advertising, publishing, and
corporate design.

TOP: Participants in the Cities
Project shared their views with
journalist Andrew Blum. The
discussion was organized by
the Canadian Consulate General.
BOTTOM: The 6th Annual
Photography Review gave a
diverse group of photographers
the opportunity to receive
feedback from top creatives.

November 2005

November 14–18

G2EXPO05

The ADC hosted G2 World-wide's exhibition showcasing a selection of G2's best creative work. They brought together agency and client-side thought-leaders and innovators to experience an inspiring event, surrounded by some of the best creative talent and work in the industry.

November 29

PHILIP HAYS MEMORIAL

The ADC was honored to hold the memorial service Philip Hays, the celebrated illustrator and educator.

ALL PHOTOS: The G2 Expo featured a cocktail reception, where guests viewed G2's best work, while meeting with agency and client-side thought-leaders and innovators.

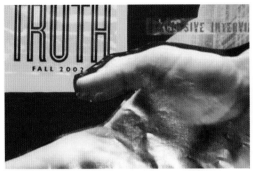

SATURDAY CAREER WORKSHOPS

This year, ADC once again invited nearly 100 high school juniors to participate in the Saturday Career Workshops. Thanks to ADC staff and our partners at the School Art League, Jane Chermayeff, Renee Darvin and Naomi Lonergan, the program continued to inspire and motivate New York City's most talented art students. Consisting of weekly sessions led by professionals in design, advertising, illustration, photography and interactive media, the workshops provide a hands-on introduction to career fields that these talented students might consider. The program is made possible by the generous support of the Coyne Foundation.

Fall workshops were conducted by Diana LaGuardia, Stephen Kroninger, Alex Suh and Boyoung Lee, Josh Gosfield and Marshall Arisman. In October, ADC hosted the Art College Seminar, inviting top art and design schools from the New York area. Representatives presented information to students, parents and teachers and reviewed student portfolios. Thanks to a grant from Time Warner, the students that participated in the portfolio review received brand new portfolio cases to display their work.

Diana LaGuardia, Stephen Kroninger and Alex Suh and Boyoung Lee returned to give their workshops during the spring session. They were joined by Jason Pacheco, Adam Jackson, and Isabel Veguilla.

During the year, we were assisted by volunteers Gui Borchert, Karen Cohn, Olivia Fincato, Elisa Halperin, Adam Jackson, Kathy Keefe and Jason Pacheco.

This year marked the final year of service for Naomi Lonergan, School Art League Education Coordinator, and Susan Mayer, Saturday Career Workshop Program Director. Both worked tirelessly to develop and expand the program. We thank them for their dedication and wish them the best.

ABOVE: Images of work produced in the Fall 2005 Saturday Career Workshops. In each workshop, leaders assign a creative project. ADC provides materials for collage, photography, painting, storyboarding and other techniques and media. Students strengthen their skills and often produce work that will eventually be included in their portfolios.

January 2006

January 25

ADC BOOK PARTY

ADC celebrated the launch of its 84th Art Directors Annual, designed by TAXI New York with a "Book Warming Party" held on January 25th. The book presented more than 1,400 images in 476 full-color pages. It was selected as a finalist in The One Show and won an American InHouse Design Award from *Graphic Design USA*.

TOP: Members, students and guests got a first look at the new Annual. CENTER: Paul Lavoie, Chairman and Chief Creative Officer of TAXI (and ADC President), addressed the crowd. LOWER LEFT: TAXI's Stephanie Yung, designer, Paul Lavoie, and Heather Doutt, account manager, joined ADC's Myrna Davis, Louis Hess, and Emily Warren in celebrating the book's success.

February 2006

February 9–11
GRAPHIC DESIGN JUDGING

February 23–25
ADVERTISING JUDGING

The juries of ADC's 85th Annual Awards were comprised of some of the very best creative professionals from around the world. Their task was to select a small body of work that would represent the most innovative work in the industry. The judges, led by chairs Brian Collins (Graphic Design and Hybrid), Kevin Roddy (Advertising), Paul Davis (Illustration), and Matt Freeman (Interactive) viewed over total 11,500 entries.

TOP LEFT: Rob Giampietro and Peter Bilak. TOP RIGHT: Chuck Anderson and Leigh Okies. CENTER LEFT: Weston Bingham, Brian Collins, Nancye Green and Yuko Shimizu. CENTER RIGHT: Mark Gross, Mike Judge, Joe Goodman. BOTTOM: Advertising judges confer over an entry.

March 2006

March 9
INTERACTIVE JUDGING

Interactive Media saw a surge in entries this year, with a forty percent increase over the previous year. Of 1,000 entries, thirty-seven earned Gold, Silver, Distinctive Merit or Merit awards.

March 10
HYBRID JUDGING

The Gold-winning entry in the Hybrid category was an innovative campaign for the Japanese search engine goo.com, which featured a combination of outdoor advertising, interactive work and guerrilla marketing.

March 20–24
SVA DISARM

Disarm: New Year, New Use. Kevin O'Callaghan, chair of 3D design at SVA, curated this year's 3D exhibition at the ADC Gallery. The design students in the BFA Advertising and Graphic Design Department used replica AK-47s to make everyday objects ranging from a baby carriage to a beer keg.

TOP: Judges rate an entry in the interactive category. BOTTOM: Work from SVA's 3D exhibition, *Disarm: New Year, New Use.*

Throughout April

SATURDAY CAREER WORKSHOPS

April 10–28

METROPOLIS VIEW

METROPOLIS Magazine presented METROPOLIS View an exhibition of the magazine's contributing photographers whose work has shaped the magazine's 25-year history.

April 25

NEW YORKER BOOK PARTY

On April 25th the New Yorker hosted a book party for Josh Kilmer-Purcell's new novel, *I Am Not Myself These Days.* The author read selected passages from his book and gave personal insight into his former double life as a creative executive by day, and drag superstar by night.

April 26

METROPOLIS NEXT GENERATION PARTY

METROPOLIS Magazine celebrated the winner of the third annual METROPOLIS Next Generation Design Competition. The event was sponsored by Maharam and Herman Miller, Inc.

TOP: Participants, volunteers and presenters from the Spring, 2006 Saturday Career Workshops. BOTTOM: The METROPOLIS Magazine exhibition party celebrated the contributing photographers whose work played a large part in the magazine's 25 years.

May
2006

May 8–9
ADC STUDENT PORTFOLIO REVIEWS

In one place, for one day, the top 100 design and advertising graduates selected by the top art schools in the U.S and abroad gathered to show their books to a range of reviewers.

May 11
PING PONG

The ADC hosted Trollbäck + Company's Fourth Ping Pong Challenge. Thirty-two teams played on four tables in an all night fight to see which team would be dubbed the new champions. Despite the best efforts of new blood brought in by the ADC, the trophies went to some old victors, José and Paul from CSA.

May 10–19
PARSONS SENIOR ILLUSTRATION EXHIBITION

From May 10th through the 19th the ADC gallery hosted the Parsons Senior Illustration exhibition.

TOP: A member of "Team America" demonstrates great backhand form at Trollback + Company's Fourth Ping Pong Challenge. BOTTOM: Students, friends and guests gathered at the Parsons Senior Illustration Exhibition.

June 8

85TH ANNUAL AWARDS GALA

The ADC's biggest party of the year. This year the we celebrated the winners of the 85th annual awards with musical guest Miri Ben-Ari, the hip-hop violinist. The Gala brought hundreds of winners, judges, members, press, and fans to see the very best advertising, graphic design, and interactive work of the year.

TOP: Kris Kiger, Judge. MIDDLE LEFT: Hip-hop violinist Miri Ben-Ari. MIDDLE RIGHT: Brad Emmett. BOTTOM LEFT: Myrna Davis and Jeroen Bours with the Chinese Consulate.

July
2006

June 9–July 7

**85TH ANNUAL
AWARDS EXHIBITION**

After the excitement of the
Gala, the winners of the 85th
Annual Awards remained on
view in the ADC Gallery for
nearly a month. The exhibition,
which will travel the world this
year, was truly an interactive
experience for visitors.

ALL PHOTOS: The Annual Awards
Exhibition featured radio and
television broadcast, as well as
kiosks for the interactive winners.
The gallery pillars were swathed
in gold, befitting this year's theme.

All year
ADC 84th Awards Travelling Exhibition

The ADC 84th Awards Traveling Exhibition enjoyed another successful and well-received tour of North America, Europe, Asia and South America. ADC welcomed new venues such as VCU's AdCenter in Richmond, Virginia, Ogilvy Johannesburg/Creative Circle in South Africa, Designers of Madrid, Association/Escuela de Arte No. 10 in Madrid, Spain, Department of Management in Culture, Ministry of Culture/BELEF Centre in Belgrade, Serbia, and the Billy Blue School of Graphic Arts in Sydney, Australia. The show was also well-received at venues we have come to know and appreciate over the years such as A+D Gallery at Columbia College Chicago, the Advertising Design Department in the College for Creative Studies, Detroit, the Association for Promotion of Visual Culture and Visual Communication (VIZUM) in Zagreb, Croatia, the School of Communication at Hong Kong Baptist University, Capital Corporation Image Institution (CCII) in Beijing, China, the Communication Design Department of Bangkok University, Creation Gallery G8 at Recruit Creative Center in Tokyo, Japan, and Panamericana Escola de Arte e Design in Sao Paulo, Brazil. All in all, it was a great year for the Traveling Exhibition in promoting the Annual Awards and the ADC.

FIRST & SECOND ROW LEFT: Panamericana Escola de Arte de Design in Sao Paolo, Brazil. SECOND ROW RIGHT: College for Creative Studies, Detroit. THIRD ROW LEFT: Columbia College, Chicago. THIRD ROW RIGHT: Ogilvy Johannesburg/ Creative Circle in South Africa. BOTTOM LEFT: Designers of Madrid Association/Escuela de Arte No. 10 in Madrid, Spain BOTTOM RIGHT: The School of Communication at Hong Kong Baptist University.

ADC Membership & Administration

Robert Barthelmes
Hugh Barton
Tripp Bassett
Christian Batres
Mary K. Baumann
Matthew Baumlin
Natalie Bazin
Allan Beaver
Christop Becker
April Bell
Archie Bell II
Benjamin Belsky
Martha Benari
Edward J. Bennett
Richard Berenson
John Berg
Robert Bergman
Julia Bernadsky
Walter L. Bernard
Mickey Beyer-Clausen
Jennifer Binder
Mat Bisher
Debra Bishop
Christina Black
Rasmus Blaesbjerg
Marina Blanter
R.O. Blechman
Robert H. Blend
Joe Bloch
Barbara Bloemink
Travis Bobbe
Carol Bokuniewicz
Joanne Borek
Jean Bourges
Jeroen Bours
Harold A. Bowman
Rick Boyko
Barbara Boyle
Bruce Erik Brauer
Al Braverman
Erica Brembos
Andrew R. Brenits
Kristi Bridges
Ed Brodsky
Ruth Brody
Christine Bronico
Paul Brourman
Claire Brown
Michael Bruce
Bruno E. Brugnatelli
Janice Brunell
Jorge Brunet-Garcia
William H. Buckley
Gene Bullard
Christopher Buonocore
Jennifer Burak
Sandra Burch
Adrienne Burke
Red Burns
Amy Byron
Mark Cacciatore
Jodi Cafritz
Nicholas Callaway
Mary Jane Callister
Jon Cammarata
David Caplan
Ken Carbone
Marcelo Cardosa
Gregg Carlesimo
Thomas Carnase
EJ Carr
Karen Carroll
David Carter
Roymieco Carter
Elaini Caruso
Kevin Cassidy
Michele Castagnetti
Diana Catherines
Arthur Ceria
Francisco Cervi
Andrew Chang
Sharon Chang
Anthony Chaplinsky Jr.
Stephane Charier
Jack Chen
Peter Chen
Ivan Chermayeff
Domingo Chozas
Richard Christiansen
Tim Chumley
Shelly Chung

Stanley Church
Seymour Chwast
Joseph Cipri
Laura Citron
Scott Citron
Andrew Clark
Douglas Clark
Herbert H. Clark
John V. Clarke
Thomas F. Clemente
Joann Coates
Claudia Coffman
Michael Cohen
Peter Cohen
Rhonda Cohen
Stacy Cohen
Jack Cohn
Karen Cohn
Jeff Cole
Alisa Coleman-Ritz
Brian Collins
James Collins
Solange Collins
Andreas Combuechen
Lou Congelio
Mary Jane Conte
Christopher Cook
Andrew Coppa
Jeffrey Cory
Gary Cosimini
Erminia Costantino
Sheldon Cotler
Susan Cotler-Block
Coz Cotzias
Michael Coulson
Robert Cox
Kathryn Craig
Meg Crane
Kathleen Creighton
Damaso Crespo
Gregory Crossley
Bob Crozier
Ethel R. Cutler
Joele Cuyler
Tracy D'Alessandro
Pier Nicola D'Amico
Kyle Daley
Jakob Daschek
David Davidian
J. Hamilton Davis
Paul Brookhart Davis
Randi B. Davis
Roland De Fries
Allison DeFord
Richard Degni
Joe Del Sorbo
David Dell'Accio
Andrew DeMattos
Venus Dennison
David Deutsch
Doug DeVita
An Diels
John F. Dignam
Roz Dimon
Jeseka Djurkovic
Jason Dodd
Michael Donovan
Louis Dorfsman
Marc Dorian
Bruce Doscher
Kay E. Douglas
Sheila Doyle
Stephen Doyle
Jing Duan
Donald H. Duffy
Joe Duffy
James Dunlinson
Bernard Eckstein
Ed Eckstein
Joe Edakkunnathu
Noha Edell
Peter Edgar
Geoffrey Edwards
Andrew Egan
Nina Eisenman
Stanley Eisenman
Chris Elliott
Judith Ellis
David Epstein
Lee Epstein
Shirley Ericson

Rafael Esquer
Robert Evangelista
Ted Fabella
Kathleen Fable
Steve Fabrizio
Ben Farber
Sally Faust
Zoe Fedeles
Michael Fenga
Mark Fenske
Andres Fernandez
Megan Ferrell
Mary Fetters
Katherine Filice
Olivia Fincato
Stan Fine
Blanche Fiorenza
Andre Fiorini
Carl Fischer
Gill Fishman
Bernadette Fitzpatrick
Emily Flake
Donald P. Flock
Patrick Flood
Marta Florin
Michael Fofrich
Ian Forbes
Tara Ford
Danielle Forquignon
Polly Franchini
Cliff Francis
Michael Frankfurt
Stephen Frankfurt
Courtney Franklin
Veronica Franklin
Bill Freeland
Christina Freyss
Stephen Friedson
Michael K. Frith
Janet Froelich
Glen Fruchter
S. Neil Fujita
Leonard W. Fury
Danielle Gallo
Brian Ganton Jr.
Maria Garffer
Gino Garlanda
Einat Gavish
Tom Geismar
Steff Geissbuhler
Tricia Gellman
Mike Gentile
Muriel Gerardi
Janet Giampietro
Rob Giampietro
Amanda Giamportone
Kurt Gibson
Claire Giddings
Porter Gillespie
Frank C. Ginsberg
Sara Giovanitti
Bob Giraldi
Milton Glaser
Marc Gobé
Bill Gold
Roz Goldfarb
Bruce Goldstein
Samuel Gomez
Garland Goode
Joanne Goodfellow
Scott Goodson
Jonathan W. Gottlieb
Michael W. Gottlieb
Jean Govoni
Tony Granger
Don Grant
Joshua Graver
Michael Gray
Ali Grayeli
Geoff Green
Jeff Greenbaum
Robert Greenberg
Sean Greenfield
Melanie Greer
Abe S. Greiss
Simon Grendene
Robson Grieve
Jack Griffin
Olga Grlic
Andrea Groat
Glenn Groglio

Raisa Grubshteyn
Victoria Grujicic
Greg Grusby
Fernando Guerrero, Jr.
Noel Haan
Lori Habas
Robert Hack
Suzanne Hader
Bob Hagel
Kurt Haiman
Jonas Hallberg
Everett Halvorsen
Charles A. Hamilton
Vincent Hamilton
India Hammer
Leslie Hammond
Sammi Han
Marie Nicole Haniph
Ann Harakawa
Joanne Harmon
Jeff Harris
Sam Harrison
Benson Hausman
Douglas Hazlett
David Heasty
Eric Hegdahl
Cheryl Heller
Steven Heller
Debbie Hemela
Michael Hennessy
Anel Henning
Randall Hensley
Erin Herbst
Lauren Herman
Craig Hern
Edgar Hernandez
Kristine Ford Herrick
Nancy Herrmann
Marcus Hewitt
Samantha Hickey
Lee Hilands Horswill
Chris Hill
Cheryl Hills
Bill Hillsman
Carolyn Hinkson-Jenkins
Stephen Hinton
Andy Hirsch
Marilyn Hoffner
Mark Hollander
Sandy Hollander
Jed Holtzman
Michael Hong
Jane Hope
Daniel Hort
Michael Hortens
Kevin Houlihan
Anne Hrubala
Douglas Huffmyer
Pia Hunter
Brian Hurewitz
Mariko Iizuka
Manabu Inada
Bob Isherwood
Jarard Isler
Sarah Jackson
Harry Jacobs
Jan Jacobs
Ashwini M. Jambotkar
Justin Jameyson
John E. Jamison
Hal Jannen
Jaime Jara Cervantes
Ron Jautz
Loretta Jeneski
Patricia Jerina
Paul Jervis
Christian Johansson
Deborah Johnson
Dana Johnstone
Paul Judice
Alexander Judson
Eric Junker
Raquella Kagan
Ric Kallaher
Jon Kamen
Lauren Kangas
Sheryl Kantrowitz
Takako Kanzaki
Walter Kaprielian
Peter Karlsson
Julieta Kattan

Stacey Katzen
Sean Keepers
David Kegel
Iris Keitel
Adam Kennedy
Nancy Kent
Katherine Keogh
Claire Kerby
Candice Kersh
Sara Kidd
Kris Kiger
Satohiro Kikutake
Chris Kim
Sung Hee Kim
Caroline King
Nathalie Kirsheh
Susan Kirshenbaum
Judith Klein
Hilda Stanger Klyde
Andrew Kner
Henry O. Knoepfler
Susanna Ko
Kurt Koepfle
Gary Koepke
Andrea Kohl
Tae Koo
Daniel Korkhov
Shea Kornblum
Isabelle Kostic
Charlie Kouns
Justin Kovics
Damian Kowal
Dennis Koye
Neil Kraft
Julie E. Kramer
Ola Kudu
James Kuang-chun Kuo
Rebecca Kuperberg
Melissa Kuperminc
Rick Kurnit
Mara Kurtz
Ande La Monica
Anthony La Petri
Micah Laaker
Meghan LaBonge
Natalie Lam
Robin Landa
Jim Larmon
Lisa LaRochelle
Stacy Lavender
Paul Lavoie
Nick Law
Amanda Lawrence
Sal Lazzarotti
Jennifer Lee
Jungsue Lee
Kelly Lee
Saehee Lee
San San Lee
Gregory B. Leeds
Maru Leon
Emily Lepore
Jim Lesser
Mark Levenfus
Rick Levine
Charlotte Lewis
Stefanie Lieberman
Huy lu Lim
Andreas J.P. Lindstrom
Sari Lisch
Douglas Lloyd
Rebecca Lloyd
Patty Loaiza
Rob Loewen
George Lois
Monica Lopez
Juan Carlos López Claudio
Miriam Lorentzen
George Lott
Diane Luger
Jesper Lund
Ronnie Lunt
Greg Lyle-Newton
Yih Ma
Jason Macbeth
Richard MacFarlane
David H. MacInnes
Anne MacWilliams
Victoria Maddocks
Linda Maglionico
Lou Magnani

Jay Maisel
Romy Mann
Antonio Marcato
Jean Marcellino
David R. Margolis
Leo J. Marino, III
Jack Mariucci
Damien Marques
Pablo Marques
Andrea Marquez
Lance Martin
Joel Mason
Flavio Masson
Susan Mayer
Marce Mayhew
Chad McCabe
Louisa McCabe
William McCaffery
Brian Matthew McCall
Jason McCann
Steve McCloskey
Mei-Lu McGonigle
Kevin McKeon
Michael McQuade
Sean McQueen
Gabriel Medina
Jeff Meglio
Nancy A. Meher
Nancy Mendez-Booth
Ralph Mennemeyer
Juliette Merck
Justin Meredith
Parry Merkley
Jeffrey Metzner
Jackie Merri Meyer
Alejandro Meza
Madeleine Michels
Eugene Milbauer
Douglas Miller
Joan Miller
Kevin Miller
Lauren J. Miller
Mark Miller
Steven A. Miller
John Milligan
Wendell Minor
Michael Miranda
Beth Mitchell
Susan L. Mitchell
Sam Modenstein
Christine Moh
Jose Molla
Sakol Mongkolkasetarin
Ty Montague
Allan Montaine
Mark Montgomery
Rachel Moog
Maureen Mooney
Jacqueline C. Moorby
Diane Moore Behrens
Dan Morales
Cristina Moreno
Noreen Morioka
Minoru Morita
Alyssa Morris
William R. Morrison
JoAnn Morton
Louie Moses
Catherine Mouttet
Zak Mroueh
Alexa Mulvihill
Andres Munera
Yzabelle Munson
Ann Murphy
Brian Murphy
S. Murphy
Joe Murray
Steve Mykolyn
Eva Neesemann
James D. Nesbitt
Barbara Nessim
Robert Newman
Maria A. Nicholas
Mary Ann Nichols
Davide Nicosia
Kari Niles
Joseph Nissen
Yuko Nohara
Barbara J. Norman
Roger Norris
George Noszagh

Joseph Nother
David November
Kevin O'Callaghan
Jerid O'Connel
Wendy O'Connor
Bill Oberlander
Amy Odell
Ethan Oh
Meaghan Oikawa
Beverly Okada
John Okladek
Lisa Orange
Peter Orlowsky
Nina Ovryn
Jessica Owen-Ward
Bernard S. Owett
Ikuko Oyamada
Onofrio Paccione
Jason Pacheco
Melanie Pack
Paula Pagano
Frank Paganucci
Mike Pakalik
Sebastian Pallares
Brad Pallas
Marcel Parrilla
Strat Parrott
Linda Passante
Marc Passarelli
Chee Pearlman
Stan Pearlman
Brigid Pearson
Regine Pedersen
Ana Perez
Christine Perez
David Perry
Harold A. Perry
Victoria I. Peslak Hyman
Christos Peterson
Robert Petrocelli
Daniel Petrucelli
Theodore D. Pettus
Allan A. Philiba
Zoe Phillips
Eric A. Pike
Ernest Pioppo
Mary Pisarkiewicz
Robert Pliskin
Peter Pobyjpicz
Brian Ponto
Thomas Porostocky
Neil Powell
Tim Powell
Dan Poynor
Domenick Proprati
Don Puckey
Liz Quinlisk
Atul Rajhans
Brad Ramsey
Peter Raymond
Christopher Reardon
Samuel Reed
Kendrick Reid
Geoff Reinhard
Herbert Reinke
Joseph Leslie Renaud
Anthony Rhodes
David Rhodes
Stan Richards
Hank Richardson
Margaret Riegel
Lianne Ritchie
Arthur Ritter
Brandon Rochon
Jonathan Rodgers
Roswitha Rodrigues
Juan Carlos
 Rodriguez Pizzorno
Zoe Roman
Andy Romano
Dianne M. Romano
Jamie Rosen
Charlie Rosner
Peter Ross
Richard J. Ross
Tim Ross
Tina Roth
David Baldeosingh
 Rotstein
Alan Rowe
Mort Rubenstein

Randee Rubin
Anthony Rubino
Henry N. Russell
Don Ruther
Stephen Rutterford
Thomas Ruzicka
Jan Sabach
Rahul Sabnis
Stewart Sacklow
Randy Saitta
Robert Saks
Robert Salpeter
James Salser
Greg Samata
Steve Sandstrom
Nathan Savage
Robert Sawyer
Julie Sbuttoni
Sam Scali
Ernest Scarfone
Wendy Schechter
Nicole Schembeck
Paula Scher
Randall Scherrer
David Schimmel
Klaus F. Schmidt
Jonathan Schoenberg
Michael Schrom
Eileen Hedy Schultz
Tom Schumacher
Scot Schy
Joe Sciarrotta
Stephen Scoble
William Seabrook, III
GL Sears
J.J. Sedelmaier
Leslie Segal
Christian Seichrist
Pippa Seichrist
Ron Seichrist
Sheldon Seidler
Don Seitz
Thomas Seltzer
Audrey Shachnow
Martin Shova
Jackie Silvan
Karen Silveira
Louis Silverstein
Rich Silverstein
Robert Simmons
Todd Simmons
Milton Simpson
Leonard Sirowitz
Jennifer Skrapaliori Graves
Robert Slagle
Spencer Slemenda
Gary Sloan
Abby Smith
Carol Lynn Smith
James C. Smith
Kevin Smith
Kimberly Smith
Todd Smith
Virginia Smith
Eugene M. Smith Jr.
Christine Sniado
Steve Snider
Dewayne A. Snype
Aniela Sobczyk
Jeronimo Sochaczewski
Russell L. Solomon
Ashley Sommardahl
Harold Sosnow
Genevieve Southern
Harvey Spears
Heike Sperber
Serena L. Spiezio
Mindy Phelps Stanton
Amy Steibigel
Robert Steigelman
Doug Steinberg
Karl Steinbrenner
Holly Stevenson
Monica Stevenson
Daniel E. Stewart
Lisa Stewart
Colleen Stokes
Bernard Stone
Jimmie Stone
Terence M. Stone
Michael Storrings

Lizabeth Storrs Donnelly
Lisa Strausfeld
Peter Strongwater
William Strosahl
Snorri Sturluson
Myrna Suarez
Fredrik Sundwall
Matt Sung
Kayoko Suzuki-Lange
Scott Szul
Barbara Taff
Elizabeth Talerman
Penny Tarrant
Melcon Tashian
Jack G. Tauss
Sarah Tay
MarkTekushan
David Ter-Avanesyan
JP Terlizzi
Beau Thebault
Winston Thomas
GMD Three
Ken Thurlbeck
Tessa M. Tinney
Jerry Todd
Flamur Tonuzi
Nicholas E. Torello
Damian Totman
Gael Towey
Jasmine Trabelsi
Guillermo Tragant
Victor Trasoff
Rodrigo Trevino
Jakob Trollback
Dominique Trudeau
Jing Jing Tsong
Linne Tsu
Eiji Tsuda
Joseph P. Tuohy
Patricia Turken
Mark Tutssel
Anne Twomey
Kristian Umlauf
Roussina Valkova
Eric Van Speights
Jamie Vance
Kimber Vanry
Carlos Vazquez
Claudio Venturini
Frank Verlizzo
Amy Vernick
Taylor Vignali
Jovan Villalba
Frank A. Vitale
John Vitro
M. Scott Vogel
Jurek Wajdowicz
Kay Wakabayashi
Rick Wakefield
Glen Waldron
Richard Wallace
Joe Walsh
Michael Walsh Jr.
Katie Walton
Helen Wan
Jonathan Webb
Jessica Weber
Roy Weinstein
Ed Weinstock
Jeff Weiss
Marty Weiss
Lindsay Weitz
Renetta Welty
Wendy Wen
Robert Shaw West
Miriam White
Sabine Wieger
Tommie Mattias Wikman
Richard Wilde
Allison Williams
Craig Williams
Keith Williams
Maurice Williams
Mike Williams
Jay Michael Wolf
Gabriel Wong
Nelson Wong
Tracy Wong
Willy Wong
Tim Woods
Fred Woodward

Nina Wurtzel
John Yacat
Megumi Soleh Yamada
Takafumi Yamaguchi
Seong Im Yang
YunSook (Lucy) Yang
Takehiko Yasui
Henry Sene Yee
Rubina Yeh
Frank Yi
Ira Yoffe
Zen Yonkovig
June Yoshimura
Frank Young
Caprice Yu
Garson Yu
Frank Zabski
Christie Zangrilli
Mark Zapico
Rony Zeidan
Yuval Ziegler
Lloyd Ziff
Bernie Zlotnick
Jonathan Zweifler
Alan H. Zwiebel

ACADEMIC MEMBERS

Academic Members
College for Creative Studies
Miami Ad School
New York City College
 of Technology
Portfolio Center
Pratt Institute
School of Visual Arts
Universidad del Pacifico
VCU Adcenter

INTERNATIONAL MEMBERS

Australia
Jo Dalvean
Kathryn Dilanchian
Ron Kambourian
Sinéad McDevitt
Ashley Ringrose
Helmut Stenzel
Karel Wöhlnick

Austria
Tibor Bárci
Mariusz Jan Demner
Lois Lammerhuber
Silvia Lammerhuber
Franz Merlicek
Roland A. Reidinger
Matthias Peter Schweger

Brazil
Ademilson Batista da Silva
Mariana Bukvic
Felipe Leite
Samy Jordan Todd

Bulgaria
Velina Mavrodinova

Canada
Jean-Francois Berube
Twinkle Brygidyr
Rob Carter, R.G.D.
Thomas Chaput
Louis Gagnon
Wally Krysciak
Jean-Pierre Lacroix
Ric Riordon
Mark Stephens

Chile
Manuel Segura Cavia

China
Han JiaYing
Mei Qi
Lai Wei
Gabriel Wong
Wang Yuefei

Croatia
Davor Bruketa
Lina Kovacevic

Denmark
Sebastian Gram

Finland
Kari Piippo

Germany
Thomas Ernsting
Roland Gloeckner
Harald Haas
Oliver Hesse
Ralf Heuel
Michael Hoinkes
Armin Jochum
Matthias Kaeding
Amir Kassaei
Peter Keil
Claus Koch
Olaf Leu
Andreas Lueck
Friederike Mojen
Ingo Mojen
Lothar Nebl
Gertrud Nolte
Brian O'Connor
Friedhelm Ott
Stefan Pufe
Andreas Rell
Achim Riedel
Sven Hedin Ruhs
Thomas Sabel
Klaus Schaefer
Hans Dirk Schellnack
Holger Schmidhuber
Marc Oliver Schwarz
Urs Schwerzmann

Beate Steil
Andreas Uebele
Mathias Vietmeier
Oliver Voss
Gabriele Zuber
Joerg Zuber

Greece
Rodanthi Senduka

Hong Kong
Sandy Choi
David Chow
Fai Desmond Leung
Tommy Li
Zheng Si Jin

Indonesia
Rainer Michael

Ireland
Eoghan Nolan
Alvin Perry

Italy
Angela D'Amelio
Titti Fabiani
Milka Pogliani
Nicola Rovetta

Japan
Kan Akita
Takashi Akiyama
Masuteru Aoba
Hiroyuki Aotani
Norio Fujishiro
Shinsuke Fujiwara
Shigeki Fukushima
Osamu Furumura
Keiko Hirata
Seiichi Hishikawa
Kazunobu Hosoda
Kogo Inoue
Masami Ishibashi
Shoichi Ishida
Keiko Itakura
Yasuyuki Ito
Tetsuro A. Itoh
Toshio Iwata
Kenzo Izutani
Takeshi Kagawa
Hideyuki Kaneko
Satoji Kashimoto
Mitsuo Katsui
Fumio Kawamoto
Yasuhiko Kida
Katsuhiro Kinoshita
Hiromasa Kisso
Takashi Kitazawa
Kunio Kiyomura
Pete Kobayashi
Ryohei Kojima
Akiko Kuze
Arata Matsumoto
Takao Matsumoto
Shin Matsunaga
Iwao Matsuura
Kaoru Morimoto
Hideki Nakajima
Katsunori Nishi
Shuichi Nogami
Sadanori Nomura
Yoshimi Oba
Kuniyasu Obata
Toshiyuki Ohashi
Gaku Ohsugi
Yasumichi Oka
Akio Okumura
Toshihiro Onimaru
Nobumitsu Oseko
Hiroshi Saito
Toshiki Saito
Michihito Sasaki
Akira Sato
Naoki Sato
Hidemi Shingai
Norito Shinmura
Radical Suzuki
Zempaku Suzuki
Yutaka Takahama
Izumi Takahashi

Masami Takahashi
Shigeru Takeo
Masakazu Tanabe
Soji George Tanaka
Yasuo Tanaka
Norio Uejo
Katsuya Urabe
Katsunori Watanabe
Masato Watanabe
Yoshiko Watanabe
Yumiko Watanabe
Akihiro H. Yamamoto
Yoji Yamamoto
Masaru Yokoi
Masayuki Yoshida

Korea
Bernard Chung
Kwang-Kyu Kim
Kum Jun Park
Seungbae Park

Malaysia
Jackal Cheng

Mexico
Felix Beltran
Vanessa Eckstein
Juan Carlos
 Hernandez Camara
Luis Ramirez

New Zealand
Guy Pask

Nigeria
Frederick-Wey Oluseyi

Portugal
Eduardo Aires

Puerto Rico
Marcelo DiFranco

Russia
Leonid Feigin
Dmitry Peryshkov

Saudi Arabia
Ahmed Al-Baz
Atul Rajhans

Serbia
Dragan Sakan

Singapore
Victor Lim
Hal Suzuki
Noboru Tominaga

Slovak Republic
Andrea Bánovská

Slovakia
Majo Polyak

Slovenia
Vesna Brekalo
Matej Koren
Matt Penko
Jernej Repovs

Spain
Jaime Beltran
Manuel Estrada Perez
Daniel Robert Prieto

Sweden
Johan Dahlqvist
Kari Palmqvist

Switzerland
Stephan Bundi
Bilal Dallenbach
Martin Gaberthuel
Igor Masnjak
Andréas Netthoevel
Manfred Oebel
Dominique Anne Schuetz
Philipp Welti

The Netherlands
Pieter Brattinga

Taiwan
I-Hsuan Cindy Wang

Turkey
Pinar Barutcu

United Arab Emirates
Sama Al Rasheed
Shahir Ibrahim

United Kingdom
Stephen Hall
James Hutchinson
Domenic Lippa
Alison Mansell
David Mason
Harry Pearce
Aaron Shields
Rob Taylor
Jacob von Dormarus

**STUDENT
MEMBERS**

Bambang Adinegoro
Joel Arzu
Whitney Beemer
Benjamin Bours
Po Yee Chen
Charmaine Choi
Hyun Joo Choi
Alex Cortani
Joseph Esposito
Ayo Fanimokun
Peter Fetsch
Dani Golomb
Michael Gordon
Rhea Hanges
Jillian Harris
Elizabeth Hawke
Riddhika Jesrani
Giovanni Jubert
Aramazt Kalayjian
Mike Keller
Beom-Seok Kim
Chul Hwan Kim
Hye-In Kim
Hyeeun Kim
Hyun Jee Kim
Yonhee Kim
Gabriela Kopernicky
Dana Kraska
Mathis Krier
Minori Kuroishi
Ying-Ching Lai
Krzystof Lararz
Pan Lau
Han-Yi Lee
Hyun Joo Lee
Graciela Meza
Angela Minton
Stephanie Mongon
Emmanuel Mousis
Eri Nagakubo
Misa Naruse
Aaron Ohrt
Sheila Paige
Eric Perry
Christian Peters
Jennifer Pi
Jessica Pietrafeso
Byron Regej
Alan Rosenblatt
Stephanie Sarnelli
Ummi Diyana Shaharun
Jillian Siegle
Yoshino Sumiyama
Manoj Swearingen
Natallia Tsynkevich
Valerie Wagenfeld
Gavin Wassung
Brittany Megan Wycoff
Makoto Yamada

Index

Other Indices

Graphic Design, Illustration & Photography Studios

Interactive Agencies & Studios

Schools & Universities

Also Available From RotoVision

RotoVision

Sales and Editorial Office
Sheridan House
114 Western Road
Hove, BN3 1DD UK
Tel: +44 (0) 1273 727268
Fax: +44 (0) 1273 727269
www.rotovision.com

Fatto in Italia*

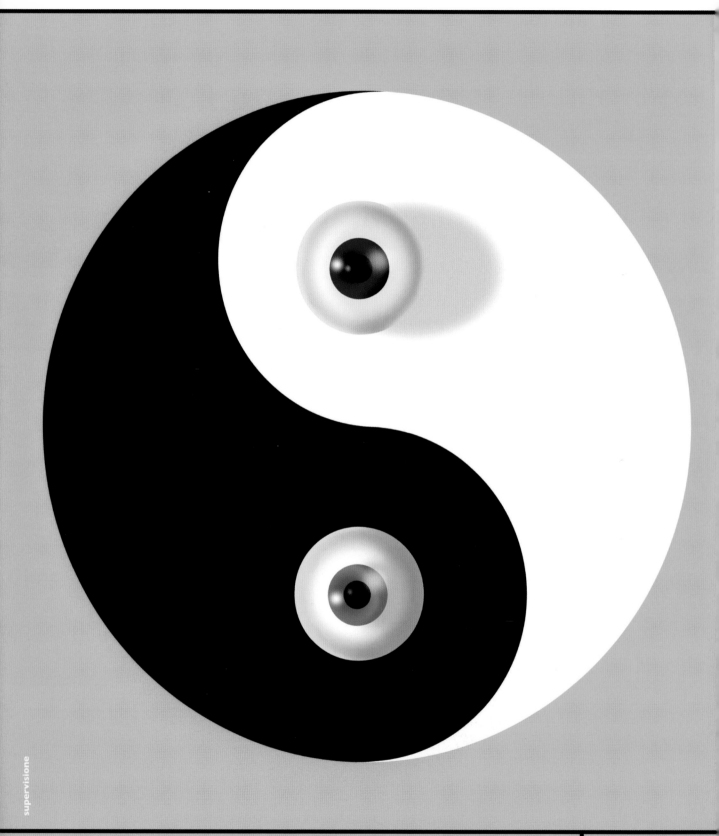

supervisione

ARTLAB

Quadrimestrale di teoria e pratica della visione, dedicato ai professionisti della progettazione grafica. Dal 2001.
Four-monthly magazine, in Italian, providing multi-disciplinary updates in the world of graphic design and imagery. Since 2001

www.artlab.it

*Made in Italy

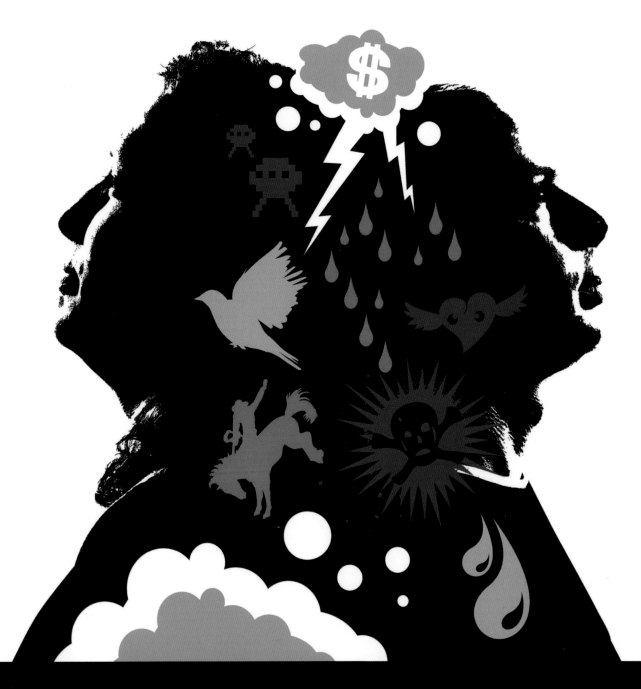

COVERING ALL THINGS
CREATIVE...

LINO Magazine is emerging globally. Covering exceptionally creative people in Design, Architecture, Fashion, Photography, Art and MixedMedia...

Australia and New Zealand's premier design lifestyle magazine

www.linomagazine.com.au

The best creative
minds rely on Creativity

TO SUBSCRIBE Visit AdCritic.com
Call 888.288.5900
E-mail subs@crain.com

TO ADVERTISE Adam Gold, Advertising Director
Call 212.210.0241
E-mail agold@crain.com

AdCritic·com spark*

Outlets for inspiring creative expression

Who knows where this year's big idea was born?
*All we do know is that we'll be at the
Art Directors Club 85th Annual Awards Gala to honor it.*

Visit advertising.yahoo.com

Design and Typography Magazine made in Argentina for the world

Since 1987, tpG has provided a forum for the debate, communication and exchange of ideas and knowledge. Its staff of advisors and contributors comprises top international specialists

tipoGráfica | Revista de diseño
JUNIO, JULIO, 2006
BUENOS AIRES, ARGENTINA

COMUNICACIÓN DAVID SLESS
El diseño de información: definir al hacer
OPINIÓN NORBERTO CHAVES
Diseño, crítica social y utopía
TIPOGRAFÍA
Premios *tipoGráfica* al diseño de fuentes latinoamericanas
HISTORIA GABRIELA SIRACUSANO
El color como clave indicial en tierras andinas
FOTOGRAFÍA JANET FOSTER
Misión en el Ártico

ISSN 0328-7777

tipoGráfica
MORE INFORMATION:
info@tipografica.com
www.tipografica.com

WWW

FTP

ASAP

24/7